Hans Holbein

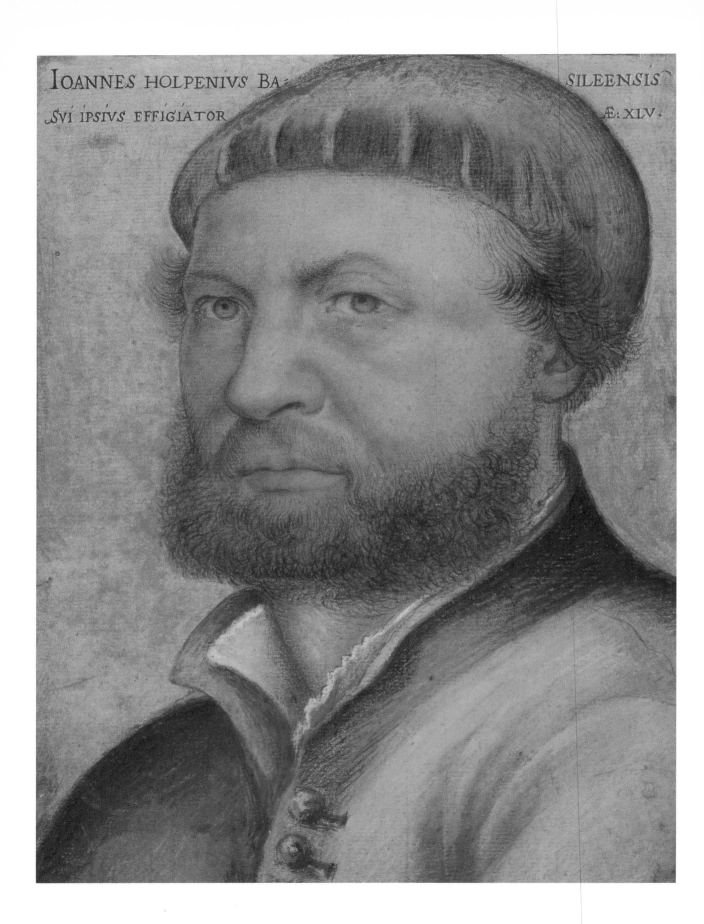

IOANNES HOLPENIVS BA= SILEENSIS

SVI IPSIVS EFFIGIATOR Æ: XLV.

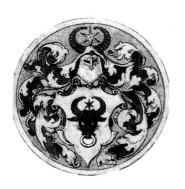

Hans Holbein

OSKAR BÄTSCHMANN *and*
PASCAL GRIENER

REAKTION BOOKS

Published by Reaktion Books Ltd
11 Rathbone Place, London W1P 1DE, UK

First published 1997

Translation by Cecilia Hurley and Pascal Griener
Designed by Ron Costley
Jacket designed by Ron Costley
Photoset by Wilmaset Ltd, Birkenhead, Wirral
Printed and bound in The Netherlands by Waanders, Zwolle

A catalogue-in-publication record for this book
is available from the British Library
ISBN 0 948462 96 5

(Frontispiece) *Self-portrait at the Age of 45*, c. 1542–3,
chalk, 23 × 18. Uffizi Gallery, Florence.
(Title-page) *The Coat of Arms of the Artist*,
pen and washes heightened with gold, 4.3 *cm* diameter.
British Museum, London.

Contents

Chronology

1497/98
Hans Holbein is born in Augsburg, the son of the artist Hans Holbein the Elder
(*c.* 1465–1524).
Hans and his elder brother Ambrosius (*c.* 1493/94–*c.* 1519) probably complete their
training in their father's workshop. Holbein the Elder is occupied on a number of
commissions in southern Germany (Augsburg, Frankfurt, Kaisheim, Isenheim in
Alsace). At the same time his brother Sigmund Holbein (*c.* 1470–1540) is working in
his studio.

1515
Holbein and his brother Ambrosius probably enter the studio of Hans Herbst in
Basle at the end of this year. It is likely that Ambrosius had spent the time since 1511/12
travelling. In 1515 he takes part in the painting of the Great Hall of the monastery of St
Georgen in Stein am Rhein. In Basle the brothers meet the theologian Oswald
Myconius (originally Geishüsler, 1488–1552), and it is possible that they attend his
writing and Latin lessons. They illustrate his copy of Erasmus' *Encomium moriæ –
Laus stultitiæ* ('In Praise of Folly') with marginal drawings and they produce a sign for
his writing and reading lessons.

1516
Holbein completes the double portrait of the newly elected mayor Jakob Meyer (1482–
1531) and his wife Dorothea Kannengiesser. Holbein signs the picture with the initials
HH and the date 1516. This signature seems to indicate that the young painter, who is
as yet only an apprentice, executes a commission originally given to Hans Herbst.
According to legal records the Holbein brothers are involved in the summer of 1516 in
a brawl with other men in Basle.

1517–19
Holbein is employed by the *Schultheiss* Jakob von Hertenstein (1460–1527) in Lucerne.
His father, the most respected painter in southern Germany, received the contract
and involved Hans the Younger and possibly also Ambrosius in the project. The
decoration of the facade is entrusted to Hans. At the same time he produces an
altarpiece for the Franciscan church in Lucerne, a portrait of Benedikt von
Hertenstein and designs for stained glass. A journey to Italy which, given the
connections of his main client with that country, would seem very possible, is not
documented. Holbein the Younger is fined on 10 December 1517 in Lucerne in
connection with a knife-fight.

1519
Holbein returns to Basle and on 25 September is received into the artists' guild Zum
Himmel as a master. He marries Elsbeth Binzenstock, the widow of a tanner. He

paints the portrait of Bonifacius Amerbach and is employed – just as his brother Ambrosius had been – by the town's publishers (Johannes Froben, Adam Petri and Thomas Wolff after 1520, Andreas Cratander and Valentinus Curio after 1521, and Johann Bebel in 1523). Nothing further is known about Ambrosius after 1519.

1520–24

These are the years of Holbein's greatest activity in Basle. On 3 July 1520 he is granted citizenship, and on 15 June 1521 he receives from the town the commission to decorate the new council chamber. Between 1520 and 1524 he also works for the councillor Hans Oberried, the town clerk Johannes Gerster (the *Solothurn Madonna*) and paints the facades of the house Zum Tanz belonging to the goldsmith Balthasar Angelroth. In addition Holbein paints the *Body of the Dead Christ in the Tomb*, the eight scenes of the *Passion of Christ*, and several portraits of Erasmus, who settles in Basle at the end of October 1521.

1524–6

It is probable that early in 1524, the year in which his father died, Holbein went to France in the hope either of procuring new commissions or of finding a position at the French court. While there he learns the technique of using coloured chalks, which he employs for the first time in the drawings he makes of statues in Bourges and in the portraits he produces in preparation for the *Darmstadt Madonna*. He discovers in France a new type of portrait and adopts the ideals of beauty of Leonardo and Andrea del Sarto.
Between the time of his return to Basle and of his departure for England must be placed the following works: the designs for stained glass depicting the Passion of Christ, the drawings for the *Dance of Death*, the first version of the *Darmstadt Madonna*, the *Laïs Corinthiaca*, *Venus and Cupid*, the *Last Supper* and the organ doors for the Basle Münster.

1526–8

Holbein's first stay in England. He travels to London via Antwerp with letters of recommendation from Erasmus addressed to Petrus Aegidius (Peter Gillis) in Antwerp and Sir Thomas More. During his first stay Holbein seems to have drawn and painted only portraits, among which are the family portrait of Thomas More and the portraits of the Archbishop of Canterbury, William Warham, of the Master of the Royal Household, Sir Henry Guildford, and of his wife Mary Wotton, Lady Guildford, and of the astronomer Nikolaus Kratzer.

1528–32

In August 1528 Holbein returns to Basle, where he buys a house. In 1531 he also acquires the neighbouring house. As early as April 1528 works of art were being removed from several churches in Basle and in February of the following year the churches were deserted during the *Bildersturm* and the remaining works of art were burned or given away as firewood. Erasmus retires to Freiburg im Breisgau in 1529. Holbein paints the portrait of his own family and transforms the *Darmstadt Madonna* into an epitaph.
In 1530 Holbein completes the painting of the council chamber and restores the painting and the gilding of the clocks on the Rheintor. It is probably just before his

second departure for England that he paints the small roundel portrait of Erasmus.

1532
Holbein begins his second stay in England. He probably left Basle before the middle of 1532 and again travels to England via Antwerp. As before he is provided with letters of recommendation from Erasmus. The Basle council that had granted him leave of absence for two years, sent to him as early as September 1532 the offer of a yearly pension of 30 florins.

1532–4
Holbein is employed as a portrait painter for the merchants of the Hanse in London, for members of the English court and for the French ambassador to England, Jean de Dinteville. It was for the latter that in 1533 he paints *The Ambassadors*, the double portrait showing Dinteville and Georges de Selve. In 1534–5 Holbein paints the half-figure portrait of Dinteville's successor, Charles de Solier, Sire de Morette. He produces the Triumphal processions of Wealth and Poverty for the banqueting-hall of the Steelyard, the Thames-side headquarters of the Hanse in London. It was also for the Steelyard that, in 1533, he prepares a decoration for the procession of Anne Boleyn at her coronation.

1533
The dates of Holbein's employment at the English court cannot be traced since the relevant documents are missing. It is probable that from 1533 on he is employed by Henry VIII to design jewellery for Anne Boleyn. Other indications of his activity there are the portraits of courtiers that are known from 1533 onwards (*Sir Richard Southwell*, 1533; *Thomas Cromwell*, 1534). In 1536 Nicolas Bourbon describes Holbein as the King's Painter. The accounts of the royal household from 1537 include Holbein as a court painter with a yearly income of £30. Among his works at this time are the portrait of Henry VIII in Whitehall Palace, the portraits of Henry's further potential spouses, and designs for decorative objects and utensils.

1538
Holbein takes advantage of a commission on the Continent to pay a short visit to Basle, where he is greeted with both honours and envy. The council of Basle raises its earlier offer for a permanent return to the town to a yearly salary of 50 florins and grants him a further leave of absence for two years were he to settle in Basle at the end of that period.
On his return journey to London Holbein takes his elder son Philipp to Paris to put him into service with the goldsmith Jacob David as a journeyman.

1539
Holbein is sent to the Continent to paint the portrait of Anne of Cleves, whom Henry VIII had chosen as his next wife after the negotiations for Christina of Denmark had fallen through. In this same year Holbein presents the King with the portrait of the two-year old heir to the throne, Edward, Prince of Wales.

1540
Holbein's uncle, Sigmund Holbein, dies in Berne. Holbein agrees to be represented

for the acceptance of his inheritance by his wife and her guardian and brother-in-law, Anthonin Schmid.

1541
Holbein produces, on command from the Company of the Barber-Surgeons, a painting showing Henry VIII granting a constitution and privileges to their guild.

1543
Holbein makes a will on 7 October that provides for the payment of his debts and the maintenance of two illegitimate children in England. It has been assumed that this will was written in preparation for a return to Basle. At the same time Holbein draws a self-portrait on which he describes himself as a citizen of Basle (IOANNES HOLPENIUS BASILEENSIS). He dies sometime between 7 October and 29 November in London, probably a victim of the plague. He was almost certainly buried either in the church of St Andrew Undershaft or in St Katharine Cree, both of which still stand in Leadenhall Street, EC3.

1 Antonius van Wyngaerde, St Paul's Cathedral, from the *Panoramic View of London*, ?1544, pen and brown ink, 25.4 × 40.5 (detail). Ashmolean Museum, Oxford.

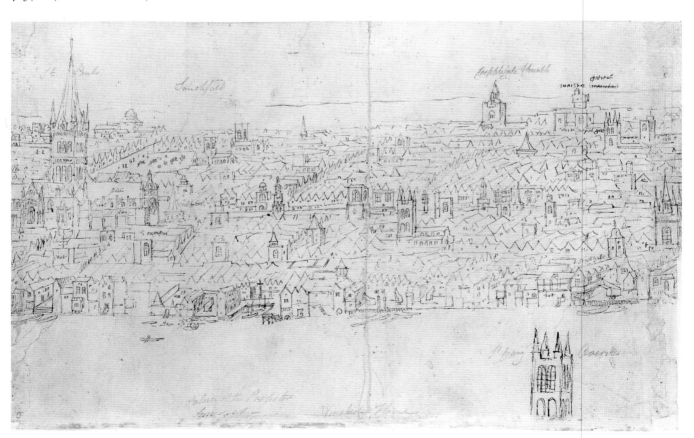

Preface

This book is neither a biography nor a *catalogue raisonné* of Hans Holbein, but an essay that seeks to cast some new light on important problems posed by his work. Our aim was to study the tasks and the difficulties faced by a Renaissance artist, one mainly active in Switzerland and England in the first half of the sixteenth century. Holbein was born in the winter of 1497–8 in Augsburg, one of the most important commercial centres in the German-speaking world. In 1515, while still a young apprentice, he found himself in Basle, a city well known for its university, as well as for its many busy printing-shops. It may be assumed that together with his brother Ambrosius he entered the workshop of Hans Herbst, whereupon he was immediately requested to make the portrait of the newly elected mayor, Jacob Meyer. In the years 1517–19 Holbein worked for one of Lucerne's great patricians, the *Schultheiss* Jakob von Hertenstein, while at the same time designing models for stained glass and painting altarpieces. After his return from Lucerne to Basle, Holbein received a major commission, the decoration of the new Rathaus; the members of the city administration added private commissions to this daunting task. He also worked for printers based in Basle and Lyon, and completed his famous portraits of Erasmus.

In 1524, probably driven by the ambition of becoming a court painter for François I, Holbein travelled to France. (At the beginning of the Reformation, Basle was becoming a difficult place for artists.) Having failed, it appears, to find patrons in France, Holbein sought for them in England: in 1526 he left Basle with a letter of recommendation from Erasmus to Sir Thomas More. In London Holbein worked for the latter and for his entourage, producing the earliest known group portrait made north of the Alps. From 1528 to 1532 he once again lived in Basle, and there he was able to finish some of the works he had undertaken before his departure. The council of Basle, however, failed to persuade Holbein to remain settled in the city, and he returned to London, where he portrayed the German merchants of the Steelyard, high officials of the court and foreign ambassadors; he also completed ambitious mural decorations, and designs for small jewels. Probably between 1533 and 1534 he became a regular painter for Henry VIII. He died at the end of 1543, probably from the plague.

In our opening chapter we deal with the way in which Holbein undertook to establish himself as an artist in a changing social context. It shows how he defined his own position by comparison with the greatest painter of antiquity, Apelles, and with the 'Apelles' of his own time, one of the greatest masters of the German Renaissance, Albrecht Dürer. It is important to see how Holbein made his claim to superiority in his art, and the role the Basle humanists played in shaping his new ideal of an artist, one rising above all craftsmen and fitted to become a court painter.

In chapter Two we raise questions that seem to have concerned Holbein himself – pertaining to imitation, the representation of figures in motion, and the representation of narratives in art. His artistic development, his ability to assimilate and transform

models are examined in the light of these questions. Chapter Three is based on these analyses, and in it we describe how Holbein managed his various tasks as a monumental painter in Lucerne, Basle and London. Almost nothing has survived of those works, except for fragments, sketches and copies. In chapter Four we tackle Holbein's religious works, principally those executed in Basle between 1520 and 1526, at a time of growing hostility from the Reformists towards images. Chapter Five is a discussion from a new viewpoint of a most controversial question, that of Holbein's relation to Italian and French art. In chapter Six we try to renew our vision of Holbein's work as a portrait painter, especially his interest in the articulation of Time and Death in the portrait. The final chapter traces the fame of our painter, from the Renaissance to the end of the eighteenth century.

Chapter One is based on an earlier text written in common and published in the *Zeitschrift für Kunstgeschichte*; chapters Two to Five were written by Oskar Bätschmann, and chapters Six and Seven by Pascal Griener, on the basis of the extensive documentation that resulted from our shared efforts. We could probably fill an entire room with the photocopied and faxed notes, questions and answers sent to one another or to other scholars over the last few years. But we have never tried to erase the differences between our respective approaches, and remain confident that they are complementary.

Our research was generously sponsored by the Hochschulstiftung of the University of Bern. This book owes much to earlier research, carried out at the instigation of Hans A. Lüthy, former director of the Swiss Institute for the Study of Art in Zurich. Respectively, as a Getty Scholar and as a Visiting Fellow of the Getty Center for the History of Art and the Humanities in Santa Monica, we have both been able to carry out our research in outstanding conditions. We should like to thank Kurt W. Forster, former Director of the Getty Center, for having shown interest in our work. Francis Haskell gave us full access to the collections of the Department of the History of Art in Oxford. A stay as Paul Mellon Fellow in the Center for Advanced Study in the Visual Arts, National Gallery of Art, made it possible to study the works of Holbein kept in Washington, DC, and allowed for important conversations with the Curator, John Hand. Georg Kauffmann allowed us to publish our first essay on Holbein and Apelles in the *Zeitschrift für Kunstgeschichte*. Positive reactions from colleagues – above all from Emil Maurer, John Rowlands, Herwarth Röttgen and Konrad Hoffmann – encouraged us to write this monograph on Holbein, which was suggested to us by Michael R. Leaman. We should like to thank our colleagues for most precious information and suggestions: Nikolaus Meier and Christian Müller (Kupferstichkabinett Basel), Christoph Müller (Chef-Restaurator, Augustinermuseum in Freiburg im Breisgau), and Gustav Solar (Zentralbibliothek Zürich). Cecilia Hurley, in addition to translating the text, took a decisive part in the rewriting of chapter Six.

Christoph Schäublin, with great patience and friendliness, corrected or retranslated our Latin transcriptions; Georg Germann and Volker Hoffmann (Universität Bern) gave us important advice on architectural matters. As ever, we have benefited from the sceptical remarks of Wilhelm Schlink (Freiburg im Breisgau); Küngolt Bodmer, Christine Day-Cavelti, Bernadette Walter and Danièle Héritier (Institut für Kunstgeschichte, Universität Bern) never spared their help in documentary research and in preliminary corrections of the text.

1 Artistic Competition and Self-definition

The divine hand of Apelles

For the German edition of Erasmus of Rotterdam's *Enchiridion* in 1521, Valentinus Curio, the Basle publisher, used an atypical printer's mark designed by Holbein the Younger (illus. 2).[1] Behind an archway supported on two decorated columns is a vaulted room; before it two seated and two standing putti hold up a monumental escutcheon. On the coat of arms appears a hand with a brush and paints, drawing a fine vertical line next to those already there. This motif is derived from Pliny the Elder's account of the legendary contest between the ancient Greek painters Apelles and Protogenes, in which they each attempted to paint the finest possible line, the *linea summæ tenuitatis*. Apelles was victorious, painting an even finer line than the one with which Protogenes had already bettered his first attempt. Pliny described the panel painting that resulted as the most famous artistic work in Antiquity.[2] Holbein chose to depict not only the panel that bore witness to this demonstration of artistic skill but added the hand emerging from a cuff of clouds, thus transforming the hand of Apelles from a merely skilful hand to a divine one. In later emblem books the hand appearing from the clouds, in accordance with early Christian and medieval authorities, would frequently be employed to represent the intervention of either a god or gods.[3] In a painted printer's sign for Johannes Froben, which can be dated to 1523, Holbein shows a pair of hands encircled by cuffs of cloud, holding the caduceus of Mercury with Christian iconographical elements, such as the dove, added to it (illus. 3).[4]

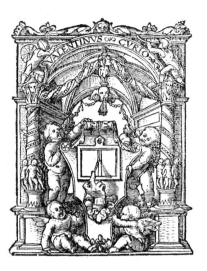

2 *The Little Plate of Apelles*, printer's mark for Valentinus Curio, woodcut, in Erasmus of Rotterdam, *Enchiridion...*, Basle, 1521. Universitäts-Bibliothek, Basle.

Once again the literary stimulus for Holbein's depiction of Apelles' hand, emerging, as it seems, from the surface of the image, is to be found in the *Historia naturalis*. Among the various works of Apelles, Pliny laid especial emphasis on a painting showing Alexander the Great with a thunderbolt in his hand. This work was renowned not only for its exceptional price of twenty gold talents but because the 'fingers have the appearance of projecting from the surface and the thunderbolt seems to stand out from the picture'.[5] What is interesting is that Holbein has chosen to repeat this innovation but with one important difference: this time it is used to represent the hand of Apelles himself.

Curio's printer's mark could be seen as merely a tribute to his skill at his trade, but it is in effect far more a representation of Holbein himself and of his main artistic concerns.[6] The entrance articulates surface and depth by means of the archway and the domed room pierced by an oculus. The putti exemplify the representation of volumes in space, while Apelles' divine hand demonstrates the artist's ability to suggest the effect of *basso rilievo*.

The earliest evidence we have of Holbein's interest in the depiction of volumes is to be found in a drawing in the margin of Erasmus' *Encomium moriæ* ('Praise of Folly'), illustrating the passage where Apelles is mentioned (illus. 4). The *Encomium* briefly refers to Venus and then directly after this moves on to discuss Apelles and Zeuxis.

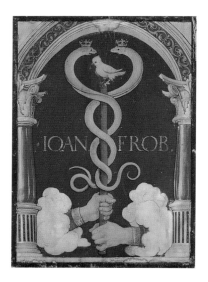

Their paintings of the goddess are not mentioned, however, and Erasmus' text concentrates on the privilege of possessing a work by these two artists. Holbein's drawing nevertheless refers back to the moment in the text in which Pliny discusses Apelles' painting of the Aphrodite Anadyomene.[7] It is indeed in this illustration that Holbein first considers the legendary ancient painter. A further commentary on artistic practice in these marginal drawings to the *Encomium* is to be found in the sketch of the Chimæra, where the mythological creature is depicted as she is described in Horace's *De arte poetica* (illus. 5). Erasmus' character of the Moria pokes fun at the rhetorical art of the preachers and the way in which they ape the ancient orators, baffling their listeners with overly subtle and abstruse theological arguments. She compares their crazy and foolish speeches, their wild combination of arguments and arbitrary use of associations, and their lack of reasoning with the Chimæra as described by Horace:

If a painter chose to join a human head to the neck of a horse, and to spread feathers of many a hue over limbs picked up now here now there, so that what at the top is a lovely woman ends below in a black and ugly fish, could you, my friends, if favoured with a private view, refrain from laughing?[8]

In the edition of the *Encomium* that Holbein illustrated with his marginal sketches – the one published in Basle in 1515 – only the first two words of Horace's text are

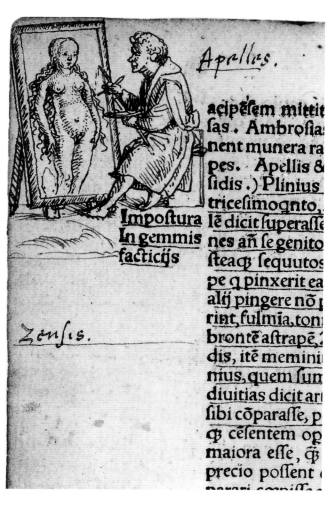

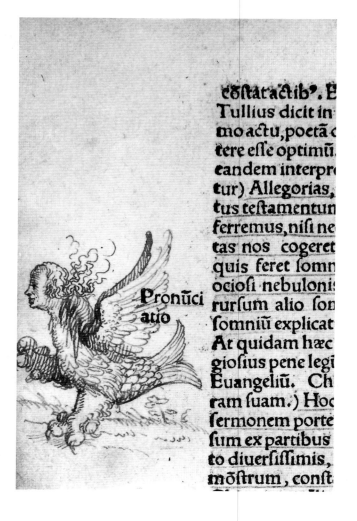

cited: 'Humano capiti &c.' Holbein must therefore have consulted Horace's text for the description of the Chimæra, while at the same time ignoring the author's refusal to accept such a fantastic artistic creation.[9] Contrary to both Horace's and Erasmus' readings, Holbein used the Chimæra as a sign of the painter's claim to fantastic inventions. An expression of this can be seen in the architectural ornamentation on the facade of the house Zum Tanz in Basle (illus. 6), which dates from the early 1520s. These ornaments follow none of the established rules, nor do they participate in any structural function. The facades are constructed in perspective for the viewer in the street, but the production of this illusion is only a part of the effect intended – that of bewildering the viewer by the means of architecture that has no functional purpose. The architectural elements – triumphal arches, colonnades, balustrades and ædicules – add their effect to that of the sculptures and figures, to propose a series of contrary movements, here jutting forwards, there receding. Some arches, leading the viewer's eye backwards, are drawn away from protruding gabled pavilions designed as frames for the doors and windows. A pillar is planted in the middle of one of these arches. In front of this again, a horse with its rider rears, while beneath them, between the wide projecting architraves of the lower triumphal arch, a terrified soldier standing on a pavilion spins around, his arm raised. To this motif of horror is added one of visual deception on the ground floor, where a figure lounges, his

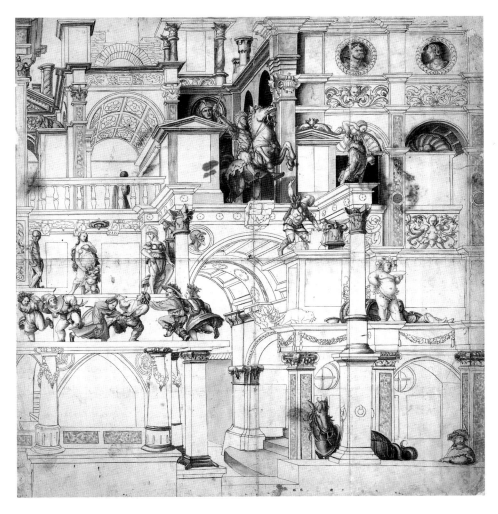

4 *Apelles Paints a Picture of Venus*, pen border drawing on fol. L 3v of Erasmus, *Encomium moriæ*, Basle, 1515. Öffentliche Kunstsammlung, Basle (Kupferstichkabinett).

5 *Chimæra*, pen border drawing on fol. Q 4v Erasmus, *Encomium moriæ*, Basle, 1515. Öffentliche Kunstsammlung, Basle (Kupferstichkabinett).

6 Copy after Holbein, *Sketch for the Facade of the 'Zum Tanz' House*, pen and washes, 62.2 × 58.5. Öffentliche Kunstsammlung, Basle (Kupferstichkabinett).

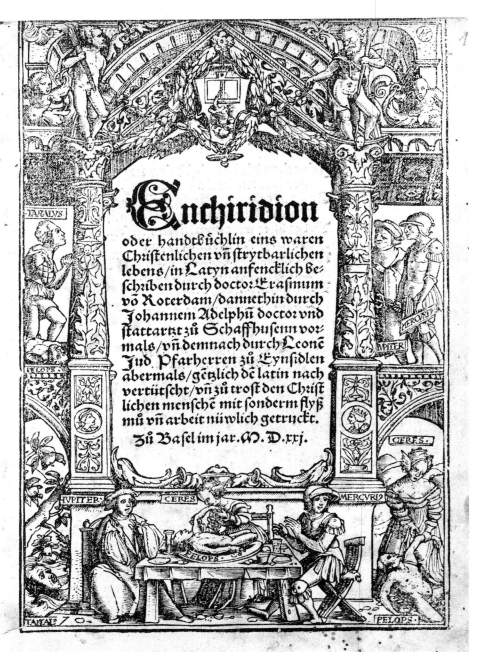

7 Title-border for Erasmus, *Enchiridion...*, Basle, 1521. Universitäts-Bibliothek, Basle.

8 Roman *Mercury*, limestone, 148 × 61. Maximilian-Museum, Augsburg.

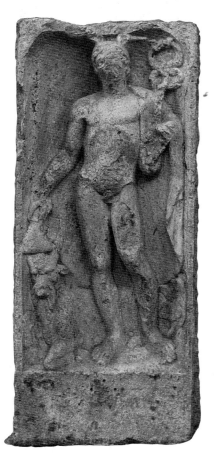

horse nearby.[10] This whole assemblage, seemingly composed without any attention to rules, establishes a chimeric architecture as the product of artistic fantasy. To achieve it Holbein uses in a masterly manner a range of devices that procure a debouchment from the surface: projections, effect of *rilievo* and lifelike imitation.

These plays on surface and depth signal Holbein's interest in what he considered to be an artistic problem of capital importance, whatever the nature of his commissions.[11] The painted surface is the raw material used by the painter to produce the magical effects of volume and life. Its architectonic equivalent is the archway, where volumes and depth combine, a form he often used. In the title-border for Erasmus' *Enchiridion* (illus. 7), one of the many graphic works he was commissioned to make at the time, the motif of the archway is varied, since Holbein hangs the panel of Apelles from the angle of the pediment beneath the arch and adorns it with garlands.

Holbein's central artistic concern has two aspects: fantastic creation and virtuoso imitation.[12] At the end of his lecture on non-Italian art since the fifteenth century in the version of 1891, Jacob Burckhardt spoke about Holbein's apparently free use of forms: 'he combines at will'. Burckhardt confronted Holbein's arbitrary combination of forms with his sensitivity to the different nature of each of his assignments: 'But he knew very well how to differentiate between their individual usages: for decorative purposes (facades, title-borders, stained glass etc.) he poured out his full resources, while his panel paintings show much more serious architectural features, and they are used in a moderate fashion or even neglected.'[13] More than being just a readiness to respond to various assignments, the aim of art was the thorough imitation of nature, limiting the freedom to combine forms.

There is for this a parallel that Holbein himself cannot have known. In the first chapter of Cennino Cennini's *Libro dell'arte*, Cennini claims for the painter the freedom to exploit his powers of fantasy, but also demands great skills of craftmanship from the artist: 'Painting requires fantasy but also the skill in craftmanship, in order to find things which have never been seen before, in order to find something beyond the shadow of natural objects, and to fix it with the hand, so that can be made to exist what does not exist' (*quello che non è, sia*). Cennini's handy formula for artistic creation was new, and it could support the claim of painting to equal poetry in prestige, a claim that was to be rich in its consequences.[14]

Relief and depth

One can try to reconstruct the reasons for which the young Holbein focused on these artistic problems, not all of which were necessarily a result of the training he received in his father's workshop. For example, he may have seen in Augsburg the Roman relief with the figure of Mercury that was excavated around 1500 near St Ulrich (illus. 8). The humanist and town secretary Conrad Peutinger had it set into the back wall of his stables, and then published it in the 1520 edition of his *Fragmenta* (illus. 9). For Albrecht Dürer, who knew of this sculpture at the beginning of the sixteenth century, it was a vital piece of evidence for his studies on proportions.[15] For Holbein, however, the relief was of interest neither purely as an archæological discovery, nor as an incentive for studies on proportions or postures. It was perhaps only one of many works that helped him to formulate his own artistic questions.

In 1505 Dürer produced engravings in which a horse was shown standing in front of an archway. These engravings have a theoretical value since, according to Panofsky, they deal with two major artistic questions. In the *Large Horse* Dürer sought to find the best expression of the volume of the animal, whose rump seems to protrude beyond the surface of the engraving. In the *Small Horse* (illus. 10) it is the ideal proportions of the animal that are being explored.[16] In the *Large Horse* a column and a wall close the composition behind the animal, while in the *Small Horse* the background produces a strong illusion of depth beyond the well-defined form. In both images the problem of proportions and of iconography are of lesser importance. In addition, Dürer intended to discuss these problems when he was working on his manual on painting. Only a fragment of the plan for this work remains, a passage where the artist evokes the relation between relief and colour.[17]

It is clear that Holbein wished to give the impression that his volumes were project-

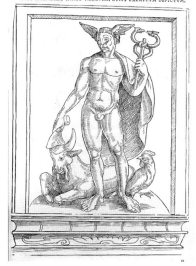

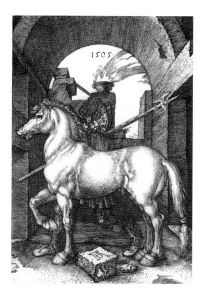

9 Anonymous woodcut of the *Mercury of Augsburg* in Conrad Peutinger, *Romanæ Vetustatis Fragmenta...*, Mainz, 1520 edition. Universitäts-Bibliothek, Basle.

10 Albrecht Dürer, *The Small Horse*, 1505, engraving, 16.5 × 10.8. National Gallery of Art, Washington, DC.

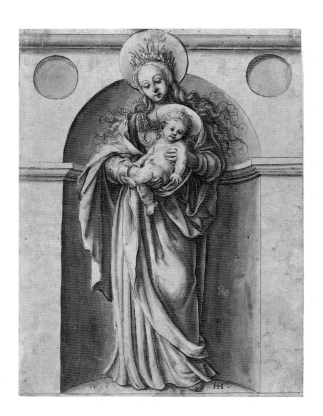

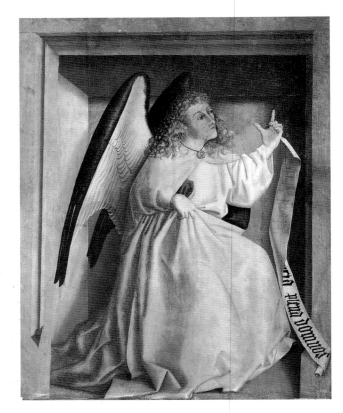

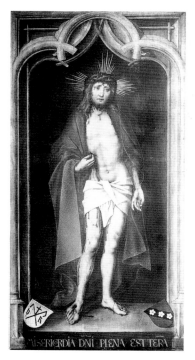

13 Hans Holbein the Elder, *Christ as the Man of Sorrows*, *c.* 1504, spruce, 115 × 55. Schweizerisches Landesmuseum, Zurich.

ing from a deep-set background: his aim by this was to give more energy to his figures. The most striking example of such a strategy may be seen in the drawing of 1520 showing a standing Virgin and Child (illus. 11). The niche seems to have been gouged into the surface of the wall; within it the artist has positioned the statue of the Virgin, drawn with great energy and *rilievo*. The fact that the Virgin was too tall in proportion to the niche did not trouble him. As far as he was concerned the effect thus attained was sufficiently striking, giving the impression that the Virgin and her Child are alive.[18]

In Basle the young Holbein may have seen a work whose importance cannot be overestimated, the *Heilspiegelaltar* painted by Konrad Witz for the church of St Leonhard. In three of the five remaining panels – the *Angel of the Annunciation* (illus. 12), the *Ecclesia* and the *Synagoge* – the surface of the painting seems to be pierced by the garment and the scrolls. In all the panels the plasticity of the figures is enhanced through their framing in a deep but narrow box. The walls are brightly illuminated or remain dark; the figures cast shadows.[19]

The outer wings of van Eyck's Ghent altarpiece exploited this device as early as 1432, but here it was rather through the imitation of stonework. This example was to lead to a vast range of refinements and imitations of natural materials.[20] Witz seems to have translated these Netherlandish sophistications into his own, simpler idiom.

Holbein the Elder must have been acquainted with such Netherlandish devices, although he does not seem to have paid too much attention to the problems involved. In some rare works, such as the *Christ as the Man of Sorrows*, he set his figure within a niche (illus. 13). But his attempts remain limited in scope: his main aim was to build his figures in *rilievo*, not to create a dynamically convincing figure through a sharp contrast between surface and depth.[21]

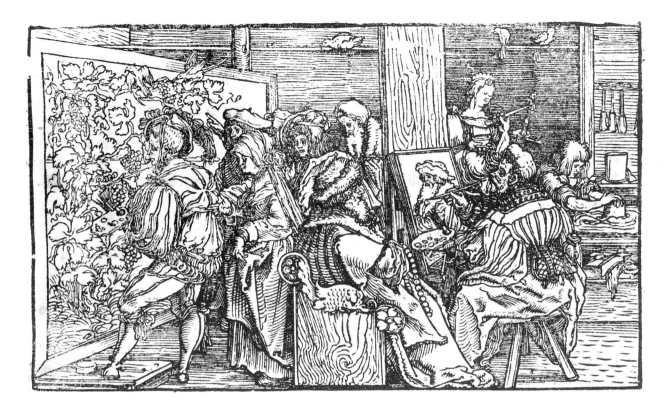

In the first German edition of Petrarch's *De remediis utriusque fortunæ*, which was published after lengthy preparation in 1532 by Heynrich Steyner in Augsburg, the Petrarch Master illustrated the desire for a painted panel (*einem gemalten täfelin*) in his representation of an artist's workshop (illus. 14). The woodcut shows both the painter at work and the amazing effect of his work. To the right we see the older painter working on the portrait of a client who sits next to him. To the left a richly dressed younger artist is putting the final touches to the vines and bunches of grapes included in an immense canvas. Behind him stand admiring spectators, while birds fly down to the canvas in order to remove the grapes. This scene refers to the famous anecdote recorded by Pliny in his *Historia naturalis*: Zeuxis painted such perfect grapes that even the birds were fooled.[22]

11 *Madonna and Child in a Niche*, 1520, pen and washes, 20.9 × 15.5. Herzog-Anton-Ulrich-Museum, Braunschweig.

12 Konrad Witz, *Angel of the Annunciation*, fragment (exterior) of the *Heilspiegel Altarpiece, c.* 1435, varnished tempera on canvas mounted on oak, 86.5 × 69. Öffentliche Kunstsammlung, Basle.

14 The Petrarch Master, *The Painter's Workshop*, woodcut from Petrarch, *Von der Artzney bayder Glück . . .*, Augsburg, 1532. Kunstmuseum, Berne.

The fame of Apelles

The *Historia naturalis* was written during the first century A D, and its author considered Apelles, who had lived four centuries earlier, to be a legendary artist. Pliny celebrated Apelles as the painter who had surpassed all other artists, be they his predecessors or those who had followed him. Through his works and his teaching manuals he had done more to improve art than any other artist. According to Pliny, Apelles insisted on the fact that in the representation of charm – *venustas* – he was superior to all contemporary painters. At the same time he did not deny that others had greater abilities in matters of composition and of perspective. Alexander the Great provided an extraordinary example of the honours deserved by great artists: visiting Apelles in his studio and discovering that the artist had fallen in love with his concubine Pancaspe

while painting her in the nude, Alexander gave her to him. For works of art by Apelles one had to pay exorbitant prices, to the extent that it was not a matter of paying by counting out the pieces of gold but rather by weighing them out.[23]

Pliny gave a short commentary on the most famous of Apelles' works: the Aphrodite Anadyomene, Alexander the Great with the thunderbolt in his hand, a naked hero and a horse, both of which rivalled nature, and portraits that so perfectly captured the features of the subjects that they allowed seers to foretell the life expectancy of those portrayed. Pliny already regretted the complete loss of many of these masterpieces: the board with Apelles' and Protogenes' lines was destroyed in a fire in Caesar's palace on the Palatine, the first painting of Aphrodite rotted away, and a second one, unfinished when the painter died, could not be completed by anyone else. Other works had been mutilated. For the artists of the Renaissance, the lost paintings and writings of the Ancients became absolute keys to their own education. In *De pictura* Leon Battista Alberti extolled, with considerable consequences, the *Calumny of Apelles* as a model for all artistic creation; that work, however, is only known through a text (illus. 21).[24] Filarete recalled the lost treatise that Apelles had devoted to his art. Dürer, in the notes to his manual of painting, bemoaned the loss of all the ancient artist's writings: 'And many centuries ago, they were true great masters, about whom Pliny writes, like Apelles, Protogenes, Phidias, Praxiteles, Polyclitus, Parrhasios and the others. Those artists have written beautiful books on painting, but alas, they are now lost. They have vanished for us, and we miss their wisdom.'[25] It was by reference to this ancient perfection, which could not be substantiated by any extant works, that Aretino refused in 1537 to grant the title of 'greatest of all artists' to Michelangelo.[26] In 1510 Nicoletto da Modena produced an engraving showing Apelles in front of a monument with two broken columns (illus. 15). The consummate artist of Antiquity is shown wearing the laurel wreath of the poet and meditating before a drawing of geometrical figures. The accompanying inscription calls him the 'POETA TACENTES A TEMPO SVO CILIBERIMVS' (mute poet, most highly celebrated of his age).[27] In a woodcut for the *Weisskunig* Hans Burgkmair illustrated the young Maximilian's visit to an artist's workshop (illus. 16), where the painter is hard at work. The text explains that a wise elder had counselled the young prince to learn how to paint. Not only had Maximilian learned the craft with great enthusiasm, but he had also gained from it much that would be of profit, especially for warfare, for architecture, for the understanding of art and for the patronage of artists. Burgkmair's woodcut, however, does not show the young monarch as a pupil, but chooses rather to represent his arrival at the artist's workshop, thus establishing an analogy between Maximilian and the painter and Alexander the Great and Apelles. The artist is exercising his skill on representations of animals and of tools, as they appear in pattern-sheets or on the so-called Holbein Table.[28]

The artists of the time were forced by the men of letters into a struggle with models and creations that were mystified as being almost unattainable.[29] The humanists found in the Ancients' writings a rich, inspiring corpus of artistic models and the warrants of their own value. Pliny, with his compilation of lost literary works provided them with a wealth of anecdotes, on which they could draw as if on an encyclopædia. Apelles' rebuke to Protogenes that the latter had not understood how to finish with a work, became in Erasmus' work the adage *Manum de tabula*: excess of meticulousness mars a literary work.[30] Both Erasmus and Melanchthon repeat the famous anecdote recounted by Pliny that the damaged *Aphrodite Anadyomene* by Apelles was not restored

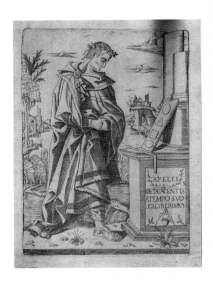

15 Nicoletto da Modena, *Apelles poeta tacentes a tempo suo ciliberimus*, engraving, *c*.1510, 20.9 × 17.7. Öffentliche Kunst-sammlung, Basle (Kupferstichkabinett).

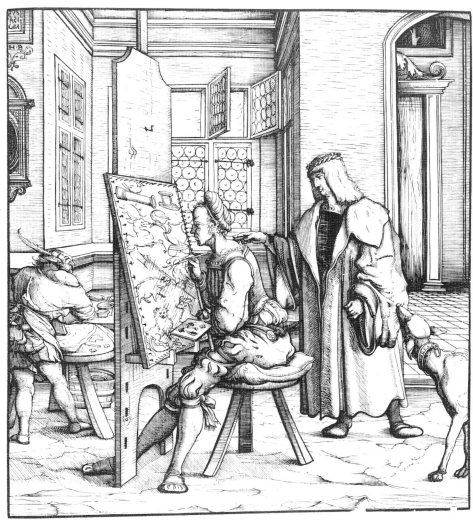

16 Hans Burgkmair, *The Weisskunig Visits the Workshop of the Painter*, 1514–16, woodcut, 20 × 19.7. Institut für Kunstgeschichte, Berne.

out of the utmost respect for the master's skill.[31] For generations of scholars this anecdote exemplified the fact that the gaps in classical literature could not be filled up. For Erasmus it represented the exemplum of absolute fame, after which many authors of his time were striving in vain. In his foreword to the edition of Pliny's works published by Johannes Froben in Basle in 1525 he sighed enviously: 'Some works were so divine that, by virtue of their art, they prevented all the artists from applying their hand, either to complete them if they were left unfinished, or to restore them if they were damaged'.[32] The artists, deprived of all painted models, were referred to individual descriptions in classical literature. Since these models were also being studied by modern scholars and men of letters, the artists who wished to base their work on classical references needed ultimately to content themselves with producing a reflection of the pictures that the humanists were outlining.[33] The metaphors of mirror and projection are illuminating for the relationship between men of letters and artists. Dürer compared the unlearned man to a cloudy mirror: 'Homo indoctus est quasi impolitum speculum'.[34] Conrad Celtis projected in 1500 the image of Apelles onto his friend Dürer: 'Alberte . . . Alter ades nobis Phidias et alter Apelles / Et quos miratur Grecia docta manu'.[35] Two skilled hands should therefore work together, one with a pen, the other with a brush. Celtis certainly had the intention, with his eulogy of the artist, to persuade him to produce a title-woodcut for a book he was preparing.

The designation 'Second Apelles' (*alter Apelles*) was, as far as we know, first used in an inscription for Fra Angelico, who died in Rome in 1455 and was buried in S Maria sopra Minerva. Nicholas V probably commissioned two inscriptions from Lorenzo Valla, one of which took into account the deceased's request that he should be famed not for the fact that he was considered as a second Apelles but rather that he had led a pious life.[36] In his *Epithoma rerum germanicarum* of 1505 Jacob Wimpheling referred to the honour of Martin Schongauer, among which was that of his famous pupil: 'His pupil Albert Dürer, himself a German, most excellent in his representation of lightning, and who in Nuremberg paints most beautiful images'. The praise accords with that of Pliny, who reckoned as the exceptional creations of Apelles the depiction of the undepictable, such as thunder, flashes of lightning and sheet-lightning.[37] The distinction of Dürer as a second Apelles was repeated by Christoph Scheurl in his *Libellus de laudibus Germaniæ* of 1508.[38] Erasmus, in his eulogy of Albrecht Dürer in 1528, which became an epitaph for the recently departed painter, called him the Apelles of his age, who had equalled and surpassed the creations of the first Apelles. Dürer had not only depicted the undepictable, but he had achieved it with the use of only one colour, that is with black lines, shading, light, lustre, effects of projection and depth.[39]

Many of the points of Erasmus' text refer, as Erwin Panofsky has shown, to passages concerning Apelles and other painters in Book xxxv of Pliny's *Historia naturalis*. This bears witness to the difficulties faced by the humanists in commenting on the worth of the artists of their day without any literary reference to classical literature. The *topoi* of the comparison and the transference of anecdotes to the modern artists acted as mediating structures between admiration and literary practice. The humanists and the artists agreed on an unspoken contract: the artists aligned themselves to the model of the *pictor doctus*, the humanists were promoted to the rank of experts on, and recipients of, art.[40] Certainly Erasmus, in a letter of introduction addressed to Peter Gillis in Antwerp, called Holbein an *insignis artifex* – an exceptional artist, but it was for Dürer that he reserved the title of the Apelles of our time.[41] The humanist Beatus Rhenanus (1485–1547) from Schlettstadt, who studied in Basle, took the opportunity in his commentary to the preface of Pliny's *Historia naturalis*, to recommend that Dürer, Holbein and other artists of the time should be called *auctores* (authors) thus developing the analogy with authors of texts, poets and savants (see the Appendix).[42]

Signatures and inscriptions

As an ambitious journeyman Holbein signed his works simply with the initials HH and the year, although he did not have the right so to do.[43] In Lucerne on the facade of the Hertenstein house (illus. 81) he incorporated an encoded signature for his work; he showed in the midline above the two pictures that related directly to his patron, a representation of Mucius Scævola, or Mucius the Left-handed (illus. 17). Holbein's first representation of the Roman hero Mucius Scævola, who as proof of his people's strength of character let his right hand burn in a fire under the eyes of the Etruscan ruler Porsenna, appeared in 1516 on the title-page to Thomas More's *Epigrammata clarissimi disertissimique viri*. Holbein was left-handed, and could not draw at all with his right hand. That Mucius Scævola was intended as a self-reference

17 *Mucius Scævola puts his Right Hand into the Fire*, 1825 pencil copy of the 1517/19 wall paintings in the Hertenstein House in Lucerne, 20.6 × 20.6. Zentralbibliothek, Lucerne.

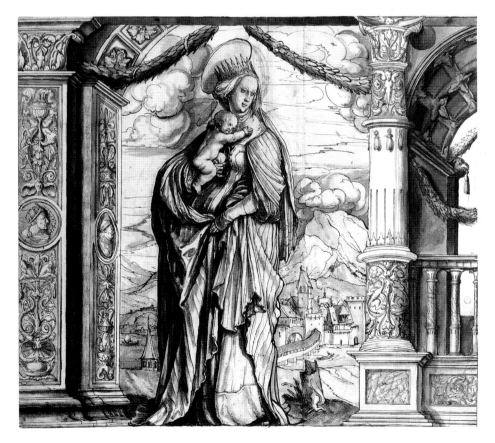

18 Workshop of Holbein, *Copy after a Stained Glass Design with Madonna and Child, c.* 1519, chalk, pen, watercolour and washes heightened with white, 42.2 × 46.6. Öffentliche Kunstsammlung, Basle (Kupferstichkabinett).

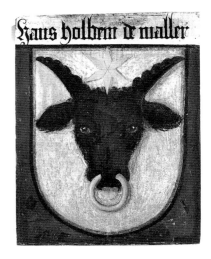

19 The coat of arms of *Hans Holbein de maller* in the escutcheon of the Society (Zunft) *Zum Himmel* in Basle, wood, 18.5 × 14.3. Historisches Museum, Basle.

is confirmed by a signature written in mirror-writing 'MVCIVSFEZ' (Mucius fec[it]) on a design for a stained glass, which is known through a studio copy from 1519 (illus. 18). This signature, which was placed on the left-hand column on a medallion, has been unexplained until now, and like the representations of Mucius Scævola, it can only be understood if the correspondence between Holbein and Scævola is known.[44] On the coat of arms for the guild Zum Himmel in Basle, where he was received as a master in 1519, another device was, however, chosen for 'Hans Holbein de maller' (illus. 19). His arms show St Luke's attribute (the bull) with a star. This is an obvious reference to the artist's association with his predecessor, Luke, author of one of the Gospels, and the legendary painter of the Virgin Mary.

It was while he was still in Lucerne that Holbein employed for the first time an imperfect tense in a signature. In the portrait of Benedikt von Hertenstein (illus. 20), one of the sons of his patron, he used the annotation 'DA.ICH.HET.DIE.GE / STALT.WAS.ICH.22. / IAR.ALT.1517.H.H. / DIPINGEBAT' (There I had this shape when I was 22 years old. 1517. H.H. painted [this]). For the frieze Holbein painted a triumphal procession, a variation on the Triumph of Caesar after Mantegna that he had already applied to the facade of the new Hertenstein house in Lucerne (illus. 81). In this inscription the sitter and the painter do not use the same language. The sitter writes as a living person and uses German, while the artist's activity is registered in Latin. Of equal importance is the fact that the artist should choose to employ the imperfect tense to describe his own activity, whereas the sitter writes about himself in the past tense.

The signature in the imperfect tense refers to Pliny's discussion in the dedication to the emperor Vespasian of his *Historia naturalis*. Here Pliny talks about the non-committal title of his work and compares this with the equally non-committal inscriptions in the imperfect tense on the masterpieces of painters and sculptors: '"Apelles faciebat" aut "Polyclitus"' (Apelles or Polyclitus was working on this). Pliny gives a detailed explanation of the use of the imperfect tense for the signature and then compares it with one in the perfect tense:

I should like to be accepted on the lines of those founders of painting and sculpture who, as you will find in these volumes, used to inscribe their finished works, even the masterpieces which we can never be tired of admiring, with a provisional title such as 'Worked on by Apelles' or 'Polyclitus', as though art was always a thing in process and not completed, so that when faced by the vagaries of criticism the artist might have left him a line of retreat to indulgence, by implying that he intended, if not interrupted, to correct any defect noted. Hence it is exceedingly modest of them to have inscribed all their works in a manner suggesting that they were their latest, and as though they had been snatched away from each of them by fate. Not more than three, I fancy, are recorded as having an inscription denoting completion – 'Made by' so-and-so (these I will bring in at their proper places); this made the artist appear to have assumed a supreme confidence in his art, and consequently all these works were very unpopular.[45]

In Pliny's view the artist's use of the signature in the imperfect tense was an expression of modesty and a form of defence against critics. At the same time this signature helped in creating the fiction that the work had been interrupted and could have been continued. This fiction of a possible subsequent completion was eliminated when the work was interrupted by death, as was the case with Apelles. By taking his

20 *Benedikt von Hertenstein*, 1517, tempera on paper, laid down on wood, 52.4 × 38.1. Metropolitan Museum of Art, New York.

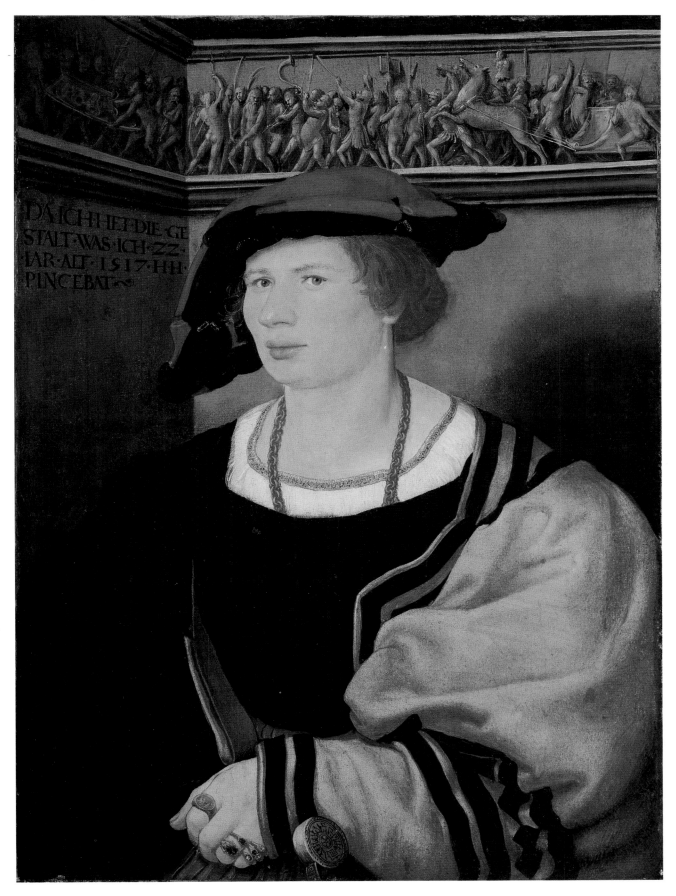

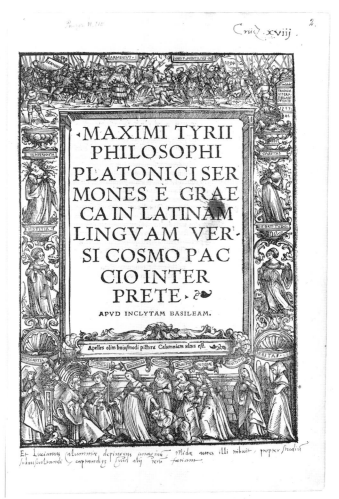

21 Ambrosius Holbein, *Title-border with the Calumny of Apelles*, published in 1518 and 1519, woodcut, 24.5 × 17, in Maximus Tyrius, *Philosophi Platonici sermones . . .*, Basle, 1519. Universitäts-Bibliothek, Basle.

22 Bonifacius Amerbach, *Sheet with Sketches of the Epigram for his Portrait*, 1519. Universitäts-Bibliothek, Basle.

hand away from the work and attesting to this with a signature in the imperfect, the artist acknowledged the unfinished state of the work and also the possibility of its subsequent completion. The signature in the perfect tense, on the other hand, declared that the work was finished and the artist's history completed. Pliny suggests that the act of finishing the work would be similar to the definitive end, which is marked by death. The imperfect tense compels the artists who survive the famous painter to take up the challenge to complete his unfinished work, only to discover their own inadequacy.

Pliny's reflections on the question of the signature were to attract much attention and many commentaries in the early sixteenth century. Around 1520 the young Bullinger, at the instigation of his tutor, carefully read a Paris edition of Pliny's works and marked the passages he wished to remember. He made marginal annotations to the discussion of Apelles' *Aphrodite*, which had remained unfinished because of the artist's death: 'Apelles cous venerem imperfectam veli quid quam nemo perficere ausus est'.[46] Here then, Apelles has left the work incomplete in order to demonstrate that no one can dare to try to finish it.

At the end of his commentary on Pliny, which was probably begun in 1524, Beatus Rhenanus discussed the reputation of the Greek painter and the question of the signature in the imperfect tense. In this connection he referred to the *Liber miscellaneorum* by the Florentine humanist Poliziano, which had been printed in Basle in 1522.[47]

26

According to Beatus Rhenanus, however, the signature in the imperfect tense no longer proved the modesty of the Classical painter. He felt that it was rather an attempt to emulate Apelles and thus to claim the same honours as he had been granted. This, in Rhenanus' view, was to the profit of the arts: 'Honos alit artes' (Honour nourishes the arts). In 1509 Christoph Scheurl recommended to his friend Lucas Cranach the use of the imperfect tense: 'I and our Pirckheimer, a man of the greatest erudition in Greek and Latin, request you to imitate what he recommended to our Dürer; so do I do it, this speech I did not make, but I was making it, I did not speak, but I was speaking, I did not declaim it but I was declaiming it'.[48] Dürer used this form of the signature in his altarpiece the *Adoration of the Holy Trinity*: 'AL-BERTVS.DVRER / NORICVS.FACIE / BAT.ANNO.A.VIR / GINIS.PARTV./ .1511.' (Albert Dürer of Nuremberg was making (this) in the 1,511th year since the Virgin birth). The signature, in capital letters, is written on a panel held by the figure of the artist himself.[49]

By his use of the signature in the imperfect, was Holbein reiterating his interest in Pliny's works or was he simply emulating Dürer, the second Apelles? In January 1519 the *Sermones* of Maximus Tyrus were published by Johannes Froben in Basle with a title-piece designed by Ambrosius Holbein (illus. 21). Around the edges of this woodcut the battle of the Germans against the Romans, the Virtues and the Calumny of Apelles are represented. In this work, commissioned in 1517, Ambrosius took up the theme made famous by Apelles, possibly based on an engraving produced at some time between 1500 and 1506 by Girolamo Mocetto.[50] In 1517 Holbein was already signing his works in the imperfect tense, and shortly afterwards he designed for Valentinus Curio the printer's mark depicting the panel that referred to the contest between Apelles and Protogenes (illus. 2). The further interest of the young artist for the legendary Classical painter is directly attested by his small painting *Laïs Corinthiaca*, which dates from 1526 (illus. 24). There were a number of women of Corinth who used the courtesan name of Laïs: one of them was reputed to be greedy for money, and it was possibly this same one who was the lover of Apelles.[51] In his painting of 1526 Holbein created a portrait of Apelles' Laïs, but for it he chose to borrow the ideals of feminine beauty established by the legendary artist of the modern age, Leonardo da Vinci. Holbein might possibly have seen some of Leonardo's works during his stay in France in 1524.[52]

In the first work that Holbein executed and signed as an independent master, the portrait *Bonifacius Amerbach* of 1519 (illus. 25), he demonstrated anew his understanding of humanist culture, albeit with the help of his client. Amerbach had been at great pains to compose the Latin distich in which the image portrayed, rather than the sitter, speaks (illus. 22). Holbein painted the verses on a small panel that hangs from a broken twig of a fig-tree, and he added in small capitals both the name of the sitter and his own with the verb 'DEPINGEBAT' and the date. The source of the roman capitals is Conrad Peutinger's publication of 1505 on the Roman inscriptions found in Augsburg (illus. 23), for which capitals similar to those in the inscriptions were cut.[53]

The epigram written by Amerbach parallels no fewer than three times the work of art with Nature. After the painted face has been granted the same value as the true face of the sitter, the outstanding achievement of the portrait as regards the portrayed is pronounced. Finally, the work of art is equated with that of Nature:

Although a painted face, I do not differ from the living visage, but I have the same

23 Conrad Peutinger, *Romanæ Vetustatis Fragmenta . . .*, Mainz, 1520 edition. Universitäts-Bibliothek, Basle.

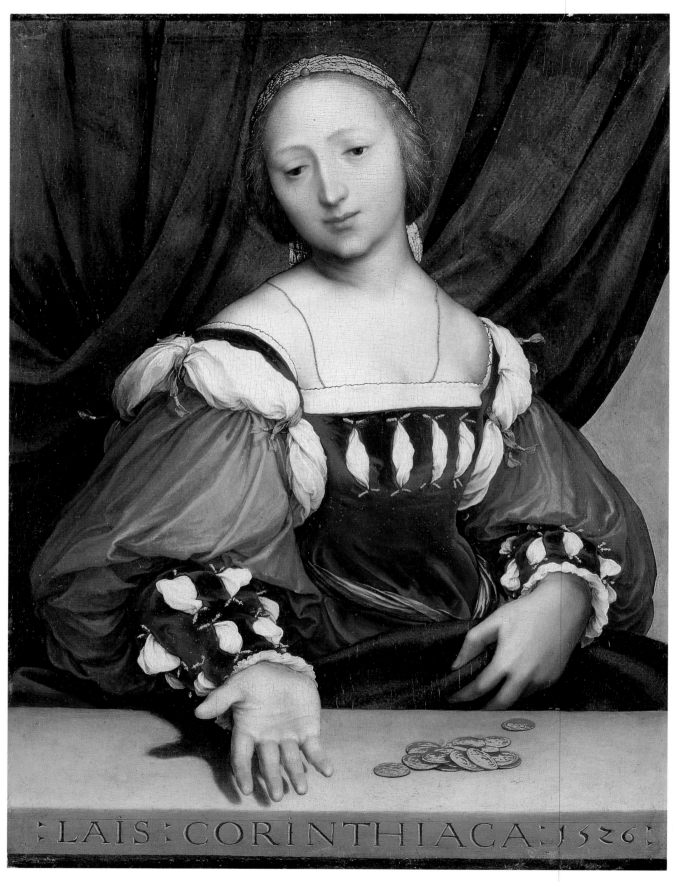

PICTA LICET FACIES VI
VAE NON CEDO SED INSTAR
SVM DOMINI IVSTIS NO
BILE LINEOLIS
OCTO IS DUM PERAGIT
TPIETH, SIC GNAVITER IN ME
D QVOD NATVRAE EST,
EXPRIMIT ARTIS OPVS·

BON· AMORBACCHIVM·
10· HOLBEIN · DEPINGEBAT·
A· M·D·XIX· PRID·EID·OCTBR

value as my Master, drawn with the help of exact lines. At the time when he had com-
pleted eight cycles of three years, [i.e., Amerbach was then 24] the work of art
represents in me, with all the exactitude that belongs to Nature.[54]

The distich describes the presence of the image, and celebrates its unsurpassable
character; it expresses, through the *depingebat*, the suspension of the work of the
artist, and the precise date assigns a limited validity to the representation, underlin-
ing a temporal splitting between the painted face and the real visage.

Holbein's portrait *Erasmus of Rotterdam* of 1523 (illus. 28), which was probably sent to
the Archbishop of Canterbury, William Warham, includes two inscriptions. One of

25 *Bonifacius Amerbach*, 1519, pinewood,
28.5 × 27.5. Öffentliche Kunstsammlung,
Basle.

24 *Laïs Corinthiaca*, 1526, limewood, 35.6
× 26.7. Öffentliche Kunstsammlung,
Basle.

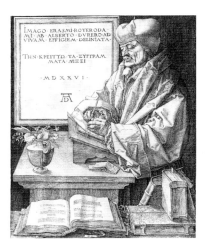

26 Albrecht Dürer, *Erasmus of Rotterdam*, 1526, engraving, 24.9 × 19.3. Öffentliche Kunstsammlung, Basle (Kupferstich-kabinett).

27 Albrecht Dürer, *Philipp Melanchthon*, 1526, engraving, 17.8 × 13.3. Staatliche Graphische Sammlung, Munich.

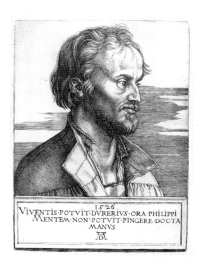

these, the identification of the sitter and of his pseudonym – that of Hercules – is on the edge of the book lying in front of Erasmus. The other is the artist's signature and is on the edge of the book resting next to the pitcher on the shelf. This second signature is in the form of a distich composed by Erasmus, which reads in full: 'M D XX III [IL]LE EGO IOANNES HOLBEIN, NON FACILE [VLL]VS / [TAM] [MICHI] MIMUS ERIT, QVAM MICHI [MOMVS ERI]T' (1523. That I, Johannes Holbein, will less easily find an emulator than a denigrator). William Heckscher relates this to an axiom of Zeuxis reported by Pliny, that carping is easier than imitating.[55] A similar literary reference can be added here: Plutarch tells in his *De gloria Atheniensium* that Apollodorus, the inventor of colour-mixing and of shading, made only one comment about his work: it is easier to criticize us than to imitate us.[56] Erasmus' distich is modelled on this passage.[57] The name of Holbein and that of Erasmus–Hercules both appear on the edge of a book. Thus Holbein has added to the parallels of Erasmus–Hercules and Holbein–Apollodorus (or Zeuxis) a further one – Holbein and Erasmus are both accorded the status of author. In conformity with the usual practice in the sixteenth century, the signature is put onto the book as if it were indeed a work by the author Holbein. The opening words 'ille ego iohannes holbein' further support this suggestion.

Dürer's known portrait engraving of Erasmus from 1526 (illus. 26) points out in the inscription that there is a contrast between the artistic image of an author and the picture we will build up of him from his writings. 'His writings will present a better picture', the Greek inscription tells us.[58] In the foreground of the engraving we see a number of books, but the author is shown engrossed in writing a letter. This hitherto overlooked detail of the engraving is important, because in the humanists' view it was letters more than any other literary creation that managed to convey the absent person's words to another absent person – *sermo absentis ad absentem*. Thus letters could, as a form of self-portrait, surpass painted or drawn portraits in terms of their faithfulness to reality, vividness and creation. Juan-Luis Vives, Conrad Celtis, Christoph Hegendorf and Erasmus all wrote treatises on the art of letter-writing, and drew on the editions of Poliziano's letters for their models of literary epistles.[59] Artistic portraits, secondary complements to literary portraits, were sent out like letters.[60] Eoban Koch 'Hessus' sent his, engraved by Dürer, to Adam Krafft with the message that his writings would depict him better than could either Apelles or the hand of any other painter.[61] Melanchthon pointed out (1521) in his preface to the Roman letters of Paul that no Apelles could match the Apostle's depiction of Christ.[62]

The dramatic implications of the difference between the literary and the painted portrait find their clearest expression in the inscription to Dürer's portrait engraving of Philipp Melanchthon (illus. 27): '1526 VIVENTIS.POTVIT.DVRERIVS. ORA. PHILIPPI. / MENTEM.NON.POTVIT.PINGERE.DOCTA / MANVS' (Dürer could paint the external and vivid features of Philipp, but the learned hand could not paint the mind). There the outer appearance is opposed to the inner self, the depictable body to the unpaintable spirit, mortality to immortality, as well as painting to writing.[63] That the representation in an image is concerned with and preserves the mortal exterior, while the text testifies to the immortal soul, is clearly illustrated by the printed portraits with their combination of the sitter's bust and a plaque bearing an inscription. The classical capitals and the carefully represented small lacerations to the panel turn them into archæological remains.[64]

Melanchthon stayed in Nuremberg in 1525 and 1526, and followed with interest the

arguments between Dürer and Willibald Pirckheimer on the question of the unpaintable and the unspeakable: Pirckheimer 'would say with vehemence, "Such things cannot be painted!" "And those things to which you refer", answered Dürer, "nobody could say what they are, nor conceive them in their mind".'[65] Melanchthon accepted that there was no forseeable end to such debates.

Holbein seems to have denied any distance between the exterior and the interior, just as he denied a belief in the impossibility of artistic creation. As a result he decided to enter into the lists with Dürer and Apelles. Characteristic of this is the inscription at the top of the portrait of Philipp Melanchthon (illus. 29), which runs: 'QVI CERNIS TANTVM NON, VIVA MELANTHONIS ORA,/ HOLBINVS RARA DEXTERITATE DEDIT' (You contemplate the facial features of Melanchthon, as if they were almost alive: Holbein has worked them out with incredible skill).[66] The portrait, which was probably painted in England in the 1530s after a model by Dürer or Cranach, contradicts the former's distinction between the body and the soul and the idea of the inferiority of the artist's representation of a person. It seems that, as a result of his second stay in England and of his concentration primarily on portraiture, Holbein renewed and honed his art. In the portrait of Derich Born of 1533 (illus. 30), he engaged himself in a direct contest with the *alter Apelles* and with the eulogy by Erasmus. The inscription on the portrait of the merchant addresses the viewer directly: 'DERICHVS SI VOCEM ADDAS IPSISSIMVS HIC SIT / HVNC DVBITES PICTOR FECERIT AN GENITOR / DER BORN ETATIS SUAE 23 ANNO 1533' (When you add the voice, here is Derich himself, in such a way that you wonder whether the painter or the Creator has made him).[67] The lack of a voice is the final element missing in a work of art, but one which no amount of artistic skill can remedy. The inscription here is a rejoinder to Erasmus' praise of Dürer: in this work of art Holbein has almost also painted the voice itself.[68] The use of the perfect tense for the signature stresses that the whole picture is completed and that the last distinction between the model and the work of art has been erased. The aim of art is the *imagines similitudinis indiscretæ* of Apelles, the portraits of complete similarity, as Pliny viewed it.

The perfect imitation, and the illusionistic presence of the sitter, through Holbein's art are celebrated in the poems of Nicolas Bourbon (illus. 31), which appeared in the 1538 edition of his *Nugæ*.[69] One poem describes the erotic effect of a sleeping boy painted by Holbein, another praises the fact that even Death has been painted in such an elaborate way that it seems to be alive. These are certainly literary *topoi*, but they place Holbein above Apelles and in the class of the immortal gods. The longer poem, which Bourbon wrote for the first edition of the *Icones* in 1538/39, speaks of unprecedented events in Elysium; Holbein's reputation has reached there, and now eclipses the fame of Apelles, Zeuxis and Parrhasios.[70] Perhaps this is also a response to Erasmus, who in 1528 had written that Apelles must now cede the palm of victory to Dürer.[71]

Probably in 1538, during his last visit to Basle, Holbein designed the portrait of Erasmus standing with a Terminus in a Renaissance arch, of which Veit Specklin produced a woodcut. The first printing, which probably followed at the beginning of the 1540s, includes in the cartouche a couplet that refers to the art that shows a physical image of Erasmus to the person who has never seen him. In a subsequent edition (illus. 32), which appeared in the late sixteenth century, a quatrain was inserted, in which Pallas, the goddess of Wisdom, praises Holbein's art by comparing it with

28 *Erasmus of Rotterdam*, 1523, wood, 76 × 51. Private collection.

30 *Derich Born*, 1533, oak, 60.3 × 45.1. The Royal Collection, Windsor Castle.

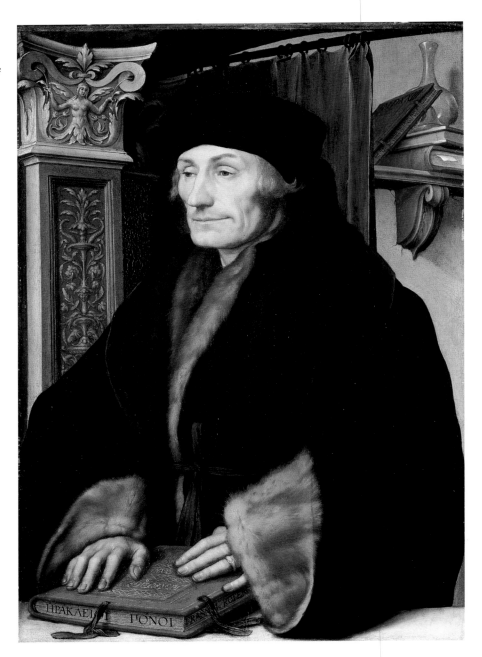

29 *The Reformer Philipp Melanchthon and the inner side of an Ornamental Lid, c.* 1532, 12 *cm* diameter. Niedersächsisches Landesmuseum, Hannover.

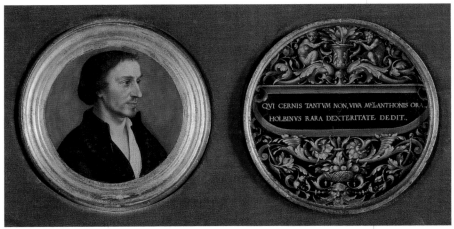

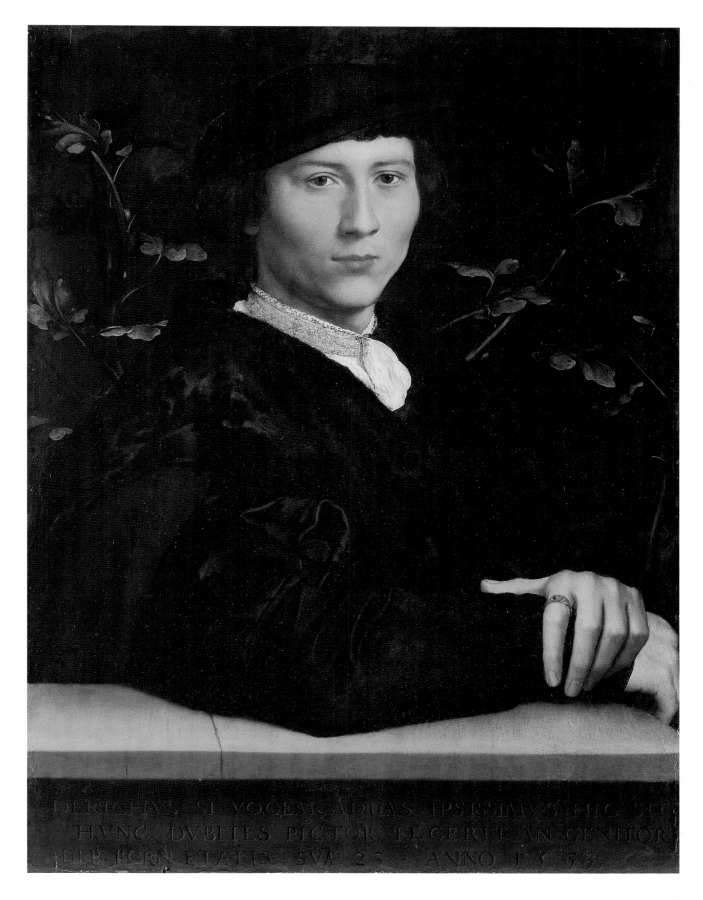

31 *Nicolas Bourbon, c.* 1535, black, white and coloured chalks, pen and black ink on rose-tinted paper, 30.9 × 26. The Royal Collection, Windsor Castle.

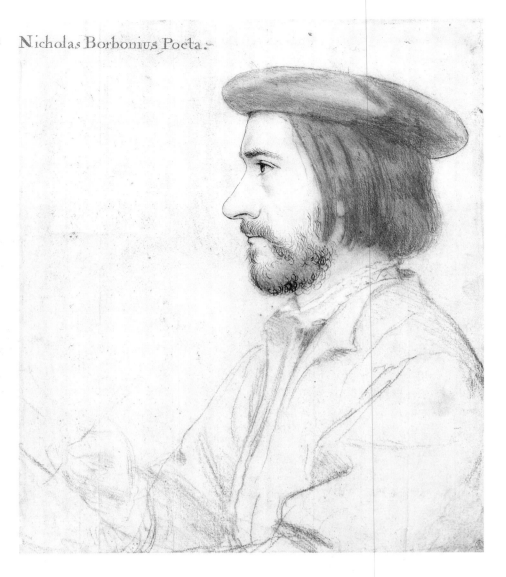

Nicholas Borbonius Poeta.

32 *Erasmus of Rotterdam* ('*Erasmus im Gehäus*'), late 16th-century version of a woodcut by Veit Specklin, 28.6 × 14.8. Öffentliche Kunstsammlung, Basle (Kupferstichkabinett).

that of Apelles and Daedalus, and accords him eternally the same rank as that of Erasmus' ghost:

Pallas Apellæam nuper mirata tabellam,
Hanc ait, æternùm Bibliotheca colat.
Dædaleam monstrat Musis HOLBEINNIUS artem
Et summi Ingenii Magnus ERASMUS opes.

Pallas, we learn, 'has admired the picture recently – it is worthy of Apelles', and she said: 'The library must keep it for ever with great respect. Holbein offers to the Muses an art of Daedalic perfection; the great Erasmus on the other side offers the treasures of the highest intellect.'[72]

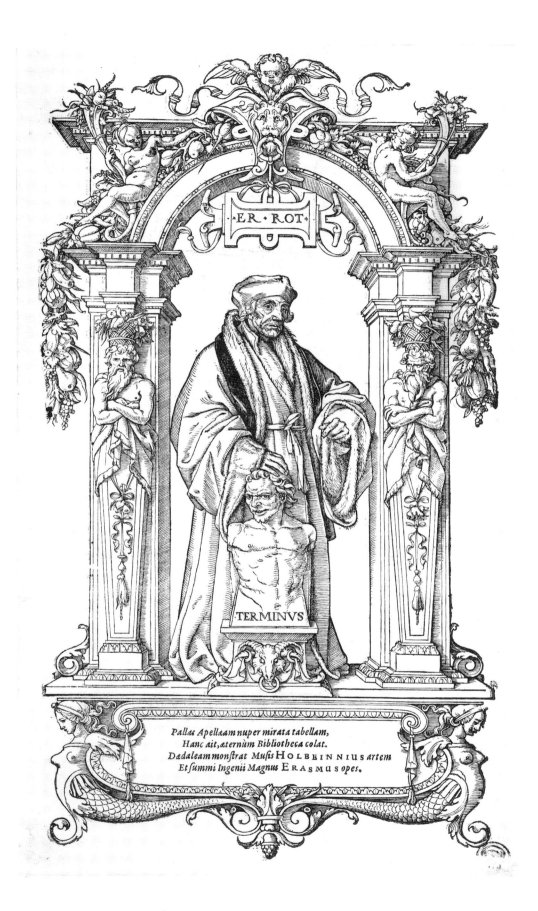

ER · ROT ·

TERMINVS

Pallas Apellæam nuper mirata tabellam,
Hanc ait, æternùm Bibliotheca colat.
Dædaleam monſtrat Muſis HOLBEINNIUS artem
Et ſummi Ingenii Magnus ERASMUS opes.

2 Figure and Movement, Invention and Narration

A typical beginning

It was probably towards the end of 1515 that Holbein entered the workshop of the Basle master Hans Herbst as a journeyman. He was almost certainly accompanied by his elder brother Ambrosius, who had until then been occupied in painting the banqueting-hall of the monastery of St Georgen in Stein am Rhein under the direction of Thomas Schmid.[1] Only one of the works entrusted to the two Holbein brothers in Basle at this time is known, the double portrait of the newly elected mayor, Jakob Meyer zum Hasen, and his wife, Dorothea Kannengiesser, which was produced by Hans in 1516.[2] It is possible that the brothers, in contravention of guild rules, were working independently for Oswald Myconius, their writing and Latin master. They illustrated his copy of Erasmus' *Encomium moriæ* with marginal drawings and they painted a sign advertising his reading and writing classes.[3] Apparently, not long after their arrival in Basle they were already active as designers of title-borders for the *Formschneiders*, the woodblock cutters (illus. 89).[4]

In the preparatory drawings for his first commissioned portrait Holbein drew the subjects meticulously, using silverpoint on white prepared paper with touches of red and black chalks. On the drawing of Jakob Meyer (illus. 34) he noted the colours in preparation for the painting itself. A feeling of unity is given to the painted double portrait (illus. 40, 41) by a coffered barrel-vault that springs from a blind arcade of pillars seen at an angle. The whole is set against a pale-blue background and is framed by two columns. Jakob Meyer sits just in front of the one that is less exposed, while the other one and the barrel-vault frame his wife, Dorothea. The painted architecture carries rich plastic decoration made up of gilded vines, acanthi, a frieze with putti and a coffered arch, and columns making up the blind arcade are of red marble. In the golden frieze above Jakob Meyer's head is a shield, supported on a garland held by two putti, where Holbein's initials and the date 1516 can also be seen. The mayor holds in his be-ringed left hand a gold coin; this may symbolize his trade and perhaps is also a reference to Basle's right to mint coins, granted that very year by Emperor Maximilian I.[5]

In his double portrait Holbein made some use of the new methods employed by artists in Augsburg, a good example of which is provided by Hans Burgkmair's portrait of Johannes Paumgartner of 1512 (illus. 33).[6] Burgkmair selected an archway as the setting for this portrait, and this feature serves to frame the work. Holbein, though, decided to use a realistic architectural feature as a spatial element that would unify two portraits. This strategy was not in itself entirely new: in 1505 Burgkmair had used a pier seen at an oblique angle as the structural link between the two wings of his diptych of Barbara and Hans Schellenberger (illus. 35, 36). In this work, the only extant double portrait by Burgkmair, we also find the blue background that Holbein was to adopt for his Meyer–Kannengiesser portraits.[7] In the Schellenberger

33 Hans Burgkmair the Elder, *Johannes Paumgartner*, 1512, chiaroscuro woodcut, 29.4 × 24.3. Staatliche Graphische Sammlung, Munich.

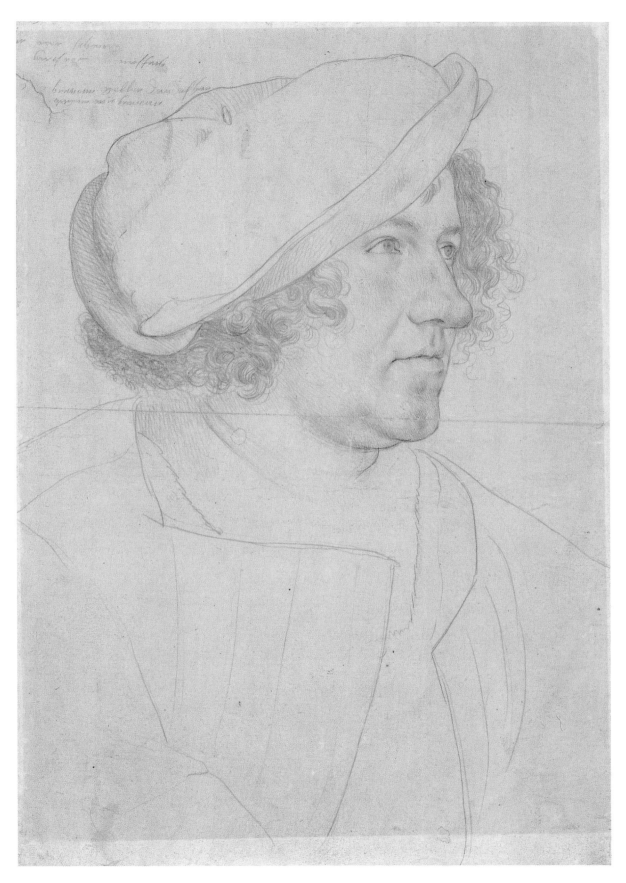

34 *Mayor Jakob Meyer zum Hasen*, 1516,
silverpoint and sanguine on paper with white
priming, 28.1 × 19. Öffentliche Kunst-
sammlung, Basle (Kupferstichkabinett).

35, 36 Hans Burgkmair the Elder, *Double Portrait of Hans and Barbara Schellenberger*, 1505, limewood, each panel 41.5 × 28.8. Wallraf-Richartz-Museum, Cologne.

37, 38 Albrecht Dürer, *Double Portrait of Hans and Felicitas Tucher*, 1499, wood, each panel 28 × 24. Kunstsammlungen (Galerie im Schloss) Weimar.

portraits, however, the sitters look out, and thus towards the viewer, rather than across at one another, while their betrothal is symbolized by the flowers they hold and by the masonry. Holbein preferred to direct the gazes of his sitters parallel to the two faces of the masonry, allowing them to meet at an imaginary crossing-point.

The methods of the Augsburg artists can only partially explain Holbein's double portrait of the married couple Meyer–Kannengiesser. Certainly the preparatory drawings are reminiscent of portrait drawings by Holbein the Elder, especially in terms of the technique, and the architectural décor can be compared with that of Burgkmair. But it is clear that Holbein the Younger attempted to incorporate other methods. For the precise details of the physiognomy and for the depiction of the relationship between the two sitters, portraits by the young Dürer must also be considered. The double portrait of the Nuremberg patricians Hans and Felicitas Tucher of 1499 provides not only a parallel for the representation of the male figure, but also a pattern for the attention to detail (illus. 37, 38).[8] Holbein did not repeat Dürer's division of the background – a brocade curtain and a landscape – but he did use the same position of the head for Jakob Meyer as Dürer had done for Hans Tucher. This pose, which entails a more pronounced overlapping of the nose and the cheek, occurs only once again in a portrait by Holbein – that of Bonifacius Amerbach in 1519 (illus. 25). In his other paintings a slight turning of the head or a three-quarters profile, as in the case of Dorothea Kannengiesser, are favoured. Just like Dürer in his depiction of Hans and Felicitas Tucher, Holbein was attempting in his first double portrait to show the relationship between a couple while still respecting their distinct characters and their status as independent persons.

In 1505 and 1507, during the outward and home journeyings of his second Italian trip, Dürer passed through Augsburg. It was probably in 1505 that he drew Georg

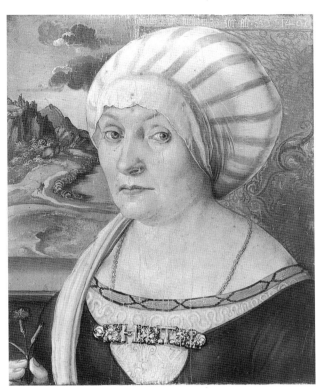

Fugger, and in 1518 that he prepared the drawing of Jakob Fugger the Rich (illus. 39) and then followed it with his painted portrait.[9] Dürer provided sketches for two of the reliefs in the Fugger Chapel in the church of St Anna in Augsburg, and it seems possible that he also participated in the architectural scheme.[10] During his second stay in Venice the Nuremberg artist was probably favoured with the commission from the Fuggers for the *Rosenkranzmadonna* for the chapel of the German merchants in the church of S Bartolomeo. In this work Dürer tried to incorporate the Northern pattern of the *Rosenkranzmadonna* into the Italian *sacra conversazione*.[11] Holbein the Elder made two portrait drawings of Jakob Fugger (illus. 42), but unlike both Dürer and Burgkmair he was not to receive any further commissions from the family.[12] Dürer must have seemed to the Augsburg artists a favoured and superior competitor.

The young Holbein found the representation of figures, the composition of figure groups in movement and the pictorial narrative less easy than precise imitation. It is true that the marginal drawings for the *Encomium moriæ* reveal wit and abundant invention, but the artist's weaknesses as shown by the rendering of figures and scenes are as easy to see as is his ambition to deal with tasks of this kind. In the scene *Apollo Slays the Children of Niobe* (illus. 43), both Apollo and the petrified Niobe bear witness to Holbein's awkwardness in drawing.[13] It was only in the mid-1520s that he was first able to deal with the problem of giving the impression of movement to his figures. Until that time he was relying on indicating movement by the position of each figure.

In this connection we must look at the copy after Lucas van Leyden's engraving of the *Ecce homo* (illus. 44), which Holbein produced in 1515–16, soon after his arrival in Herbst's studio.[14] Copies after models were part of an apprentice's training, and it is likely that even as a journeyman Holbein also had to do this to prove his worth.

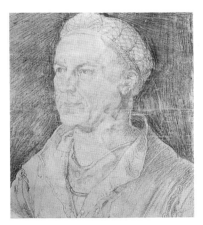

39 Albrecht Dürer, *Jakob Fugger the Rich*, *c*. 1518, charcoal or chalk, 35 × 29.2. Staatliche Museen zu Berlin – Preußischer Kulturbesitz (Kupferstichkabinett).

OVERLEAF
40, 41 *Double Portrait of Mayor Jakob Meyer zum Hasen and his Wife Dorothea Kannengiesser*, 1516, tempera on limewood, each panel 38.5 × 31. Öffentliche Kunstsammlung, Basle.

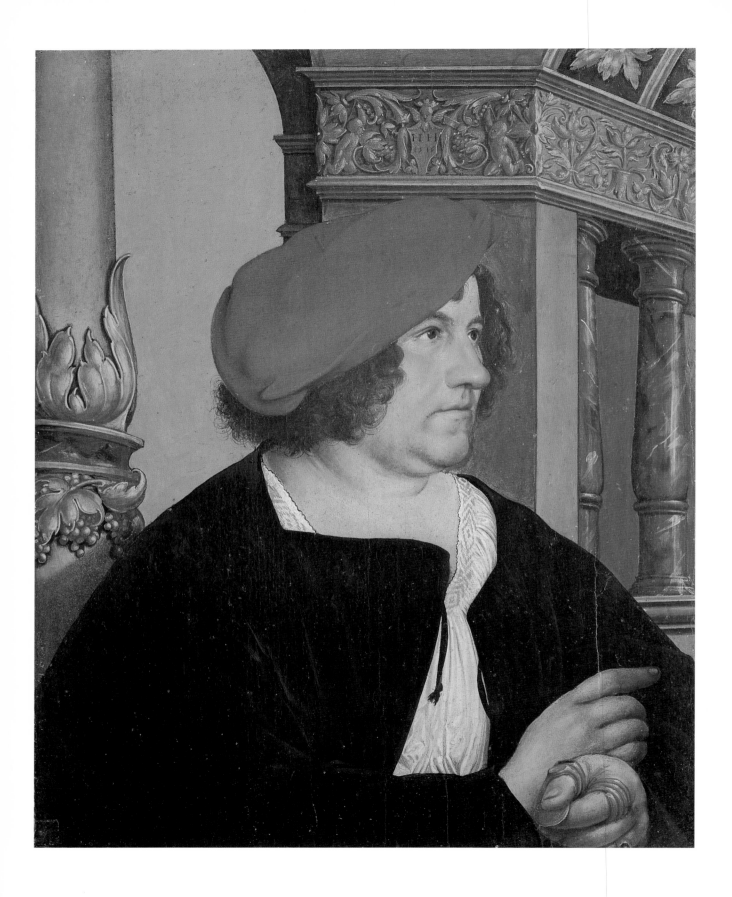

40

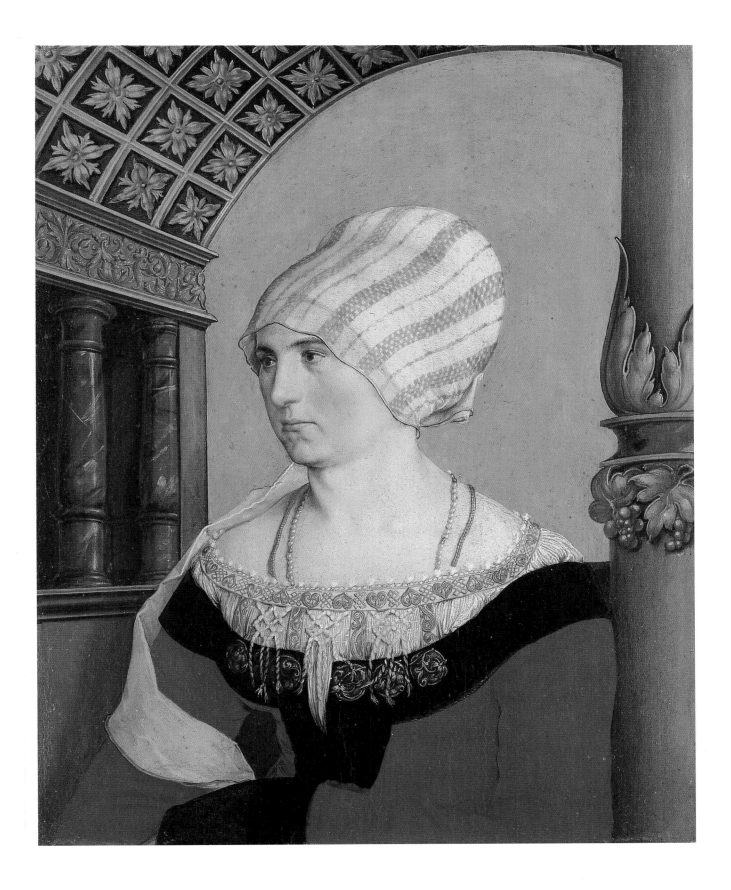

Hans Holbein the Elder, *Jakob Fugger the Rich*, silverpoint with later ink inscription, 13.6 × 9. Staatliche Museen zu Berlin – Preußischer Kulturbesitz (Kupferstichkabinett).

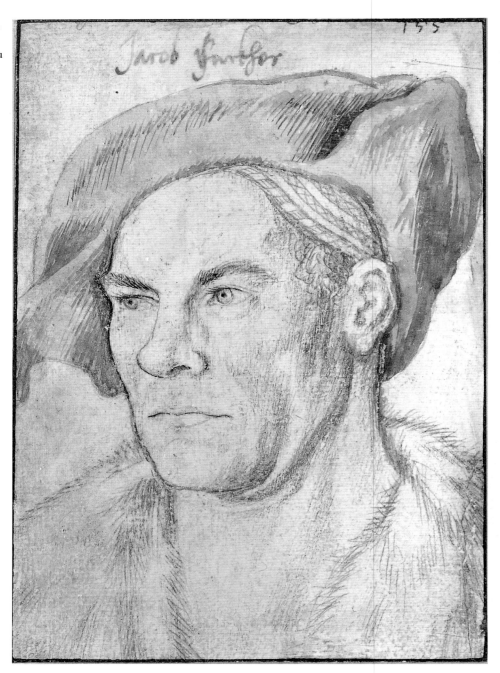

His drawing (illus. 45) is definitely more than just a tracing, and differs from the original not only in its dimensions but also in technique (pen and wash), in individual figures and in the representation of the crowd. The division between the dark and the light areas is so different from that of the model that there is a contrast between the horizontally and vertically shaded zones and the luminosity of the buildings and the central square. Holbein has extended his clouds over the whole sky, while Lucas van Leyden had accumulated them on the right-hand side. A dramatization is apparent in the group of people in the foreground: this group comprises fewer people than the one in van Leyden's engraving, and they are evidently engaged in a heated discussion. Holbein has eliminated the low grassy mound in the foreground and has thus reduced the distance between the group of figures and the viewer. Van

Leyden gave little enough space to the scene of the exhibition of Christ to the crowd in his print, but Holbein reduced it even further, so that it has only a secondary importance in his version.

Our knowledge of Holbein's background enables us to understand his interest in the engraving by van Leyden. His father had represented the exhibition of Christ in several Passion cycles. In his cabinet Amerbach had copies of Holbein the Elder's preparatory sketches for the wings representing the Passion on the high altar in the Frankfurt Dominican church and also for the scenes of the Passion that are now to be found in Donaueschingen. Jörg Schweiger's drawing after Holbein the Elder's *Ecce Homo* (illus. 47), concentrating as it does on the depiction of the figures, corresponds to the principle maintained in all such scenes by this artist: to have few figures

44 Lucas van Leyden, *Ecce Homo*, 1510, engraving, 28.5 × 45. Graphische Sammlung Albertina, Vienna.

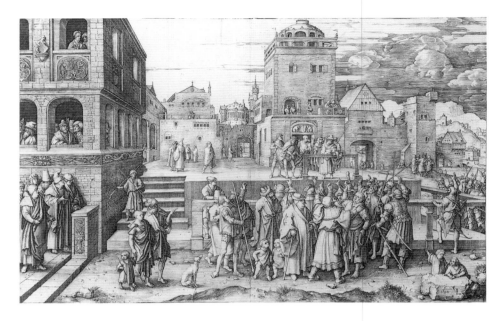

45 *Ecce Homo*, copy after Lucas van Leyden, *c.* 1515–16, pen with grey and brown washes, 36 × 51.6. Öffentliche Kunstsammlung, Basle .

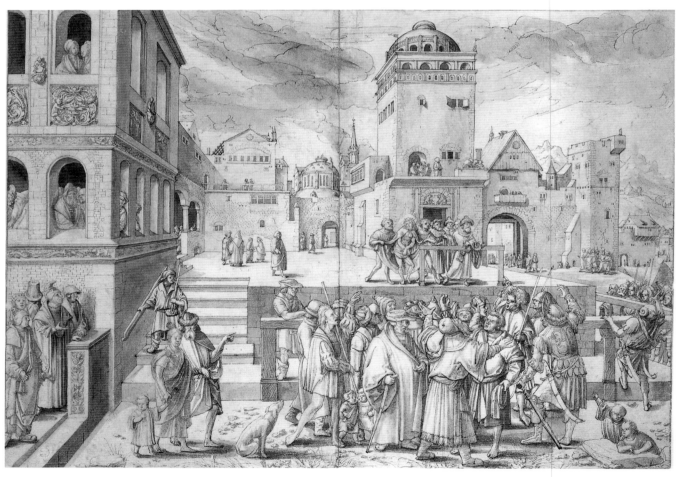

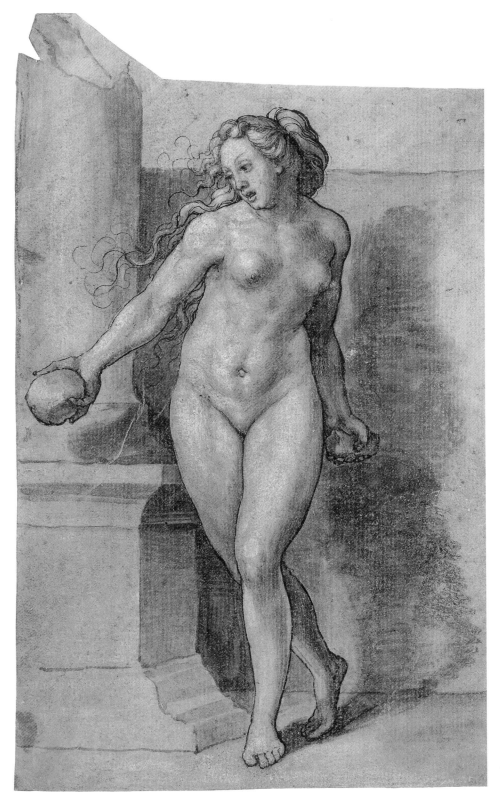

46 *Female Figure in Motion Next to a Broken Column* (the so-called '*Stone-Thrower*'), *c.* 1526, brush and pen with grey wash heightened with white on red tinted paper, 20.3 × 12.2. Öffentliche Kunstsammlung, Basle (Kupferstichkabinett).

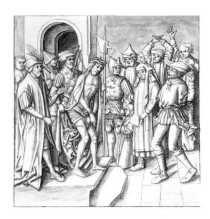

47 Copy from the circle of Jörg Schweiger after Hans Holbein the Elder, *Ecce Homo*, c. 1505–10, pen with grey and brown washes, 30.3 × 28.8. Öffentliche Kunstsammlung, Basle (Kupferstichkabinett).

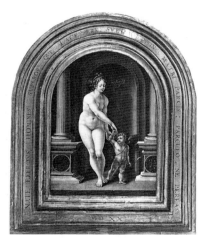

48 Jan Gossaert (called Mabuse), *Vénus and Cupid*, 1521, wood, 41.5 × 30.7. Musées Royaux des Beaux-Arts de Belgique.

acting against a flat, poorly decorated stage.[15] The large town square, the distancing of the main scene, and the foreground filled with various groups in van Leyden's version provides the strongest contrast to the static and narrowly staged representation of Holbein the Elder's *Ecce Homo*.

The study of figures and proportions

Holbein was a highly perceptive and intelligent artist, but not an intellectual one in the same way as, for example, Dürer. While the latter had a developed interest for academic subjects and for questions relating to the theory of art, Holbein did not trouble himself with any of the main theoretical branches of painting, be it an outline of perspective or a study of human proportions. Only a few drawings betray a passing interest in these questions, and they do not seem to have been part of a larger ensemble.

The drawing *Female Figure Next to a Broken Column* (illus. 46), which has been incorrectly described as 'A Woman Throwing a Stone', shows a naked twisting female beside a pedestal supporting a broken column. Her strained, twisting pose can be understood in a new light when compared with the engravings that have been considered as its models. In this context Agostino Veneziano's *Cleopatra*, a copper-engraving of 1515, or Marcantonio Raimondi's *Adam and Eve* have been cited, but their Northern counterparts, such as Jan Gossaert's *Venus and Cupid* (illus. 48) of 1521, should not be discounted.[16] Gossaert integrated the representations of an axial twisting figure from two engravings executed by Marcantonio Raimondi after Raphael. From one of these (catalogued as Bartsch 311) he borrowed the figure of Venus and the idea of the niche, and from the other (Bartsch 297) the small figure of Cupid. Certainly Gossaert differed from the original in reversing the direction of the figure of Venus, but, unlike Holbein, he did not try to alter the direction of the head in relation to the shoulders. Gossaert set his figure in front of a niche framed by two fluted columns mounted on pedestals. Both he and Holbein thus achieved a contrast between the movement of the human figure and the immobile architectural volumes. In his drawing Holbein worked on the contrast between the planar surface of the wall, the volumes of the column and pedestal and the twisting body. By this means he was trying, as he had in the earlier portrait of Benedikt von Hertenstein (illus. 20), to achieve the formation of an illusion of space through the casting of shadow.

The question of why Holbein's naked female should be holding stones in both hands and what allegorical significance there is in the combination of this twisting naked figure with the broken column has not yet been answered. It can hardly be a drawing that takes as its subject a thrower of stones. It is rather a contribution to the problem of a human figure represented with several twists of the body's axis. The figure's right arm with the rounded stone is in the same position as that of Adam's in Dürer's copper-engraving of *Adam and Eve*. Dürer made studies for the positioning of both Adam's arm and hand (illus. 49). In this preparatory drawing both the arms shown hold an apple, while in the engraving Adam's arm is stretched out, reaching for Eve's fruit.[17] A parallel for the twisting figure with crossed legs is to be found in Gian Jacopo Caraglio's *Thetis* (illus. 50), an engraving made in 1526 after a drawing by Rosso Fiorentino.[18] Here we see a naked figure with wind-swept hair, the body twisted into a contorted position and casting a shadow that falls across the framing niche. In Holbein's drawing, however, the position of the arm is

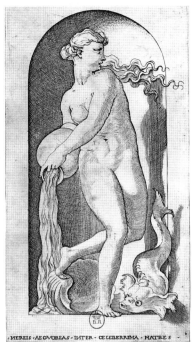

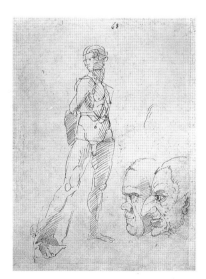

the opposite to that in the engraving by Caraglio. A similar difference can be seen in a version of the *Thetis* cast in the workshop of Severo da Ravenna.[19] This small bronze statuette provides us with a mirror-image of Holbein's *Female Figure*, but there is a clear parallel despite a few minor differences of detail.

A figure that reveals a similarly contorted position, although this time in *contrapposto* and with stereometric shapes inscribed on it, can be found in Dürer's so-called Dresden Sketchbook (illus. 51). Dürer circumscribed the twisting of the hips with a trapezium and the twisting of the upper body with a trapezoid, and turned the head to look out over the right shoulder, which has been pushed forwards.[20]

Dates suggested for the drawing of the *Female Figure* vary between 1520 and 1543. Possible arguments against an early date are the technique and the use of a prepared paper. The argument for a late date must take into account the question of why Holbein, after producing more advanced work, should not have been able to adapt earlier models to produce a more natural representation of movement.[21] An early dating cannot be maintained when the reference to Caraglio's engraving is assumed, nor can a late one unless we are willing to accept a continued clumsiness in the adaptation of models. The publication of Caraglio's engraving after Rosso in 1526 could give a clue as to the dating of Holbein's drawing. This assumption would also correspond with the artist's intensified interest in Italian forms.

Unusual among Holbein's drawings are two sheets that deal with human proportions, with the turning of the head and with studies of the head and hands in perspective. The sheet with the proportioned figure and the study of a head (illus. 52) comes from the so-called English Sketchbook, an octavo scrapbook that was not assembled before the time of Basilius Amerbach.[22] The stimulus for the proportional study must have been provided by Dürer's *Vier Bücher von menschlicher Proportion* of 1528. Among the many schematic illustrations that Dürer's infinite meticulous measurements document, one of the earliest must have been authoritative for Holbein:

49 Albrecht Dürer, *Studies of the Arms and the Hand of Adam with Rocks and Bushes*, 1504, pen with brown and black inks, 21.6 × 27.5. British Museum, London.

50 Rosso Fiorentino, *Thetis*, engraved by Gian Jacopo Caraglio, 1526, 20.3 × 10.7. Bibliothèque Nationale de France, Paris.

51 Albrecht Dürer, *Stereometrically Schematized Figure in Multiple Rotation next to Two Heads*, *c*. 1514, pen, 21.2 × 15.1. Staatsbibliothek, Dresden.

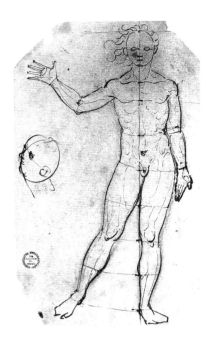

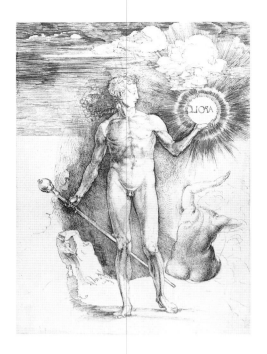

52 *Sketches with a Proportion Study of a Figure and Study of a Head*, after 1538, pen over chalk, 13.4 × 8.1. Öffentliche Kunstsammlung, Basle (Kupferstichkabinett).

53 Albrecht Dürer, *Male Proportional Figure Eight Heads Tall*, in his *Vier bücher von menschlicher Proportion* [Nuremberg], 1528. Bayerische Staatsbibliothek, Munich.

54 Albrecht Dürer, *Apollo and Diana*, *c*. 1501, pen drawing, 28.3 × 20.5. British Museum, London.

a male figure that is in accordance with the Vitruvian canon and sets the length of the head at one-eighth of the total body length (illus. 53).[23] While Dürer, following Alberti, always paid attention to volumetric proportions, Holbein contented himself with only the simplest scheme: a vertical line as the median line, the whole divided into eight equal parts, and with the same scheme then applied to the outstretched leg and the bent arm. It is possible that before producing his proportioned figure Holbein had consulted the first works of Dürer, which resulted from the latter's studies of the *Apollo Belvedere* and of Vitruvius, and found their expression in drawings such as *Apollo and Diana* (illus. 54) and in the copper-engraving of *Adam and Eve*.[24] The combination of the stretched leg and the bent arm that Holbein's figure reveals can be found in various drawings and engravings by Dürer and in his study-book on proportions.[25]

Holbein's second study sheet was the *Studies of Head, Hand and their Perspective* (illus. 55), as seen from various points of view. It contains further studies for the twisting and elevation of a schematized head, a proportions study of the hand that can be traced back to Dürer, and two drawings for the representation in perspective of the upper body of a figure and of a hand.[26] The studies of heads relate to the fourth sheet of Erhard Schön's study-book *Unnderweissung der proportzion unnd stellung der possen*, which first appeared in Nuremberg in 1538 and then in 1540 and 1543 in enlarged editions. In the fourth plate (illus. 56) and the fifth one, Schön shows for both a male and a female schematized head the various possible changes in posture and elevation.[27] For his studies of heads from various points of view Holbein must have drawn inspiration from these two sheets. Here too, however, just as he had with Dürer, he simplified the schema.

The connection with Schön's study-book would suggest a late dating for Holbein's sheet. The fact that there is also a head study on the sheet with the proportioned figure makes it likely that this sheet too was produced after the publication of Schön's book in 1538 rather than just after the publication of Dürer's book on proportion that appeared in 1528.[28] Even if the later dating were assumed to be correct,

55 *Studies of Head, Hand and their Perspective*, after 1538, pen over chalk, 13.2 × 19.2. Öffentliche Kunstsammlung, Basle (Kupferstichkabinett).

56 Erhard Schön, *Rotation and Turning of a Proportional Male Head* from his *Unndermeissung. . .*, Nuremberg, 1543.

this would still leave a question open: why should Holbein, who was by then established as a portrait painter at the English Court, have been interested in producing proportions and perspectives of this type?

The 'Passion of Christ': an experiment

In 1644 during a sitting for the portrait of Duke Maximilian I of Bavaria, Joachim von Sandrart mentioned his enthusiasm for Holbein's *Passion of Christ* (illus. 57), which he had seen and copied in Basle's Rathaus. Sandrart considered this painting to be Holbein's crowning achievement. The electoral prince set his heart on having the work with its eight scenes of the Passion of Christ and he immediately sent a negotiator to Basle, with his permission to offer the unrivalled sum of 10,000 guilders. But the Basle government resisted the temptation of the money and refused to accede to Maximilian's wish.[29] Sandrart's report remains the earliest piece of evidence that we have concerning the painting's display in the Rathaus. Nothing is known about the commission, the patron, the contract, the purpose of the work or its date. Since no resolution by the council at Basle is known, the idea of the Rathaus as the original destination for the work must be discounted, as Woltmann pointed out as early as 1866. Possibly the painting was first removed to the Rathaus for protection during the Basle *Bildersturm* of 1529. Since Hegner's publication in 1827 it has generally been assumed that the painting, composed of four narrow panels, was originally planned as an altarpiece or served as the wings to a retable.[30] Its iconography does not exclude the latter possibility but, since the reverse sides of the panels are not painted, they could definitely not have served as wings. There is no positive clue that this painting, any more than Holbein's other religious pictures, could have been intended as an altarpiece. These other works, however, are accepted as such without any further examination.

The iconography of the *Passion* is extremely conventional: the division of the panels

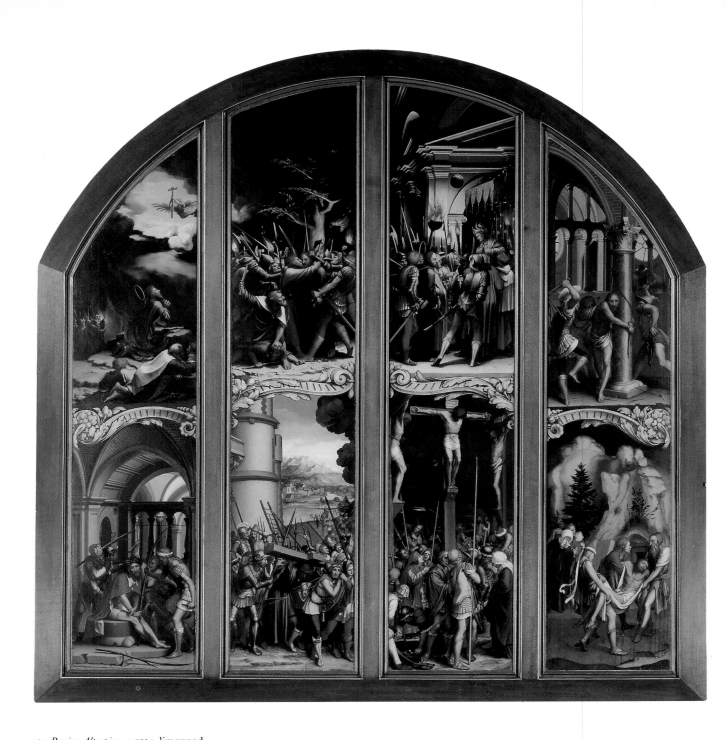

57 *Passion Altarpiece, c.* 1524, limewood,
outer panels 136 × 31 and inner 149.5 ×
31. Öffentliche Kunstsammlung, Basle.

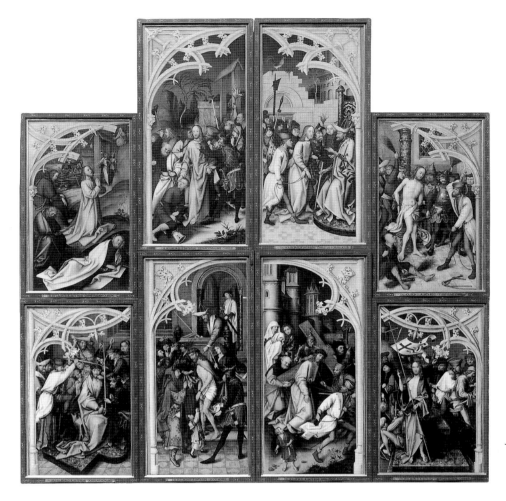

58 Hans Holbein the Elder, *Eight Scenes from the Passion of Christ* (exterior of the Kaisheimer altarpiece), 1502, pinewood, outer panels 142 × 85 and inner 179 × 82. Alte Pinakothek, Munich.

and the choice and arrangement of the scenes differ very little from, for example, the outside of the altar that Holbein the Elder had painted in 1502 for the Cistercian church in Kaisheim near Donauwörth (illus. 58).[31] A similar iconographical programme is to be found in the eight-part Passion cycle by Holbein the Elder for the high altar in the Dominican church in Frankfurt. Another series of twelve panels, the so-called *Grey Passion*, of which eleven are now to be found in Donaueschingen, take as their first scene the Carrying of the Cross and as their last the Resurrection. Between these are featured, among others, the Preparation of the Cross, the Deposition and the Entombment.[32] The iconographical changes made by Holbein the Younger fall within the range of the variations to which the eight-scene Passion cycles were subject. The scenes in the upper register correspond to those found in the upper register of Holbein the Elder's *Kaisheimer Altarpiece*. But in the lower register we find the Ecce Homo replaced by the Carrying of the Cross, followed by the Crucifixion and the Entombment. Holbein the Elder had omitted these last two scenes from his altarpiece at Kaisheim, which he closed with the Resurrection.

An unusual element of the Basle *Passion Altarpiece* is the use of lighting effects. Holbein chose to depict the first three scenes of the upper part as taking place at night, and various light sources provide the light and shadow. This interest on the part of the artist for repeated night scenes and their management corresponds with Albrecht Altdorfer's *Passion of Christ* on the wings of the former *Sebastiansaltar*, which was

painted between 1509 and 1516 for the church of St Florian bei Linz.[33] Here, as in Holbein's altarpiece, the third night scene is Christ before Caiaphas (illus. 59), and two torches and two lamps illuminate the High Priest on his throne and the figures standing around Christ. A massive pillar is brightly illuminated, and its capital casts a shadow onto the end wall of the arch. In Holbein's scene four torches throw light up across the architecture and down over the figures (illus. 61). In contrast to Altdorfer's scene we must also assume a further, external light source that manifests itself in the shadow cast by the foregrounded soldier and in the glints of his armour.

Caiaphas, the High Priest, gives vent to his indignation at Christ's blasphemy by ripping his clothes. The sources for this scene were the Gospels of Matthew and Mark, and the event can also be seen on Dürer's two series of reproductions, the *Small Woodcut Passion* and the *Engraved Passion*.[34] Holbein altered the direct confrontation of the High Priest and Christ: he exploited the narrow format to bring the group of captives right up to the foot of the throne, raising Caiaphas above the throng. The division of the scene is maintained in the separation of the group marked by the upright standing figure of Christ and the soldier whose back is towards us and who leans forward, about to take a step. In the first of his ten designs for stained glass of the Passion cycle, Holbein showed Christ before Annas (illus. 60). According to the Gospel of St John it was Annas who carried out the first questioning of Jesus, during which he was whipped by a soldier. In his *Small Woodcut Passion* Dürer brought together these two elements – Caiaphas tearing Christ's garments and the soldier assaulting him – but Holbein preferred to keep one scene for the painted Passion and the other for the stained glass series.[35]

The Entombment (illus. 62), the last scene in Holbein's *Passion Altarpiece*, has two identifiable models. One is Mantegna's engraving *The Entombment* (illus. 63), or possibly the reversed copy of it made by Giovanni Antonio da Brescia, while the other is Dürer's version of the episode in his *Small Woodcut Passion* (illus. 64).[36] Kugler and Burckhardt recalled in 1847 the *Borghese Entombment* by Raphael, while Woltmann in 1866 referred to Mantegna's engraving, which had also served as a model for Raphael.[37] Actually, Holbein seems to have transformed Mantegna's rendering of the scene in the same way as Raphael had before him: both of them made much clearer the effort involved in carrying the body by emphasising the way in which the figures are straining under the weight. Likewise they both point to the limpidity of Christ's body and the distance of the rocky outcrop. The similarities with Raphael's work extend to the posture of the body: the arm hanging limply down and the rather forced position of the lower leg. Holbein includes a third man who is helping to carry the body, holding Christ just under the right arm. The differentiation between the bearers and the group of mourners in Holbein's scene corresponds to the dual division of the scene in Mantegna's and Raphael's works. Dürer's version must have provided some inspiration, however, especially since his rocky tomb was closely imitated here.

We have no certain documentary evidence that can help in dating Holbein's *Passion Altarpiece*. Woltmann first attributed it to the years before 1520, but in the second edition of his work he preferred to date it later than the *Last Supper* of *c.* 1524 (illus. 196) and connect it with Leonardo and Mantegna rather than with Dürer. Kugler and Burckhardt disagreed with this and preferred to maintain a date before 1520 for its composition. Their comparisons privileged painters of the Lombard and the Roman schools. Their assessment of the painting runs as follows:

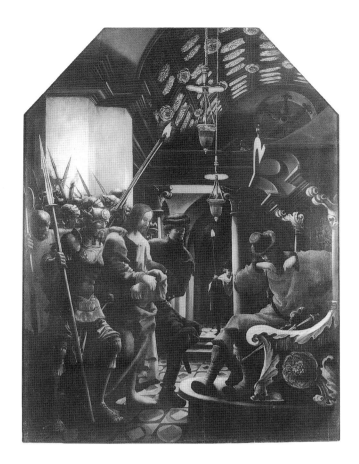

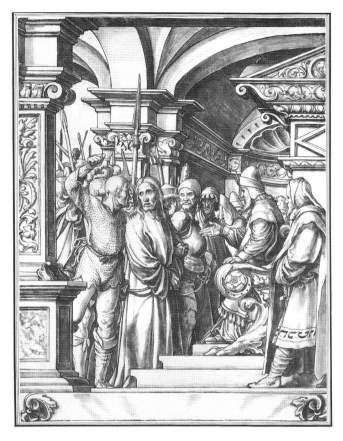

The whole betrays the character of intense detail studies as if this time the artist had wished to give the most complete and thoroughly developed image. That may explain the awkward, self-conscious and deliberate nature of this work which distinguishes it from his earlier and later works.[38]

If one dates the *Passion Altarpiece* to after Holbein's journey to France in 1524 on the grounds of the artistic technique, an interesting question is raised: how can we explain Holbein's simultaneous but distinctive artistic orientations? The *Venus and Cupid* (illus. 194) and the *Laïs Corinthiaca* (illus. 24) point above all to the Lombard school, while the *Stained-glass Designs for the Passion of Christ* are based on engravings by Schongauer and Dürer. The *Last Supper* (illus. 196) takes Leonardo's painting as a starting-point and then adds Northern figures. The opening scenes of the *Passion of Christ* adopt a conventional iconography with the night scenes of the Northern schools; the final scene sees a variation on Mantegna's *Entombment* with elements of Dürer added. Thus it is that the *Passion of Christ* is of interest when compared with the *Last Supper*: in each work the artist takes a different starting-point and achieves an integration of two very distinct styles. The *Passion of Christ* aims to integrate Italian elements into a Northern framework, while the *Last Supper* adopts a Milanese pattern and peoples it with Northern figures.

59 Albrecht Altdorfer, *Christ before Caiaphas*, *c*. 1509–16, spruce, 129.5 × 97. Augustiner-Chorherrenstift St Florian, near Linz.

60 *Christ before Annas*, pen and grey wash, 42.9 × 30.5. Offentliche Kunstsammlung, Basle (Kupferstichkabinett).

OPPOSITE PAGE
61 Detail showing *Christ before Caiaphas*, from the *Passion Altarpiece* (illus. 57).

62 Detail showing *The Entombment* from the *Passion Altarpiece* (illus. 57).

63 Andrea Mantegna, *The Entombment*, *c*. 1470, engraving, 34 × 48. Graphische Sammlung der Eidgenössische Technische Hochschule, Zurich.

64 Albrecht Dürer, *The Entombment* (from the '*Small Passion*'), *c*. 1509–10, woodcut, 12.8 × 9.7. Staatliche Graphische Sammlungen, Munich.

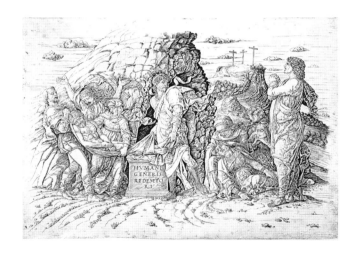

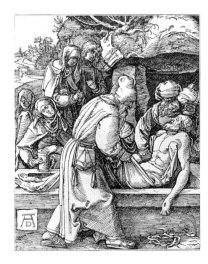

Death's dance: the metamorphosis of the 'Totentanz'

Holbein's *Dance of Death* was first printed in 1538 in Lyon by Melchior and Gaspar Trechsel. It appeared under the title of *Simulachres & historiees faces de la mort* and was published by the booksellers Jean and François Frellon.[39] This first edition consisted of 41 woodcuts by Hans Lützelburger after drawings by Holbein; in subsequent editions until 1562 the series was increased by a further ten images that had been drawn by Holbein but were then cut by another.[40] On Lützelburger's death in the summer of 1526 the Trechsel brothers claimed ownership of the woodblocks that had already been cut as well as those that had been prepared for cutting as compensation for an advance they had made to him.[41] The publication of the *Dance of Death* had probably been planned for 1526 or soon after, but it was not until 1538 that it actually appeared, as a result of the involvement of the Frellon brothers in the project. In the same year they also published Holbein's illustrations to the Old Testament, the *Historiarum ueteris instrumenti icones*.[42]

Holbein based his work on the traditional Dance of Death. He altered the pattern in a series of individual scenes that deal with Death's baleful interventions in every person's daily affairs, be they sinful or virtuous, idle rich or hardworking poor. Holbein's Death adopts many forms: a cardinal in the papal presence, a cupbearer before a monarch or drunkard, a robber with a rich man. He also appears as a horseman's rival, a lord's peasant and a husbandman's horse driver. Only in a few of the scenes – for example those that include a queen, a bishop or an abbot – do we witness the moment when the horrified victim is being seized (illus. 66). The taking of the queen is represented as a dreadful event, with several attendants struggling to keep her from Death the court-jester. One panic-stricken mistress flings her hands into the air, while a courtier strives hopelessly to part the pair. Death, however, is triumphant: he brandishes the hour-glass in which the sands have run through.

Until the nineteenth century there was a famous Dance of Death on the cemetery wall (the Friedhofsmauer) of the Predigerkirche in Basle. Painted after the plague (*Pest*) of 1439, it was destroyed in 1805.[43] In Berne between 1516 and 1519–20 Niklaus Manuel painted a Dance of Death on the Friedhofsmauer of the Dominikanerkloster, which has come down to us in the form of copies together with the verses that recount the dialogue held with Death.[44] In 1596 Hans Bock the Elder produced a sample-sheet of a copy of the Basle Dance of Death for the Archduke Mathias of Austria, the brother of Emperor Rudolf II (illus. 65). It shows the first two pairs of the cycle, in which both pope and emperor are led away by Death.[45]

Holbein's series begins with a prelude concerning the arrival of Death as a result of the Creation following the Fall of Man. The representation of the pope, when compared with that in the Predigerkirche cemetery's Dance of Death, makes it clear that it is not merely a case of the mortality of Man, whatever his rank in life (illus. 67). The pope is represented at the moment of his greatest temporal function, the coronation of an emperor. In the presence of Church leaders the pope holds the crown over the head of the kneeling, foot-kissing emperor. Death is doubly present in this scene: clutching the cloak of a cardinal he hides behind, and hovering next to the pope, within the baldachin. His grin freezes the moment of the coronation. At the same time one devil leans down from one of the baldachin's ridges, while a second fiend clutching a papal bull hovers into view. Holbein's woodcut does not

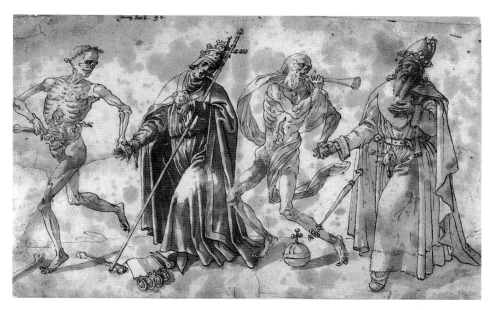

65 Hans Bock the Elder, *Pope and Emperor*, copy after the *Prediger-Dance of Death* in Basle, 1596, pen and grey wash, 19.2 × 31.3. Öffentliche Kunstsammlung, Basle (Kupferstichkabinett).

66 *Death and the Queen*, woodcut in *Les Simulachres & historiees faces de la mort*, Lyon, 1538. Zentralbibliothek, Zurich.

67 *Death and the Pope*, woodcut in *Les Simulachres & historiees faces de la mort*, Lyon, 1538. Zentralbibliothek, Zurich.

Mulieres opulentæ ſurgite,& audite vocem meam.Poſt dies,& annum,& vos contur≤ bemini.

ISAIÆ XXXII

Leuez uous dames opulentes.
Ouyez la uoix des treſpaſſez.
Apres maintz ans & iours paſſez,
Serez troublées & doulentes.

Moriatur ſacerdos magnus.
IOSVE XX
Et epiſcopatum eius accipiat alter.
PSALMISTA CVIII

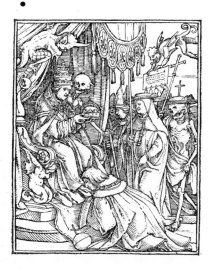

Qui te cuydes immortel eſtre
Par Mort ſeras toſt depeſché,
Et combien que tu ſoys grand prebſtre,
Vng aultre aura ton Eueſché.

C iij

simply juxtapose the highest ecclesiastical authorities with Death, it also shows the pope as having fallen into the hands of the arch-fiend, and hence is the Antichrist. The model for this was surely the woodcut illustrating the kissing of the foot in the *Passional Christi und Antichristi*, published in 1521 in Wittenberg with a series of 26 woodcuts by Cranach the Elder and his workshop and with commentaries by Philipp Melanchthon and Johann Schwertfeger.[46] In his pamphlet of 1520, the *An den christenlichen Adel deutscher Nation*, Martin Luther described the kissing of the foot as a typical example of the Antichrist's behaviour: this he established by a direct comparison between it and the washing of the feet undertaken by Christ.[47]

Many woodcuts of the *Simulachres* series formulate with considerable force a criticism of the clergy. In a nobleman's vineyard Death tears the hat from the head of the cardinal who is profiteering from livings and indulgences. Death apes, with a grin on his face, the rhetorical gesture of the preacher. He uses a mendicant friar's begging-bag to strangle him, and he extinguishes the flame of life in the bedchamber of the sinful nun whose lover sits on her bed and plays music. From among the clergy it is only the bishop, shown as the leader of his flock, and the canon, occupied in his regular prayers, who are spared from criticism. Holbein also shows the corrupt judge and the councillor who, with the Devil on his shoulder, dismisses the poor while Death prepares his downfall.

In the image of the count (illus. 69), Death, in the guise of a rebellious peasant with a coat of arms, raises his arm to strike his lord, who in fearful despair attempts to flee. A scene that refers to the strained relationship between lords and peasants was already to be found in Holbein's *Todesalphabet* of *c*. 1524 (illus. 68). Three uncut copies of the whole alphabet show that the roman initial letters were accompanied by printed texts from the Bible; this suggests that the sheet was originally intended as a handbill.[48] The text accompanying the initial K, in which Death strikes a lord with a flail, quotes Psalm 48, where it is said that neither worldly goods nor honours can accompany a man at death. More than half of the biblical quotations that appear in the first Lyon edition of the *Simulachres* correspond to passages in Holbein's *Todesalphabet*. Neither the passages from the Bible nor the accompanying quatrains make more than an allusive reference to the contemporary historical situation that Holbein's image illustrates.

The heading to the *Todesalphabet*, is the passage from Proverbs 30:18–19, which poses the problem of the path to be followed by mankind. The initials, from A with the concert given by Death, to Z with the Last Judgment, stress the frailness of Man. With the text chosen to close the series, Isaiah 40:6–8, the question raised in the heading is answered: everything passes away, but the Word of the Lord remains for Eternity ('aber das wort des herren bleybt in ewigkeit'). This corresponds to one of the Reformation's battle-cries, which first rang out from the court of Saxony, and appeared in 1534 on the title-page of Luther's first complete edition of the Bible.[49] In the preface to the first edition of the *Simulachres* (1538), Jean de Vauzelles praised the book for making visible the invisible abstraction of Death, and the *historiees faces* as examples of Death's intrusion into every circumstance in life. Beneath each of the images in the series we find a quotation from the Bible as well as an explanatory quatrain. At the end of the book are four learned treatises by Vauzelles on the subject of Death as it had been treated by the Church Fathers. The subjects covered include the different types of Death that await the good and the wicked according to the Old Testament and the New, the ideas of the philosophers and the heathen authorities, and the necessity of Death.[50] In the 1542 edition the Frellon brothers replaced Vauzelles's treatises

68 Detail of *Alphabet with Dance of Death* (illus. 71).

Quoniam cũm interierit non fumet fe=
cum omnia,neꝗ cum eo defcẽdet glo
ria eius.

 P S A L . X L V I I I

Aᴜec foy rien n'emportera,
Mais qu'une foys la Mort le tombe,
Rien de fa gloire n'oftera,
Poᴜꝛ mettre auec foy en fa tombe.

with two translations of Lutheran texts from Augsburg and two sermons by Cyprian of Carthage and John Chrysostom. In France, the chief inquisitor, Vidal de Bécanis, placed the book on the Index in 1540, the French edition of 1542 was banned by the Sorbonne and the university of Louvain proscribed the Latin version.[51]

In many of Holbein's images of Death, neither the intended victims nor the bystanders are aware of his presence. The dialogue between Man and Death as it is staged in the traditional *Totentanz* has here been modified. The image is instead intended for the reader and the beholder, who must reckon with the unexpected irruption of Death into their everyday life. The quotations from the Bible and the quatrains serve to reinforce the idea of the transitory nature of mankind. Similarly, a woodcut by Urs Graf of 1524, *The Mercenary, Lansquenet, Harlot and Death* (illus. 70), advises the viewer to acknowledge the presence of Death.[52]

The first edition of 1538 closes with Death's coat of arms. Two patricians, a woman and a man, hold the coat of arms, and the man looks outwards while with his left hand he points to the fragile image on top of the helmet. Two skeletal arms hold a roughly-hewn stone above an hour-glass. The quotation from the Bible and some lines of verse invite the reader to contemplate the idea of Death. The promise is that a life without sin will be rewarded with a peaceful end. The stone menacingly suspended above the fragile hour-glass, and the skull from which a worm creeps, reinforce vividly the idea that even Death himself will not escape the Last Judgment, repre-

sented on the preceding page. For Eramus of Rotterdam, Holbein produced *c.* 1525 a design for a stained glass showing Terminus, the god of boundaries, and the motto 'CONCEDO NVLLI' – I yield to nobody (illus. 72).[53] The inspiration for this motto had its origin in a gift. In 1509 Erasmus had received a precious Roman intaglio with a figure of Dionysus; he was told that the figure represented Terminus. The words *Concedo nulli* became Erasmus' popular motto: they adorned both his seal and the portrait medal of him executed by Quentin Massys in 1519. Its meaning was ambiguous, although a Christian interpretation was clear enough: no human being can evade Death.[54] It could also be related to the staunch resistance of Erasmus himself, born out of his conviction that he could eventually triumph even over death itself.[55] In turn, Holbein's coat of arms of Death expresses a hope in the Christian victory over it.

'Icones': narrative

In the *Icones*, a series of images based on the Old Testament, Holbein also made use of earlier models that he then adapted to his own purpose.[56] The *Entombment of Joseph*

(illus. 73) is based on the corresponding scene by Erhard Schön and Hans Springinklee (illus. 75). These two artists from Nuremberg had designed new illustrations for two editions of the Bible, published for Anton Koberger in 1518 and 1520 in Lyon.[57] For the Bible that Holbein's woodcuts were to accompany, the same format was chosen. A comparison of the woodcuts for the first chapter of Exodus enables us to measure the extent of his adaptations. In both cases successive scenes are laid out in a carefully delimited space; here we see the burial of Joseph and the subsequent order given to the midwives by the new Egyptian ruler to slaughter all future new-born Hebrew boys. Schön and Springinklee chose to juxtapose the two scenes with their emphasis on strict narrative sequence. Holbein, however, significantly changed the burial scene, including the sarcophagus and composing anew the groups of figures, using to advantage his knowledge of Mantegna and Dürer (illus. 63, 64). He pulls into the mid-ground the scene with Pharaoh, the palace and the midwives by the balcony, but relegates to the distance the scene of the massacred children. The coherent organization of space was for Holbein an integral element of a profound understanding of the links between the various parts of the narrative.

Thus Holbein here used the whole space to develop his narrative rather than limit himself to lining up figures in the foreground. This latter device had been his practice in previous years. The whole space is occupied by a mass of details, cities and landscapes, and it is within this framework that the narrative is inscribed. In this instance, as in the case of the *Dance of Death*, he worked out very carefully the expression of his figures, a singular achievement given that the format was very small (6 x 8.6 cm), and required the most exacting precision from his woodcutter.

The *Icones* devote three separate images to the story of Job, whom God allowed to be tempted by Satan. The first of these (illus. 74) shows Job sitting helplessly on a dungheap, the laughing-stock of his wife and friends. In the background his house and stables are going up in flames. In the second scene, a pitiless repetition of the first one, Job sits among the ruins of his house, while his friend Eliphaz sternly rebukes him. In the third scene Jehovah finally appears, in a storm, to respond to Job. The latter sits, naked, at the centre of the image, just as the figure of Man was to in the later painting *The Old and the New Testament* (illus. 161). Schön and Springinklee, however, did not produce a single woodcut illustrating the story of Job for either their Lyon or Nuremberg editions.

Luther's third part of the *Old Testament* appeared in 1524 in Wittenberg. It had only two illustrations – the title-page and a large woodcut by Cranach the Elder. In this we see in the foreground the mocking of Job on the dungheap. A wall separates this from the background scene, where we are shown all of Job's misfortunes (illus. 76). Above this central portion are the prophets, and below is the fulfilment of their prophecies, Christ the Saviour, who accepts the martyrdom of the Cross.[58] What is being implied here is not the Reformation's interpretation of that biblical scene, whereby Job was seen as the prefiguration of the sufferings of Christ.[59] In his introduction to the Book of Job, Luther established a distinction between claiming justice and receiving God's mercy; to exemplify this he compared Job, who in his pains could not see the mercy of God, with Christ, who made that mercy visible.[60]

The accent Holbein gives to the story of Job in the *Icones* is in tune with Reformation attitudes. He not only produced a title-page for Luther's New Testament published in Basle (illus. 121), he also participated in the illustration of Luther's translation of the Old Testament, printed by Adam Petri in 1523 and 1524, and by

71 *Alphabet with Dance of Death, c. 1524,* single leaf woodcut with type printing, 27 × 34. Kunstsammlung der Veste Coburg.

72 *Stained Glass Design with Terminus, c. 1525,* pen and brush with washes and watercolour, 31.5 × 21. Öffentliche Kunstsammlung, Basle (Kupferstichkabinett).

IOSEPH sepelitur. Filii Israël in Aegypto
dura seruitute opprimuntur. Obstetricum
piarum industria exprimitur.

EXODI I.

Ioseph est mort, & mis en sepulture,
Israël souffre une grand tyrannie,
Matrones sont de si doulce nature,
Qu'elles ont sauué à tous masles la uie.
C 2

IOB bona omnia dissipat Satan, & eius libe-
ros percutit, expetita facultate à Domino.
Laudat Deum in sua afflictione.

IOB I.

Iob par Satan (ayant de Dieu licence)
Souffre en ses biens grand persecution:
Ses enfans perd, dont il a patience,
Louant son Dieu en telle affliction.

73 *The Entombment of Joseph and the Tyranny of the Egyptian King*, woodcut in *Historiarum ueteris instrumenti icones*, Lyon, 1547. Zentralbibliothek, Zurich.

74 *Job*, woodcut in *Historiarum ueteris instrumenti icones*, Lyon, 1547. Zentralbibliothek, Zurich.

75 Erhard Schön, *The Entombment of Joseph and the Tyranny of the Egyptian King*, woodcut in *Biblia cu cocordantiis veteris . . .*, Lyon, 1518. Bayerische Staatsbibliothek Munich.

76 Lucas Cranach the Elder, *The Mockery of Job*, 1524, woodcut, 22.5 × 16. Staatsbibliothek, Bamberg.

SENNACHERIB blafphemus inuadit Iudã.
Ezechias hortatur populum ad fiduciam in
Deum. Orante Ezechia, Angelus Affyrios
perfequitur.

II. PARALIP. XXXII.

Sennacherib en Iudée fait guerre,
Ezechias le peuple en Dieu exhorte,
Et luy priant, Affyriens par terre
L'ange pourfuit en fa puiffance forte.

Thomas Wolff in 1524.[61]

It is clear, however, that in the three images illustrating the story of Job, Holbein was more interested in narrative devices than in a Reformationist interpretation of the scenes. What mattered to him was the composition of narrative in a small format, even when the narrative itself assumed gigantic proportions. Thus the defeat of King Sennacherib's army in front of Jerusalem is a monumental work encapsulated in a minute area (illus. 77). In fact Holbein received no commissions for frescoes between 1524 and the completion of the murals in Basle's Rathaus in 1530. It was rather in the microcosmic world of the *Icones* that he developed his abilities, increasing the expressive power of his figures in motion and sharpening the spatial effects. It is easy to compare the *Defeat of Sennacherib* with the drawing of a battle of *c.* 1530 (illus. 78) to see how Holbein could progress, either by repeating or varying a theme.[62]

The dating of the sketches for the *Icones* varies between 1526 and *c.* 1529–30.[63] The late dating is based on the assumption that there are stylistic variations between the *Dance of Death* and the *Icones*, but the difference between the two undertakings should be taken into account here. The monumental aspect of some of the woodcuts in the *Icones* cannot be explained by the simple fact that they were executed at the same time as the artist was completing the last murals for the Rathaus. Rather, these woodcuts are to be seen in conjunction with the works executed for Luther's texts and in relation to the activities of the Trechsels in Lyon and of Hans Lützelburger in Basle. Thus we can say that Holbein's contribution to the *Icones*, as well as the *Dance of Death*, were completed before his departure for England in August 1526. The prodigious impact of the two series of images remains to be studied.[64]

77 *The Defeat of Sennacherib*, woodcut in *Historiarum ueteris instrumenti icones*, Lyon, 1547. Zentralbibliothek, Zurich.

78 *Battle*, *c.* 1530, brush and pen with washes, 28.6 × 44.1. Öffentliche Kunstsammlung, Basle (Kupferstichkabinett).

3 Monumental Decorative Works

Lost masterpieces

The sole examples of Holbein's numerous monumental decorative works to survive are the organ doors for the Basle Münster. Only some fragments, a few preparatory schemes, copies after these schemes, and subsequent – not always reliable – copies of the works testify to this important part of his artistic creation. These scanty remains are tantalizing fragments of his extensive monumental works for both private and public clients, which often constituted a substantial part of his artistic activity. Between 1517 and 1519 Holbein was engaged on painting the facade of the Hertenstein house in Lucerne. In 1521 the Basle council gave him the important commission for the painting of its new chamber. During the early 1520s he undertook the facades of the house Zum Tanz in Basle. It is also possible that he produced two schemes for other facade decorations. In 1525–6 he produced the organ doors for the Basle Münster and in 1530 he completed the decoration of the council chamber. Later, in London, he was involved in some similar schemes, but not as many as in Switzerland. In 1533 he produced some decorative pieces for the Steelyard and in around 1536 the mural for Henry VIII in Whitehall Palace.

The monumental paintings Holbein produced began to fall into disrepair relatively quickly, mainly because of unfavourable climatic conditions but also because of shortcomings in the technique he employed and various structural problems.[1] This was aggravated by lack of interest in and disdain for the paintings. Indeed, by the next century few people in Lucerne or Basle were aware of the name of the artist who had been responsible for the facade of the Hertenstein house. And although Charles Patin included the altar in the Franciscans' church in his catalogue of 1676 that lists Holbein's works, the Hertenstein house was ignored.[2] In 1825 the house was demolished, and it was probably also in the nineteenth century that Zum Tanz suffered the same fate. (This latter house was replaced by a new building that was itself only to survive until 1907.) In fact, by 1579 two of Holbein's paintings in the council chamber in Basle were already in such poor condition that they had to be restored, or even repainted, by Hans Bock the Elder. During demolition work in 1817 and 1825, parts of the original work were found hidden beneath wallpaper; these were copied and then destroyed. The works in London fared no better. The paintings for the Steelyard were lost in a fire in the Moravian town of Kroměřiž in 1752, and the mural in Whitehall was destroyed in the huge conflagration of 1698.

The meagre remains that we have make it extraordinarily difficult to gain a precise idea of Holbein's monumental decorations or to gauge his abilities in coping with the task. The artist showed himself to be very critical about his earlier works on the occasion of his visit to Basle in 1538, and it was only when looking at the house Zum Tanz that he would concede that it was not entirely bad – 'ein wenig gut'.[3] Any analysis of Holbein's monumental decorations must be balanced against his fame as a painter

of portraits and miniatures. Here we must again consider the questions of invention and narrative that have already been examined.

Facade decoration

In Lucerne Jakob von Hertenstein (illus. 79) had a new four-storey house built for him and his fourth wife Anna von Hallwyl after 1510. Hertenstein (*c*. 1460–1527) had, through his four marriages, judiciously increased his fortune. He had been involved in the Ravensburg commercial company since 1495, he was the governor of various provinces and was first chosen as *Schultheiss* (president of the government) in 1515, a post he was to hold four times between then and 1522. He was the representative of Lucerne in the Diet and was for a while the protégé of Maximilian I. In addition to this he was one of the most important representatives of French interests in inner Switzerland. As a result he was one of the most powerful men in the confederation.[4] The main front of his house in Lucerne looked out onto the Kapellplatz (illus. 80). Lucerne was a busy port of call on the north–south trade route: here large amounts of goods could always be found being loaded on vessels bound for distant places or transferred from incoming boats to local wagons. Between 1517 and 1519 both the inside rooms and the external walls of the Hertenstein house were painted.[5]

Although we know who commissioned the work, we have no record either of the contract itself or of the artists with whom it was agreed. It is not clear whether Holbein the Elder or Holbein the Younger had received the commission from Hertenstein. It should not be forgotten that in the years around 1515 Holbein the Elder was one of the best-known artists in the southern German territories and that Hertenstein did have business interests that reached as far as Ravensburg. The younger Holbein was not yet a master and thus not able to sign a contract.[6] In fact neither he nor his

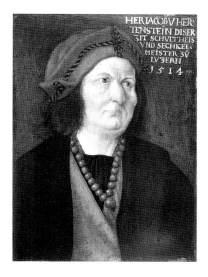

79 Unknown painter, *Jakob von Hertenstein*, 1514, oil on wood, 30.5 × 22. Kunstmuseum, Lucerne (on loan from the Gottfried Keller-Stiftung).

80 Detail from Martin Martini's engraved city map of 1597, showing the Chapel Square in Lucerne with the Chapel Church, the Sust and the Hertenstein House (the last-named can be seen at centre-left, a stepped-gabled house facing onto the square, on the corner of the Sterngasse). Zentralbibliothek, Zurich.

81 Reconstruction by Heinrich Alfred
Schmid of the facade of the Hertenstein
House in Lucerne, published in 1913.

father had any experience in large-scale wall paintings, whereas Ambrosius was at least working on those for the monastery of St Georgen in Stein am Rhein. However, although Ambrosius could have completed a contract in Lucerne, he was received into the Basle guild Zum Himmel in February 1517, and was granted citizenship the following year. This would tend to suggest a longer uninterrupted period in the city than would have been possible if he had worked at Lucerne.[7] Of the three extant preparatory drawings for the decoration of the Hertenstein house, one is in Holbein the Elder's sketchbook now in Basle, lending weight to the idea that he was involved in the work. Two preparatory drawings for the facades themselves have been attributed to Holbein the Younger.[8] Given that the attribution of the drawings is correct, it would seem that Holbein the Elder undertook the interior work and that his son was responsible for the facades. The few fragments of the paintings that remain confirm that they were executed *al secco* on plaster rather than *buon' fresco*, the genuine fresco technique.[9] The copies that were made in 1825 were done in great haste shortly before the demolition of the house and at a time when the murals were scarcely visible. Although most of them are small line drawings in pencil, they do permit, when consulted in conjunction with a sketch of the arrangement, a reconstruction of the overall programme (illus. 81). Unfortunately, they cannot be used as a means of estimating how the work was divided up, or of determining whether other artists were involved.

In the development of the iconographical programme Holbein had to comply with the social and learned claims of his noble patron. In the centre panel between the first and second storeys was the so-called 'Königsprobe' (or 'Leichenschiessen'), the King's Test. This macabre story is to be found in the *Gesta Romanorum*, a medieval book of legends, whose only German edition appeared in Augsburg in 1489. The story relates how a test was performed to ascertain the correct heir from among a number of descendants: the legitimate successor was the one who refused to shoot

82 Anonymous pencil copy of 1825 after Holbein, *The Trophy Bearers after Andrea Mantegna's 'Triumph of Caesar'*. Zentralbibliothek, Lucerne.

83 Andrea Mantegna, *The Trophy Bearers in the 'Triumph of Caesar'*, *c.* 1498, engraving, 28.7 × 26.5. British Museum, London.

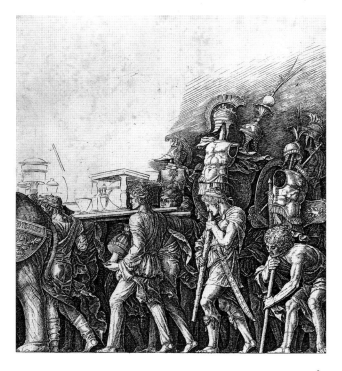

an arrow into his father's corpse.[10] On the facade of the Hertenstein house this scene is flanked to the left and the right by the marriage coats of arms of Jakob von Hertenstein and his four wives. Clearly the central mural was a reminder from Hertenstein to the offspring of his various marriages. In the nine panels between the second and the third floors Holbein painted a copy of Andrea Mantegna's *Triumphs of Caesar*, a work that Mantegna had originally made for the Marchese Francesco Gonzaga between 1484 and 1493.[11] In the centre above the second storey was the copy of the *Bearers of Military Trophies and Spoils* (illus. 82, 83). By means of this copy after Mantegna, the *Schultheiss* of Lucerne appropriated for himself a work that a famous artist had created for the important Marchese of Mantua. This artistic reference thus gilded the Lucerne patron's own social status. Hertenstein must have viewed this appropriation as being justified not only because of his position in Lucerne but because of his own family's history. He and Anna von Hallwyl were descendants of the victor of the Battle of Grandson (1476), in which the invading Burgundian army of Charles the Bold was defeated near the lake of Neuchâtel; there the Swiss Confederation won the richest spoils of its history.[12] In Mantegna's work the fifth canvas in the series is taken up by the *Trumpeters and Elephants*. At Lucerne this was replaced by the *Bearers of Military Trophies and Spoils*, and its positioning surely confirms it as a reference to the family's history, just as is the portrait of Hertenstein's son Benedikt (illus. 20), which includes another version of the triumphal procession. This emphasis on the middle portion of the facade must have been the reason for which Holbein included here, on the very uppermost row, the representation of Mucius Scævola as his artistic signature.[13] The artist's use of Scævola as a signature must, in his view, have justified this privileged position amongst the examples of ancient virtue.[14]

Since Holbein had not made a copy after Mantegna's work before, it is plausible to assume that the stimulus to produce this one came from Hertenstein himself, and that it was the patron who provided the painter with the relevant material, for both the *Bearers of Military Trophies and Spoils* and the *Elephants* (illus. 85) were available in reproductive prints made after Mantegna's preparatory drawings. It is possible that for his work Holbein made use of not just the engravings by and after Mantegna but also the twelve sheets of the woodcut series of the *Trivmphvs Cæsaris* made by Jakob von Strassburg after designs by Benedetto Bordone that was printed in Venice in 1503.[15] These woodcuts are by no means straightforward copies after Mantegna but can fairly be described as variations on the triumphal procession of Caesar. A comparison of the engraved *Elephants* (illus. 85), of the woodcut of 1503 (illus. 86) and of the drawing of 1825 (illus. 84) shows that here Holbein based his work on the engraving made by an Italian close to Mantegna rather than on the cruder print cut by the German. Neither the series of woodcuts nor the available engravings after Mantegna include all the subjects that Holbein represented in Lucerne. Thus the question remains as to whether the young artist was not actually sent by his patron to Mantua with the precise aim of examining the full cycle of Mantegna's *Triumphs of Caesar*. The very fact that Holbein was engaged in work over a period of two years at the main point of exchange on the north–south trade route and for a family with wide-ranging political, commercial and military interests must at the very least suggest that this possibility should be carefully examined.[16]

Five examples of masculine and feminine moral virtue drawn from ancient history were used by the artist on the uppermost storey to complete the facade decorations. A sketch for one of these panels survives (illus. 88); the blank spaces take into account

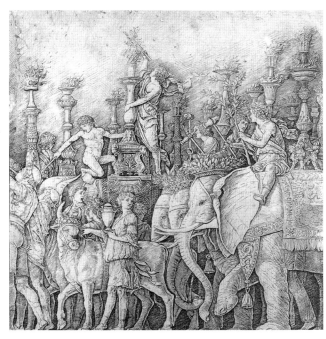

84 Anonymous pencil copy of 1825 after Holbein, *The Elephants after Mantegna's 'Triumph of Caesar'.* Zentralbibliothek, Lucerne.

85 Andrea Mantegna, *The Elephants,* *c.* 1500, engraving, 28.6 × 26. British Museum, London.

86 Jakob of Strassburg, *The Elephants* from *Triumphus Caii Iuli Caesaris,* 1503, woodcut, *c.* 30 × 40. Öffentliche Kunst-sammlung, Basle (Kupferstichkabinett).

87 *Sketch for the Decoration of the Hertenstein House*, 1517/18, pen, watercolour and washes, 30.9 × 44.4. Öffentliche Kunstsammlung, Basle (Kupferstichkabinett).

88 *Leaina before the Judges*, 1517/18, pen and grey wash, 21.2 × 16.4. Öffentliche Kunstsammlung, Basle (Kupferstichkabinett).

89 Title border for Heinrich Glareanus, *Isagoge in musicen* . . ., Basle, 1516. Universitäts-Bibliothek, Basle.

the positioning of the roof-supports. The drawing represents the Greek courtesan Leaina who bit off her own tongue when called before the Athenian judges so that she should not have to testify against the tyrant-slayer Aristogeiton.[17] At the angle of this storey, on the corner of the Kapellplatz by the Sterngasse, Marcus Curtius is shown, the hero who, astride his mount, leapt into the abyss (illus. 164).

It is probable that Holbein intended to decorate the ground floor with architectural motifs that integrated the entrance door and the windows. The preparatory drawing for the right-hand side of the ground floor (illus. 87) shows the entrance door of the house framed by columns that support a highly decorative semi-circular arch that surrounds an equally animated tympanum. By a play with illusion the grating of the cellar vault has been pushed back deeper. This has been achieved by the depiction of the columns placed before it, the panelled arch that springs from pillars, and the steps above the grating just in front of the masonry wall with a balustrade before it.[18] This combination of modernizing a facade and of witty disarray was later to be carried to an extreme by Holbein in the decoration of the facade of the house Zum Tanz in Basle.

In his sketch for the painted architectural details in the entrance area Holbein used elements similar to those found in his architectonic title-borders for printed books. The earliest example of such work by him, dating to only shortly before his work at Lucerne, is the signed border with nine putti that first appeared in Heinrich Glareanus' *Isagoge in musicen* published by Johannes Froben in the early summer of 1516 (illus. 89). Clearly the idea for the various friezes on Hertenstein's house depicting playing or struggling putti came from his contemporaneous designs for title-borders.[19] It should here be noted that it was only in the ground-floor design, and possibly in the scenes showing the 'King's Test' and 'Leaina', that Holbein used the architectural knowledge he had gained in Augsburg. By contrast, the individual sections of the *Triumphs of Caesar* were framed in a conventional way with pilasters or columns.

In Stein am Rhein, the house Zum Weissen Adler still has the mural decoration that was probably painted *c.* 1520 for the merchant Sigmund Flaar, a former Bürgermeister of Constance (illus. 90). The artist to whom the work was entrusted was Thomas Schmid, who had previously been working at the monastery of St Georgen.[20] Regular repairs and repaintings, necessary as a rule every two generations because of climatic conditions, have preserved this work, which can be contrasted with Holbein's Hertenstein house. The architectonic decoration shows massive pillars on the ground floor, smaller corner pillars and round columns on the first floor and two coffered arches on the second floor. These are all arranged so that they are seen in perspective by the viewer standing in the street. Various allegories of Virtues and Vices are to be seen. Framed by the arches are two scenes from Boccaccio's *Decamerone*; between the second and third floors is a parable that takes unity as its theme, and the story of the 'King's Test'. On the topmost floor the allegorical figure of Justice is shown on the left. This is followed by the victory of Prudence over Malice and to the right we see a figure astride a leaping horse.

In his bold and witty facades for the house Zum Tanz in Basle Holbein turned decidedly away from both the conventional division of the facade into sections and from the narrative and allegorical programme of the representation of the Virtues (illus. 92).[21] Likewise he abandoned the correspondence between the building's structure and the architecture painted onto it. The decoration for the Hertenstein house is less daring in that respect. However, the low viewpoint chosen for the procession

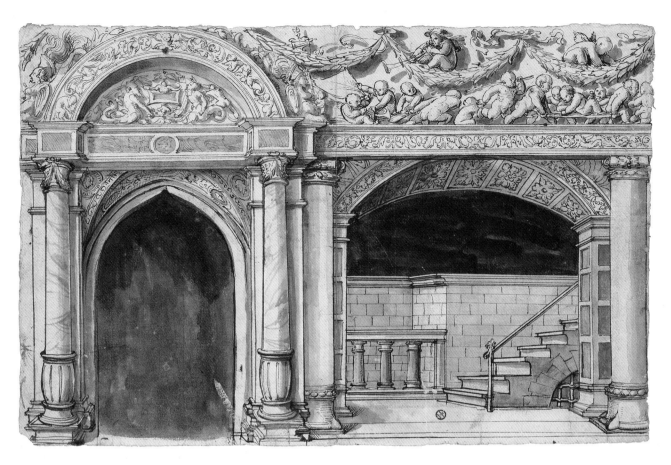

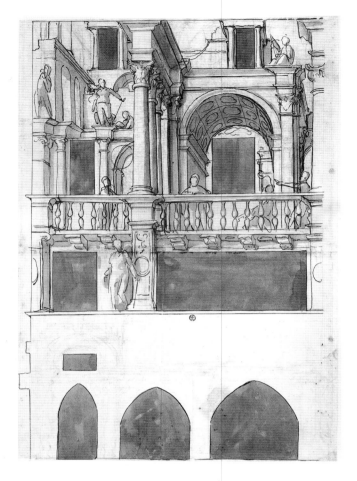

90 Street facade of the 'Zum Weissen Adler' House, Stein am Rhein, *c.* 1520.

91 *Sketch for the Zum Tanz Facade on the Eisengasse, c.* 1523, pen and washes, 53.3 × 36.8. Öffentliche Kunstsammlung, Basle (Kupferstichkabinett).

92 Model reconstruction of the 'Zum Tanz' House, 1984. Öffentliche Kunstsammlung, Basle (Kupferstichkabinett).

imitating Mantegna's *Triumphs of Caesar* shows that he had already discovered how to organize a work according to the position of the beholder, and consequently forsook the partition of his facades into distinct fields. He played at will with painted architectural elements (illus. 91). In the sketches for the Zum Tanz (illus. 6, 93), all three triumphal arches are misplaced; one is partially obscured by a colonnade that straddles the balustrade, another is intersected by a pavilion, while the third is a fantastic composition of angles, columns, pedestals and architraves. This puzzling architecture is populated by small figures who look down into the street or play with a dog behind the balustrade. One sits quietly next to his horse while another on horseback seems in imminent danger of falling. Both facades seem to be ripped open or left unfinished at the top; a peacock and a tree have found a place there. Similar illusions of ruins were to be included in Sebastiano Serlio's *Regole generali d'architettura* of 1537, the first of his architectural treatises.[22] Such a breach of all the principles governing architecture has always exerted a kind of fascination. Holbein may have sought some inspiration from existing decorations that he had seen in Nuremberg or in Augsburg, but only to a certain extent. His interest must have been focused on the play between viewer and viewed and on a challenging use of perspective.[23] Later, both Tobias Stimmer and Hans Bock the Elder were to exploit similar devices (illus. 94); Bock's design for the facade of the Zwinger house (1571) combines a moral warning against arrogance with the artistic hubris of his architectural fantasies. The whole composition is subordinated to two large-scale allegorical figures, those of Prudence and Fortune. The me-

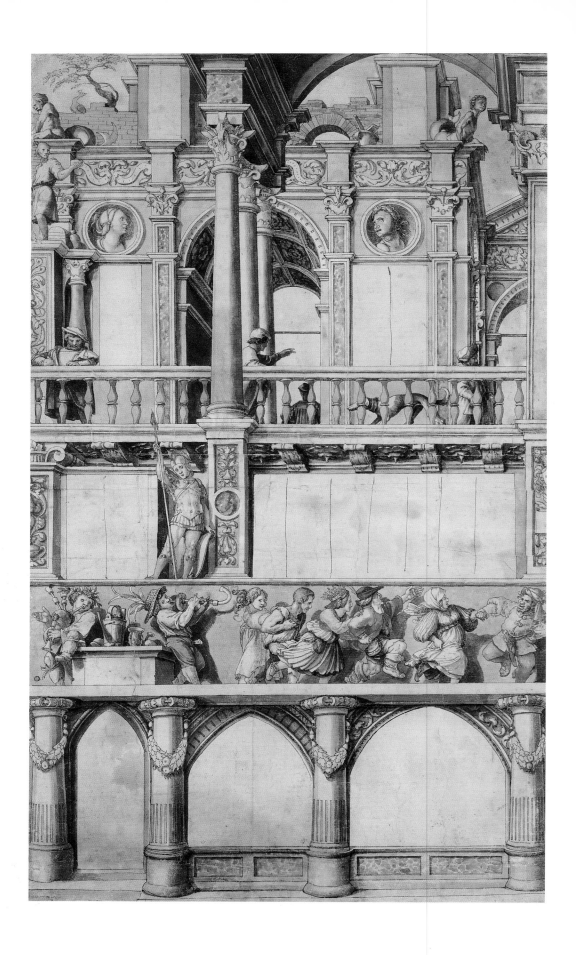

94 Hans Bock the Elder, *Sketch for a House facade with Prudence and Fortune*, 1571, pen and grey and purple washes, 49.4 × 39.4. Öffentliche Kunstsammlung, Basle (Kupferstichkabinett).

dallions show the fall of Icarus and of Phaethon, examples of excess, arrogance and stupidity. The architectural decoration of the facade is broken by a rift in the middle: here, at the bottom, lies a monster, the Chimæra. In the oculus high above it a thundering Jupiter can be seen. The second sketch solves the iconographic riddle: a huge *quadro riportato* with Jupiter and the fatal collapse of Bellerophon, who fell from the winged horse Pegasus and landed on the Chimæra. It is probable that Theodor Zwinger, who commissioned this cycle, insisted on a readable iconography, suitable to the moral purpose of the whole work.[24] The message is the same: a warning against hubris, the vain desire to ascend to higher spheres. The design selected by the artist provides another comment on artistic excess and illusionistic architecture. If Holbein adopted the beautiful Chimæra from Horace, that is the figure of poetic licence appropriated by the artists, Bock chose rather to refer to the fearful Lycian monster, which was destroyed by Bellerophon with the help of Pegasus, the horse beloved of the poets. According to Alciati's *Emblematum libellus*, such a combination could symbolize victory in the struggle against strong and crafty enemies.[25]

93 Copy after Holbein, *Sketch for the Facade on the Eisengasse*, 16th century, pen and watercolour, 57.1 × 33.9. Staatliche Museen zu Berlin (Kupferstichkabinett).

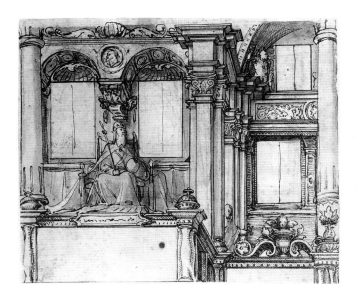

95 *Sketch for a Facade Decoration with Enthroned Emperor, c.* 1524–5, pen and grey wash, 16.7 × 19.9. Öffentliche Kunstsammlung, Basle (Kupferstichkabinett).

96 Bernardo Prevedari, *Interior of a Ruined Sacral Building,* 1481, engraving after Bramante, 70.5 × 51.3. British Museum, London.

The design for the house Zum Tanz was probably followed by a scheme for a facade that was not executed. The sketch shows a seated emperor (illus. 95), and the architectural décor has replaced the chimerical creation with an almost entirely classical style. It is a fragment of a mural for a first or second floor, and would have extended over the facades of two houses built next to one another.[26] The copper engraving that Bernardo Prevedari executed after a drawing by Bramante showing a once-magnificent building falling into ruin has already been identified by Jacob Burckhardt as providing part of the inspiration (illus. 96). Certainly the pediment jutting forward and supported on pillars matches, apart from a few details, the left-hand side of the building in Bernardo's engraving.[27] Holbein has also maintained the perspective, and here too he planned that his design should be viewed from below. The same can be said of the figure of the emperor seated on his throne, the console above him and the two arches that serve as window-frames. It seems, however, that the columns on either side defy the rules defined in Italy's Renaissance: they do not fit with the rest of the construction.[28]

The dates that have hitherto been proposed for the Zum Tanz house range from 1519–20 to 1531–2, mainly based on stylistic analyses. However these, with their untested hypotheses about general and individual artistic development, cannot give us any precise date without recourse to material or documentary evidence.[29] If one combines the evidence of historical dates with what is known of Holbein's working practice it is, in fact, possible to be more precise. In the autumn of 1519 Holbein became a master in Basle, and the commission for the decoration of the council chamber followed only in June 1521. This work was, however, interrupted for a period of several

years at the end of November 1522. The Virgin Mary produced for the town-clerk Gerster and possibly also the epitaph altar for the councillor Oberried (who was director of public buildings) may certainly be linked with this public commission. Since the owner of the house Zum Tanz, the goldsmith Balthasar Angelroth, was the brother-in-law of the town-clerk, it is possible to assume that his commission for the facade paintings likewise followed close on that given by the city council. It is true that only a few of Holbein's works can be attributed with any certainty to the period between October 1519 and June 1521, but the same is also the case for the time between the beginning of his work on the council chamber and his journey to France in the early part of 1524. In fact, for this latter period only the portraits of Erasmus are definitely known. As for the time between his return from France and his departure for England in the late summer of 1526, Holbein was occupied on several different projects: the *Simulachres*, the *Icones*, the *Last Supper*, the organ wings for the Basle Münster, the *Designs for Stained Glass Showing the Passion of Christ* and the *Darmstadt Madonna*. These dates, combined with stylistic differences and norms of development, make it unlikely that Holbein could have produced the design for the revolutionary facade paintings of the house Zum Tanz directly after his work in Lucerne or before the decoration of the Basle council chamber.[30] For in this latter scheme he limited himself on the whole to a conventional sequence of allegorical and historical images. Thus the most likely date for the Zum Tanz project would seem to be between the end of 1522 and early 1524.

A further, weighty, argument can support this date. The commission to paint the house's two facades could only have been executed with the help of a workshop team, and we have no evidence that Holbein had such a team in 1520. Likewise, painting the council chamber in June 1521 would also have entailed support from assistants and apprentices. When such help was available Holbein could have felt able, at the end of 1522, to take on the relatively extensive commission for the painting of the two facades after the work on the council chamber. One difficulty remains if this date is accepted: for the painting of the Zum Tanz he was paid only the meagre sum of 40 florins, according to Theodor Zwinger's report of the affair written in 1579.[31] For the council chamber the first payment in 1521–2 was of 120 florins, to which should be added a further 60 florins for its completion in 1530. Thus the rather miserly payment of 40 florins does not help in ascertaining the date of the commission: it represents a sum that could equally well have been paid in 1520 to an artist at the beginning of his career or in 1523 to a workshop that was short of commissions.

The Basle council chamber

The contract for painting the council chamber was concluded on 15 June 1521. The fee of 120 florins was to be paid in instalments, the last of which was given on 29 November 1522, when the council agreed that the back wall should remain unpainted for the time being. Obviously there was no argument with Holbein's opinion that the work done was sufficient for the payment he had received. The decoration of the room was finally completed by the artist in 1530 for a supplementary sum of 60 florins.[32]

The painting of the council chamber was not simply a public commission of the

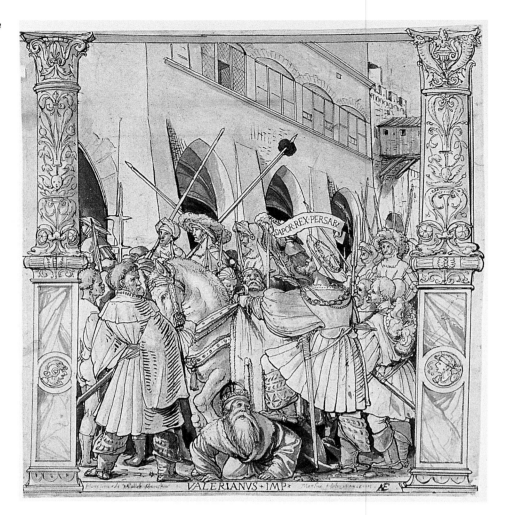

97 *The Humiliation of the Emperor Valerian by the Persian King Sapor,* 1521–2, pen, watercolour and grey wash over chalk sketch, 26.8 × 28.5. Öffentliche Kunstsammlung, Basle (Kupferstichkabinett).

98 Copy after Holbein, *Sertorius and the Example of the Horses, c.* 1540, pen, 28.1 × 70.1. Öffentliche Kunstsammlung, Basle (Kupferstichkabinett).

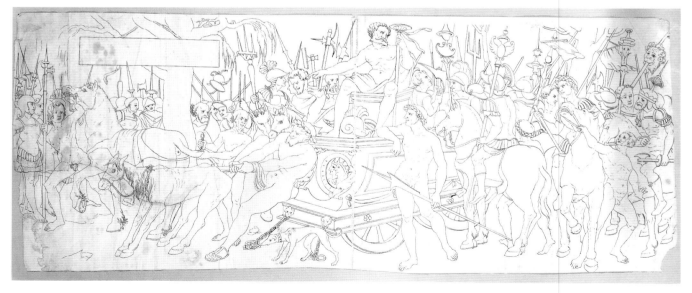

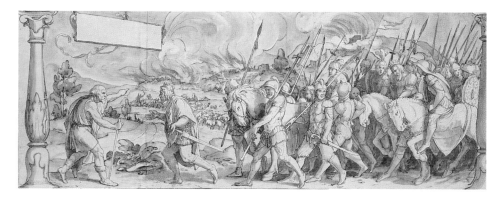

99 *Saul and Samuel*, sketch for a wall painting in the Council Chamber of the Rathaus in Basle, *c.* 1530, pen, watercolour and grey and brown washes over chalk, 21 × 52.4. Öffentliche Kunstsammlung, Basle (Kupferstichkabinett).

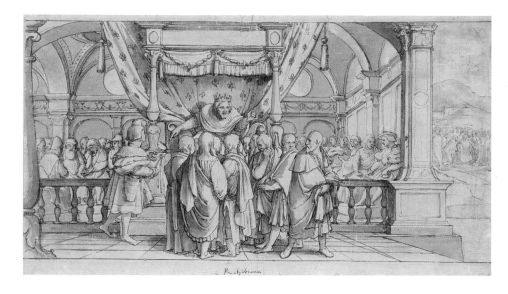

100 *The Anger of Rehoboam*, sketch for a wall painting in the Council Chamber of the Rathaus in Basle, *c.* 1530, pen, watercolour and grey wash over chalk, 22.5 × 38.3. Öffentliche Kunstsammlung, Basle (Kupferstichkabinett).

101 *Head and Hand of King Rehoboam*, fragment of the wall painting of *The Anger of Rehoboam*, 1530, fresco secco, 28 × 41.5. Öffentliche Kunstsammlung, Basle.

102 Jakob Heinrich Scherb, *Ground plan and longitudinal section of the Council Chamber of the Rathaus in Basle*, 1817. Staatsarchiv Basle.

utmost importance, for it was also a political affair. Construction of a new council house was decided on in 1503, two years after Basle's alliance with the Confederation, and marked the citizens' declaration of their liberation from episcopal rule.[33] In 1501 the council had for the first time refused to swear the oath to the bishop on the Münsterplatz. In December 1513 the Basle envoys in Zurich asked the other Confederate states for a donation for stained glass for their new-built council house. Ten out of the twelve windows bore imperial coats of arms, testifying to the fact that they were self-governing under the Emperor. The Basle window in the council house displayed the arms of the town with, on either side, the Virgin Mary and Emperor Henry II.[34] During the first meeting in the new council chamber the independence of Basle from the bishop was declared. At the same meeting all secular citizens were forbidden to swear the oath to the ecclesiastical ruler.

Since Salomon Vögelin's work it has been assumed that the humanist Beatus Rhenanus was involved in the work in the council chamber. He may have designed the mural decorations or, at least, have participated in the project by choosing and drafting the numerous inscriptions.[35] The new chamber was constructed by adding another storey to the existing council house after 1517; it was lit by five large southwest facing windows (illus. 102). The murals were to decorate the two shorter walls, each of about ten metres in length, and the long north-eastern wall, which measured about twenty metres but was broken up by windows, doors and a stove. The room was between 3.7 and 4 metres in height, but the seating that ran around the perimeter of the room meant that the band to be painted was only about two metres deep. From the few fragments that survive we know that Holbein painted *al secco* onto the plaster. However, due to the effects of humidity, the paintings disintegrated rapidly. Thus, in 1579 Hans Bock the Elder was asked to replace parts of them. A description of the completed paintings was never made, but as a result of various renovation works in 1817 and 1825 some remains were found under wallpaper on the long wall. These were then copied, and it is interesting to note that the format of the copies differs from that shown in the preparatory sketches. A number of ingenious attempts have been made to reconstruct the council chamber, working with various drawings, copies of sketches, texts, and copies of the wall paintings themselves. This led, however, to a far from clear resolution – a questionable reconstruction of the allegorical figures and historical pictures.[36]

The decoration was composed of historical scenes and allegories of Virtues. Generally the historical scenes were bordered with painted pilasters or columns, and separated from one another by life-size Virtues in painted niches. It can be assumed that the arrangement was such that the allegories complemented the moral of the historical scene. Thus there was an image of the Persian king Sapor who humiliated his defeated rival, the Roman emperor Valerian, even to the extent of using him as a footstool (illus. 97). The allegories that stood on either side of this scene were probably those of Temperance and Wisdom. The 1521 programme included a series of tales from ancient history (and possibly also Christ and the Adulteress), which served a didactic purpose as illustrations of good and bad government and leadership. These historical examples were more a declaration *by* the council than they were a reminder to it. However it seems that Holbein did not in 1530 execute the paintings that had possibly been planned as early as 1521–2, but he developed new themes that had not formed part of the original programme. It is possible that he proposed in 1530 that the remaining wall should be decorated with the scenes of *Sertorius*

and the Example of the Horses (illus. 98) and *Croesus Burned at the Stake*.[37] Perhaps these suggestions belonged thematically to the original programme. However they were not carried out; instead two from the Old Testament were chosen, the sketches for both of which are extant. *Saul and Samuel* (illus. 99) shows King Saul who had won many victories but was disobedient; in spite of the prohibition by the prophet Samuel he brought home captives and spoils and was therefore cursed. *The Anger of Rehoboam* (illus. 100) is a didactic scene showing the cruel ruler and his downfall caused by harsh oppression. The fragment of this mural (illus. 101) proves that this painting was indeed executed (which is not certain in the case of some of the extant sketches) and that there were considerable differences between the scheme for the work and the painting itself. The intermediate stages between the sketch and the executed painting are missing, as is almost always the case in Holbein's works: only one of his cartoons survives (illus. 108).

A comparison of the sketch of 1521–2 and the two of 1530 shows a development from a packed scene to compositions with more movement and points of focus. Between these two stages of his work came the demanding commission of the *Icones*, and also the work on the large figures on the organ doors for the Basle Münster in 1525–6 (illus. 103, 104). On the left door Holbein represented the holy imperial couple of Henry II and Kunigunde. Opposite them, on the right door, are the Madonna and Bishop Pantalus. In the sketch Holbein planned to represent both Henry and the Madonna with an imperial crown, but in the executed works the Madonna is not wearing one; the reasons for this change are not known.[38] Basle honoured the Holy Emperor Henry II as the builder of the cathedral and the restorer of the bishopric. Early historians, like Petermann Etterlyn and Sebastian Münster, mention the link between Henry II and Basle.[39] The gold altar frontal of Basle Münster, which dates from 1020–30, shows the two sacred founders, Henry and Kunigunde,

103, 104 *Sketches for the Organ Doors of Basle Münster, c.* 1525–6, pen over chalk with washes, 38 × 60.4. Öffentliche Kunstsammlung, Basle (Kupferstich-kabinett).

105 Emanuel Büchel, *The Organ in Basle Münster with opened Doors*, 1775, pen and watercolour, 39.3 × 45.1. Öffentliche Kunstsammlung, Basle (Kupferstichkabinett).

in full regalia at Christ's feet.[40] Holbein adopted for the organ doors a moderate view from underneath corresponding to the position of the organ, which was about eleven metres above the pavement (illus. 105). He chose, however, to paint life-size figures. These are perhaps the artist's first painted three-dimensional figures. It is evident from the fact that he has avoided using bright colours that the main quality he sought both in the sketch and in the executed work was plasticity.

Monumental paintings in England

Possibly the two largest monumental decorations that Holbein painted in England were the Triumphal Processions of Wealth (illus. 106) and Poverty (illus. 107) for the hall of the Steelyard, the offices of the Hanse in London. The *Triumph of Wealth* measured 244 x 616 cm, the *Triumph of Poverty* 222 x 301 cm, and in both the figures were somewhat less than life-size.[41] The fortified Steelyard was a short distance above London Bridge on the north bank of the Thames. Apart from the Merchants' Hall, of which we find a first mention in 1260, it included warehouses, offices and lodgings. In 1598 Elizabeth I revoked the Steelyard's privileges, and the Merchants' Hall was ravaged. James I returned the Steelyard to the Hanse in 1606, and Henry, Prince of Wales, received the two Holbein paintings as a gift in 1609 or 1610. After Henry's sudden death in 1612, the paintings passed into the hands of his brother Prince Charles, who exchanged them for pictures in the Earl of Arundel's collection. Sandrart saw them in Arundel's possession in 1626 or 1627.[42] Along with Arundel's other works of art, Holbein's Triumphal Processions were shipped to Holland in 1641, and in 1655 were bought at auction, together with the family portrait of

Thomas More, by the brothers Franz and Bernhard von Imstenraedt from Cologne. In 1670 their collection became the property of the Archbishop of Olmütz, Karl von Liechtenstein, who placed his Holbein pictures in his summer residence, Schloss Kremsier, where they were destroyed by fire in 1752.[43]

After his arrival in London in 1532 Holbein was variously employed as a portrait painter by the Hanse merchants.[44] This work must have pleased the Hanse since they then entrusted him with the commission for two large paintings for their Hall. Whether it was they who chose the themes to be painted or the artist who proposed them is not known. Koegler suggested in 1931–2 that there was a relationship between Holbein's paintings and two works by classical authors: the *Pluto* of Aristophanes and the essay *Timon* by Lucian. He also mentioned the debate between Wealth and Poverty written by the Nuremberg author Hans Sachs in 1531, *Klag Antwort und urteyl, zwischen Fraw Armut und Pluto dem Gott der reichthumb welches unter yhn das pesser sey*, as a literary reference for the murals.[45] However, none of these possible literary parallels proposes the idea of a triumphal procession, and there is no plausible link between Sachs's conventional dialogue and Holbein's contrasting Triumphs of Wealth and Poverty. Holbein must have developed the image himself as a result of his long-held interest in Mantegna's *Triumphs of Caesar*, coupled with his knowledge of triumphal processions such as Dürer's *Triumph of Maximilian I* or the *trionfi* in Francesco Colonna's *Hypnerotomachia Poliphili* published in 1499 in Venice.[46]

Holbein's representations of the triumphs of Wealth (Plutus) and of Poverty (Penia) may be thematically opposed but they are very similar in structure. Both processions are mainly learned explanations of the causes of wealth and poverty, of opposed forces, of Virtues and Vices, of actions and punishments. Second, should the need arise, a moral could be drawn from a sensitive examination of the murals: a moral that possibly went beyond the widely accepted and customary understanding of the changing nature of good and bad fortune and would not lead to a flat exhortation for seemly restraint.[47] Poverty's cart is driven by Hope (Spes), behind whom sit Industry, Practice and Memory. In the *Triumph of Wealth* it is Fortune who sits in their place behind the wagon-driver Reason (Ratio), and she showers out her gifts, just as in the other picture Industry gives the setsquare and the axe to the craftsman. Behind the elderly, crippled and blind figure of Wealth (Plutus) the goddess of vengeance, Nemesis, with a bridle and a square, flies over all of those who like Midas or Croesus are heading for disaster as a result of their greed. The rhythmically arranged procession of Wealth and the blocking of Poverty's cart by asses and oxen represent the struggle between Virtues and Vices. In the *Triumph of Wealth* Trust struggles against Deception, Generosity (Liberalitas) uses a whip to flog Avarice. In the second pair Equality is striking Possession while Justice (Iustitia) reins in the obedient Contract (Contractus). In the *Triumph of Poverty* oxen and asses pull against each other as the embodiments of Stupidity, Laziness, Sloth and Negligence. They are beaten by four lively female figures representing Moderation, Restraint, Diligence and Work. It is noteworthy that almost all the figures in the *Triumph of Poverty* are looking backwards over their shoulder. Only one of them, the one who has taken the tools from the figure of Industry, does not. However, in the *Triumph of Wealth* not a single figure is looking backwards.

There is no indication as to the arrangement of the pictures in the banqueting-hall of the Merchants' Hall in London, even though these were famous works that had already been reproduced as prints by *c.* 1561. For the difference in the formats and the

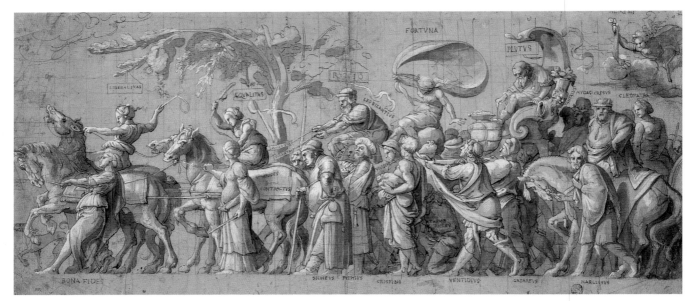

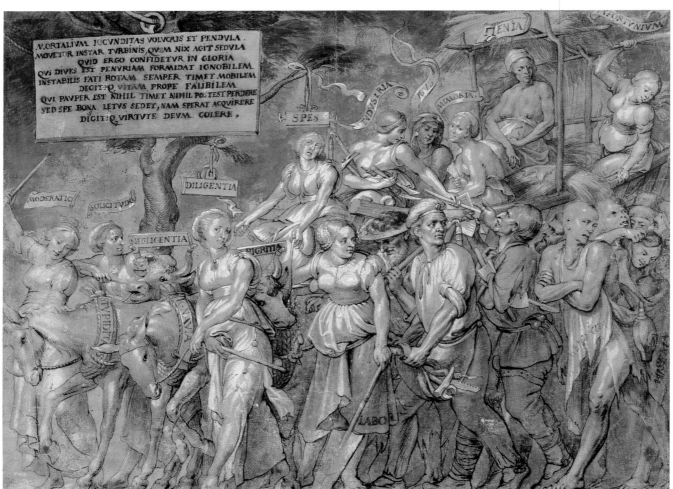

106 *Sketch for The Triumph of Wealth*, 1532–
3, pen, watercolour and washes height-
ened with white, 25.3 × 57. Musée du
Louvre, Paris (Cabinet des Dessins).

107 Copy, attributed to Lucas Voster-
mann the Elder, of Holbein's *The Triumph
of Poverty*, pen, watercolour and washes
heightened with white, 43.7 × 58.5. British
Museum, London.

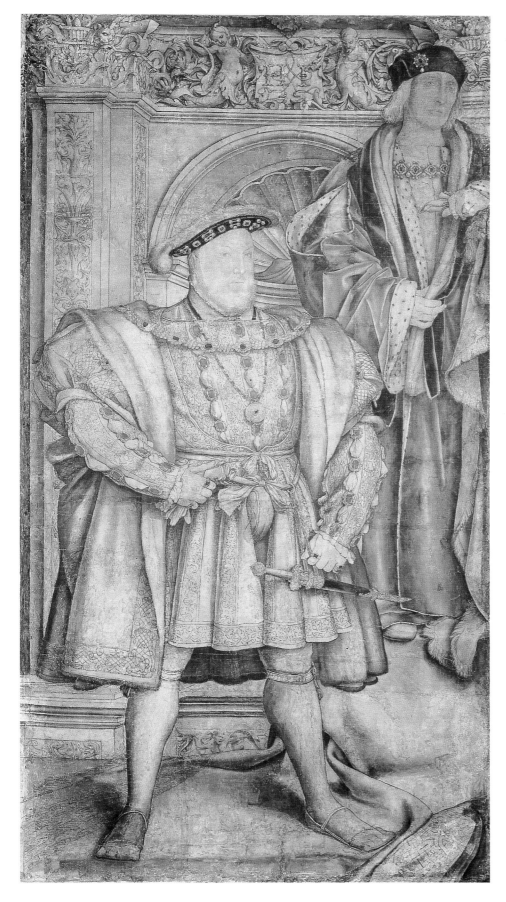

108 *Cartoon with Kings Henry VII and VIII for the Wall-painting in Whitehall Palace*, 1537, pen and washes on paper mounted on canvas, 257.8 × 137.1. National Portrait Gallery, London.

fact that both triumphal processions are moving in the same direction no explanation can be offered. The technical assessments are either unreliable or led to confusion; it was probably a painting in grisaille with white heightenings on a blue ground, executed in distemper on canvas, that is the so-called *Tüchleinmalerei*.[48]

Following a suggestion of Woltmann, the drawing by Holbein preserved in Berlin, the *Apollo and the Muses on Parnassus* (illus. 109), has been accepted as a sketch for a festival decoration commissioned by the Hanse merchants for the Steelyard. The occasion of this decoration would seem to have been the procession of Anne Boleyn, the second wife of Henry VIII, from the Tower of London to Westminster for her coronation in May 1533.[49] Nothing further has been discovered about the drawing since Woltmann's time, nor about its relationship to the decoration.[50] It is uncertain whether the group of figures by the fountains from which hock flows, was intended to be painted or to be acted out as a tableau. The festive occasion of the crowning of the new queen, her procession past the Steelyard along Thames Street and the wine and music mentioned in descriptions do allow us to conclude that the drawing was a décor serving as a background to figures playing music.

Anne Boleyn, probably Holbein's first protector at the English Court, was beheaded for alleged infidelity on 19 May 1536, and very shortly afterwards Henry VIII married Lady Jane Seymour. Neither the precise moments of Holbein's regular em-

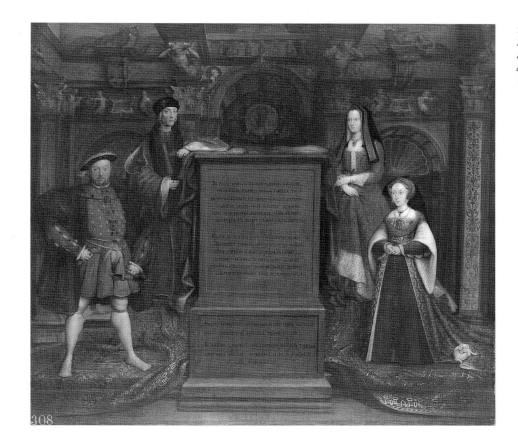

ployment at the English Court nor his position can be determined, since the account books for the years 1533 to 1537 are missing and the first entry that can be found relates to a quarterly payment of £7 10s in 1538. But in 1537 Holbein was at work completing a large mural (270 x 360 cm) in Whitehall Palace with the portraits of Henry VIII, his father Henry VII, his mother Elizabeth of York and his wife Jane Seymour. In 1667 Remigius van Leemput prepared a copy of this painting for Charles II (illus. 110).[51] The life-size figures are drawn up symmetrically, arranged in an echelon, around a large stone pedestal. The Latin inscriptions praise the picture and pose the question as to which of the represented heroes is the greater. Should it be the father, the ultimate victor in the Wars of the Roses and the bringer of peace, or the son who purified the altar of an unworthy people, and with unerring skill overcame the claims of the Pope to restore the Protestant religion?[52]

Holbein's mural in the King's antechamber showed the Tudor dynasty that acceded to the English throne in 1485 with the Welshman Henry, Earl of Richmond (1457-1509). For this work Holbein drew on his own full-length portrait of *The Ambassadors* (illus. 223), but he modified the relationship between the figures. Leemput's copy shows the sumptuous room with lateral niches and one central larger one. The four figures are arranged around the imposing pedestal after the pattern of the saints in a *sacra conversazione*. On this pedestal leans Henry VII, the founder of the dynasty. The cartoon that survives (illus. 108) for the left-hand side allows us to comprehend at least partially the tremendous effect of the mural, which was destroyed by fire in 1698.[53]

4 Religious Works:
The Making of Erasmian Art

The end of the religious commissions

In 1521–2 Holbein painted the *Body of the Dead Christ in the Tomb*, a long panel whose striking effect has not diminished over the centuries (illus. 112).[1] The face of Christ, his hands, the deep wound on his chest, and his feet have already assumed a green hue, that of dead flesh in the first stages of putrefaction. The mouth and the eyes are wide open. The narrow niche hides a stretched and emaciated body. Strands of hair look as if they are breaking through the surface of the painting; the right hand even seems to reach towards the beholder. Holbein's interest in macabre scenes and disturbing effects is perfectly in tune with the world of Mathias Grünewald. At a very young age Holbein must have accompanied his father to Isenheim in Alsace, for between 1509 and 1516–17 Holbein the Elder received a number of commissions from the hospice there; the Crucifixion scene and the *predella* of Grünewald's *Isenheim Altarpiece* (1512–15) must have had a striking effect on the young man (illus. 113). But if his first imitations of Grünewald had aimed rather at understanding the beauty of his saintly figures, he was now mature enough to tackle the most gruesome effects dear to the older master. Hans Burgkmair, the Augsburg artist who knew the Holbein family well, exploited this vein of the macabre in his depiction, dated 1522, of a decapitated head (illus. 111).[2] It is possible that Holbein's panel was intended to be exposed as part of a Holy Tomb, either taking the place of a sculpture or serving

111 Hans Burgkmair, *A Decapitated Head*, 1522, charcoal heightened with white, 19.9 × 25.6. British Museum, London.

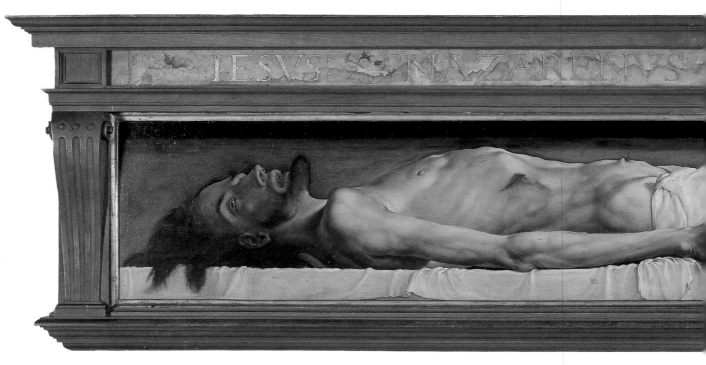

as a lid laid over a sepulchre.³ Yet Holbein transformed the image of the Christ at rest into the dreadful vision of a corpse, that of a man who had been condemned to death. Only the specific character of the wounds betray the identity of Christ, and with it reinstate the painting's sacred dimension.

A fascination for this work remained unabated over the centuries. A number of copies were made, bearing witness to its popular appeal. In 1867 its fame was sufficiently great to lure a Russian author to Basle, and it was powerful enough to bring him to the brink of collapse. Fyodor Dostoyevsky stood mute before the panel, and his wife had to drag him away to avert the risk of an epileptic fit seizing him. Dostoyevsky incorporated his experience into *The Idiot* (1868–9), a novel in which a Prince Myschkin admires a copy of the painting in the house of Rogoschin and remarks that such a picture has the power to make the beholder lose his faith.⁴ In the religious context of the 1520s, such an idea is of course a misconception; on the contrary, the painting was a work of piety. For example, by displaying his tortured Christ both on the Cross and laid out in his *Isenheim Altarpiece*, Grünewald sought to instil deep feelings of guilt and empathy in the beholder. Holbein's *Body of the Dead Christ in the Tomb* proposed a shocking representation of the Son of God, at the precise moment when he endured the fate of a simple human being. Such an onslaught on the worshipper's feelings may best be appreciated when contrasted with

113 Mathias Grünewald, *Lamentation and Entombment of Christ* (predella of the *Isenheim Altarpiece*), 1512–15, panel, 67 × 341. Musée d'Unterlinden, Colmar.

BOTTOM
112 *Body of the Dead Christ in the Tomb*, 1521–2, tempera on limewood, 30.5 × 200. Öffentliche Kunstsammlung, Basle.

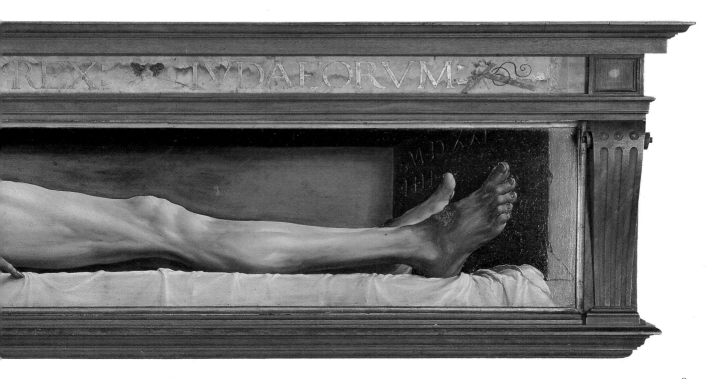

ORAE COMPASSIO-
IS BEATAE MARIAE VIRGI-
quas papa Clemés dicitur compoſuiſſe,
conceſſiſſe eas deuoté dicentibus qua-
ngentos dies indulgentiarum.

❡ Ad matutinas. Hymnus.

Ora matutina Mariæ nunciatur,
Quòd Iefus à Iudæis falſis capti-
uatur. Domum Annæ petiit : illuc
m ſ

cõuiuium uocatis, ſo
la domi remanſerit,
quæ apud Naſonem
tranſformatorū libro
octauo ſic, Tangit &
ira deos, at nõ impu-
ne feremus Quæcḫ,
inhonoratæ, nõ & di
cemur iultæ, In quit,
& Oeneos ultorem
ſpreta per agros, Mi-
ſit aprum. De hac re
mult' eſt iocus apud
Lucianum, in conui-
uio philoſophorū, ſi-
ue Lapithis. Tufcu-
lum.) Thure olim li-
tabant & mola. Plini
us in præfatione, Et
mola tantum falſa li-
tant, qui non habent
thura. Eſt autem mo
la far toſtum, ſale cõ
ſperſum, quo hoſtiæ
aſpergebantur, dictū
a molito farre. Dia-
næ debeã inuidere.)
Apud Scythas Thau-
ricæ Dianæ, hūano

Supſtitio-
ſus cultus
imaginum

Mola

Dianæ humano ſanguine

114 *The Lamentation over Christ, c.* 1522–3, metalcut by J. Faber, in *Hortulus Animæ,* J. Frellon, Lyon, 1546. Bayerische Staatsbibliothek, Munich.

115 *The Worship of the Madonna as Folly,* pen border drawing in Erasmus, *Encomium moriæ,* Basle, 1515. Öffentliche Kunstsammlung, Basle (Kupferstich-kabinett).

Dürer's figures of the Saviour, even Holbein's *Christ as the Man of Sorrows* (illus. 185), where the artist seeks to deepen our pity by enhancing the beauty of Christ's body.[5] 'Martyrizing' the feelings of the beholder through such graphic and repugnant details seems to correspond to a type of sensibility that thrived in the Low Countries in the latter part of the fifteenth century, and which is called the *devotio moderna*.[6] A book of devotion illustrated by Holbein provides some help in understanding the new current of religious sensibility: the metalcuts were executed for Jacob Faber's *Hortulus animæ* in 1521–3, but they appeared only in 1546 in Lyon, at Jean Frellon's printing-house. One metalcut shows the *Lamentation over Christ* (illus. 114). The traditional group of figures surrounding the mutilated figure – the Virgin, Mary Magdalene, John and Joseph of Arimathea – provides a model with which the pious readers of the book could empathize.[7] In the *Body of the Dead Christ in the Tomb*, however, the intensity of the dramatic scene is produced not through the disposition of mourning figures, but rather through the dramatic staging of the corpse itself.

In the *Encomium moriæ* written in 1509, Erasmus deprecated the cult of religious

116 Anonymous illustration of *The Clearing of the Churches in Zurich in 1524*, in Bullinger's *Reformationsgeschichte*. Zentralbibliothek, Zurich.

statues as being foolish and superstitious. The illustrations made by Hans and Ambrosius Holbein in Myconius' copy provide a witty counterpart to such a statement (illus. 115), and include drawings showing a worshipper praying to St Christopher or to the pagan gods.[8] Later the Reformation's leaders levelled social and theological arguments against the cult of pictures, resulting in the conviction that religious sculptures should be removed from churches to cleanse the worshipping of God from contaminating superstitions. At first Luther was rather moderate in his opinions on the matter of images, but by 1522 he had already been overruled by a more radical colleague from Wittenberg, Andreas Karlstadt, who was violently attacking the depiction of divinities, the cult of sculptures, and even the artists responsible for them.[9] In Zurich in 1524 Huldrych Zwingli secured the official removal of such church decorations (illus. 116) and their prohibition for the future.[10]

At the time it was of course all too easy to deceive worshippers with apparent 'miracles'. In 1509 the Dominicans of Berne and the apprentice tailor Hans Jetzer were seized and tried for the crime of perpetrating fake ones; their 'miracles' included

OVERLEAF
117 *The 'Solothurn Madonna'*, 1522, limewood, 140.5 × 102. Kunstmuseum, Solothurn.

118 *The 'Darmstadt Madonna'*, 1526–9, limewood, 146.5 × 102. Schlossmuseum, Darmstadt.

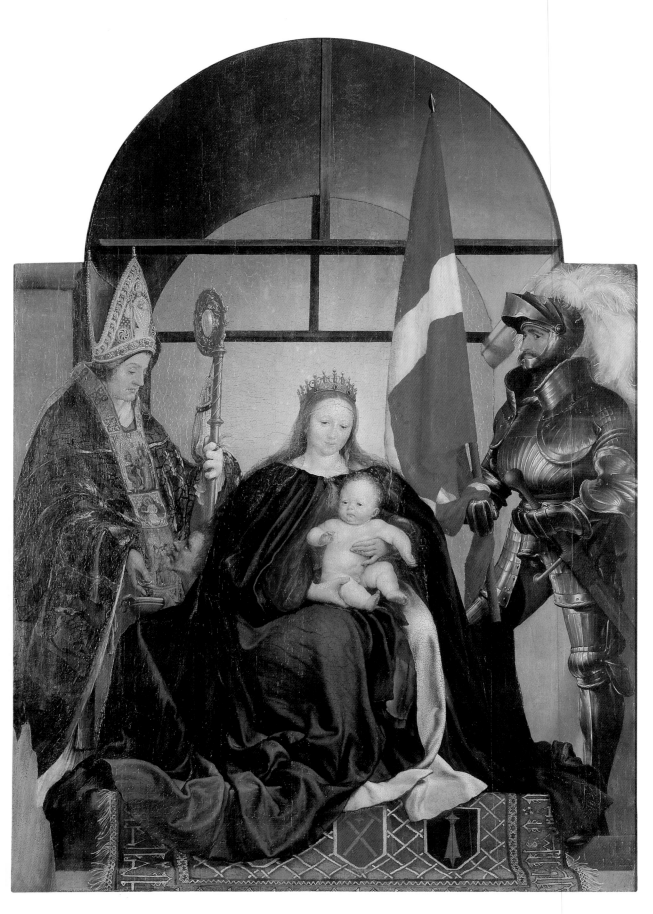

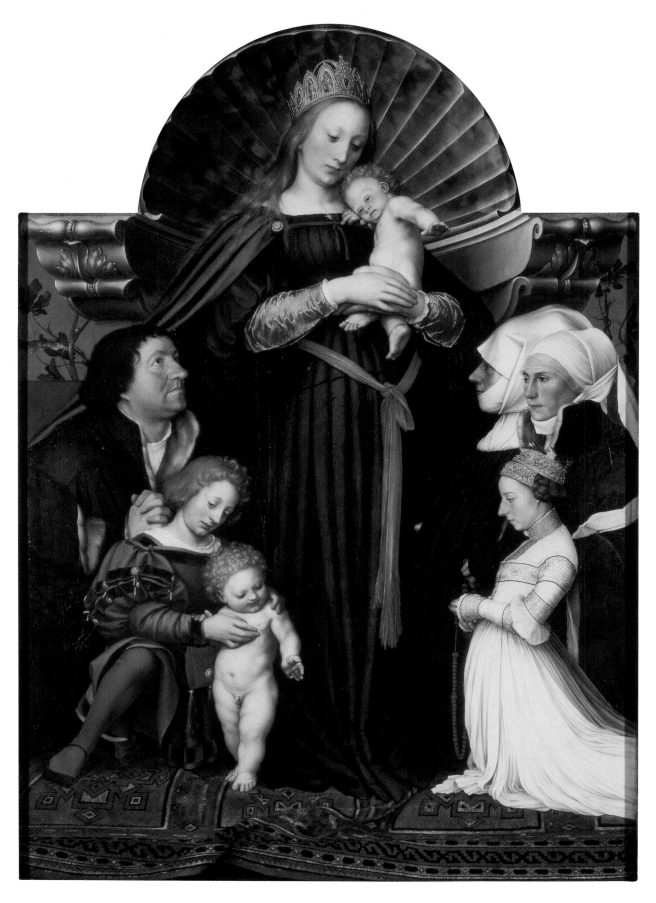

119 Urs Graf, *The Fraud of the Crying Pietà*, woodcut in Murner's *Von den fier ketzeren Prediger...*, Strassburg, (?)1509. Stadt- und Universitätsbibliothek Berne.

120 Michael Ostendorfer, *The Adoration of the 'Schöne Maria' of Regensdorf*, 1519–20, woodcut, 63.5 × 39.1 (Dürer's annotated copy). Kupferstichkabinett der Veste Coburg.

the use of a singular statue of the Virgin Mary made by Jetzer that, at suitable moments, sent tears rolling down Mary's cheeks. Pope Julius II was called on to save the Dominicans from their humiliation, but he needed the military might of Berne for his own campaigns; for him, the lives of four monks were negligible when compared with his own necessity for mercenaries. In due course the Franciscans of Berne seized on this wonderful opportunity to wage war against their enemies: they commissioned a text from Thomas Murner, which was then illustrated by Urs Graf, in which the whole fraud was exposed, including the so-called miracle of the weeping Madonna (illus. 119).[11] Even some artists began to frown on the misuse of images, such as the case of the *Schöne Maria* ('beautiful Mary') in Regensburg. During a pogrom ruthlessly carried out in Regensburg in 1519, a stonemason miraculously survived after the high vault of a synagogue under demolition had collapsed on him. This marvel was immediately attributed by the cathedral preacher Balthasar Hubmaier to the image of Mary. In a woodcut of 1519–20 Michael Ostendorfer depicted the chapel that was quickly built on the site (illus. 120), and included a statue of the Virgin and Child surrounded by a crowd of pilgrims, some of whom are rolling on the ground in ecstasy. The sheet illustrated here was owned by Dürer: in due course, as a true Lutheran adept he noted (in 1523) on the sheet his disapproval of such images. For Dürer, that particular Virgin was a mere fiction, whose cult was against the letter of the Holy Scriptures, but which was permitted by the bishop for

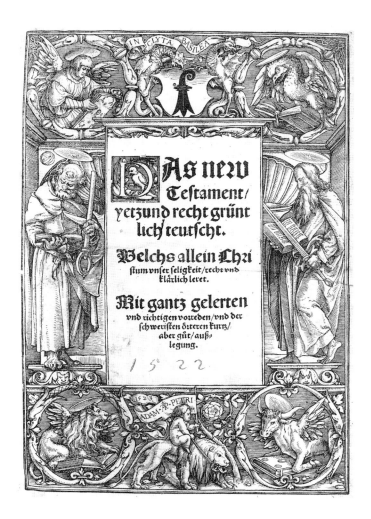

the financial rewards it brought to the cathedral.[12] Dürer, however, knew that his argument was a double-edged weapon: the art of painting was under attack. In his dedicatory epistle to Willibald Pirckheimer for the *Underweysung der Messung* (1525), the artist defended vehemently the rights of painting against those who despised it on the grounds of its contribution to superstition and idolatry.[13]

Through its economic prosperity and its virtual political autonomy, Basle was a paradise for printers; they enjoyed relative freedom, and some of the best craftsmen of the trade worked there.[14] As a result Basle became the main centre for diffusion of the Reformation's ideas. It was in Basle that the major works of Luther were printed and reprinted.[15] In 1520 the city council sensed the dangers involved, and issued a warrant authorizing reprints of Luther's writings, but declining all protection to the printers were they to be sued by other members of the Swiss Confederation. The printing-houses did not hesitate to run the risk of being caught; the benefits involved were too important. For example, when Luther's translation of the New Testament was published in Wittenberg in 1522 by Melchior Lotther (this was simply a German translation based on the Greek and Latin texts corrected by Erasmus), Adam Petri managed to issue a reprint in December of the same year bearing a beautiful title-page designed by Holbein (illus. 121). However, the name of the translator was omitted, as were the outrageous illustrations made by Cranach for the Apocalypse. Instead Holbein was requested to opt for a very orthodox iconography:

122 *Erasmus of Rotterdam*, 1523, tempera
on paper mounted on pinewood, 37 ×
30.5. Öffentliche Kunstsammlung, Basle.

the symbols of the Evangelists adorn the title-page dated 1523, and the two major patron saints of Rome, Peter and Paul, have a prominent place.[16]

It is true that between 1521 and 1529, Erasmus, one of the most powerful opponents of the Reformation, was living in Basle (illus. 122). Erasmus hoped that in condemning idolatry, he could ensure a rational use of cult images. In the debate concerning images and their use he maintained a moderate stance, as did his friend Thomas More.[17] When the Zurich reformer Huldrych Zwingli (illus. 123) attacked the idea of the Virgin Mary as a mediator between men and God, Erasmus composed a fictive letter (1526) under the name of the Madonna of Mariastein – a place of worship near Basle.[18] The Madonna bemoans the fact that her former worshippers have abandoned her. In earlier times she had been richly dressed and admired by pious pilgrims; now she is alone in her sanctuary, and clothed in rags. She is treated with indifference, apart from a few, somewhat dubious, calls for help. She threatens to take her revenge with the help of St Paul and St Bartholomew; she will not part with her Son.[19] Contrary to Zwingli, Erasmus attributed powers to the Madonna of Mariastein, although he was not above poking fun at the superstitious worship of images in his *Encomium moriæ*, and comparing the cult of the Virgin to that of Proserpina in his *Modus orandi Deum* (1524).[20]

A subtle and moderate approach to the problem had no chance of prevailing against more radical views. The reformers pushed for the orderly destruction of all objects of Catholic mummery to be found in churches; Zwingli ordered the removal of paintings and statues from places of worship in 1524, and the city council at Berne passed a similar resolution. A design for a stained glass provides a striking illustration of such mass destructions: made in 1527, it represents the burning of the statues of Baal and Asherah outside the temple at Jerusalem, by order of King Josiah and the High Priest (illus. 124). In reality, the officials were rapidly overrun by the crowd, eager to destroy the former objects of worship: in Berne, a fight broke out in the main church in 1528, and youngsters, helped by a gang of cobblers, destroyed what they could.[21] In Basle a group of citizens pulled down sculptures and paintings in the main churches. The following year the carnival developed into a wave of iconoclasm, and the city council forbade the installation of statues in cult places on 1 April.[22] Those families that had bequeathed works of art to their parish or to religious institutions reclaimed them, saving them from gratuitous destruction. It is due to the prompt reaction of the town secretary Johannes Gerster that Holbein's *Solothurn Madonna* still exists; and the Oberried family rescued the wings from an altarpiece they had given to their church – these are now in Freiburg im Breisgau.[23] Even the *Darmstadt Madonna* may have survived by chance (illus. 118): Holbein was reworking it in his studio at the time, at the request of Meyer zum Hasen.

Holbein produced a large number of religious paintings between 1520 and 1526: the *Oberried Altarpiece* and the *Body of the Dead Christ in the Tomb*, then the *Solothurn Madonna* (1522), followed by the great *Passion* and the *Last Supper*. In addition he completed ten designs for stained glass on the theme of the Passion of Christ, decorated the doors of the organ in the cathedral, and painted the *Darmstadt Madonna*.[24] By 1526, however, he could not expect to receive any further commissions for religious works. It was on his return from England in 1528 that he was asked to rework the *Darmstadt Madonna*, but it seems likely that this was his last religious commission in Basle.[25]

ANNO AETATIS EIVS XLVIII.

Q V I Christo & patriæ uixit docuit uigilauit,
Pro Christo & patria fortiter occubuit,
Sed quid retulerit qua tandem morte necetur
Cui dum uiuebat uiuere Christus erat:
Zuinglius occubuit, sed corpore, cætera nunquam
Non meliore sui parte superstes erit.
Rumpere liuor edax, uita qui perpete Christo
Quicq; bonis manet, haud mortuus esse potest.
Mors etiam lucro est, multo iam fœnore mentis
Fortius exurgent femina sparsa pie.
Die Octobris XI. Anno Domini M. D. XXXI.

123 Portrait of Huldrych Zwingli, woodcut after Hans Asper in Zwingli's *In Evangelicam historiam de . . . Iesu Christo*, Zurich, 1539. Zentralbibliothek, Zurich.

124 Niklaus Manuel Deutsch, *The Destruction of the Idols by King Josiah* (stained glass design), 1527, pen and washes, 43 × 31.9. Öffentliche Kunstsammlung, Basle (Kupferstichkabinett).

The Madonnas

The *Solothurn Madonna* (1522) illustrates Holbein's first attempt to produce an ambitious devotional picture. It was commissioned by Basle's town secretary, Johannes Gerster, and his wife Frau Barbara Guldinknopf (illus. 117).[26] The painter was only 25 years old, and his task was to make a *sacra conversazione*, that is, a depiction of a group of saints gathered around the Virgin and Child. Until recently the destination of this commission, its exact function, even its iconography, were not understood. A careful analysis of the work enriches considerably our understanding of religious painting at the time of the Reformation.

The bishop in the *Solothurn Madonna*, and who is shown giving alms to a beggar in an engraving by Israel van Meckenem (illus. 126), is unmistakably St Martin. Yet he

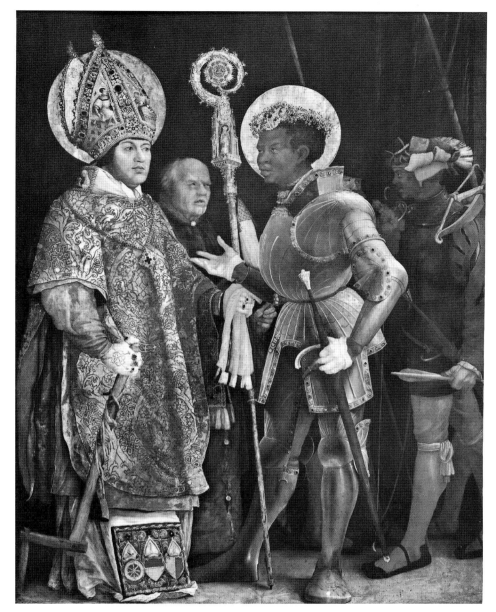

125 Detail showing SS Erasmus and Maurice, from Grünewald's *Mitra of S Erasmus*, *c.* 1520–24, wood. Alte Pinakothek, Munich.

has repeatedly been identified as St Nicolas of Myra because a representation of Nicolas appears on the bishop's mitre. This does not in itself provide any clue as to the identity of the bishop, however. A simple comparison may be found: Grünewald's *Mitra of S Erasmus* (illus. 125), probably commissioned by Cardinal Albrecht von Brandenburg between 1520–21 and 1524. Erasmus' mitre is decorated with two figures – St Maurice and St Nicolas of Myra.[27] Gerster probably requested the inclusion of Nicolas: he was the patron saint of the notaries, Gerster's profession.

The identity of the knight in the *Solothurn Madonna* has caused even more difficulty. Those who thought that the painting, which has been in Solothurn since 1864, must have been commissioned for the city's main church, supposed him to be St Ursus, Solothurn's patron saint. However, his armour and his flag identify him only as one of the members of the Theban legion, martyred for their faith

126 Israel van Meckenem, *St Martin as a Bishop*, 2nd half of the 15th century, engraving, 15.8 × 8.5. Bibliothèque Nationale de France, Paris.

99

127 Urs Graf, *The Discovery of the Sarcophagus of St Ursus*, single leaf woodcut, Basle, 1519, 32.1 × 26.4. Zentralbibliothek, Zurich.

128 E. Schmid, x-ray photograph of the '*Darmstadt Madonna*' (illus. 118).

under the Roman emperor Maximian Augustus. That legion also included St Maurice, St Gereon and many others. Other scholars have identified him as St George, although no dragon is present.[28] Without further documents attesting more particular links to a precise member of the legion, or to a *locus* where Holbein's picture was worshipped, any attempt to discover the saint's identity is doomed to failure.[29] It would seem that Holbein has indeed painted a St Ursus in the *Solothurn Madonna*, but this identification, as we will see, far from proving the connection of the picture with Solothurn, reinforces rather the hypothesis that it was destined for the church of St Martin in Basle.

Solothurn was a major centre where the cult of St Ursus was celebrated. In order to rejuvenate enthusiasm for St Ursus the city ensured that his legend spread, and they regularly staged a discovery of his relics. When in the summer of 1473 a large number of bones were unearthed in Solothurn they were immediately associated with the martyrs of the Theban legion, with the benediction of the then bishop of Lausanne, Giulio della Rovere, later Pope Julius II. A great celebration followed in 1474 in the city's main church.[30] For this occasion the Swiss communities interested in receiving remains of the holy martyrs were presented with some relics. The church of St Martin in Basle duly sent an ambassador, who returned with some bones; coming from a city whose patron was St Ursus, they were identified as those of that holy knight. A reliquary was commissioned by the clerics of St Martin.[31] In 1519 the rediscovery of St Ursus' sarcophagus prompted a new campaign of promotion: probably on order from the city council, Urs Graf designed a lavish print (illus. 127): St Ursus stands with his flag, and worshippers kneel in front of the sarco-

phagus beneath the city's coat of arms.[32] An accompanying text celebrates the wonderful discovery. In 1521 the sarcophagus was opened amid great ceremony: the church received significant offerings.[33]

The format of the *Solothurn Madonna* and its low viewpoint, makes it impossible that it was destined for private use in Gerster's modest house in Rheinsprung. It was most probably made for St Martin in Basle (illus. 129). Gerster was more than just a simple member of the parish community, for he was one of the *provisores*, the church aldermen.[34] We know that he had chosen to be buried in the charterhouse of Klein-Basel, but the Holbein picture is not registered among the gifts made by him to that institution. It should, however, be noted that the charterhouse and the parish of St Martin had close connections. The saints surrounding the Virgin were revered in the church of St Martin, through altars and relics.[35] In addition to this Gerster seems to have shown a keen interest in the legend of the saints of the Theban legion.[36] In other words Holbein's painting may be understood in connection with Gerster's devotions in his own parish. It may be supposed that the *Solothurn Madonna* was commissioned subsequent to the publicity surrounding the opening of the sarcophagus of St Ursus; it may have been presented to the church in 1522 for St Ursus's day, or that of St Martin, respectively 30 September and 11 November. In all probability it was an epitaph, a devotional piece to the memory of a family whose members were eager to gain eternal life after their death.

At the beginning of 1528 the *Solothurn Madonna* was removed from St Martin's, together with other paintings and sculptures. The famous collector Basilius Amerbach must have seen it: at some date before 1585–7 he received a copy of the Christ Child from the painter Hans Bock the Elder (illus. 130).[37] The artist even produced a *Virgin and Child* whose composition is extremely similar. Those elements lead us to believe that Holbein's masterpiece was still accessible near Basle, for example in the monastery of Mariastein, a Catholic institution very close to the city.[38] By the seventeenth century the painting was lost; a small drawing after the figure of St Ursus is the only document recording its existence in Switzerland *c.* 1638.[39] Thirty years later Charles Patin published the first *catalogue raisonné* of Holbein's works: although he undertook thorough research, he did not come across the painting, and neither did his friend Sebastian Faesch.[40] In 1864 Holbein's *Solothurn Madonna* was discovered in a tiny chapel near Grenchen by two men: a restorer and paint-dealer with a developed connoisseur's eye named Franz Zetter, and a friend, the painter Frank Buchser.[41]

In 1526 the Reformation was effectively stemming the demand for devotional pieces. Holbein found the time to complete his masterpiece, the *Darmstadt Madonna* (illus. 118), in 1526 for a rich banker named Jakob Meyer. Meyer was a prominent figure in Renaissance Basle – a great diplomat, head of the Basle contingent in many Italian wars involving Swiss regiments, and a former mayor of the city (illus. 34, 40). The picture portrays the Meyer family in prayer before the protective Virgin, who encloses them within her long cloak.

When Holbein completed the picture shortly before his departure for England, the panel did not correspond to its present state: x-ray photographs, combined with three preparatory drawings, give us some clues as to the original composition (illus. 128 and 189). After his return from England in August 1528, Holbein was requested to add the portrait of Meyer's first wife, Margaretha Baer, who had died in 1511; he also removed the cloth that obscured most of Dorothea Kannengiesser's face; the

129 Matthäus Merian, detail showing the Church of St Martin and the bridge over the Rhine from his etching of a *Bird's-eye View of the Town of Basle from the North*, 1614. Öffentliche Kunstsammlung, Basle (Kupferstichkabinett).

130 Hans Bock the Elder, *Copy after Hans Holbein the Younger of the Christ Child from the 'Solothurn Madonna'*, before 1585–7, oil on limewood, 35 × 27. Öffentliche Kunstsammlung, Basle (Kunstmuseum).

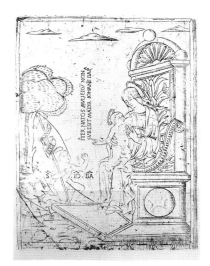

131 Anonymous Milanese, *Madonna Enthroned with Christ and St John the Baptist*, *c.* 1480–90, engraving. Bibliothèque Nationale de France, Paris.

132 Anonymous, *Virgin and Child, Angels and Putti*, *c.* 1475, cast-bronze plaquette from Ferrara, 13.5 × 8.9. National Gallery of Art, Washington, DC.

long hair of her daughter Anna was remodelled into a complex plait that symbolized her betrothal.

The Virgin, standing before her throne, bears the Christ Child in her arms. She wears an imperial crown. To her left, Jakob Meyer kneels with his son, who holds up a naked child. On the right-hand side are to be seen Anna, her mother Dorothea Kannengiesser and Meyer's first wife, Margaretha Baer. The steps leading to the throne are richly carpeted, the folds of which add to the dynamic character of the scene. Behind the throne a fig-tree stands out against a blue background.

The naked child held by Meyer's son has always been understood to be another son of the family. Such an identification poses a number of problems: the child is naked, and no archival material records that Jakob Meyer had more than one son.[42] But once the infant is read in conjunction with the Virgin and the Christ Child, its identity becomes clear: this is surely St John the Baptist. Such combinations were popular in Italy in the second half of the fifteenth century. A Milanese engraving, for example, the *Madonna Enthroned with Christ and St John the Baptist* (illus. 131) dated 1480–90, shows the *Maria lactans* with Jesus and the naked infant St John, who kneels on the pavement below the throne.[43]

It would seem that the form of the protective Virgin provided Holbein with a point of departure. Comparison of his work with a typical representation, such as the *Kaisheimer Schutzmantelmadonna* (illus. 133) designed by his father between 1505 and 1509, betrays the differences between a mere repetition of this popular iconography and its bold transformation by the young master.[44] It is a traditional depiction of a protective Virgin who towers above the other figures and wears a voluminous cloak.[45] In the *Darmstadt Madonna*, by placing a shell-hood niche in the background, decorated with a console on either side, and by making the Virgin seem almost as tall as the height of the niche, Holbein was also indicating another iconographical model, that of the standing Virgin and Child before the throne. Strictly speaking, the niche is not a throne; it is only the contrast between the narrow niche and the height of the Virgin that suggests we are confronted with a Virgin enthroned, a very widespread genre of Italian devotional art. A Florentine engraving dating to 1480–90 (illus. 134) shows the scene in a similar fashion: the standing Virgin and Child are attended by St Sebastian and St Catherine and two angels. The massive throne behind the Virgin is placed in an open space in front of a wall; the semi-circular form of the throne's canopy is supported by a pair of scrolled consoles. Some plaquettes schematized such compositions for collectors and devotees alike, such as the Ferrarese *Virgin and Child, Angels and Putti* of *c.* 1475 (illus. 132).[46] These small-format bronzes were widely diffused: a copy of this particular one was given to Basilius Amerbach in Basle in 1583.[47]

It is difficult to decide whether Holbein was following Netherlandish or German models, or if he drew rather on Italian patterns. The Northern type of the standing Virgin was already a common feature in Gothic cathedrals: she was often seen as a symbol of the Church, sitting on the throne of Solomon, as in Rogier van der Weyden's *Virgin and Child Before the Throne of Solomon*, *c.* 1430–32 (illus. 135). Through the works of Jan van Eyck, Rogier van der Weyden and Petrus Christus, the depiction of the standing Virgin became a well-known feature of Northern art, and in Italy too.[48] The earliest example of an Italian picture with such a scheme is the *Barbadori Altarpiece* (illus. 136) by Filippo Lippi, a panel that was commissioned in March 1437, and destined for the sacristy of S Spirito in Florence.[49]

133 Hans Holbein the Elder, *The Maria Misericordia from Kaisheim* c. 1505–9, woodcut, 34.8 × 26.8. Staatliche Museen zu Berlin – Preußischer Kulturbesitz (Kupferstichkabinett).

134 Florentine School, *Madonna and Child before the Throne with SS Catherine and Sebastian*, c. 1480–90, engraving. Bibliothèque Nationale de France, Paris.

135 Rogier van der Weyden, *Virgin and Child before the Throne of Solomon*, c. 1430–32, oak, 18.9 × 12.1. Kunsthistorisches Museum, Vienna.

136 Filippo Lippi, *Virgin and Child surrounded by Angels, the Kneeling SS Frediano and Augustine* ('*Pala Barbadori*'), after 1437, wood, 208 × 244. Musée du Louvre, Paris.

137 *Standing Madonna in Front of the Throne*, woodcut, in Jean Pélerin le Viateur, *De artificiali perspectiva*, Toul, 1505.

The engraved copies produced in Italy, however, as well as the plaquettes, may have provided Holbein with the material that he needed. Even the treatise published in Toul in 1505 by Jean Pélerin le Viateur (Viator), *De artificiali perspectiva*, recommended a form of standing Virgin enthroned (illus. 137), which was nothing more than a copy of the Ferrarese plaquette of 1475 mentioned above (illus. 132). Viator prided himself that his book would be of interest to French, German and Italian artists. In due course (in 1509), a pirated edition was being sold by Jörg Glockendon in Nuremberg.[50]

Functions

The religious paintings made by Holbein in the 1520s pose real difficulties for scholars; their function and their destination are not generally known.[51] The two Madonnas have incorrectly been assumed to be altarpieces. As early as 1866, Alfred Woltmann expressed some doubt with regard to the legitimacy of such an hypothesis for the *Darmstadt Madonna*.[52] It should be pointed out though, that due to a total lack of documentary evidence, the destruction of the original picture frames, and the absence of good comparative material, it is extremely difficult to reach any firm conclusion. We are left with the task of identifying, in the works themselves, some indications of their original function.

In the *Darmstadt Madonna* the Virgin Mary wears an imperial crown (illus. 138), whose shape is close to that of the legendary crown of Charlemagne, a masterpiece of the tenth century. Dürer drew that same imperial crown (the *Reichskrone*) in 1510–11 while engaged in portraying the emperor on commission from Nuremberg; from 1424 onwards the regalia had been exhibited in that city (illus. 139).[53] The main features of the crown are the plaquettes of which it is composed, and the bow over it. It was worn over a version of a mitre with two horns (*cornua*). The mitre and the crown symbolized the temporal and the spiritual dimensions of the emperor's authority.[54] The Church of the Holy Ghost preserved the imperial insignia, which were exhibited once a year after Easter in the main market-place. The *Heiltumbuch* of Nuremberg, published in 1487 for the first time (illus. 140), proudly recorded the exhibits and praised their miraculous healing powers.[55] Through the intermediary of German humanists such as Willibald Pirckheimer and Conrad Celtis, the cult of the imperial crown enjoyed a revival in the portrayals of Maximilian I and Charles V; Habsburg authority was celebrated through recondite, learned allegories.[56] The most magnificent example is the immense woodcut realized by Dürer under Pirckheimer's direction – the triumphal arch in honour of Maximilian, where his virtues are celebrated, and the imperial mystique rejuvenated.[57]

One may well wonder how this whole imperial mystique could make sense in a painting created in Basle, a city that enjoyed the imperial freedom, but which had allied itself with the Swiss Confederates in 1501 – a group of cantons that, after centuries of struggle, had managed to break free of Habsburg rule. A few works of art enable us to understand this apparent paradox. In 1513 the city received as a gift twelve pieces of stained glass from its new allies: ten of them exhibit proudly each allied canton's coat of arms together with that of the empire.[58] Petermann Etterlyn printed in his *Kronica von der loblichen Eydgenoschaft* (1507) a woodcut designed by the Master MD, again exhibiting the arms of the members of the alliance, together with the imperial coat of arms topped with the imperial crown (illus. 141). At a time when

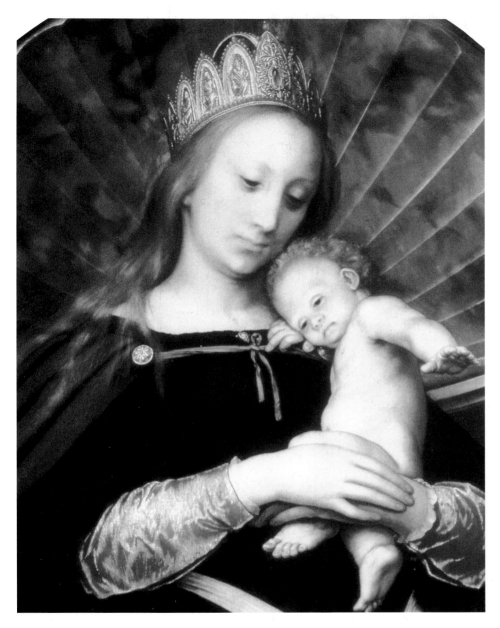

138 Detail of the Virgin wearing the Imperial Crown from the '*Darmstadt Madonna*' (illus. 118).

139 Albrecht Dürer, *The Imperial Crown*, 1510–11, pen and watercolour, 23.8 × 28.9. Germanisches Nationalmuseum, Nuremberg.

140 Anonymous woodcut of *The Imperial Crown and the Imperial Insignia in Nuremberg*, in *Heiltum zu Nürnberg*, P. Vischer, Nuremberg, 1487. Bayerische Staatsbibliothek, Munich.

141 Master MD, *Coat of Arms of the Empire
and the Imperial Crown Surrounded by the
Arms of the Twelve Cantons and their Allies*,
woodcut, 17.5 × 23.5, in Etterlyn's
Kronica . . ., Basle, 1507. Universitäts-
Bibliothek, Basle.

142 Attributed to Michael Erhardt,
Epitaph for Ulrich of Rechberg (d. 1501),
c. 1492–3, sandstone relief, 180 × 113.
Cathedral, Augsburg.

144 Unknown master, *Sacra Conversa-
zione with SS Theodule and Antony*, *c*. 1510,
wood, 123.5 × 81.5. Musée d'Art et
d'Histoire, Geneva.

145 Attributed to Hans Burgkmair, *The
Patron Saints of the Missal Curiense*, 1497,
coloured woodcut with pen inscriptions,
25.7 × 16.5, Augsburg: Erhard Ratdolt,
1497. Staatsgalerie Stuttgart.

the empire no longer posed a threat to the Swiss, the cantons seemed to share a vain
pleasure in parading their noble connections. For example, in 1514 Adam Petri printed
a poem to the glory of Maximilian I written by Heinrich Glareanus, who had pre-
sented it to the emperor himself two years earlier. Urs Graf designed the title-page,
where the imperial arms are surrounded by those of the sixteen cantons; a second
large woodcut places these coats of arms under the protection of the imperial eagle.[59]

Jakob Meyer, a mere money-lender and officer, was the first *homo novus* to become
mayor of Basle (1516).[60] But in 1521 he was indicted, under suspicion of having em-
bezzled part of the wages due to his soldiers from the king of France; he was demoted
and jailed. Meyer was a staunch Catholic, and he fought the Reformation to the
last. He seems also to have been very keen not to cause any offence to the *Fürstenthumb
Oesterreich* through involvement in religious controversies, as he himself said in
1529.[61] At a time of religious turmoil, the Virgin seemed to represent the traditional
values that were under threat.[62]

The *Darmstadt Madonna* may first have been conceived as a votive picture; Holbein's
patron was recommending his family to the Virgin and demonstrating his faith in
the Catholic creed and his respect for the former imperial links. The fig-tree evokes
Eve, the first woman, whose sin was redeemed through the anti-Eve, the Virgin
Mary who gave birth to Christ.[63] The rosary held by Anna is made of coral, a material
supposed to offer protection against ghosts and diseases.[64]

When Holbein agreed in 1528 to change certain features of the original painting,

Meyer wished to transform the picture into an epitaph – hence the inclusion of his first wife. The original frame, which may have borne the names of all those represented, no longer exists. An epitaph was generally prepared long before the death of the family members.[65]

The exact function of the *Solothurn Madonna* is more difficult to assess; the *sacra conversazione* was used in a number of different contexts. In addition, the concept has often been misunderstood: the term *sacra conversazione* does not mean 'holy conversation' but 'community of saints'.[66] In 1979 Rona Goffen correctly pointed out that the term was first used in 1763 in an Italian inventory; it has biblical, patristic and liturgical connotations, all indicating the community of saints.[67] In Italy, from the early fourteenth century, the pattern became an important part of tombs, epitaphs, votive images and altarpieces. In the North, the *sacra conversazione* was used above all for epitaphs throughout the fourteenth and fifteenth centuries, before it became a favourite theme in the graphic arts after 1500. In southern Germany, the *sacra conversazione* remained more or less associated with the epitaph. The most significant of these monuments may be found in Augsburg's cathedral; among epitaphs made between the fourteenth and the seventeenth centuries, the Virgin with saints and devotees is one of the more important groups (illus. 142).[68]

143 Anonymous painter, *The Virgin with a Butterfly* (epitaph for Petrus de Molenduin), 1459, panel. Musée d'Art religieux et d'Art Mosan, Liège.

It is not certain that the *sacra conversazione* was also used for altarpieces in the North during the fifteenth century. The number of surviving religious pictures is very small, and most of them have been removed from their original settings. The knowledge of the specific functions of pictures is not yet fully developed, and little can be deduced from the paintings themselves. Jan van Eyck's *Madonna of Canon van der Paele* of 1436 in Bruges has long been considered to be an altarpiece, although it is most probably an epitaph.[69] A *sacra conversazione* whose function as an epitaph is secure enough, due to the survival of its original frame, is the *Virgin with a Butterfly* of 1459 in Liège (illus. 143). There is only one known example of a *sacra conversazione* in Switzerland that predates the *Solothurn Madonna*: it was made for a religious institution in the territories now belonging to Switzerland (illus. 144). The enthroned Virgin with her Child, St Theodule and St Antony the Hermit forms perhaps the central part of a triptych that was on display around 1510 in Berne or in Valais.[70]

But Holbein did have another resource at hand that was of great interest to him for his work: the title-pages of missals and breviaries, which were published in Augsburg, Nuremberg and Basle. In the *Missale Curiense* published in 1497 by Erhard Ratdolt in Augsburg for the bishop of Chur, a woodcut depicts the Virgin and Child surrounded by saints and worshipped by the patron (illus. 145).[71] The composition seems to have aroused some interest since Urs Graf borrowed it when working on his own title-page for the *Liber Missalis Augustensis*, published by J. Wolff von Pforzheim in 1511 in Basle for the bishop of Augsburg. In this image St Ulrich and St Afra flank Augsburg's patron saint.[72] Even Holbein used such a scheme with patron saints when he completed his design for the woodcut decorating the *Statutes of the City of Freiburg* of 1520 (illus. 146).

Holbein chose to frame the Virgin in his *Solothurn Madonna* in an archway (illus. 117); she, the Child and the two saints seem to have been positioned on a stepped podium. The archway marks the limit between this world and the heavens – behind them an aureole lightens up a bright blue sky, and light from two sources illuminates the scene. The saints seem to guard the portal to heaven. In front of such a picture worshippers would plead for mercy, hoping that the Virgin would intercede on their

behalf. Hans Baldung Grien found a similar way of staging such a relationship in his large-format woodcut of 1515–17, the *Virgin and Child* (illus. 147).[73] The Virgin's cloak, with its rippling folds, lifts in a breeze, and is surrounded by putti and clouds. Above the archway the Holy Ghost flies into view. The apparition of the Virgin fulfils the hopes of those who pray to her.[74] The entrance to heaven – the *porta coeli* – was an allegory of the crowned Virgin, the porch of the church a metaphor of the portals of heaven, and the church a symbol for heaven itself. The Virgin embodying the Church was a very powerful motif during the fifteenth century in the Netherlands and in the Rhine region. This so-called *Kirchenmadonna* corresponded with a very popular metaphor that figured in many sermons at the time, whereby Mary is compared with a temple, and thus with the House of God.[75]

One of the more interesting *Kirchenmadonna* is that painted by Quentin Massys, which combines the church and the portals of heaven (illus. 148). The Virgin stands in a porch, her Child on her arm, and she is dressed in a superb white cloak embroidered in gold. Behind her angels play music or hold roses or garlands. A second archway is furnished by the frame with its columns and tympanum, in which Christ enthroned is represented. Among the decorations embellishing the porch are the statues of the prophets. In the opening the painter has placed a throne with a baldachin, a choir of angels and a garden. Mary enters through this portal as the Queen of Heaven; this realm is part of her iconography, as are the temple of Solomon and the garden of Paradise. The inscription on the archway describes the Madonna as the 'Regina Celi'.[76]

Some elements seem to indicate that the *Solothurn Madonna* was an epitaph. Both the painter and his patron had learned to appreciate that new Italian form of the *sacra conversazione* as it was used in the Upper Rhine region – for epitaphs. Many epitaphs can still be seen in Basle cathedral's crossing, as well as in St Martin's. It is true that none of them predate the period of the *Bildersturm*, but it should be remembered that St Martin's was stripped of its works of art in 1528. The practice of the installation of epitaphs survived, albeit in a different form. It could be argued that in the *Solothurn Madonna* the patron and his wife are not actually represented, since the only reference to them comes in their coat of arms woven into the carpet. There are, however, a number of parallels that can be cited here, such as that of Bernardus Artzat (1517) in Eichstätt, or the perfectly preserved *Meiting Epitaph* of *c.* 1525 in the church of St Anna in Augsburg, attributed to Jörg Breu the Elder (illus. 149). The members of the Meiting family are mentioned in the inscription, with their respective dates of death, but none is actually represented on the monument.[77]

In his *Darmstadt Madonna* (illus. 118) Holbein executed a work that was between a votive picture and an epitaph, very similar to the Northern type. Through the presentation of the Virgin as a very human figure, with Christ and St John, it is akin to Hans Memling's *Epitaph for the Family of Jacques Floreins* (illus. 150), made *c.* 1490 in Bruges. Memling arranged the male and female members of the family on either side of the enthroned Virgin, flanked by St James and St Dominic. The Virgin's position is enhanced by the baldachin within which she sits, and which in turn is placed in the choir of a church. The arrangement is typical of that of an epitaph.[78] The garments of Jacques Floreins's wife are those of a widow – her husband had died before the painting was commissioned. Another panel, a fragment attributed to Bernhard Strigel from Memmingen (*c.* 1513), documents a practice that was current in southern Germany at the time, and which is fairly similar (illus. 151). The inscription allows

147 Hans Baldung Grien, *The Virgin and Child at the Gate of Heaven*, *c*. 1515–17, woodcut, 37.8 × 26.1. Öffentliche Kunstsammlung, Basle (Kupferstichkabinett).

146 Title woodcut for *Nüwe Stattrechten und Statuten der loblichen Statt Fryburg...*, Basle, 1520. Universitätsbibliothek, Freiburg im Breisgau.

148 Quentin Massys, *Madonna and Child in the Portal*, before 1500, oak, 54.5 × 37.5. Musée des Beaux-Arts, Lyon.

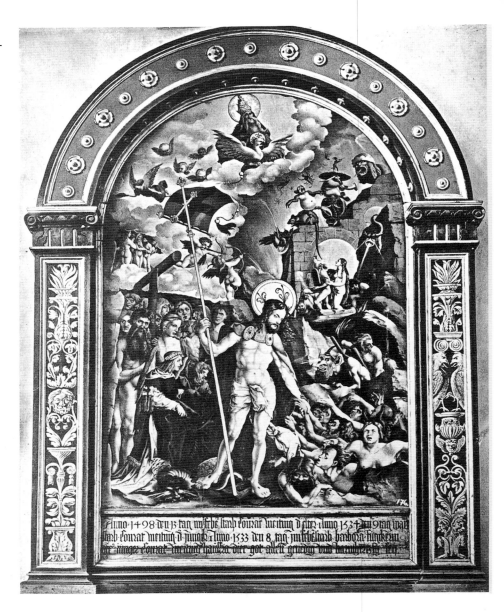

149 Attributed to Jörg Breu the Elder, *Epitaph for the Meiting Family, c.* 1525, lime-wood, 208.5 × 128. Evang.-Luth. Kirchenstiftung S Anna, Augsburg.

us to imagine that the (lost) upper part of the painting represented Christ on the Cross. On the fragment that remains, the husband and wife, and both their living and deceased children, are lined up.[79]

The exact function of the *Oberried Altarpiece* (illus. 154, 155, 156), painted by Holbein together with his father at the beginning of the 1520s for an influential member of Basle's city council, is not known.[80] No document helps us to determine its original location, and all attempts at reconstructing the complete altarpiece have failed. In 1944/45 it was discovered that the backs of the panels were bare, but no further technical examination was undertaken.[81] It is not clear whether the two surviving panels functioned as altar-wings. It is possible that they were commissioned as part of an altarpiece, although the resulting ensemble would have been larger than was customary in Basle at the time. In any case, given the destructions rife in the city during the *Bildersturm*, it is impossible to say with any certainty whether the work was completed. It is extremely difficult even to decide if the whole work had been intended

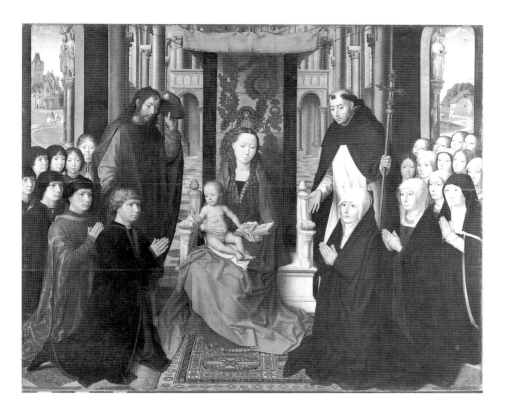

150 Hans Memling, *Epitaph for the Family of Jacques Floreins* (so-called '*Madonna of Jacques Floreins*'), *c.* 1490, oak wood, 130.3 × 160. Musée du Louvre, Paris.

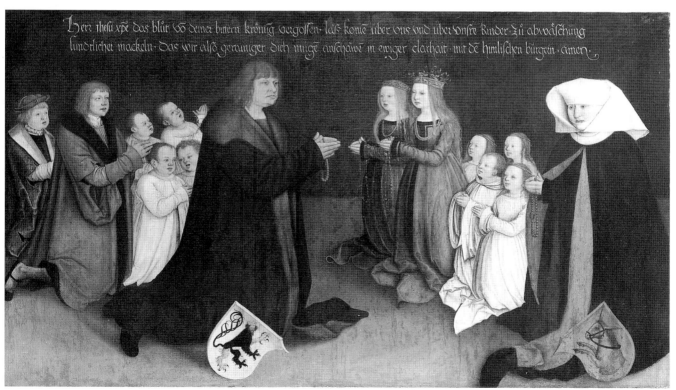

151 Attributed to Bernhard Strigel, *Epitaph for the Funk Family* (fragment), *c.* 1513, wood, 58 × 99. Museum zu Aller-heiligen, Peyersche Tobias Stimmer-Stiftung, Schaffhausen.

as an altarpiece or an epitaph. Similar altarpieces with donors are to be found, for example Dürer's *Paumgartner Altarpiece* – a painting that was later removed (1613) from the church of St Catherine in Nuremberg.[82] Equally convincing is another example from Augsburg: a large epitaph in two parts (illus. 152, 153) attributed to Leonhard Beck, and made for Martin Weiss and Elisabeth Fackler before 1520.[83]

Erasmian pictures

During the Reformation a radical criticism of religious imagery developed that was to have enormous consequences for artists of every kind. Holbein was no exception. It is well-known that after mastering the realm of Catholic imagery he was invited to design woodcuts for somewhat aggressive, Lutheran publications printed in Basle. Towards the end of the 1520s it became clear that the two positions were incompatible, and that an artist had to align himself with one or other of the two sides. As we will see, Holbein refused to do this. What is still unknown is his contribution to the Erasmian, moderate approach towards religious images – critical of the traditional Catholic practice, but rejecting Protestant radicalism.

A capital, and humorous, detail has been overlooked in the *Solothurn Madonna*: the representation of the centurion of Capernaum embroidered on the pluvial of St Martin (illus. 160). The Gospels give slightly varying accounts of the episode: an officer from Capernaum in Galilee begged Jesus to heal his sick son. He agreed to visit the young man, but the centurion refused, arguing that Jesus' powers were such that he could heal his son without seeing him.[84] For Erasmus, Luther or Sir

152, 153 Attributed to Leonhard Beck, *Two-part Painted Epitaph for Martin Weiss and Elisabeth Fackler, with St Martin, Christ, Mary with Child, St Elisabeth and the Two Donors*, before 1520, wood, 154.7 × 121.4 and 153.7 × 121.1. Staatsgalerie, Augsburg.

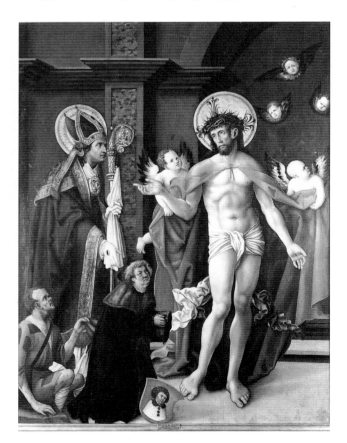
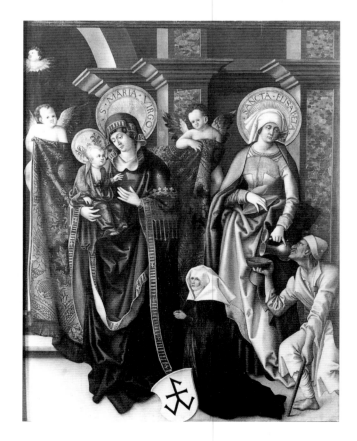

154 Detail from the 'Oberried Altarpiece' (illus. 155).

155, 156 *The Birth of Christ* and *The Annunciation to the Shepherds – Adoration of the Magi* (interior wings of the so-called 'Oberried Altarpiece'), *c.* 1521–2, pinewood, each 230/31 × 109/10. University Chapel of the Münster, Freiburg im Breisgau.

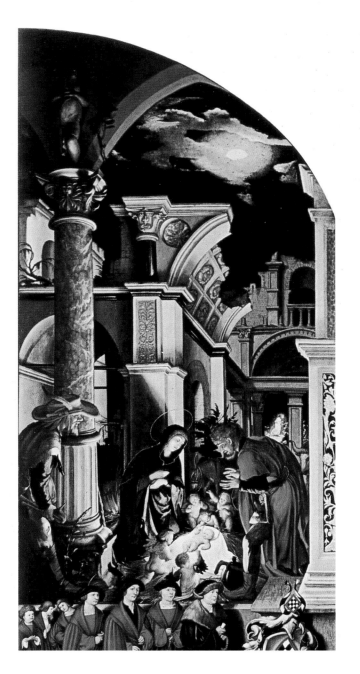

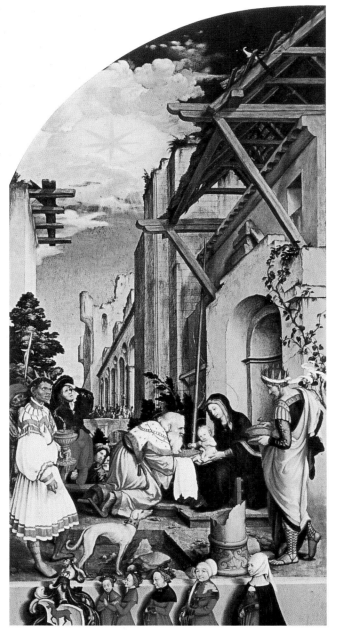

Thomas More, this episode epitomized the true, deep inner faith as opposed to the superstitions and external manifestations of worship represented by the fashion for relics or the abuse of religious works of art.[85] Erasmus praised such a feeling of immediacy between the Christian and his God in his own commentary to the Gospel of St Matthew, published by Adam Petri in Basle in 1522 – that is, at the very time when Holbein was working on the *Solothurn Madonna*.[86] One year later, the painter was working on a portrait of Erasmus. This work (illus. 122) portrays the famous scholar writing his commentary to the Gospel of St Mark, which was published in 1524.[87] The commentary on St Matthew was produced at the request of Cardinal Mathieu Schiner, a Swiss diplomat well acquainted with Johannes Gerster. Gerster had participated, under Schiner's direction, in the mission sent to Julius II in Bologna. It is impossible to know whether it was Holbein or Gerster who chose to have the centurion depicted in the *Solothurn Madonna*. At any rate, the image proposes a very subtle balance between the almost superstitious worship of pictures and their utter rejection. The centurion functions as a kind of *pharmakon*, a remedy for the potential dangers involved in the humanized representation of divinities. The picture itself presents us with a straightforward Virgin, who seems to be close, accessible to her worshippers. As an Erasmian picture, the *Solothurn Madonna* transformed the understanding of the *sacra conversazione*: here it is the Virgin who is the great intercessor. The saints surrounding her also assume a new, Erasmian meaning: St Martin, for Erasmus, was an apostle of tolerance. Both the centurion of Capernaum and St Ursus embody the *Miles christianus*, the soldier of Christ. In his *Paraphrasis in Evangelium Matthaei* (1522), Erasmus borrows, just as Thomas Aquinas had done, the Capernaum episode to compare the Christian with a soldier. Such a parallel tallies perfectly with Ursus, the saintly fighter of the Theban legion. Moreover, in 1503 Erasmus had written his *Enchiridion Militis Christiani*, where Christians are compared with an army devoted to a good cause, headed by Christ himself.[88] The historical context of the *Enchiridion* was the long fight of the Christian world against the Ottoman empire. The heroism of the *Miles christianus* recalled that of the men who fought to repel the heathens. A title-woodcut by Ambrosius Holbein for Ulrich Krafft's *Der geistlich Streit* of 1517 (illus. 157) conveys that Christ is a captain leading his troops to victory against the dragon; in his hand is a banner bearing the Crucifixion. The sub-title of the book promises to teach how 'Christ our commander fights for the whole human race under the banner of the Holy Cross'.[89]

Such a vision of Christianity was bound to appeal to Johannes Gerster. He seems to have enjoyed epics, and the story of Ursus must have reminded him of the crusade led by Barbarossa, culminating in the conquest of Jerusalem. Johannes Adelphus Mulich had written an account of this adventure, which he then dedicated to Gerster.[90] Hence the complex construction of the picture. St Martin and St Ursus guard the entrance to heaven, but the centurion of Capernaum reminds the viewer of the possibility of immediate access to God through a simple act of inner faith. The saints and the Virgin herself are highly individualized, as if they were almost human, rather than divine, beings. The artist did not adorn them with haloes; discreet rays of light surround the Virgin's head. The simple architecture chosen for the setting, the lack of a throne, betray a careful avoidance of unnecessary luxury. The *Solothurn Madonna* is one of the very rare works of art that may be recognized as truly Erasmian in spirit; it demonstrates how the art of the Reformation could have developed had it not been overwhelmed by fanaticism.

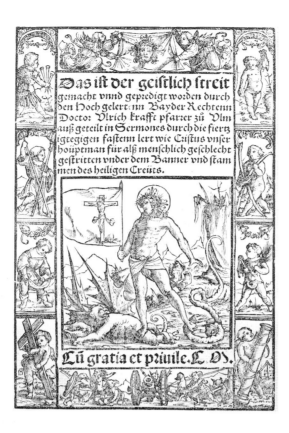

Holbein may not have been a committed theologian, but he could not remain totally indifferent to the religious struggles of his day. Above all he was living in a city in which most artists could earn their living by working for publishers. And what those publishers wanted were woodcuts advocating the new faith, while lambasting the corruptions of Rome. The woodcutters approached Holbein with requests to translate religious polemics into images. Every detail was discussed, as can be seen in two major works, cut by Heinrich Lützelburger after Holbein's designs around 1522–3. Both woodcut pictures illustrate attacks by Martin Luther against Rome: *Christ as the Light of the World* (illus. 158) and *The Selling of Indulgences* (illus. 159). All extant copies of these woodcuts have been trimmed to the border, and therefore do not enable us to see which text they were intended to accompany on a single sheet.[91] The printing-house of Froschauer in Zurich bought up the woodblocks, and reprinted one of the images – the *Christ* – but used it at the head of a calendar made for Johannes Copp (1527).[92]

In both woodcuts the true believers are contrasted with the corrupt clergy of the Roman Church. In *The Selling of Indulgencies*, the turpitudes of the Pope are associated with those of King Manasseh and King David, two notorious sinners of the Old Testament; in *Christ as the Light of the World*, simple peasants follow the Son of God, while Aristotle, Plato, the Pope and the Church Fathers fall into the abyss. The bipartition found in these two woodcuts was a traditional form, often seen in the medieval *Blockbücher*, but here it has been invested with a new purpose, typical of Reformist imagery: the juxtaposition of the two images was intended to educate the viewer in the distinction between good and evil. Cranach the Elder and Younger and Georg Pencz were the great masters of this genre.[93]

It is most probable that the woodcut *Christ as the Light of the World* was closely related to the publication of Luther's *Auszlegung der Episteln und Evangelien [. . .] vom Christag biß Uff den Sonntag nach Epiphanie*, which appeared in 1522 in Wittenberg, and in the same year in Basle from Adam Petri's press.[94] The sermon for Christmas includes long developments on Christ as the true light of the world. Luther's explanation of

In the image, the following inscriptions appear: LEX · GRATIA · MYSTERIVM IVSTIFICATIONIS · IVSTIFICATIO NOSTRA · AGNVS DEI · PECCATVM · HOMO · VICTORIA NOSTRA · MORS · MISER EGO HOMO, QVIS ME ERIPIET EX HOC CORPORE MORTIS OB NOXIO? RO. 7 · ESAYAS PROPHETA · IOANNES BAPTISTA · ECCE VIRGO CONCIPIET ET PARIET FILIVM · ISA. 7 · ECCE AGNVS ILLE DEI QVI TOLLIT PECCATV MVDI IO. 1

the Gospels challenges the followers of Plato: 'The Platonists have added their useless and empty talk to St Augustine on that passage, so that it looks so pretty and shines so beautifully, that thereupon they were called divine philosophers'. The false and confusing teaching of the philosophers is contrasted with the absolute clarity of Christ's directions. The sermon for Epiphany attacks the great master Aristotle, who taught foolish matters: 'der ubirster meyster aller hohen schulen, nicht alleyn gar nichts von Christo leret, sondernn eytell solch nerricht ding'.[95] With the help of an idiosyncratic allegorical interpretation of the Bible, Luther forged a powerful weapon against the Catholic hierarchy: Herod here was to be read as representing the Pope, the cardinals, the bishops and the priests, all of whom Christ will destroy. The star, high in the sky, provides a clear symbol of the new understanding of the Holy scriptures: 'nit anders, denn das new liecht, die predigt und Euangelium, mundlich und offentlich predigt wirt die Schrifft nit ehe vorstanden, das liecht gehe denn auff'. In turn, Holbein has depicted a great and ornate candlestick borne by the symbols of the Four Evangelists, visible to all worshippers, and which they should follow.

161 *The Old and the New Testament, c.* 1535, oak, 49 × 60. National Gallery of Scotland, Edinburgh.

The second woodcut (illus. 159) clearly relates to Luther's pamphlet of 1521 against the papal bull *Exurge Domine* (15 June 1520), a denunciation of 41 heretical propositions in Luther's works. In his defence, Luther referred to King Manasseh, 'das yhm got seyn sund vorgeben wolt umb gottis guttickeit unnd seiner zusagung willen, nit angesehn sein vordienst'. To the repentant sinner is opposed an arrogant, unrepentant Pope Leo X; the latter, the text says, would never acknowledge his unworthiness as had the centurion of Capernaum, but would rather request God to forgive him straightaway: 'her, vorgib mir wirdigen und wol vordienten unnd ganz gnugsamen heiligen mein szund'.[96]

Holbein, it seems, attempted, as did Erasmus, to strike a balance between two extremes: the pagan-like worship of idols, and the unilateral condemnation of religious pictures. It is easy to understand why Holbein, a painter, may have been convinced that images had a role to play in the new faith. Both men refused to be drawn into the confessional controversy and to make their position clear. In 1530 Holbein was requested to state his exact religious convictions since it had been noticed that he was no longer attending church. His response was that he would need more precise information before he could reach any decision.[97] Gerster, who commissioned the *Solothurn Madonna* in 1522, refused to convert to the Protestant faith. In the same way, his friend Conrad Peutinger, Augsburg's city clerk, resigned from his position rather than bow to the pressure to convert. For a painter, conversion to Protestantism had far-reaching consequences, entailing the loss of a significant number of patrons, chief among whom was the Church.[98] Nevertheless, Holbein could not forget that in his marginal drawings to Erasmus' *Encomium* (1515), he had lambasted those who mixed worship with superstition.[99] A few years later, the artist was to produce a design for an engraving that sums up, more than any written discourse, his opinion on such matters: an illustration for the *Precatio dominica* written by Erasmus and published in 1523. It is the fifth engraving in the book, the *Panem nostrum*, 'Give us our daily bread' (illus. 162), where a preacher stands before the group of his parishioners who have gathered for Mass and Communion. In the background is a large altarpiece, in front of which two candles have been lit. This altarpiece's size, its frame, its very proximity to the celebration of the Eucharist afford it a position of prominence. It is impossible to envisage what is represented on it, but one may assume that no saint is depicted, nor any object of superstition.[100]

The *Darmstadt Madonna* seems rather to be a work that was in tune with Catholic ideas – thus comparable with the Madonna of Mariastein as Erasmus had presented her, speaking in her own defence in the pamphlet against Zwingli of 1526. However, the Virgin is only distinguished from the members of the family through her idealized face. The problem faced by the artist was that of not diminishing the real presence or the vivid aspect of the Virgin in contrast to the human figures surrounding her. Holbein designed his Virgin with a throne and an imperial crown, but refrained from attributing haloes to Christ and St John the Baptist. The painter managed to show the response of Mary to those who adore and pray to her; she seems to be on the verge of moving forwards to meet her worshippers, whom her Son blesses.

It was most probably after his departure for England that Holbein completed the *Old and the New Testament* (illus. 161). The painter opposed the Law and Mercy, the Fall and Redemption, Death and Resurrection, faithful to the Reformation taste for striking oppositions between evil and good. That Holbein's picture should been seen in conjunction with Cranach the Elder's woodcut, *The Justification of the Sinner*

Unser täglich Brot gib
uns heüt/

162 *Panem nostrum*, metalcut by the
Monogrammatist CV, 8.6 × 6.4, in
Erasmus, *Præcatio dominica*, Basle, 1523.
Offentliche Kunstsammlung, Basle
(Kupferstichkabinett).

before the Law through God's Mercy and Grace (before 1530), is evident.[101] In order to complete this commission, Holbein drew on his now large experience as a designer for Protestant woodcuts: each element of the panel would require a careful reading in order to deliver what seemed to be the equivalent of a devout speech. In deference to the visual rhetorics prominent in German prints of the Reformation, he divided the space in half, separated by a tree, green on one side, barren on the other. Sitting helpless and naked under the tree is Man, comforted by the prophet Isaiah and St John the Baptist: they point out to him Mary and the *Agnus Dei*, in whom the sinner can hope to find salvation.

5 Italian and Northern Art

The leaping horse

163 Thomas Schmid and others, *Marcus Curtius*, wall painting, formerly cloister of St Georgen, Stein am Rhein, 1516.

164 Anonymous copy of 1825 after Holbein, *Marcus Curtius*, pencil and washes, 20.6 × 20.6. Zentralbibliothek, Lucerne.

The motif of the horse-rider leaping out from the wall illustrates vividly how Holbein reconciled the differences between Italian and Northern art. In strictly iconographical terms the image relates to the feat of a Roman hero, Marcus Curtius, whose act of bravery occurred in 362 B C. In order to save Rome he volunteered to sacrifice himself to the gods: an abyss had opened deep into the surface of the Forum, and he – astride his horse – leapt into it.[1] Holbein playfully painted his Marcus high up on the facade of the Hertenstein house in Lucerne (illus. 164), where the horse in the top right-hand corner seems to leap out into a void. An earlier example of Marcus Curtius on horseback, brandishing his sword, is to be found among the murals of 1516 decorating the Great Hall of the monastery of St Georgen at Stein am Rhein (illus. 163).[2] In this latter there was a strong element of illusion in the representation, and it was not until he was engaged on the house Zum Tanz in Basle, after his work in Lucerne, that Holbein, who must have known of the scene at Stein am Rhein, felt ready to evoke this aspect. On his Basle facade the rider is seen from below; he seems to leap out from a pavilion, frightening a soldier who seeks shelter (illus. 165). This inclusion of a soldier does not belong to the traditional iconography of Marcus Curtius: Holbein may have drawn it from Marcantonio Raimondi's engraving *Orativs* (Horatius Cocles), or from ancient representations of emperors on horseback.[3] The *concetto* was designed to impress the beholder, or at least to arouse his admiration. It was an effective design: fifty years later, Tobias Stimmer would use it on the facade of the house Zum Ritter in Schaffhausen.[4] Even as late as the seventeenth century, Joachim von Sandrart recorded the effectiveness of such devices.[5]

The motif was certainly not invented by the anonymous artist employed at Stein am Rhein, and Holbein's own version was executed even later. One finds it in Venice, where it formed part of Pordenone's design for the decoration of the external walls of the Palazzo d'Anna (illus. 166). The movement of the leaping horse is accentuated through a play between surface and depth. The sketch is dated *c.* 1535.[6] Pordenone may have sought inspiration from Giorgione's canal facade of the Fondaco dei Tedeschi (the German merchants' offices).[7] Unfortunately, nothing now remains of it; Ridolfi tells us that he saw 'perspectives of columns and between them men on horseback and other fantasies'.[8] Vasari deplored the damage it had already suffered, and in the absence of any visual sources only cursory descriptions recorded in the seventeenth and eighteenth centuries allow us to envisage it.[9] But from the fifteenth century onwards, the motif of the leaping horse often appears on frescoes in Verona and Trento.[10]

The Marcus Curtius representations in Stein am Rhein and in Basle should be seen in the light of the Italian models, even if it remains impossible to give a more precise counterpart in Verona, Trento or Venice. They have been unconvincingly

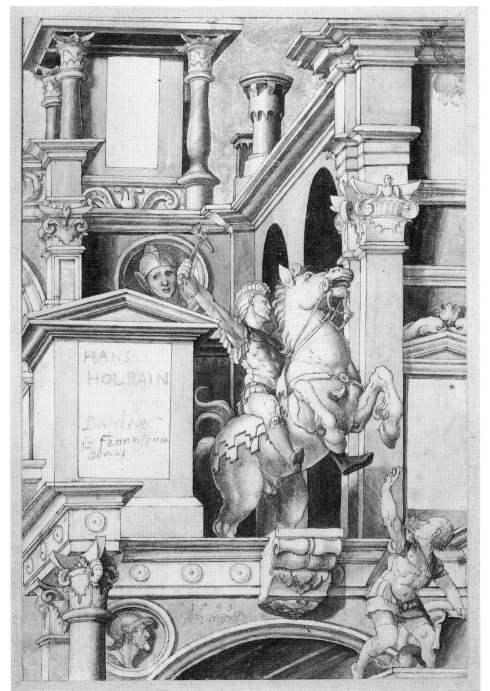

165 Niklaus Rippel, copy after Holbein, detail of the 'Leaping Rider' from the *Facade of the 'Zum Tanz' House*, 1590, pen, watercolour, 30.9 × 20.1. Öffentliche Kunstsammlung, Basle (Kupferstich-kabinett).

166 Giovanni Antonio de Sacchis, 'Il Pordenone' (*c.* 1484–1539), detail with the 'Leaping Rider' from a *Sketch for the Facade of the Palazzo d'Anna*. Victoria & Albert Museum, London.

167 *Stained Glass Design with the Coat of Arms of Fleckenstein*, 1517, pen and washes, 41.9 × 28.5. Herzog-Anton-Ulrich-Museum, Braunschweig.

168 Sebastiano del Piombo, *SS Bartholomew and Sebastian before the Gate*, exterior sides of the organ wings of S Bartolomeo di Rialto, *c.* 1507–9, each 293 × 137. Galleria dell'Accademia, Venice.

169 *The 'Solothurn Madonna'* (see illus. 117).

paralleled with Leonardo's sketch for a monument of a figure on horseback.[11] The question of the diffusion of such a motif thus remains unresolved, due to a lack of written or visual evidence. In the case of Holbein, unfounded hypotheses have often been bolstered by supposed models that he may have known, but which have since vanished, or they have been based on the assumption that he travelled in Italy.

One case illustrates this point to perfection. While he was in Lucerne, Holbein made a design for a stained glass for the Fleckenstein family (illus. 167) in which two men are shown supporting a shield. Their posture is strikingly similar to that of figures on the organ doors painted by Sebastiano del Piombo for the church of S Bartolomeo di Rialto in Venice (1507–9): on the outer surface an arch is shown, flanked by the figures of St Bartholomew and St Sebastian (illus. 168); on the inner one, St Louis of Toulouse and St Sinibaldus are framed in niches.[12] Holbein's design seems to imitate this spatial arrangement. Even the *contrapposto* of the figure to the right is drawn from Sebastiano's model. Thus, although the shield and the costume conform to those that normally appear on German and Swiss stained glass of this type, the architectural setting and the point of view are very new.[13] The young artist repeated such a compositional pattern in his ambitious panel, the *Solothurn Madonna*, dated 1522 (illus. 169).

That S Bartolomeo di Rialto should house such a panel is of the greatest importance for our analysis. The church is located at a very short distance from the Fondaco dei Tedeschi. Moreover, the right-hand chapel in the choir belonged to the Brotherhood of the German merchants: from 1506 onwards it was decorated with Dürer's

masterpiece, the *Rosenkranzmadonna*, painted in Venice, probably on commission from the Fugger family in Augsburg.[14] Any Northern visitor would have wanted to see that famous image in S Bartolomeo. On the panels decorating the organ they could have identified St Sinibaldus as the patron saint of Nuremberg. Holbein's drawing and also his *Solothurn Madonna* seem to be the only traces of a Northern interest in Sebastiano del Piombo's work for S Bartolomeo.

The *Solothurn Madonna*, a *sacra conversazione* in an archway, shows that by 1522 Holbein had evidently acquired a deep knowledge of Venetian art. Among the numerous examples of *sacre conversazioni* that feature an archway, only one can be very closely compared with the *Madonna* of 1522: the *Pala dei Mercanti* executed in 1474 by Francesco del Cossa for the Merchants' Forum in Bologna (illus. 170).[15] St Petronius and St John the Evangelist flank the Virgin enthroned with her Child. The two paintings have a different format; the throne, the position of the saints and the colours do not compare. Yet the arrangement of the figures, the posture of the Virgin, the architecture seen in perspective and the sky are strikingly similar. In addition, Holbein's beggar, kneeling somewhat awkwardly in front of St Martin, is in a comparable position to that of the donor on Francesco del Cossa's panel.[16]

Thus the composition of the two panels is close, and the position of the beggar in Holbein's picture, so similar to Francesco del Cossa's figure of the donor, is possibly not a mere coincidence. It is true that many Italian engravings of the 1520s popularized the motif of the *sacra conversazione*, but they do not offer such precise analogies

170 Francesco del Cossa, *Pala dei Mercanti (Sacra Conversazione with SS Petronius and John the Evangelist)*, 1474, tempera on canvas, 227.5 × 267. Pinacoteca Nazionale, Bologna.

171 Vincenzo Foppa, *Sacra Conversazione with SS Faustino and Giovita*, *c*. 1500, canvas, 227 × 204. Pinacoteca Tosio-Martinengo, Brescia.

with Francesco del Cossa's work. Johannes Gerster, who commissioned the *Solothurn Madonna*, may have provided the link between Francesco del Cossa and Holbein since he undertook diplomatic missions in 1510 in Italy, travelling through Milan, Piacenza, Modena and Parma to Bologna. Or Holbein himself, if he ever did travel in Italy, may have seen Francesco del Cossa's picture in the Merchants' Forum.[17]

It is also possible that Holbein only had a rather rough copy of Francesco del Cossa's panel at his disposal. More probably in this case, just as in other of his panels, the *Solothurn Madonna* was composed through a form of *ars combinatoria*, combining elements from various models. One of these, the most popular, is the scheme of the simple *sacra conversazione* as it was used throughout the Southern Alps and in Lombardy – in votive pictures for the long walls of churches, in altarpieces or in objects of private devotion.[18] A typical example is the *sacra conversazione* (illus. 171) by Vincenzo Foppa in Brescia. The Virgin is enthroned under a baldachin in a large room, between St Faustino and St Giovita. A carpet covers the platform on which the throne is set. The composition is striking because of its sheer simplicity, and must have been easy to imitate.[19] The panel was probably made for the main altar of the Oratorio di S Faustino in Riposo in Brescia.[20]

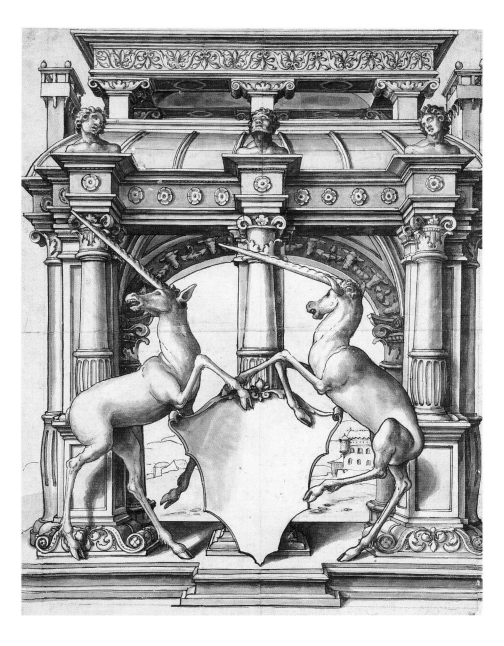

172 *Stained Glass Design with Two Unicorns,*
c. 1522–3, pen, washes and watercolour,
41.9 × 31.5. Öffentliche Kunstsammlung,
Basle (Kupferstichkabinett).

Architectural décors

A thorough examination of Holbein's acquaintance with Italian art should take into
account his artistic practice, and lay aside the doctrine of the predominance of
styles and of stylistic history. This doctrine, which dominated throughout the nine-
teenth century, postulates that style is the *summa* of all formal details, the decisive in-
strument for the differentiation of epochs in the history of art. Within the 'epochs'
defined through a formalist approach, differences are interpreted as marks of provin-
cialism or of belated use of known patterns. Although styles are the creation of
modern art historians, they have been seen as forces that have been at work through-
out the history of art. A total dedication to formal description, the definition of
epochs through mere formal criteria and the delimitation of stylistic periods mark a

patent failure of art history, while nevertheless providing popular knowledge with simplistic criteria for the critical appraisal of culture. Recent interpretations of the plurality of styles have shown how questionable is the definition of epochs through conceptions of style; however, the classification of art-works according to stylistic criteria has not yet been revised, nor has it been harnessed to serve to build more complex models of the history of art.

To reduce these abstract concepts of style to more closely defined formal descriptions constitutes a long and daunting task; it is equally difficult and yet necessary to distinguish different epochs through a multitude of factors, and to replace the predominance of styles by a careful analysis of the variety of artistic tasks faced by artists. A simplistic view of the succession of styles should give way to a more refined observation of the relation between styles, tasks or genres, artistic problems and representations of the artist himself and of his work. All these elements must in turn be confronted with the patterns circulating in artistic circles, and with the demands of both patrons and the wider public.

Thus it was that until the 1920s, Holbein was labelled an eclectic artist, due to a predominantly stylistical approach to his achievements. So, for example, in 1847 Kugler and Burckhardt formulated the young artist's dilemma in the following way:

All those works are of very different styles; he was a precocious talent, quick at changing his way of executing his works; he took into account many influences from different sides, until, enriched by all those borrowings, he found his original direction again.[21]

Burckhardt was to revise this vision of the individual development as a process of self-estrangement and rediscovery in his lecture 'on non-Italian art since the fifteenth century' (1891), where he drew a link between the free combination of architectural forms and the requirements associated with the artistic task involved in each work commissioned to him.[22]

Holbein did not acknowledge styles as norms, but considered his work rather in terms of tasks and sources of artistic effects. He would adapt the form to the genre of the work entrusted to him and would only then allow his artistic fantasy to find its expression. Hence the great difficulties involved in any attempt to pinpoint his references; it is almost impossible to draw from the knowledge of his models an analysis of his stylistic borrowings. For example, his sketch for a stained glass with two unicorns (illus. 172) has been discussed in conjunction with an illustration for a *Caryatum Porticvs* (illus. 173), published in Cesare Cesariano's 1521 edition of Vitruvius.[23] Even when the link between the two representations has been accepted, it has to be noted that Holbein has turned the illustration from the book into something different. In both there is a direct, frontal view, and both the timberwork and roof are similar. However, Holbein has transformed the portico into a free-standing architectural entity, the caryatids have vanished, and the caryatid busts have been changed into male portrait busts on the pilasters.

In his woodcut for the title-page of the *Missale Speciale* of 1521 (illus. 174), Holbein placed the *Intercessio*, the prayers of the Son and of the Mother to an angry God the Father, in an architectural setting that is, ultimately, reminiscent of Masaccio's *Trinity* (c. 1427) made for S Maria Novella in Florence (illus. 175). Masaccio presented the Trinity as a combination of a throne of grace (*Gnadenstuhl*) and Crucifixion in a chapel or a tabernacle with a coffered ceiling. Above the sarcophagus containing the

173 Cesare Cesariano, *Caryatvm Porticvs*, woodcut in his translation of Vitruvius, Como, 1521.

Missale Speciale
nouiter impzessum:
summo studio ac di-
ligentia emendatu z
castigatum: additis
nonnullis missis no
uarum festiuitatum
que pzius infer
teno fuerat.
In inclyta Basilea.
O. D. rri

175 Masaccio, *Trinity*, c. 1427, fresco, 667 × 317. S Maria Novella, Florence.

remains of Man, two kneeling figures are placed on either side, in front of the pilasters of the painted triumphal arch.[24] Masaccio may have been guided by Brunelleschi, and realized a new architectural type through the depiction of a series of identical elements, and the opening up of the space inside the painted chapel.[25] Giovanni Bellini – and perhaps Antonello da Messina – used Masaccio's invention *c.* 1475 in order to create a new Venetian type of *sacra conversazione*. In his title-page design Holbein maintained the idea of the triumphal arch with a coffered ceiling, but opened the arch to the sky beyond and placed his standing figures in front of the pilasters. He used the architecture to enhance the *Intercessio*'s meaning by means of an iconographical device. The angry Judge becomes a form of divinity guarding

176 *Epitaph for Jakob Fugger*, 1510–18, marble, St Anna, Augsburg.

177 Hans Daucher, *Madonna and Child with Angels*, 1520, sandstone, 42 × 31. Städtische Kunstsammlungen, Augsburg.

178 Tullio Lombardo, *Monument of Andrea Vendramin*, from Cicognara's *Storia della scultura . . .*, Prato, 1823.

the arch; as for Christ and his Mother, they become intercessors on behalf of all sinners. Under Christ's and Mary's feet those souls waiting to enter Paradise are nourished with milk and blood.[26]

Holbein had at his disposal a good knowledge of the architectural forms of the Italian Renaissance. The Fugger chapel in St Anna, Augsburg, decorated between 1509 and 1518 by Dürer among others, betrays a close acquaintance on the part of the Northern artists with Italian forms.[27] Among the *basso-rilievos* the epitaphs for Jakob Fugger (illus. 176) include the depiction of two vaulted rooms with columns and soldiers. This representation and Masaccio's fresco may have been important references for Holbein.

In 1520 Hans Daucher completed a *basso-rilievo* in sandstone; the carving shows Mary with her Son, angels and putti under a baldachin, all positioned before a triumphal arch (illus. 177). That architectural décor and a very similar one painted by Holbein the Elder in *The Fountain of Life* have been associated with Tullio Lombardo's tomb for the Doge Andrea Vendramin (illus. 178).[28] The vaulted baldachin and the motif of the Virgin with putti may be traced back to Dürer's drawing made in 1509, *The Holy Family in the Hall* (illus. 180). Dürer placed the Virgin with her Child and the putti playing music between the two columns in the foreground; behind, sitting at a table, half-asleep near a beer tankard, is Joseph. This drawing served as a model for the altarpiece in the Church of the Assumption of Maria Schnee, Augsburg, completed by Jörg Breu the Elder.[29] Dürer's baldachin seems to draw on one main source, the ciborium of 1452 designed by Michelozzo for S Miniato al Monte in Florence (illus. 179).[30] His work there is clearly copied in a small model of painted

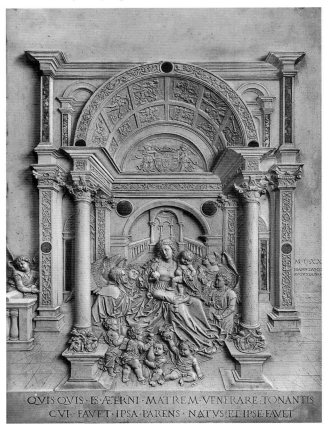

architecture, the *Judgment of Solomon* (illus. 181), attributed to Conrad Appodeker, or Conrad Schnitt as he was named in the documents attesting his new membership of the guild Zum Himmel in Basle (1519).[31]

Around the year 1520 Holbein experimented with a number of possible combinations for the Virgin and Child alone, or sometimes with the Holy Family, against an architectural background. In the drawing *Maria lactans between Two Columns* (illus. 182), he pushed the Virgin further towards the edge of the image, and chose a low viewpoint. A perfectly symmetrical view of the Virgin between the columns is avoided by choosing an angled view. The contrast between the mother offering her breast to her child and the 'framing' of the figures between two columns heightens, more than Dürer ever managed it, the difference between human closeness and divine distance.[32] The drawing of the *Holy Family* (illus. 184), dating to the years 1518–19, exploits very similar devices.[33] Columns and entablatures jut forward, the niche is adorned with a shell and topped with a richly decorated pediment and a coffered arch. It has not been possible to trace any model for such an architectural presentation, even in Como or Venice. Holbein set aside the knowledge he had gained in Augsburg to follow the example of the painted architecture typical of Filippino Lippi, in his fresco *The Triumph of St Thomas Aquinas* (illus. 183) at S Maria sopra Minerva in Rome.[34] This painted architectural décor contains all the elements that are found articulated in the same manner in Holbein's drawing.

The small diptych *Christ as the Man of Sorrows and the Virgin as Mater Dolorosa* (illus. 185, 186) demonstrates that the young artist allowed his rich imagination to run free, even before the time when he completed the monumental decorations on the

179 Michelozzo Michelozzi, *Tabernacle*, 1452. S Miniato al Monte, Florence.

180 Albrecht Dürer, *The Holy Family in the Hall*, 1509, pen and washes, 40.9 × 27. Öffentliche Kunstsammlung, Basle (Kupferstichkabinett).

181 Conrad Schnitt, *The Judgment of Solomon*, c. 1520–30, wood, 58 × 45. Öffentliche Kunstsammlung, Basle.

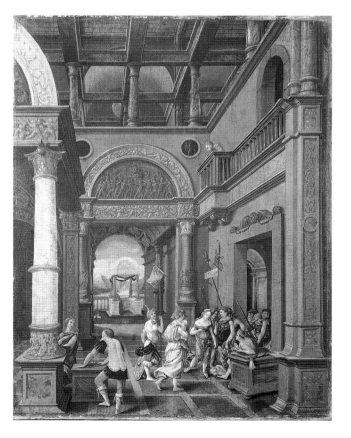

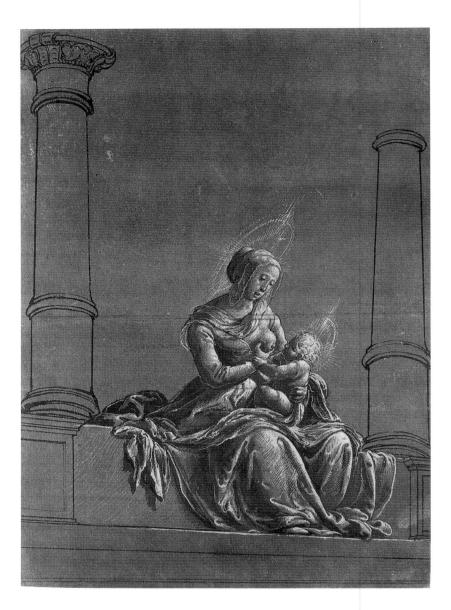

182 *Maria lactans between Two Columns,*
c. 1520, pen and brush heightened with
white, 21.2 × 14.8. Öffentliche Kunst-
sammlung, Basle (Kupferstichkabinett).

183 Filippino Lippi, *The Triumph of St*
Thomas Aquinas, 1488–93, fresco. S Maria
sopra Minerva, Rome.

OPPOSITE PAGE
184 *The Holy Family, c.* 1518–19, pen and
grey wash, heightened with white, on red-
brown primed paper, 42.7 × 30.8. Öffent-
liche Kunstsammlung, Basle
(Kupferstichkabinett).

PAGES 132 & 133
185, 186 *Diptych with Christ as the Man of*
Sorrows and the Virgin as Mater Dolorosa,
c. 1520, limewood, each 29 × 19.5. Öffent-
liche Kunstsammlung, Basle.

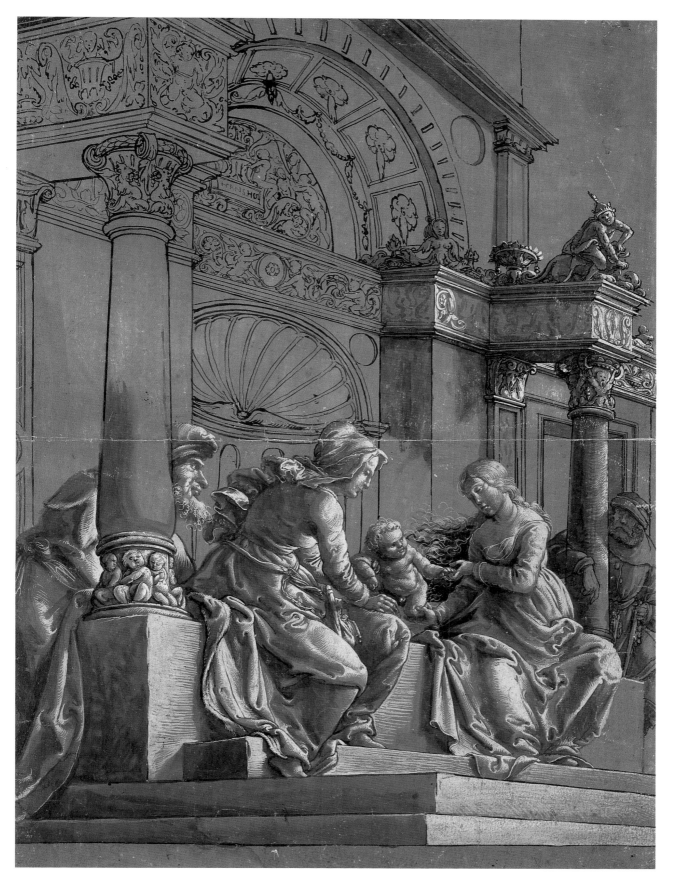

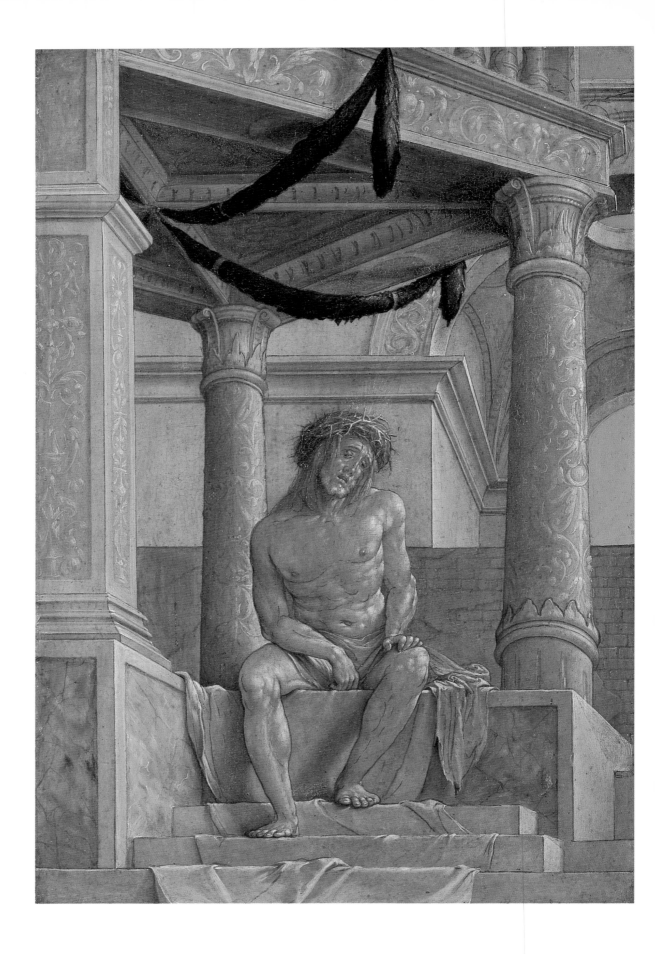

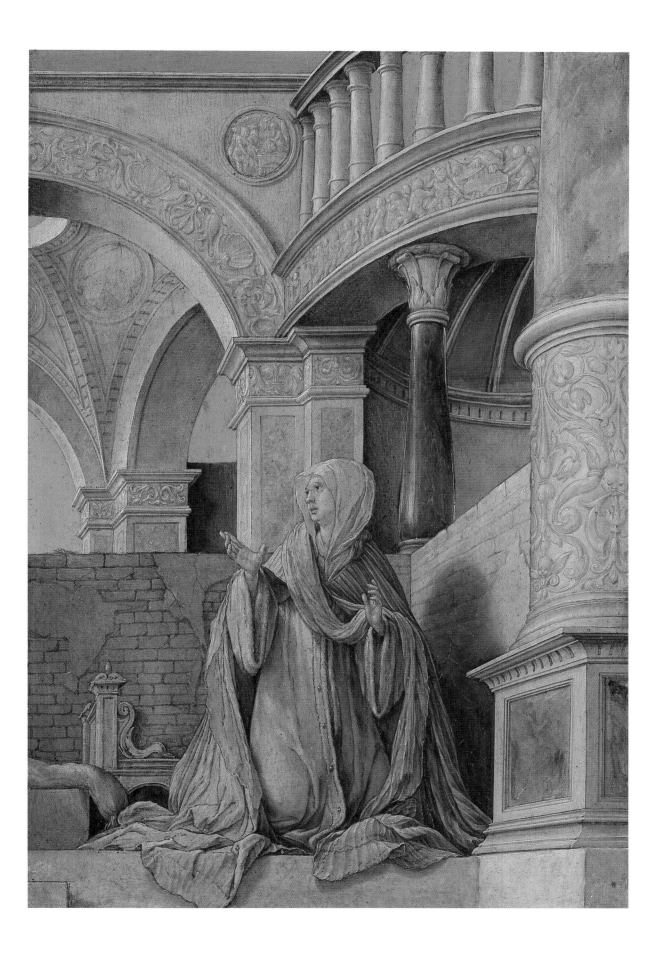

facade of the house Zum Tanz.[35] The diptych seems to constitute the earliest example of Holbein's free usage of various, somewhat arbitrary, architectural forms, painted with the utmost precision. While he was proving his mastery of Italian architecture through the sound, regular depiction of buildings – as in the design for a stained glass, the *Madonna and Child with St Pantalus* – he also allowed himself the greatest liberties in his architectural representations for the house Zum Tanz.[36] At the time when he was composing his Virgins with the help of Italian patterns, he was also drawing heavily on Dürer and Schongauer for his stained-glass designs for the *Passion of Christ* (illus. 60), blending the architectural forms to his taste. As for the art of the Upper Rhine region – from Hans Baldung Grien to Grünewald – he seems to have found it a less important source of inspiration.[37]

Italian forms and French technique

In 1524 Holbein travelled through France. While in Bourges he copied meticulously one statue of Jeanne de Boulogne (illus. 188) and one of the Duke Jean de Berry.[38] Through his choice of medium (black and coloured chalks), the statues suddenly come to life. Holbein had used such a technique for the first time in his drawing of the Meyer family (illus. 189), while engaged on the *Darmstadt Madonna*. He seems to have reserved the technique of coloured chalks for his portraits, whereas the sketches for stained-glass designs or monumental decorations were made with either pen and wash or with watercolours. These two portrait drawings probably suggest that Holbein learned the new technique in France. It is true that long before 1524 he had been using coloured chalks, but he had confined their use to enhancing an outline that he had already established in silverpoint, in pen and wash, or in watercolours, as seen in his early portraits from Basle.

It has been proposed that Holbein learned the new technique from Jean Clouet. But the facts are difficult to interpret; nearly all of Clouet's drawings are made in black and red chalks, and very rarely include colours.[39] However, it should be pointed out that in his *Codex Atlanticus* Leonardo acknowledged the help of the French artist Jean Perréal; in Milan, in 1499, the latter had shown him how to use dry colours, and Leonardo employed this, for him, novel technique for the first time in his portrait of Isabella d'Este (1499). Bernardino Luini followed suit in his drawing *Young Woman with a Fan* in the Albertina.[40] Thus it seems that Holbein did not necessarily learn the new technique directly from the Clouet family, but more probably from a member of Leonardo's circle in France, or from his *epigones* in Milan.

What Holbein did learn from Clouet was rather the art of the court portrait. The French artist focused on the physiognomies and hats of his sitters. The use of red chalk was intended to enliven the face; as for the chest, Clouet defined it with a few expressive lines and with some hatchings. It is true that in Holbein's drawings for the Meyer portraits the lines are very faint and elusive below Jakob Meyer's collar (illus. 34). The purpose of these sparse, thin lines is to capture the main features of the chest and costume rather than to express them with a bravura that pays homage to the virtuoso mastery of the hand. The brown colouring of the beard in the portrait of Guillaume Gouffier, Seigneur de Bonnivet, of *c.* 1516 (illus. 190), is produced by hatchings in which red and black chalks are combined.[41] Holbein's portrait of Sir Nicholas Carew (illus. 191), which probably dates to *c.* 1527 and thus during his English

period, betrays an awareness of new powers of expression; there is the same concentration on the head and the hat, the same elliptical play on the rest.[42] In addition, Holbein here used not only red and black chalks, but also a yellow one – the same combination as is found in the portrait drawing of Mary Wotton, Lady Guildford (illus. 226). But what is at stake above all here is the enhanced value of the drawing – not only as a preparatory piece for a panel painting, but as a work of art in its own right.[43] The French and Italian practice of court portraiture must surely have aided Holbein in developing a new awareness of the function of his drawings.

Holbein adopted the French type of the court portrait (illus. 193). Due to the lack of precise chronological indications it is difficult to assess the exact corpus of drawings he may have known. The French type consists of a half-figure portrait, frontal or slightly turned to the right, with superb, voluminous garments. The effect of such official portraits is heightened by ensuring that the half-figure is actually too large to fit exactly within the limits of the frame. The most obvious example of the French type is the famous *François I* (illus. 192). The King, portrayed in half-figure, is presented as a voluminous silhouette on a rich red brocade background. His black hat with an ostrich feather, the chain of the Order of St Michael, the black-and-white striped costume, delicately embroidered with gold, compose a solemn and splendid figure. Small details are finely polished: the King is shown holding a glove in one hand, while the other rests on a sword-hilt above green velvet.[44] This triumphal composition is attributed to Jean Clouet and dated to before 1525. However, other scholars have opted for a joint attribution to Jean and his son, François, which would entail a date closer to 1529–30.[45] Holbein repeated the same pattern when executing a large portrait of Henry VIII – of which only copies remain.[46] Originally it was most probably Jean Fouquet whose *Charles VII* (Paris, Louvre) provided the pattern that was subsequently worked on by great international artists such as François Clouet, and even Joos van Cleve in his *François I* (1529-30), or Jan Gossaert in the *Portrait of an Nobleman*.[47]

Very shortly after his return to Basle from France Holbein probably painted the small panel *Venus and Cupid* (illus. 194). This work may be seen as a first response to those by Italian painters that could be admired in François I's collection; it marks the early formulation of an aesthetic ideal. In 1526 there followed a similar painting, the *Laïs Corinthiaca* (illus. 24), whose dimensions are slightly larger; in the same year, Holbein was commissioned to paint the *Darmstadt Madonna* (illus. 118), and it was surely with pride that the young artist bestowed the same Italian, Leonardesque face on his figure of the Virgin. In the *Laïs*, as well as in the *Venus and Cupid*, the position of the two young ladies evokes that of Christ in Leonardo's *Last Supper* (illus. 195).[48] In Holbein's *Last Supper* (illus. 196), which was badly damaged during the *Bildersturm* of 1529, many art historians have seen evidence of Holbein's fascination for Leonardo. However, apart from the three window openings, the face of the Christ and the dispute of the Apostles, Holbein borrows hardly any elements from Leonardo. Not only did he realize a completely different composition, but he also gave grotesque faces to Judas and to some of the other Apostles. His *Last Supper* does not try to imitate an Italian model, but rather to transform it according to Northern requirements.

The *'Belle Ferronnière'* (illus. 187) in the Louvre, probably a work by Boltraffio, also offered a welcome point of departure from which Holbein could then explore his own variations of beauty. The Louvre picture shows an unknown lady of the Milanese court sitting behind a low stone slab.[49] Holbein could appreciate such compositions,

PAGES 136 & 137

188 *The Statue of Jeanne de Boulogne in Bourges*, 1524, black and coloured chalks, 39.6 × 27.5. Öffentliche Kunstsammlung, Basle (Kupferstichkabinett).

189 *Anna Meyer*, c. 1526, black and coloured chalks, 39.1 × 27.5. Öffentliche Kunstsammlung, Basle (Kupferstichkabinett).

PAGES 138–139

190 Jean Clouet, *Guillaume Gouffier, Seigneur de Bonnivet*, c. 1516, black and red chalks, 25 × 19.8. Musée Condé, Chantilly.

191 *Sir Nicholas Carew*, c. 1527, black and coloured chalks, 54.8 × 38.5. Öffentliche Kunstsammlung, Basle (Kupferstichkabinett).

187 (?) Giovanni Antonio Boltraffio, *'La Belle Ferronnière'* (*A Lady at the Court of Milan*), c. 1495–9, wood, 63 × 45. Musée du Louvre, Paris.

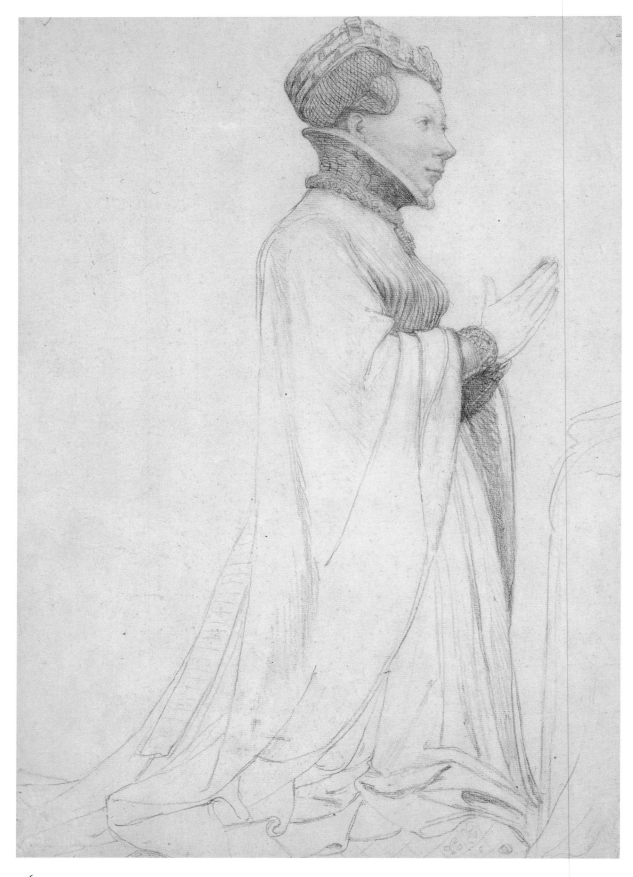

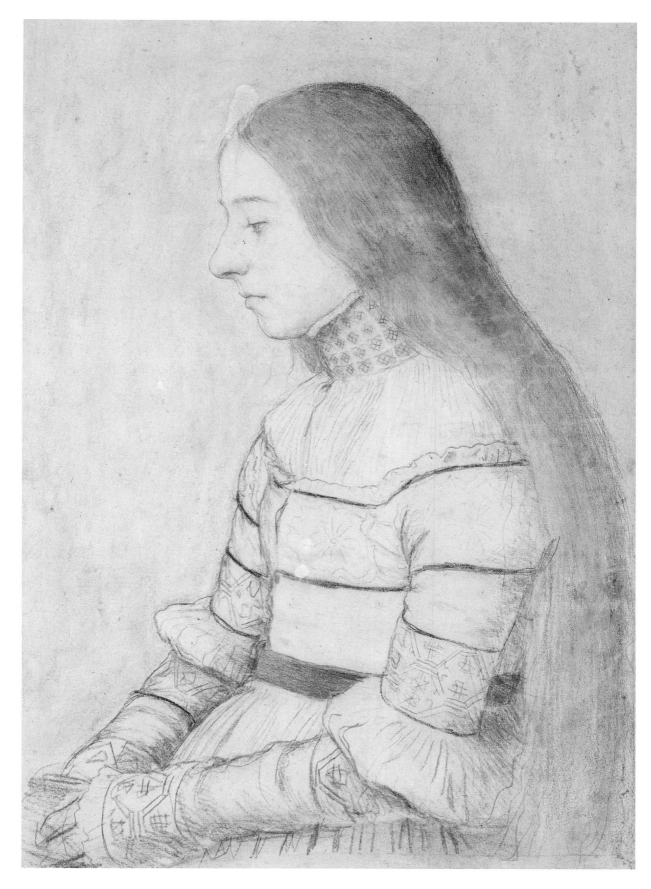

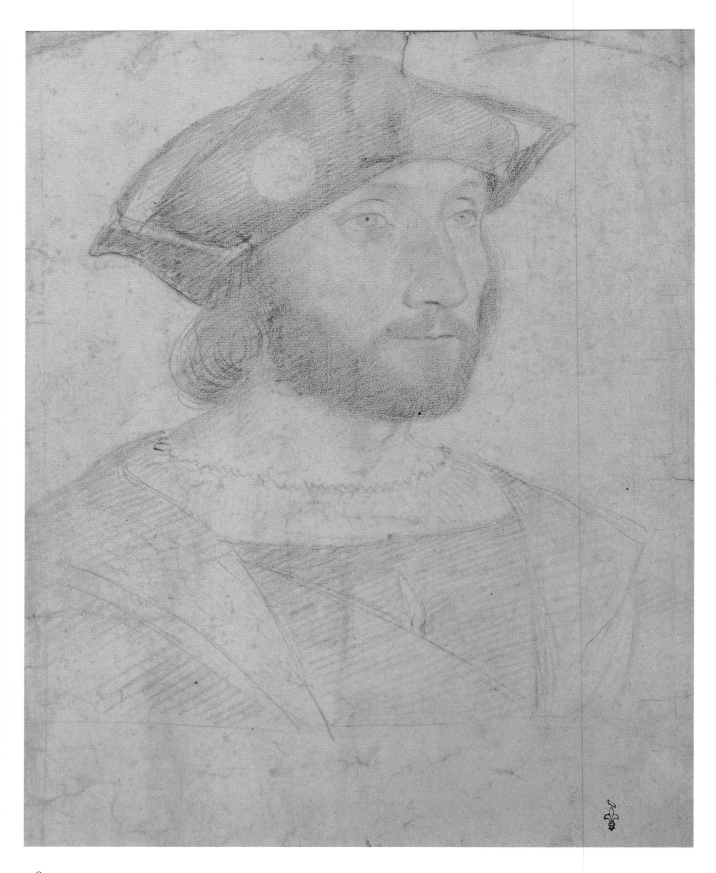

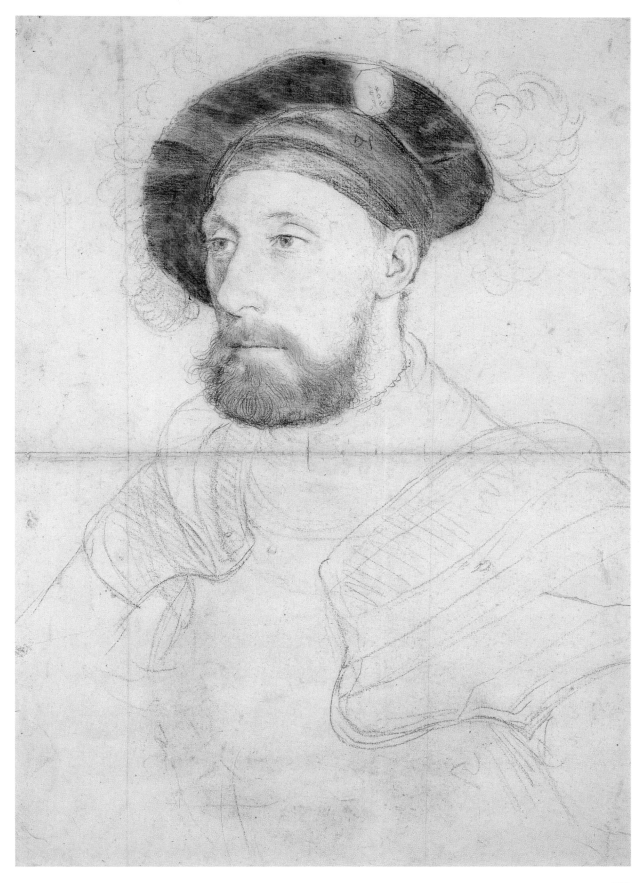

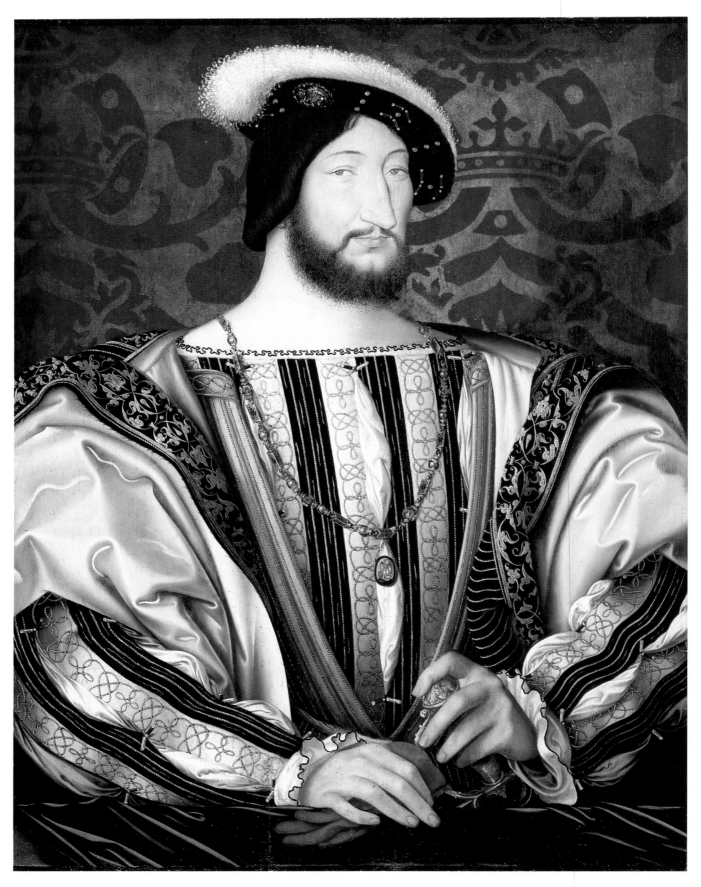

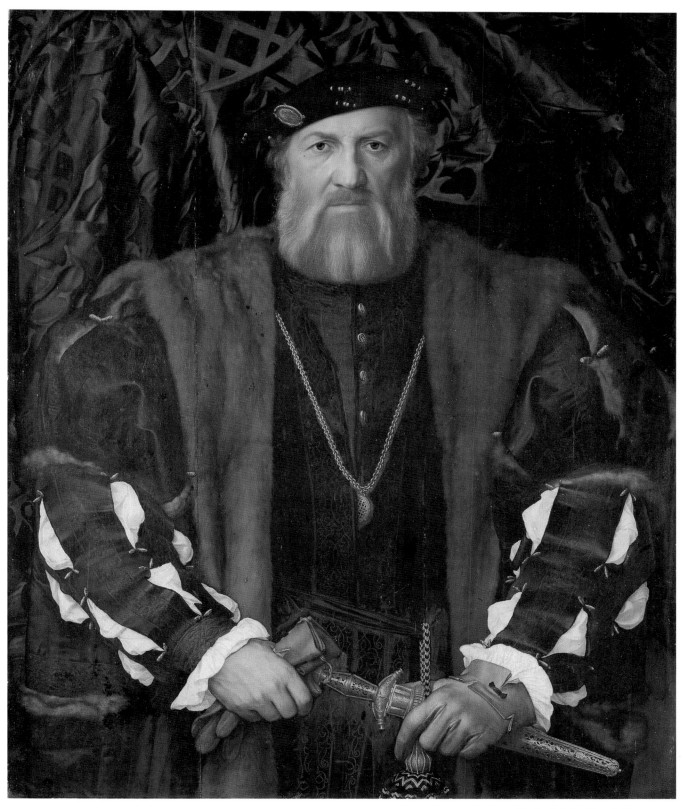

192 Jean Clouet, *François I, King of France,*
1520s, oil on wood, 96 × 74. Musée du
Louvre, Paris.

193 *Charles de Solier, Sieur de Morette,*
1534–5, oak, 92.5 × 75.5. Staatliche
Kunstsammlungen Dresden, Gemälde-
galerie Alte Meister.

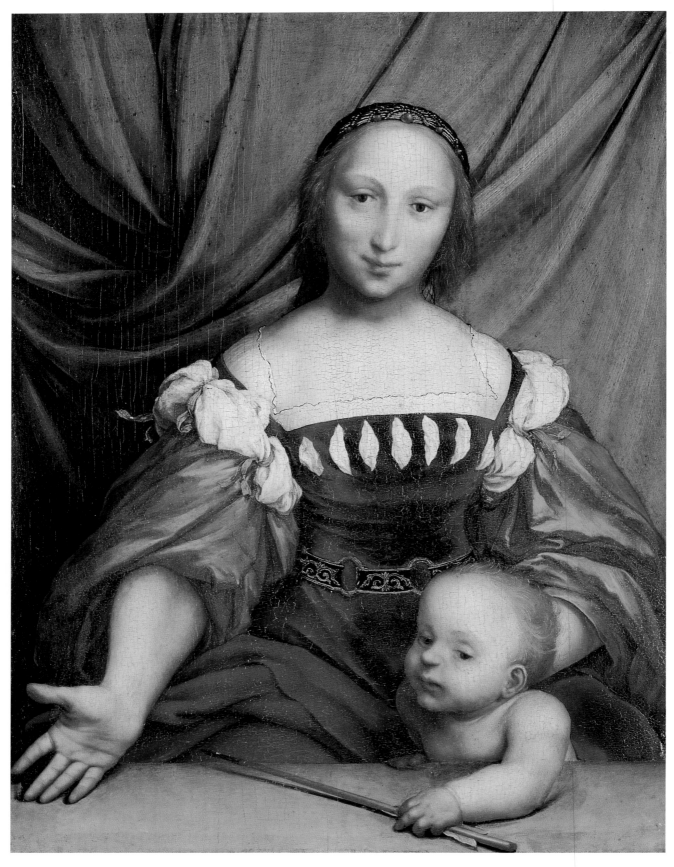

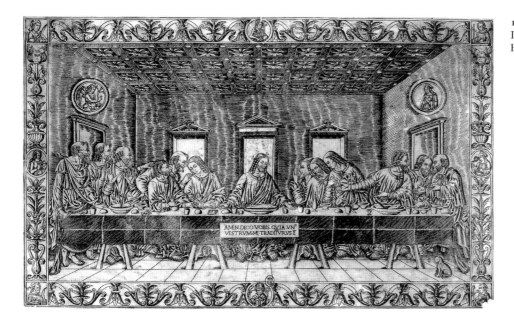

195 Anonymous engraving after
Leonardo da Vinci, *The Last Supper*, *c*. 1500.
Bibliothèque Nationale de France, Paris.

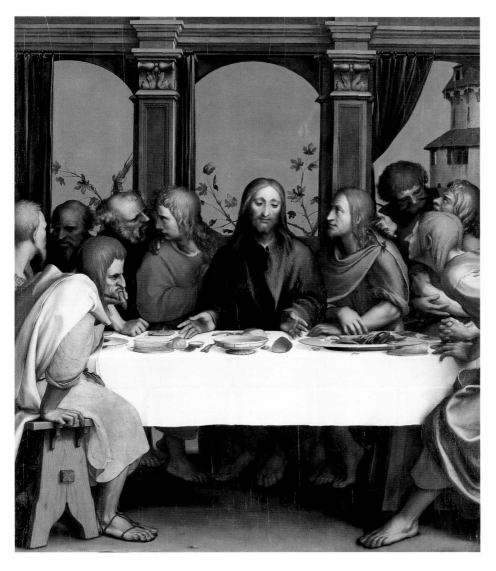

196 *The Last Supper*, *c*. 1524, limewood,
115.5 × 97.5. Öffentliche Kunstsamm-
lung, Basle.

OPPOSITE PAGE
194 *Venus and Cupid*, *c*. 1524, limewood,
34.5 × 26. Öffentliche Kunstsammlung,
Basle.

even with his cultural background, as indeed his portrait of Erasmus bears witness (illus. 28). However, Holbein did not exploit this combination of beautiful visage and balustrade for a portrait, but rather for a mythological representation – *Venus and Cupid*, and then for the legendary lover of artists, *Laïs Corinthiaca* (illus. 24). In both pictures the artist has achieved a much more direct contact with the beholder than had Boltraffio: the viewer is almost apostrophized by the figures. Another portrait, *Jeanne d'Aragon* by Raphael and Giulio Romano, could also have been a reference for the young painter. The panel was given by Cardinal Bibbiena, on behalf of Leo X, to the French monarch in 1518.[50] Holbein may have tried, in these two small pictures, to attract a public of refined collectors.

A singular painting is the *Noli me tangere* (illus. 197) at Hampton Court Palace, which was first included in the corpus of Holbein's work in 1895, though its place has never been settled very satisfactorily.[51] Mary Magdalene's costume, her jar, the similarities between the painting and *Venus and Cupid* as well as *Laïs Corinthiaca* seem to indicate that it was made between 1524 and 1526. Holbein could have drawn some inspiration from well-known engravings by Lucas van Leyden (1506 and 1519) or from Fra Bartolomeo's panel depicting the same event, which belonged to François I.[52] He preferred to illustrate the Gospel of St John (20:14–18), and to stress vigorously the movement, in the sunset, of the two figures. Mary turns towards Christ, who seems to be stepping back. Secondary scenes appear on both sides – the open grave with the angels and the young men returning to the city. The position of Mary's body has only one parallel in Holbein's work: the *Female Figure in Motion* (illus. 46).

The *Darmstadt Madonna* poses many difficulties in relation to Holbein's understanding of Italian art. It seems that no panel representing the Virgin and Child with St John the Baptist is known in the North before that date.[53] In the South the iconography is very common, especially in Florentine and Lombard painting, from

the mid-fifteenth century onwards.[54] In Milan, Leonardo produced his famous *Virgin of the Rocks* (illus. 199) between 1483 and 1490: John the Baptist, the Virgin and an angel pay homage to Christ. The panel was painted for the Confraternità della Concezione, and destined for the church of S Francesco Grande in Milan (1493), but was probably sold by Lodovico Sforza to Louis XII. It is mentioned in the royal collection at the time of François I.[55] It seems that a similar piece by Raphael had been obtained by François for Fontainebleau, the *Madonna and Child with St John the Baptist*.[56] How did Holbein come to see such models? It is possible that it was during his travels in France in 1524; if not, he may have known drawings or engravings made after them. A good example of the international diffusion of Leonardesque art in France is a French panel dated 1520, the triptych of St Pantaleon; this painting derives its composition from another version of Leonardo's *Virgin of the Rocks* that at the time was still in Milan.[57]

Holbein tried to incorporate such new forms into his own artistic production with the ultimate aim of the combination of different patterns. The *Darmstadt Madonna* draws on the iconography of the 'Schutzmantelmadonna' (the Virgin as Protector), that of the Virgin and Child with St John the Baptist, and that of the Virgin standing in front of her throne. Very good parallels may be found, which aid in identification of the elements here combined. A small picture now in the Louvre, the *Madonna and Child, Surrounded by Six Angels and St John the Baptist* (illus. 200), substitutes a standing Virgin in the representation of the Virgin with Christ and St John.[58] Another piece offers even more striking features: the main altarpiece of the Chiesa del Collegio Papio in Ascona (1519), whose central section was painted by Iohannes Antonius de Lagaia from Ascona (illus. 198). Here in the *Madonna della Misericordia*, we have the Virgin standing in front of her throne in a magnificent room; two pilasters frame the space topped by an entablature. Arranged symmetrically on either side of the Virgin are male and female figures who place themselves under the protection of the standing Virgin, whose head – as in Holbein's picture – nearly overlaps the top edge of the shell adorning the niche.[59]

Ascona, at the northern end of Lake Maggiore, was situated on the main line of traffic between North and South, just as was Basle. For both goods and travellers it was an important station on the journey to northern Italy. The strategic position of Ascona, the similarities between Lagaia's panel and the *Darmstadt Madonna* are so striking that Holbein may well have seen the panel, or at least have been indirectly acquainted with it. At any rate, in their attempt to combine two iconographical patterns, both artists achieved fairly analogous results. The similarity between the position of the figures of the people of Ascona and that of the Meyer family must surely be regarded as more than a pure coincidence. In one respect, however, Lagaia's *Madonna della Misericordia*, the *Pala Sforzesca* in Milan and Lippi's *Pala Barbadori* all differ from the *Darmstadt Madonna*: Holbein's masterpiece is constructed and functions as an epitaph, according to the Northern tradition.[60]

198 Antonio de Lagaia, *Madonna della Misericordia*, 1519, wood, centre of altar polyptych. Chiesa del Collegio Papio, Ascona.

The 'Italian Journey'

In 1604 the biographer Carel van Mander wrote a short biography of Holbein that was to remain a standard reference for centuries. In it van Mander insisted that Holbein 'had not been in Italy'.[61] This affirmation has too often been accepted at face value.

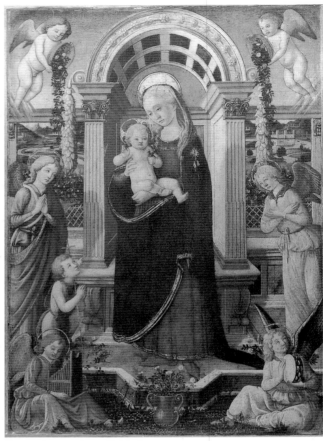

199 Leonardo da Vinci, *Madonna of the Rocks, c.* 1483–90, canvas, 199 × 122. Musée du Louvre, Paris.

200 Florentine School, *Madonna and Child, Surrounded by Six Angels and St John the Baptist as a Child*, 48 × 35. Musée du Louvre, Paris.

It should be remembered that the biographer had found it difficult to gather his information:[62] for example, his dates of birth and of death for Holbein are both wrong. Second, his work was written with the clear intention of proving a point against the Italian school: the Northern artists were in no way inferior to either the Florentine or Roman schools. Van Mander, as will be explained in chapter Seven, wanted to show that such a superb artist as Holbein had attained perfection without Italian schooling of any sort. He went so far as to record Hendrick Goltzius's testimony regarding Federico Zuccaro: the great Italian artist, on inspecting Holbein's paintings for the London Steelyard (illus. 106, 107), had declared that they were of a higher standard than any by Raphael.[63]

Over the last 150 years the question of Holbein's journey has not been resolved. In the *Handbuch der Geschichte der Malerei*, Franz Kugler and Jacob Burckhardt proceeded with great caution in their discussion of the 'Influences of the Italian manner':

Where some elements crop up in his early work, it is enough to assume that Holbein became acquainted with prints by Mantegna's school; for the later period, one does well have to accept the idea of a trip to Italy, even a short one, at least in Northern Italy, inasmuch as features reminiscent of Leonardo are all too evident.[64]

Burckhardt returned to the question in his *Lectures* of 1891, and suggested that Holbein might have travelled in Lombardy in 1517: at that time, the artist's chief interests were the study of perspective, that of Italian architecture, especially of Lombard ornaments.[65] However, a mere comparison of Holbein's works with Italian paintings or sculptures does not provide enough evidence to prove that point: the corpus of Italian engravings was large enough, at the beginning of the sixteenth century, to furnish Holbein with plenty of patterns.[66] John Rowlands does not exclude a journey to Italy, but is inclined to limit that experience to the period when the young artist was working in Lucerne.[67]

Any comparison of Holbein's paintings with Italian works may allow a reconsideration of his direct or indirect acquaintance with them. The problem is to assess the difference between the use of forms attesting a general knowledge of Southern practices, and the specific borrowings, which should rather prove a direct acquaintance, *in situ*, with Italian works.[68] Painters such as Holbein the Elder and others had, as early as 1500, imitated the miraculous picture of S Maria del Popolo; around 1520 the graphic arts attest a fashion for cycles of main and side altarpieces in southern Germany.[69] The connections between Augsburg and Venice were extremely close, and we can assume that a precise knowledge of Italian art must have been fostered in the North by steady economic and artistic exchanges between North and South. Jacopo de' Barbari, for example, or Albrecht Dürer or Hans Burgkmair the Elder attest to that fact.[70] It seems that in Basle and Lucerne Holbein developed further his knowledge of Italian forms and devices. His use of models, their appropriation through transformations and combinations, differs from that of most of his contemporaries only in one major point: he relied on fantastic invention as much as on any other method. Models, to him, were a means to an end: they helped to execute precise tasks. As such, they do not bear testimony to a new direction in – or a new aim of – his artistic endeavours. Many factors should be taken into account in the discussion of Holbein's connection with Italy. Above all, the similarity of some of his works to Italian paintings, when analysed with precision, yields interesting results; a good knowledge is required of the media that allowed for the diffusion of patterns and compositional schemes – engravings, drawings, paintings – in Italian and Northern art. It is also possible to imagine how the artist travelled, according to the necessities of his work and following the well-known routes connecting North and South through Switzerland. Important also is Holbein's own understanding of the styles that were fashionable at the time; we have seen that he used them for specific purposes. At any rate, it is most probable that Holbein went to Italy at the time when he was painting the facade of the Hertenstein house.[71]

The first important journey made by Holbein in 1515 from Augsburg to Basle is typical of the travels undertaken by young apprentices. His journey across France in 1524 betrays an attempt to find a place as a court painter with François I. But even though this aim was no doubt uppermost in his mind, he never neglected other sources of income, designing models for woodblock carvers or for goldsmiths. Lyon was very important for the printing trade and also an economic centre of excellence, where banks were extremely active. The Ravensburg company of commerce, to which Jakob von Hertenstein belonged, and the Tuchers from Nuremberg had warehouses there. In 1526 Holbein left for England via Antwerp – another economic centre of great importance. He made that journey on Erasmus's recommendation and with the hope of succeeding where he had failed in France. It is thus clear that

after his departure from Augsburg he does not seem ever to have travelled for leisure or to further his artistic education, but rather on an assignment, or in the hope of receiving one.

The close similarities between the *Solothurn Madonna* and specific works by Francesco del Cossa and Sebastiano del Piombo, between the *Darmstadt Madonna* and Italian models, and the adaptation of Italian architectural forms pose in new terms the problem of Holbein's knowledge of Italian art. Nevertheless, they do not decide which of the two hypotheses is more appropriate – that of direct contact with Italy, or that of a mediated acquaintance with Italian forms and devices which were circulating between South and North.[72]

Until now any decision on this issue has remained impossible, due to a lack of conclusive evidence. It is astonishing to see that a crucial document dated 1538, and published by Eduard His as early as 1870, should never have been discussed properly in that respect.[73] The text is a contract drawn up for Holbein, at the instigation of the Mayor and council of Basle, probably before his last departure for England. The city council obviously attempted to convince the artist to remain in the city. A yearly salary of 50 florins was promised to him with additional payments for all the works he executed. According to the terms of this proposed contract, Holbein was allowed to maintain contact with his other patrons – kings, princes, aristocrats and city councils – but he was not allowed to leave Basle for extensive periods abroad. All his commissions had to be executed in Basle itself. There is a further, very interesting, clause:

Those works of art he will execute here [in Basle], once, twice or three times a year, as long as they are always executed under our patronage and with our permission, not behind our backs; he may sell those works in France, England, Milan or in the Netherlands.[74]

Thus it would only have been for selling his works or putting the finishing touches to them that Holbein was allowed to travel. It is absolutely clear that the contract makes precise reference to the conditions posed by the artist himself, who wanted the freedom to maintain contact with his existing patrons. The lawyers of the city council mention only a limited, restrictive number of geographical areas covered by the agreement – most certainly those areas he already knew from personal experience, and where his patrons were living. We know for certain that Holbein travelled and worked in France, in England and in the Low Countries, where he also bought his panels ready to be painted. Thus, on the strength of this document, it may also be assumed that Holbein also travelled and worked in the Duchy of Milan.

6 The Portrait, Time and Death

The Renaissance portrait

At the time when Holbein was painting his first portraits the very art of portraiture had become a matter of considerable interest in Germany. First, since the task of the painter encompassed the faithful rendering of the features of his model, the portrait was included in a vast series of representations whose aim was to observe the elements of nature. Portraits were called *contrefeit*, *contrafactum*, as were all representations of objects or persons.[1] The fascination for the true, scientific representation of the objects of nature could only increase at a time when it was becoming possible to publish richly illustrated surveys of natural history. The almost magical attraction of science encouraged the careful, painstaking description of the world. The *Nuremberg Chronicle* purported to be much more than a mass of entertaining stories: the foreword promised that, in contemplating the images, the reader would have the illusion of witnessing them, and seeing them moving, alive.[2] This effect of reality was due to the constant development of new representational conventions, that is, new styles of representation. Peter Parshall has rightly noted that most scientific illustrations – of plants, animals, etc. – bore the name corresponding to their category, but were not signed, in order to increase their objective dimension. The art of portraiture is to be understood within this new evolution. However, the painter did not want his work to remain anonymous.[3] It had to be both a faithful observation of nature and a show of invention – two conflicting qualities. The aim of the Northern portraitist was to draw attention to his own skills through different devices – compositional, chromatic, iconographic.[4] Last, but not least in importance, he was expected to describe an individual as a member of a (social) category.

The second, but crucial, feature of the reproductive image in the Renaissance was its temporal dimension: the *contrefeit* is often described as painted *ad vivum*; the artist underlined the physical proximity between the observer–artist and the observed during the fabrication of the image. Imagined or not, this proximity was singled out as a legal warrant of authenticity.[5] In 1533 Holbein painted the portrait of a merchant who had this inscription added: 'When I was 33 years old, I, Dirk Tybis at London had this appearance and marked this portrait with my device in my own hand and it was the middle of March in the year 1533 by me Dirk Tybis'.[6] The portrait required that a viewer should acknowledge this proximity and see it as the pattern of another, nearly similar relation: the *hic et nunc*, the immediate relation of the viewer himself to the portrait. The legal definition of the portrait increased its value as a testimony, but it automatically reduced its validity to a short period of time, pointing out the ageing process, working on the sitter's face, and slowly distancing the model from his own image. A woodcut made in Augsburg for Petrarch's *Artznei* (1532) depicts a man, head in hands, terrorized by the slow, inexorable passing of time (illus. 201).[7]

Schmertz.

201 Petrarch Master, illustration of *Sorrow* from Petrarch, *Von der Artzney bayder Glück . . .*, Augsburg, 1532.

SVA CVIQVE PERSONA

202 (?)Raphael, *SVA CVIQVE PERSONA*, painted wooden lid for a portrait painting, *c.* 1510, 73 × 50.5.

The claims of truthfulness, often advanced in an inscription on the picture itself, dissembled a complex process of transformation of the sitter – a transformation that required the painter to exert his inventive power while pretending to hide it. The most important task of any portrait painter is to make a *persona* for his sitter – a mask that should define and enhance the sitter's rank and dignity, together with his or her personality.[8] A wooden portrait cover attributed to Raphael (illus. 202) bears a mask with this inscription: 'SVA CVIQVE PERSONA' ('To each human being his own mask).[9] In a seminal essay, Louis Marin has elaborated on this point to perfection: the portrait is a *protractus*, it brings forward the features of the represented, out from himself so to speak, and seen in this way the mask is revealing: it needs *schemata* to reveal an individuality, to mark its features in a forceful way.[10] But the mask metaphorizes another contribution of the artist: that of producing the mask suited to his patrons' wishes, a mask to be worn on the stage of the world, the *theatrum mundi*. The features chosen for the mask create a new identity for the sitter. Erasmus used to joke about this, saying that if a beard was enough to give a man the appearance of a philosopher, then a goat could become Plato.[11] But *protractus* also implies that the delineation *stands in place of* the real face; the role of the portrait is to substitute a mask for the face of the sitter, or even to turn his face into a mask whose legitimacy is drawn from the representation. The word *contrefeit*, which designated a portrait, also meant *forgery*. To achieve such a harmonious confusion between the portrait and the face of the sitter was the task of the painter. It required that the features of the individual should be *transfigured*, without altering the resemblance. It prepared for the glorious moment when, after the death of the sitter, the identification between himself and his *persona* should be complete.

Reading Renaissance collections of biographies enables the modern historian to understand such a complex system. Andrea Fulvio's *Illustrium imagines* was published to great acclaim in 1517. Its purpose was to furnish the portraits of Roman emperors and statesmen, drawn after ancient coins; each woodcut was accompanied by a short biography.[12] The first portrait, however, is of particular interest, since it was

not chosen from among the heroes of histories by Livy or Tacitus, but rather from mythology: the figure of the god Janus (illus. 205). The text explains that Janus was the first in human history to have fixed the features of illustrious men by his invention of the art of minting coins, duly decorated with heads. Here the portrait is qualified as an object of social exchange, and it contains a warrant of the value exchanged – that is, the value of the mask as well as that of resemblance. In his *Prosopographia*, Heinrich Pantaleon followed in the footsteps of Fulvio, but this time for Germany. He too assigned to Janus the first place in his long list of historical biographies.[13] In his compendium, Janus' representation is the portrait *par excellence*: the god has two faces, looking in opposite directions, since his life had stretched over *two centuries*. The portrait thus accomplished the dream of the sitter: not only did he exist for his own life-span, but he also survived, through his representation, over the centuries to come. After the sitter's death his portrait survives, unaltered; the *punctum* characteristic of the portrait is exchanged for an unchanging and unchangeable appearance; an inscription, on Hermann tom Ring's portrait of Joseph Münstermann (illus. 203), reads as follows: 'What Nature gave, painting, like poetry, is rendering, in order to keep for a long time, that which passes away'.[14] Alberti had defined the power of painting in similar words: 'Painting contains a divine force which not only makes absent men present, as friendship is said to do, but moreover makes the dead seem almost alive'.[15]

But in the Northern countries, over the fifteenth century, the enhanced powers of the portrait had quickly been acknowledged as dangerous. Like mirrors, they were objects of vanity, of worldly pride; the young Holbein himself mocked those obsessed with their own appearance (illus. 204).[16] Portrait painting witnessed the confrontation between a meditation on death – the *memento mori* – and a glorification of the magical powers of painting. At the time when Holbein was working for his first sitters, portraits were less often enclosed in a box, but framed to be hung on the wall. This new mode of display in private apartments increased its autonomy.[17] Painters and humanists created a number of marks whose aim was to inscribe, in the portrait itself,

203 Hermann tom Ring, *Joseph Münstermann*, 1543, oil on oak, 67 × 47. Westfälisches Landesmuseum, Münster.

204 *A Fool Contemplating his Image in the Mirror*, pen and ink drawing in a margin of Erasmus, *Encomium moriæ*, Basle, 1515.

205 Andrea Fulvio, woodcut of Janus from *Illustrium imagines*, Rome, 1517.

206 Rogier van der Weyden, verso of *The Braque Triptych*, *c.* 1452, wood, 41 × 34 each. Musée du Louvre, Paris.

its own self-criticism as a source of false pride and illusion. Originally these marks were added to devotional pictures: on the back of his diptych with St John the Baptist and St Veronica, Hans Memling painted a skull with the inscription 'MORERIS, you will die'.[18] The Braque triptych in the Louvre was even more forceful: on the back the viewer could see a skull and a cross with these words: 'Look at yourselves here, you vain and fiery people; my body was beautiful, now it is flesh for worms'. In such paintings, the skull functioned as a 'mirror' where every worshipper could see his own anticipated portrait, deprived of all its glorious, individual features, and reduced to a universal skull (illus. 206, 208).[19] When portraits of donors were included in such devotional pictures, similar iconography could seem to be most damaging criticism of portraiture. Even so, works such as the Carondelet diptych show that some patrons did not shy away from having their features recorded (illus. 207).[20] Here, what is denounced as a mask is not the *persona* itself, but rather the whole flesh covering the skull, which hides the universal, mortal element of human beings. The *Dance of Death* had for a very long time been the main form of expression of human fears concerning the afterlife, with skeletons enjoying a last dance with

207 Jan Gossaert (called Mabuse), *Carondelet Diptych*, 1517, wood panels, each 43 × 27. Musée du Louvre, Paris.

kings, popes or merchants before taking their lives. However, Holbein's contemporaries preferred to focus their attention on the secret, gradual work of Death on the living body. The meditation on Death was interiorized.[21] In 1538 the *Simulachres & historiees faces de la mort*, illustrated with woodcuts designed by Holbein, concluded that as far as Death is concerned, 'l'invisible ne se peult par chose visible proprement représenter'.[22] Painting the invisible became an artistic challenge. This exchange between aesthetic and ethical values is very significant. We have seen how meaningful was the *pingebat* used by Holbein and numerous other modern 'Apelles' to sign their works. To leave a picture unfinished was to celebrate, above and beyond the work of art itself, the pleasure of painting.[23] But within the Christian ethos, the unfinished portrait also marked the struggle of the artist against the irrepresentability of Death. The text of the *Simulachres* is very clear on that point: the craftsman who translated Holbein's designs into woodcuts is described in the following terms by the author of the text, Vauzelles: 'Death, fearing that this excellent painter could paint her so alive that she would not be feared any longer, and that he therefore would become immortal, shortened his days to such an extent that he could not finish many other figures designed by him'.[24] Similarly, Niklaus Manuel represented himself in his own *Totentanz*, brush and stick in hand, at the very moment when Death stops his arm, leaving his work incomplete.[25]

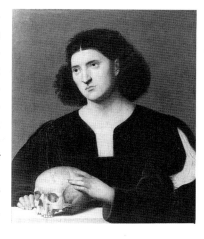

208 Bernardo Licinio, *A Young Man with a Skull*, 1520s, oil on canvas, 75.7 × 63.3. Ashmolean Museum, Oxford.

Young Holbein

Holbein's early years as an apprentice and journeyman are not well-documented, but he learned the trade of a portraitist in his father's studio. Holbein the Elder's *Man with a Fur Hat* (illus. 209) and also his *Montenuovo Madonna* (illus. 210) illustrate his practice in the years just preceding the date when his son can first be traced in Basle.[26] Both paintings can be seen as bold artistic statements. The figure of the elderly bearded man is framed in an elaborate decoration in the Italian style, probably inspired by a woodcut. It resembles a portrait of a famous man, similar to such images found in the books of the time. The printed book was no doubt an important reference for a young artist like his son, who was to move to Basle in the hope of working for well-known publishers. The frame adds a modern touch and increases the illusion of volume through the use of a simple device: a frame with *basso-rilievo*. From the illusionistic architectural background to the very border of the panel the artist has superimposed the forms, in a subtle device of overlapping of volumes. We have here a majestic image of a man whose *persona* can be inferred from the rich fur hat and coat, while the scroll suggests his statesmanlike, scholarly ambitions, by borrowing the antique *gestus* of the philosopher. The inscription chosen conforms to what had become a topos – the phrase 'when I was 52, there I had this form [*Gestalt*]'.[27] The glorious image is denoted as a time-bound form – perfectly faithful, but only for one year. The representation acknowledges its own punctual character, but this very acknowledgment enhances the objective status of the portrait as the product of an observation of the sitter at a precise moment. The word *Gestalt* used in the inscription is of paramount importance: the portrait offers us two *Gestalt*. Here we have not just a face, but a shape, almost a pattern; this first pattern is admittedly given some individual characteristics, but is ultimately analagous with the pattern of the background, which was in turn reused for the *Montenuovo Madonna*.[28] Thus although

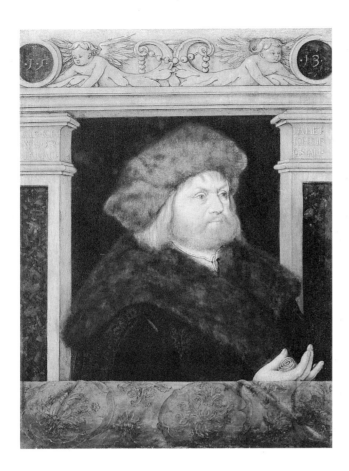

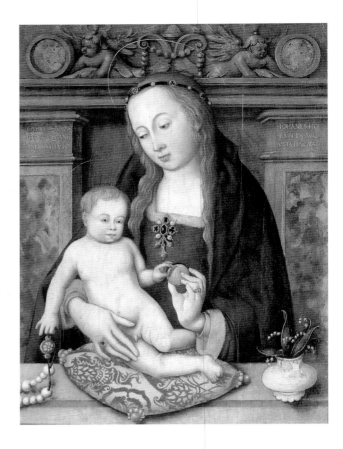

209 Hans Holbein the Elder, *A Man with a Fur Hat*, 1513, tempera on pinewood, 41 × 30. Öffentliche Kunstsammlung, Basle.

210 Hans Holbein the Elder, *Virgin and Child (Montenuovo Madonna)*, c. 1513, tempera on pinewood, 46 × 34. Location unknown.

this Virgin and Child is still very Gothic in form, it gained a modern aspect through the application of a modern pattern, and served as a demonstration of skill. Holbein the Elder's awareness of, and pride in, his skill is all too evident in the inscription on the painting: 'it is more easy to criticize than to imitate'.

After his return from Lucerne Holbein was granted the status of master, and could at last carry out lawfully his own production under his own name. As we have seen in chapter One, the small portrait commissioned by Bonifacius Amerbach was a display of scholarship on the part of the sitter, and the painter graciously submitted to his patron. The inscription celebrates the verisimilitude of the painted face, but limits its validity to the youthful years of the sitter. The fig-tree placed behind Amerbach sharpens that distinction: we have seen in chapter Four that in his religious works Holbein made use of this plant to signify the Original Sin and its main consequence, the mortal nature of Man. Transposed onto the background of a portrait, that symbol reminds the viewer of the mortality of the sitter aiming at immortality through his representation. An unobtrusive element, it replaces the menacing presence of the skeleton, which was still used by painters in Basle at the end of the fifteenth century.[29] Death develops within a life, like a tree. The inscription implies that the young man has grown to his current age, like a tree; a parallel development is that of Death growing in a life. The student in academic dress wears a white shirt, whose fresh appearance evokes that of the snow-topped mountains in the background. Holbein has not opted for great chromatic contrasts, but rather for a harmony of turquoise-greens and blues. Thanks to his preparatory drawings the artist's practice at that time can be traced.[30] Using a large sheet of unprimed paper,

he drew the face of his sitter *ad vivum*, enhancing his features with coloured chalks. It was then either pricked and pounced onto the panel or the main lines were transferred with the help of a metal point onto the wooden surface. It was then that Holbein took liberties with his model. Even if the direct transfer from the sheet to the panel seemed to guarantee a perfect imitation of nature, it also permitted the artist to turn a portrait into a work bearing the mark of his own art.

In 1523, two years after his return to Basle, Erasmus became a good patron for the painter.[31] The most famous philosopher of the Christian world was not a keen art-lover, but he did know, better than anyone else, how to exploit the depiction of his own features. He certainly possessed a developed gift for self-mockery, as his caricatures on the manuscript of his commentary to Jerome attest (illus. 211). Throughout his life Erasmus managed to ensure a livelihood without accepting any responsibility as a teacher or as a bureaucrat. He preferred to depend on the goodwill and generosity of influential patrons. To do this he maintained a huge correspondence with his protectors, and would occasionally send them his own portrait – always close, always distant. On 3 June 1524 he wrote to Willibald Pirckheimer: 'Recently I sent again two portraits of Erasmus to England, painted by a very skilful artist. That artist carried along my portrait to France. The King again invites me to come.'[32] Erasmus rarely yielded to the wish of his patrons to grant him positions bearing responsibilities, hoping that they would be satisfied with a shadow of himself, either verbal or visual. In this context it is significant that he speaks of his image as if it were a third party. When Erasmus approached Holbein in 1523 he most certainly had a very clear idea in mind. In 1517 and 1519 he had ordered two portraits of himself from Quentin Massys – a painting and a medal. Since these were to shape his opinion on all future portraits of himself, they must briefly be discussed.

When Erasmus began to make use of portraits, he was already 50, and in frail health. He saw these representations, together with his own written works, as his testament to the world. First, he had himself depicted in a diptych, together with his friend Peter Gillis, the town clerk of Antwerp; the picture was intended as a gift for Thomas More, a wealthy friend in England who had discussed his *Utopia* with Erasmus. On 8 September 1517 Erasmus wrote to More: 'I send you the two portraits, so that we may stay with you, even if some fatality separates us from each other'.[33] Massys shows Erasmus writing his Paraphrase of St Paul's Epistle to the Romans (illus. 212); Gillis, a letter from More in his hand, watches his companion and seems to be interrupting his concentration (illus. 213). As we have seen in chapter One, Renaissance humanists often compared a letter with a portrait: a letter not only communicated its contents but also depicted its writer. Erasmus was to send this double portrait with a letter, thereby doubling his presence. The portraits would enable the three friends to enjoy the illusion of being reunited in London. However, in Massys' painting Peter Gillis holds a letter by More in his hand, thereby bearing testimony to the latter's absence. More was particularly impressed by the quality of the handwriting on the painted letter, virtually identical to his own. For these scholars, Massys prepared a scriptural metaphor of the mimesis, evoking Vasari's wish that a good artist should recognize 'the different manners of the artists, as a skilful secretary recognizes the various handwritings of his colleagues'.[34] In order to compensate for the impossibility of the three being united in one place, unless by the intermediary of the painting,[35] More used two strategies. In his letter of thanks to Gillis, he included a poem in which the picture itself was made to speak. In addition More

211 Erasmus, *Caricature*, pen and ink drawing in the margin of his *Scholia* to St Jerome's *Letters*, Universitäts-Bibliothek, Basle.

212 and 213 Quentin Massys, *Double Portrait of Erasmus and Peter Gillis*, 1517, oak, 73.7 × 55.2 (Private collection); anonymous copy, painting on wood transferred to canvas (Galleria Nazionale d'Arte Antica, Rome).

214 Quentin Massys, reverse of a bronze or bell-metal medal of Erasmus (copy sent to Erasmus in 1519), 10 *cm* diameter. Historisches Museum, Basle.

asked Gillis to send him back his own letter: 'put next to the picture' the very document that attested his own absence would 'double the miracle' of the two friends' presence, as if the perfect similitude of the painted and the actual letters attested, through a *synecdoche*, the truthfulness of the whole painting.[36] But above all, Erasmus insisted on the fact that More should understand that this double portrait was but the external appearance of frail mortals, whose shape was vacillating. He pointed out that, half-way through the sittings, the painter had to stop because the two friends had fallen ill and thus their features had changed too much. The frailness of Erasmus' health is contrasted with the robust vitality of his work. Massys underlined this element by implying a reference to St Paul, whose letter to the Romans is the text that Erasmus is shown preparing. On the shelves are his New Testament and the works of St Jerome, the 'Divus Literarum Princeps', the patron saint of Christian scholars, whose letters Erasmus edited.[37]

The second reference for Holbein's work must have been the medal executed for Erasmus by Massys, which the Christian philosopher regarded as one of his best likenesses, sending it to numerous friends and patrons (illus. 214).[38] That his own coined image was used as a form of exchange currency is clear, given that Erasmus chose to send a cast in either bronze or lead according to the importance of the person receiving it. On the obverse one could see Erasmus in profile, with the inscription 'A better portrait will his writings show' (in Greek) and 'Image made after the living features' (in Latin). On the reverse was the deity Terminus with the motto 'CONCEDO NVLLI' (I yield to nobody), and two further mottoes, in Greek and Latin respectively: 'Consider the end of a long life' and 'Death the ultimate line of [all] things'.[39] In a letter to Alfonso Valdes, a secretary to the emperor Charles V, Erasmus remarked on his choice of this emblem: 'you will probably object: "you could have just as well chosen a skull"'. Erasmus was all too aware that the Terminus had a much subtler value, especially the sentence pointing out that the ultimate outline of all things, that very line which enables the painter to circumscribe objects, is

215 *Terminus, device of Erasmus of Rotterdam*, after 1532, oak, 21.6 × 21.6. Cleveland Museum of Art.

Death. Holbein himself was requested to draw this emblem, once for a stained glass to be presented to the university of Basle (illus. 72), and again on a small circular panel (illus. 215).[40]

In 1523 it fell to Holbein to paint Erasmus; the scholar would have been keener to employ the great Dürer, but the latter could not find the time; later, in 1526, when Dürer completed Erasmus' engraved portrait, he was even rather disappointed.[41] Erasmus and Holbein came to be on friendly terms:[42] for the artist, Erasmus was no longer the abstract figure whom he had drawn in the *Encomium moriæ*, reduced to the *typus* of the scholar.[43] The most important among the portraits of Erasmus completed in 1523 was probably made for William Warham, Archbishop of Canterbury, who had increased the scholar's pension: it shows with great splendour how Holbein could incorporate the individual features of Erasmus into the *typus* of the scholar (illus. 28). Erasmus sits in front of a slab, a slab that is more like a monument than it is a writer's desk. The ageing, weary philosopher is wrapped in a voluminous, fur-lined gown that serves to accentuate his frailness; in a pensive mood, he calmly relishes the result of his herculean labours.[44] The red book is not a single publication by Erasmus, but rather the epitome of them all, bearing the inscription: 'The Works of Hercules'. The physical age of the scholar is thus opposed to the youthful vigour of his work. The background defies the rules of perspective; Holbein's only concern is to accord to the symbolical objects their due place. The pilaster to the left is designed in accordance with the Vitruvian canon and develops the comparison between Antique and modern grandeur. The curtain, establishing a flat green background against which Erasmus is inscribed, employs a strategy that will be used in *The Ambassadors* (illus. 241): the objects half-hidden behind this curtain provide the key to the understanding of the picture. The red book with the inscription 'ille ego ioannes holbein' has been discussed in chapter One; an empty glass bottle is a discreet allusion to the traditional sealed bottle figuring in most representations of

St Jerome in his studio and which recalled Jerome's work on the virginity of Mary. Erasmus' bottle is without a seal, thus distancing the allusion. Through this picture Erasmus erected a large monument to himself: not only his letters but, by extension, all his translations and his writings were meant to draw the portrait of the writer. Hence the double-bind: the painted portrait's value is here lessened by the inclusion in it of a reference to the importance of the literary portrait. Erasmus, as we have seen, always insisted on his poor health when sending such portraits: the face of the sitter is described as that of a human form, doomed to decay and die, but which points to the eternal portrait of Erasmus in writing.

Holbein produced another type for Erasmus, where the reference to St Jerome is more plain: a cheap version conveys the main features of the type (illus. 122).[45] The colours chosen by Erasmus are more austere: black and dark green dominate. Erasmus is writing the Paraphrase to St Mark, which he was completing in 1523. He is seen in profile, at close range – the border of the picture cuts off the writing-box; his patrons could witness that miracle: a genius, writing his commentary with great ease. This picture, on paper, was kept by Holbein, probably because he could use it as a model; the Louvre version, destined for a patron, is more finished, in order to pay homage to a distinguished friend, as a gift.

Means and ends

As we have seen in chapter Five, Holbein's journey to France had an immediate impact on his artistic practice, including portraiture. He even adapted modern portrait patterns, especially after the Italian manner, as a means of experimenting with other forms of painting, such as mythological pictures. The *Laïs Corinthiaca* and the *Venus and Cupid* took part of their inspiration from the Leonardesque portrait popular in Milan and at the French Court at that time (illus. 24 and 194).[46] At the same time Quentin Massys was trying to clothe Cesare da Sesto in Flemish dress, or, like Holbein, to apply a Leonardesque look to the face of the Virgin (illus. 216, 217, 218). Holbein took this further and used the form of the Milanese portrait to produce what may be described as an artistic manifesto. He was already looking for new patrons, and attempted to seduce them with pictures whose *Venustas* was obvious, and which seemed to solicit collectors, as did Lucas Cranach the Elder's *Venus and Cupid* (illus. 219). Another Venus by Cranach bears an inscription addressing the viewer and warning him of this very power of pictorial seduction.[47] Likewise, Holbein depicted his Laïs – a lover of Apelles – with her open hand stretched towards the beholder and prospective collector, offering him a new and glorious *Venustas* in exchange for some gold coins. The bold colours, the careful and inspired rendering of materials, was to become a feature of Holbein's later portraits.

Two years later the artist was ready to offer his services to foreign courts. At the age of 29 he left Basle for London, passing through Antwerp, where he may have visited Massys. He took advantage of his stay in Antwerp to buy some oak panels, fearing that he would not find any of sufficiently good quality in England.[48] He arrived in London in December 1526, armed with the recommendation from Erasmus to Sir Thomas More. More, who was then 49 years old, was a wealthy and powerful member of the King's council. Knighted in 1521, he had become Speaker of the House of Commons in 1523. It was clear that he could be of help to Holbein. The

216 Quentin Massys, *Virgin and Child (Rattier Madonna)*, 1529, wood, 68 × 51. Musée du Louvre, Paris.

217 Circle of Quentin Massys, *Virgin and Child with the Lamb*, wood, 110 × 87. Muzeum Narodowe, Poznań, Poland.

218 Cesare da Sesto, *Virgin and Child with the Lamb*, after 1511, tempera on wood, 37 × 30. Museo Poldi-Pezzoli, Milan.

219 Lucas Cranach the Elder, *Venus and Cupid*, 1506 (recto 1509), chiaroscuro woodcut, 28.2 × 18.9. Staatliche Museen zu Berlin – Preußischer Kulturbesitz (Kupferstichkabinett).

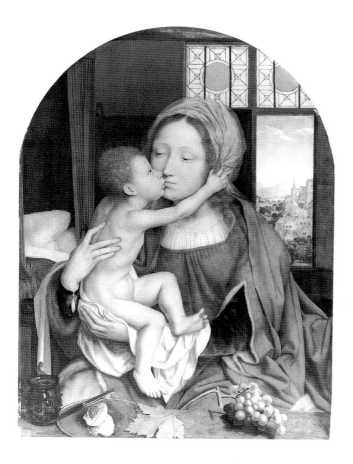

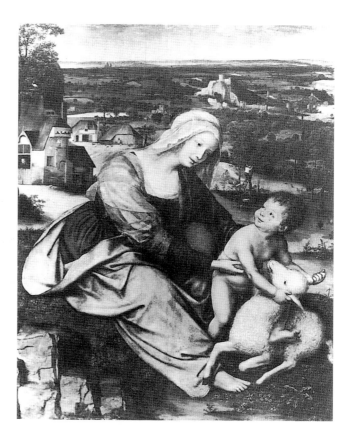

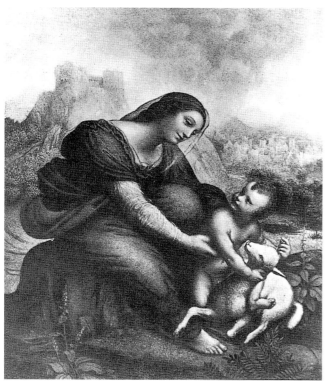

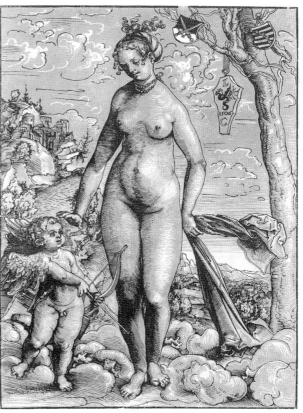

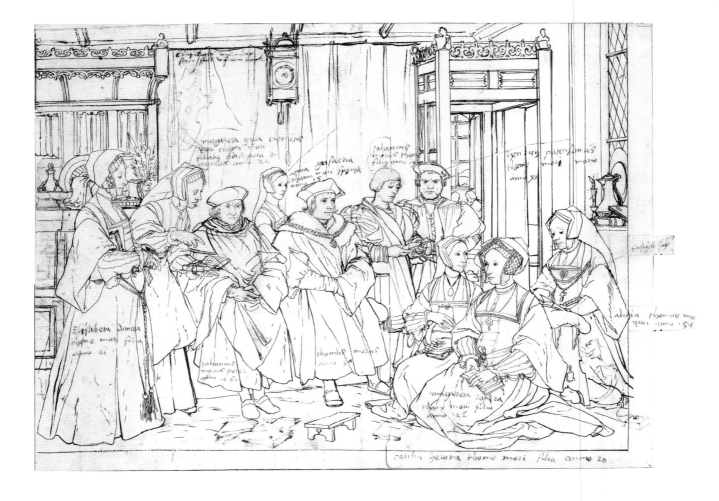

220 *Sir Thomas More and his Family*, 1527,
pen and black ink on paper, 38.5 × 52.5.
Öffentliche Kunstsammlung, Basle
(Kupferstichkabinett).

author of *Utopia* duly obliged, and set out to test the painter's capacity by commis-
sioning a portrait. Evidently Holbein had no difficulty in convincing his most
recent mentor of his exceptional abilities: in a letter dated 18 December 1526, More
exclaimed 'Your painter, my dearest Erasmus, is a wonderful artist'. He added that
he would do all in his power to help him. More posed for the artist in simple garments
and without his livery collar – he was well-known for his lack of ceremony. However,
in order to take full advantage of the most picturesque effects, Holbein transformed
his patron into a truly magnificent King's servant. After having pricked the drawing
in order to transfer it onto the panel, he added some arresting features (illus. 221).[49]
The golden livery collar with portcullis singles out the dutiful high-ranking civil ser-
vant; the black and red velvet, the fur, the green silk, each of these materials is min-
utely detailed, with great attention paid to the individual rendering of the rich
textures. It would seem that More felt that the cuffs of his official costume were too
showy, since they were subsequently overpainted by the artist in favour of a more
simple design. Like Erasmus in the earlier portrait (illus. 28), More wears a large fur
coat, and is leaning over a slab into which the date of completion of the picture is
carved. The flamboyant composition, with its bold harmony of greens and reds, at-
tracts so much attention that the viewer could almost be in danger of neglecting the
delicately painted face of the sitter.[50] In itself the More portrait was the best advertise-
ment for Holbein's artistic skill. More then went ahead with the commission for a
group portrait of his family. Although this painting has vanished, two life-size

221 *Sir Thomas More*, 1527, oak, 74.2 × 59.
Frick Collection, New York.

: Waramus Arch Bᵖ Cant:

162

222 *William Warham, Archbishop of Canterbury*, 1527, black, white and coloured chalks, with traces of metalpoint, 40.7 × 30.9. The Royal Collection, Windsor Castle.

223 *The Astronomer Nikolaus Kratzer*, 1528, oak, 83 × 67. Musée du Louvre, Paris.

copies exist, and the surviving preparatory drawing (illus. 220) allows us to see in it a pioneering work – the first conversation piece ever created in German art.[51] On this drawing – unusual for Holbein since it is linear, mainly in pen and ink – the identity of each sitter has been carefully marked by Nikolaus Kratzer, the Astronomer Royal and a close friend. In the middle of the composition More and his father are enthroned, surrounded by various relatives. More's wife, eyes cast down, is the last figure on the right-hand side. The elegant interior is decorated with expensive items, such as the clock and fine furniture. The family is here represented as a Christian community about to pray: a daughter, Cicely Heron, holds her rosary, while others have opened their prayer-books. Once again More wears his livery collar – a rather improbable feature given that the scene is at home. In order to enhance the familiar character of the gathering the artist has added some amusing details, like the monkey near More's wife, or the viola da gamba on the wall together with the inscription 'claficordi und ander seyte spill uf dem buvet' (meaning that the viola had to be placed instead on top of the buffet). The drawing was given to Erasmus by Holbein himself, and the former interpreted the open space of the room as a sign of warm welcome. In a letter dated 6 September 1529 to Margaret Roper, More's daughter, Erasmus remarked that 'it is so successful that if I had been in person in your home I would not have seen more'.[52]

Gradually the circle of Holbein's patrons widened, and he was requested to paint one of the greatest protectors of Erasmus, the Archbishop of Canterbury, William Warham (illus. 222).[53] One version was destined for the Archbishop's palace, and a second was sent to Erasmus, in exchange for his own portrait (illus. 224).[54] On either side of the Archbishop, his insignia picked out with gold add a rich touch to the green-brocade background, while to the left is the crucifix adorned with jewels, bearing his arms and his motto 'Auxilium meum a Domino', and to the right his mitre lies on a splendid oriental carpet. The Archbishop's age and the date are written on a piece of paper attached with sealing wax; this painted label reminds the viewer that the portrait is a flat, painted surface while producing another illusionistic device. But the most striking feature of this picture is its resemblance to that of Erasmus of 1523: it was most probably at Warham's own request that Holbein painted him in bust, and placed his hands in the same position as those of the great scholar in his portrait (illus. 28). In order to provide some reason for the gesture, the artist made Warham lay his hands on a large but unencumbered cushion, traditionally occupied by a prayer-book – which is here actually lying next to it. Such a composition marked a victory for Erasmus: by means of his image he had managed to create a community of scholars who were not only paying respect to his genius, but who even went so far as to imitate his *gestus*. On contemplating Warham's portrait Erasmus may have remembered with delight More's letter of 7 October 1517, in which he said: 'I cannot really resist the tickling sensation of glory, which is aroused in me by the feeling of conviction that I will be recommended to posterity through Erasmus' friendship, of which letters, books and portraits bear testimony, like many other marks of his friendship'.[55] Warham was happy to be recognized by posterity as a friend of Erasmus, and through a reversal of the hierarchy it was he, the protector, who unassumingly imitated his protégé's pose in his own portrait.

Holbein's masterly understanding of court portraiture enabled him to develop some reflections on the magic of portraiture. Although certain of his portraits, such as the *Lady with a Squirrel* (illus. 227), combine English dress with a background

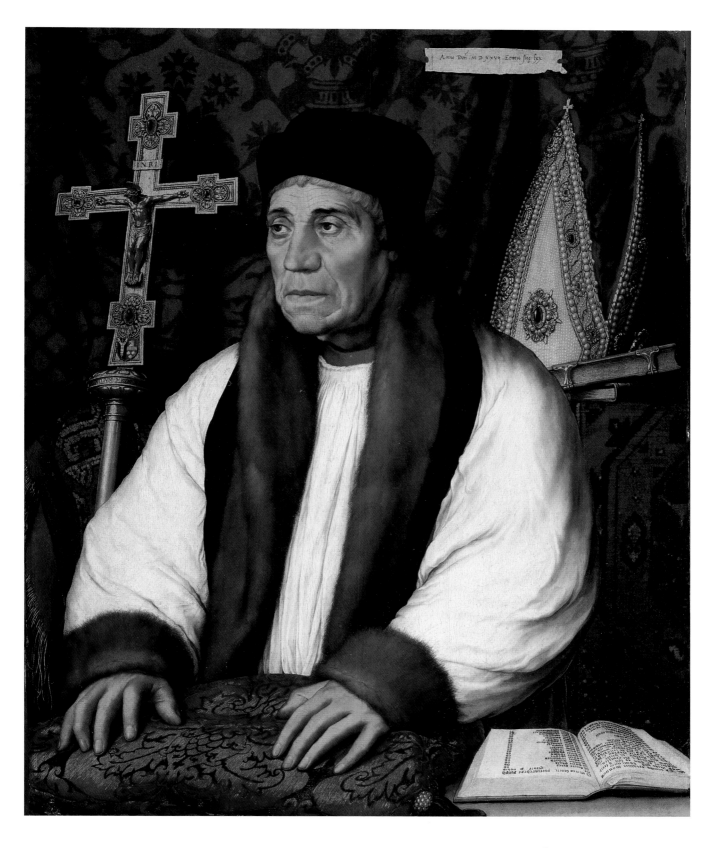

224 *William Warham, Archbishop of Canterbury*, 1527, oak, 82 × 67. Musée du Louvre, Paris.

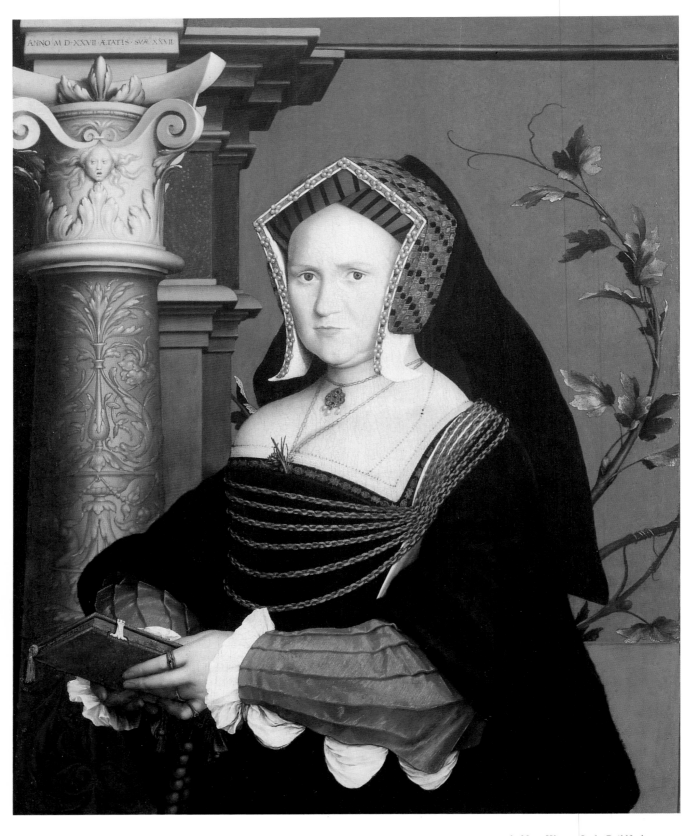

225 *Mary Wotton, Lady Guildford*, 1527,
oak, 87 × 70. St. Louis Art Museum, MO.

226 *Mary Wotton, Lady Guildford*, 1527,
black and coloured chalk on white paper,
55.2 × 38.5. Öffentliche Kunstsammlung,
Basle (Kupferstichkabinett).

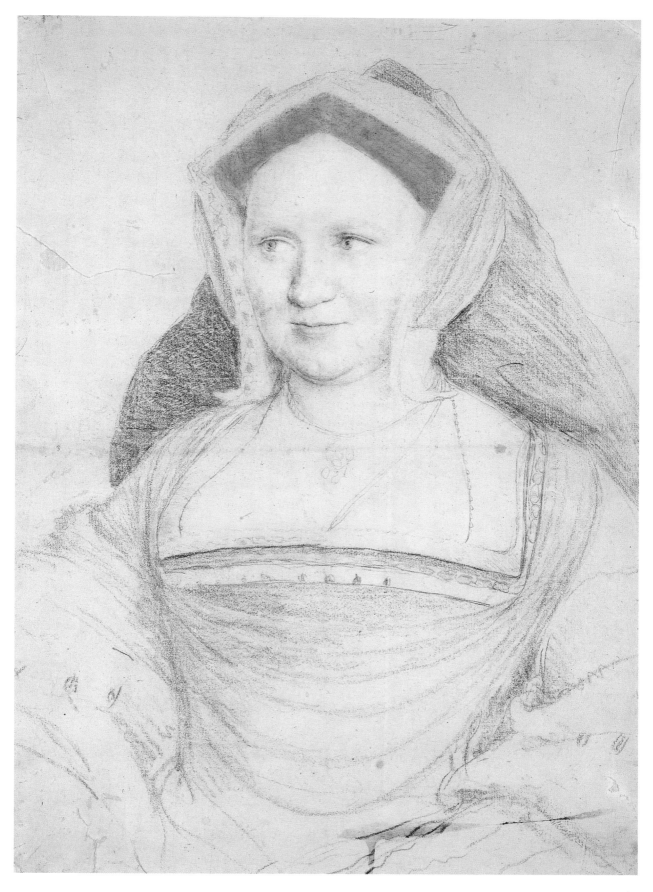

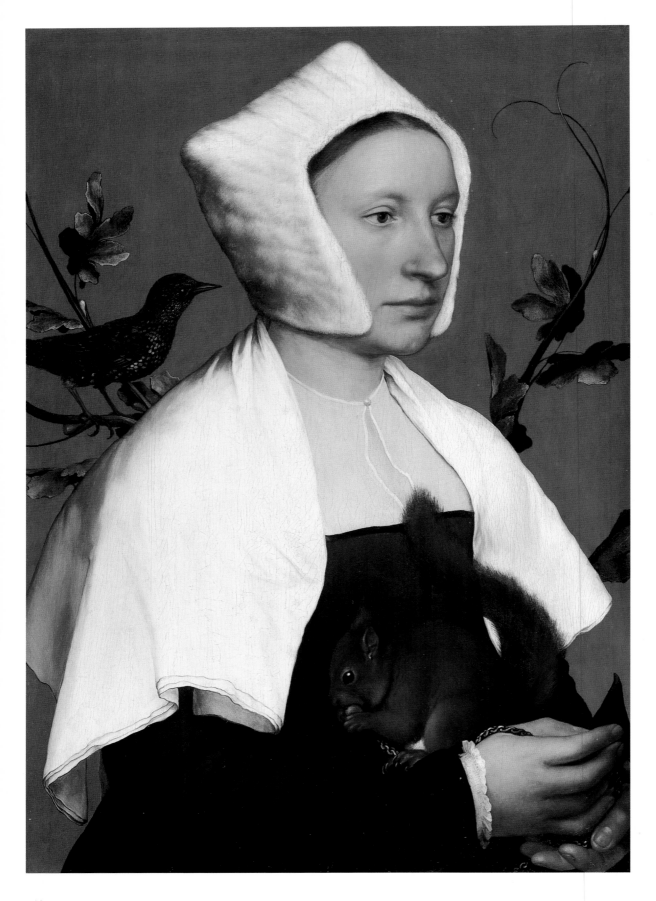

entirely similar to that of the Basle period, in others he experimented with the new Italian manner, making them well-tuned *concetti*.[56] On preparing the portrait of Mary Wotton, Lady Guildford, the wife of the Comptroller of the Royal Household, Holbein made a drawing in which his sitter smiles vivaciously (illus. 226).[57] In the painting, on the contrary, this same sitter has an entirely different expression, and her pallid impassiveness forms a very striking contrast to the darker, livelier complexion and features of her husband in the pendant (illus. 225, 229). Her smile has all but disappeared; severe, almost austere, she stares at the beholder. Her pale complexion is echoed by that of the carved architecture. The *persona* dominates over the individual. Holbein's *concetto* is to be found on the capital where a petrified female head is carved.[58] Alberti recommended the use of a Medusa head to adorn pilasters.[59] For the Ancient Greeks the Medusa had the power to turn into stone any who looked directly at her, and Perseus only succeeded in killing the Medusa by avoiding looking at her. The figure on the capital is surely a victim of the Medusa, petrified just as she was trying to escape, hence her eyes turned to the right, the viewer's left, and the mouth open to cry out. In order to understand how a classical myth of this kind could become a pregnant metaphor in the hands of an artist, we should remember that for the emblematist Andrea Alciati, the Medusa, with two dolphins, could evoke the sudden and violent death of a youth (illus. 228).[60] The *Anthologia Græca*, a collection of Greek poems compiled by a Byzantine monk in the second half of the thirteenth century, and re-edited with great success by More, Erasmus, Alciati and Bonifacius Amerbach, records similar events, where living beings suffer death or transformation.[61] For example, an epigram by Ausonius celebrates a monkey – the very metaphor for artistic mimesis – who mimes to perfection, imitating Niobe turned into stone and Daphne into a laurel tree, becoming 'in wood like Daphne, in stone like Niobe'.[62] Another Niobe by Praxiteles is praised in the following terms: 'The gods turned me into stone, and as I was a stone, / Praxiteles made me live again'.[63] What is at stake here is the power of the painter; this power is no longer described as the ability to produce a lively appearance with limited temporal validity, but rather to petrify his subject for eternity. Sitters must 'die'; while sitting, they prepare themselves for that death: 'While the painter thus reproduced all your characteristics, you, I am sure, kept your expression unchanged for a long time.'[64] Only through the work of a good painter can the sitter recover another, eternal form of life. Such a paradox was clearly expressed by More; if a painter depicts a rhetorician, the representation is speechless, motionless: 'Sextus himself is silent; the image of Sextus exercises his art. / The image itself is the rhetorician; by means of the image the rhetorician has become an image.'[65] In his representation, the rhetorician must 'die', and it is only as a picture that he recovers another power of expression. Holbein was formulating the magical power of the artist, who not only imitates nature, but even captures it and petrifies it through his gaze. In turn the portrait is sufficiently arresting to compel us to stand, immobile, mesmerized, before it.

Holbein was to elaborate further on these problems, as is very clear when one considers the Toledo portrait of a lady, who may have been a member of the Cromwell family (illus. 230).[66] Against a luminous grey background Holbein detaches the figure dressed in black. The whole portrait seems to be almost an elaborate setting for the face, for the immaculate white collar and embroidered sleeves, and especially for the golden jewel worn by the sitter. Most conspicuous is this large pendant with a black stone, representing a biblical scene, that of Lot's wife and daughters fleeing

228 Anonymous woodcut of Medusa and two dolphins in Alciati's *Emblematum Libellus*, Paris, 1542.

OPPOSITE PAGE
227 *A Lady with a Squirrel*, oak, 54 × 38.7.

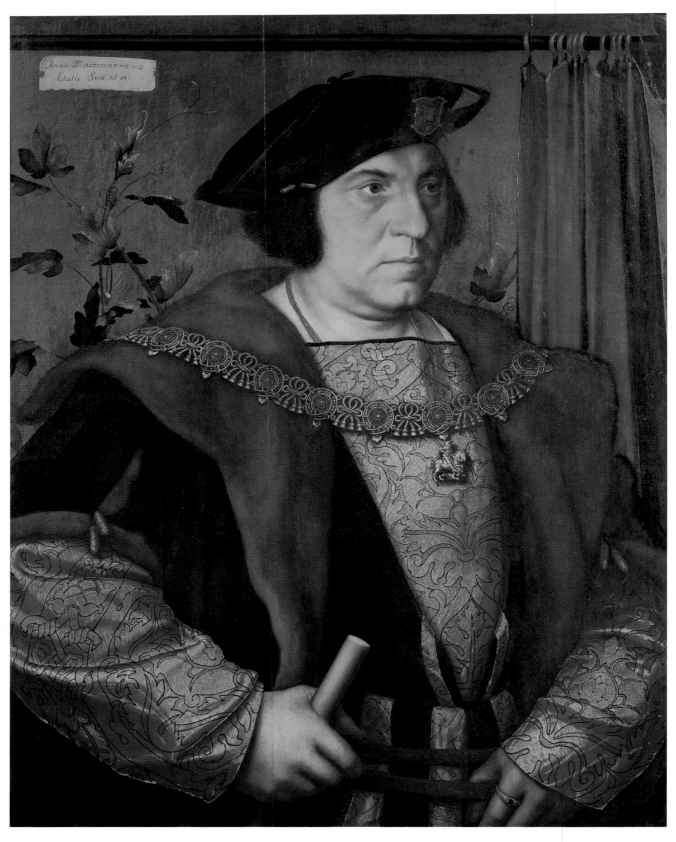

229 *Sir Henry Guildford*, 1527, oak,
82.6 × 66.4. The Royal Collection,
Windsor Castle.

230 *A Lady, probably a member of the*
Cromwell Family, 1536–40, oak, 74 × 51.
Toledo Museum of Art.

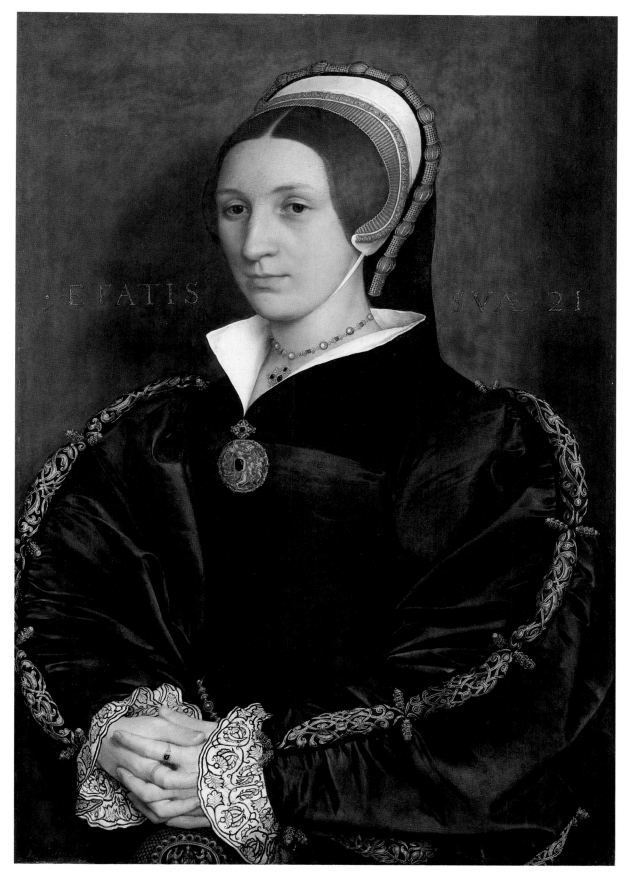

ETATIS SVÆ 21

231 *Lot, his Wife and Daughters leaving Sodom*, 1536–40, pen and washes on paper, 5 *cm* diameter. British Museum, London.

burning Sodom. In the centre, the body of Lot's wife is carved from black stone. Because she looked back at Sodom, against divine prohibition, she was turned into a pillar of salt. The very metamorphosis of the living into stone is the theme of the jewel, as is indeed that of the portrait. Holbein himself designed the jewel, and his preparatory drawing for it survives (illus. 231).[67] His choice in this portrait was not so much motivated by a wish to propose a moral to his sitter, but rather to emphasize the boldness of his *concetto*.[68] Presenting a jewel as a petrified body enhances the power of the artist, who can effect the same transformation on his sitter. As a result of his *concetto* the stone becomes a vivid metaphor of the metamorphosis operated by the portrait. Cellini recommended to jewellers to find clever *invenzioni* that could increase the aesthetic and material value of a stone.[69] Thus in this work Holbein was displaying his skill both as a jeweller and as a painter. Furthermore, his invention aimed at defining the power of portrait painting itself: transformed in this manner his sitter remains beyond life and death, immobile and eternal.

Before returning to Basle in 1528, Holbein executed one last portrait, unusual in both its form and content (illus. 232). Thomas Godsalve of Norwich and his son John were landowners, considerably below the status of Holbein's other patrons.[70] The father, however, nourished high ambitions for his son (illus. 233). Through his own connections with Thomas Cromwell he was to realize this dream and push his offspring into the higher ranks of the royal administration: under Edward VI, John became a knight and a Comptroller of the Mint. Judged against Holbein's other works of the time this double-portrait appears rather plain and conservative; the artist has accustomed us to bolder compositions. The background is dark blue and unornamented. This is probably to be attributed to the fact that Godsalve paid a lower price for it. The position of the sitters is closer to that characteristic of the portraits of the Basle period. The continuity between the table and the border of the painting accentuates the effect of proximity between the sitters and the viewer. More, when writing about the Massys double portrait in a letter dated 7 October 1517, had said 'they seem to detach themselves and to come forward, thanks to the rilievo given to their figure'.[71] The play on the sitter's handwriting is again present: on a piece of paper seemingly glued to the panel is 'Anno D[o]m[ini] MD XXVIII'. On another piece of paper, just in front of the sitter, Godsalve has written in his own hand 'Thomas Godsalve de Norwico Etatis sue Anno quadragesimo septo', bearing witness to the legal dimension of the mimesis. The two juxtaposed faces are so similar that they immediately betray a very close kinship. Thomas Godsalve has fathered a son in his own image; the *genitor* is here seen as a *pictor*. This reminds us of the inscription to be found on Derich Born's portrait: 'You would wonder whether a painter or a father made this'.[72] In the painting Thomas has precedence, for John is sitting slightly behind him. Thomas will survive through his son; such immortality is promised to him through his descendants even though he himself is mortal. This idea, very important during the Renaissance, prompted Montaigne to wonder: 'What a strange thing it is, that drop of semen from which we are made, and which bears all the impressions, not only of the body of our fathers, but of their thoughts and feelings.'[73]

Soon after his return to Basle, Holbein attempted to represent his own lineage, but in a completely different fashion. By this time he had earned a considerable sum, which he invested in a house in the St Johann Vorstadt in Basle. The portrait of his wife, Elsbeth Binzenstock, and their two children, Philip and Catherine, may well have signalled a wish on his part to settle in the city once more (illus. 234).[74] Painted

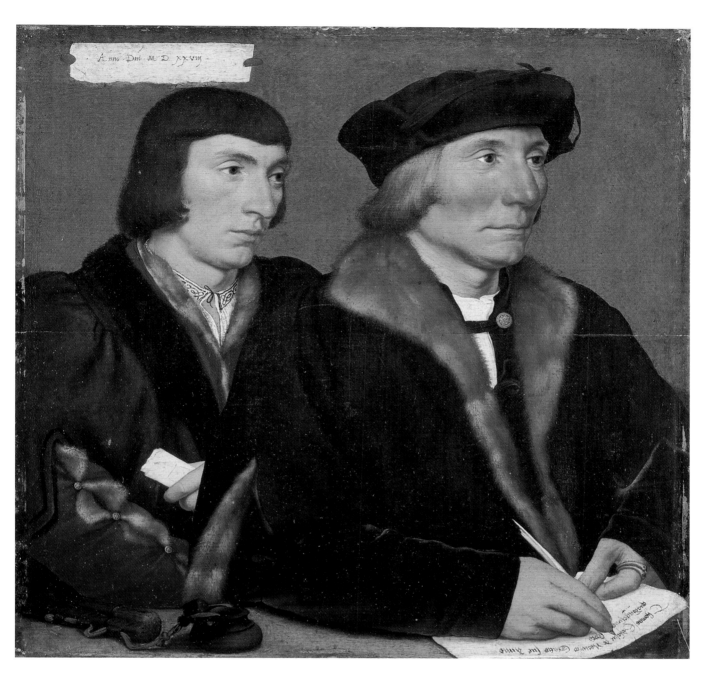

232 *Thomas Godsalve and his Son John*, 1528, oak, 35 × 36. Gemäldegalerie, Dresden.

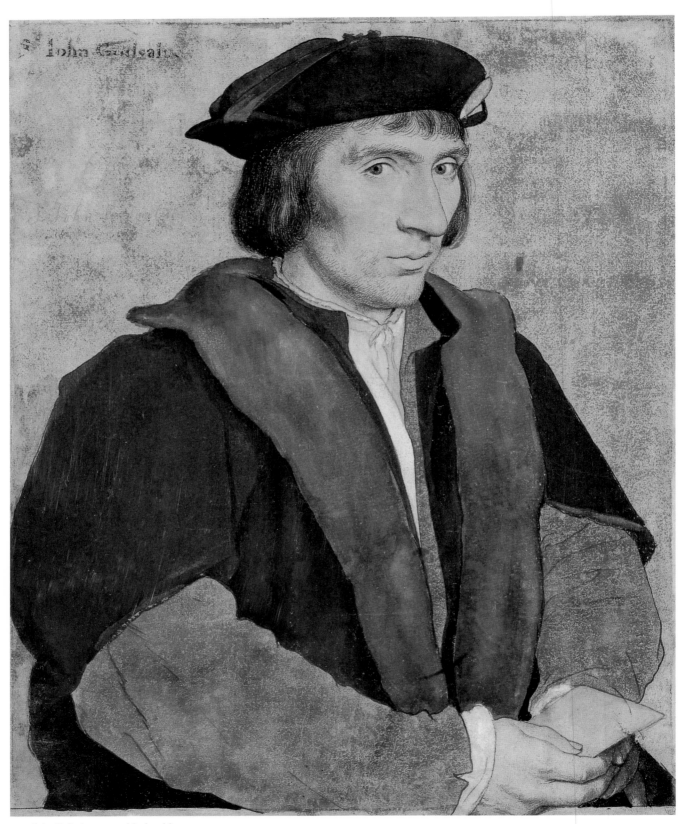

233 *John Godsalve, c.* 1532, black, white
and coloured chalk, with watercolour
and bodycolour, and ink applied with
pen and brush on pink prepared paper,
36.2 × 29.2. The Royal Collection,
Windsor Castle.

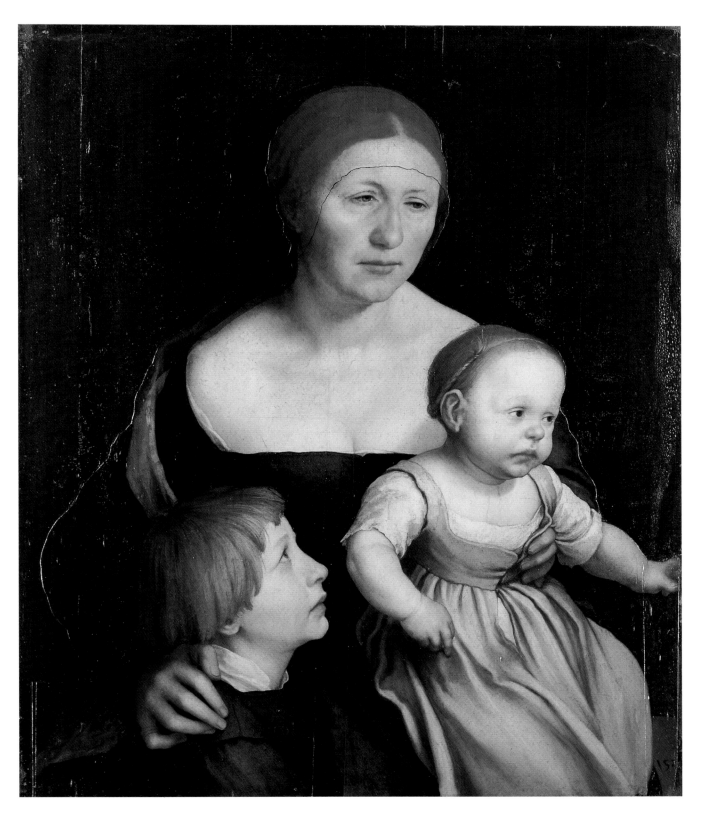

234 *The Artist's Wife, Elsbeth Binzenstock, and her Two Children, Philip and Catherine*, (?)1528, four sheets of paper glued on panel, 77 × 64. Öffentliche Kunstsammlung, Basle.

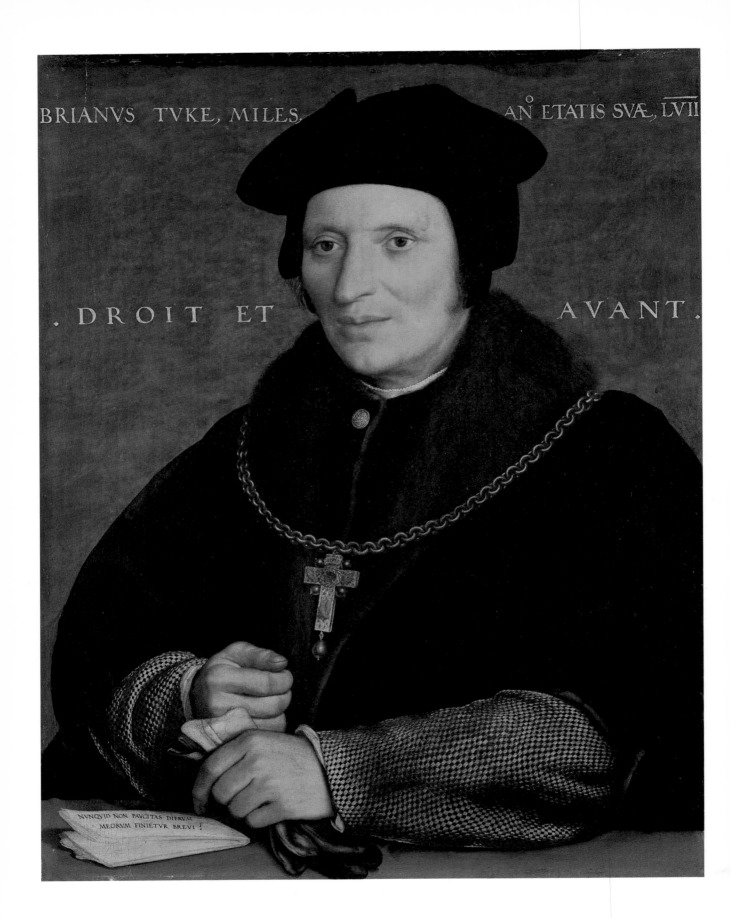

BRIANVS TVKE, MILES, AN° ETATIS SVÆ, LVII

. DROIT ET AVANT .

NVNQVID NON PAVCITAS DIERVM MEORVM FINIETVR BREVI !

on paper, like the portrait of Erasmus writing, this work also remained in his wife's possession for a long time.[75] The plain black background must have been added at a later date when the paper was glued on wood. A sixteenth-century copy, formerly in the Trümpy collection in Glarus, might well show the work in its original format: Catherine's fingers are not cut by the picture border, and a Renaissance niche may be seen in the background, recalling those niches designed by Holbein the Elder.[76] On either side of the panel, columns and pilasters frame the space, as in the Meyer portraits. The contrast between the rich background and the humble garments worn by Elsbeth and her children is striking, not least given the supposed riches of a husband and father recently returned from England.[77] Holbein has managed to give a fresh and vivid view of his children: while his wife gazes into the void, his son and daughter seem to be attracted by a mysterious object to the right, beyond the boundaries of the picture. The composition has often been compared with that of a Virgin and Child with St John the Baptist; the very same artist who had used the features of his wife when painting the *Solothurn Madonna*, and incorporated a group portrait of the Meyer family in the *Darmstadt Madonna*, could use a religious model to depict his own private and 'holy' family. Indeed, Elsbeth wears a dark-blue gown and a pink shawl – the very same colours chosen in reverse by Holbein for the Virgin Mary in the 1522 picture. The allegorical dimension of this family portrait was clearly recognized at the time: another late sixteenth-century copy of the picture turned the group portrait into a *Caritas*.[78]

In 1532, after four years in Basle, Holbein once more left his family to travel to England. He seems to have passed through Antwerp again, since he bought oak panels in Flanders. At the time of his arrival in London, Henry VIII's attempts to marry Anne Boleyn had strained relations with the Church of Rome to such an extent that Henry refused to pay the *Annates* to the Pope. A faithful Catholic, More resigned the Chancellorship. In addition, Archbishop Warham had just died, thus Holbein was losing major patrons and must have tried to gain favour with the new masters of the day.[79] It is perhaps to this that Erasmus was alluding in a letter to Bonifacius Amerbach, where he stated that 'Holbein disappointed those to whom he had been recommended'.[80] Holbein had to find a way of earning a living. One of the new figures at Court was Sir Bryan Tuke, a cunning administrator. Born *c.* 1475, Tuke was 57 at the time Holbein completed his portrait (illus. 235). In 1517 Tuke had been appointed Governor of the King's Posts, supervising Henry's dispatches and those of his administration.[81] Tuke survived all the shocks and reversals of Henry's reign, becoming French Secretary to the King, and, in 1528, Treasurer of the Royal Household. He must have had some scholarly interests since he wrote a preface to the works of Chaucer, published with a title-page after Holbein. Tuke was no doubt keen to gain immortality through a portrait; in his preface to Chaucer's works, he expressed true fascination for the primitive invention of all instruments of memory, the 'dilygence or polycy of people after dyvers fourmes figures and impressions... used for memorie and knowledge of things'.[82] In 1528, a serious illness had brought him close to his death. By commissioning a portrait from Holbein in memory of his recent sufferings, he granted the artist full scope to examine once again the relationship between portraiture and death.

Among the extant works this is the only example of Holbein's use of a mottled-brown background, evoking a rare wood. He selected three main colours to produce a wonderful harmony: red, gold, dark brown. The combination of any two of these

235 *Sir Bryan Tuke, c.* 1532, oak, 49 × 39. National Gallery of Art, Washington, DC.

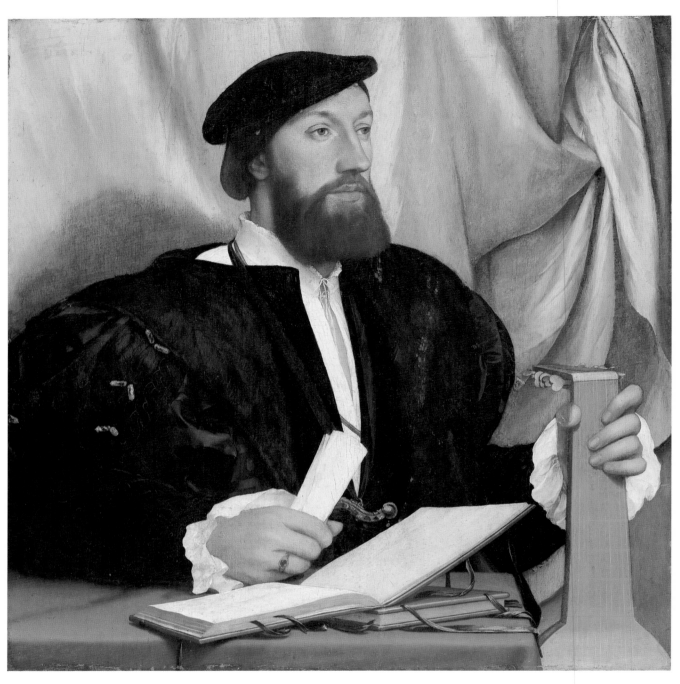

236 *A Man with a Lute, c.* 1533 – 6, oak, 43.5
× 43.5. Staatliche Museen zu Berlin
(Gemäldegalerie).

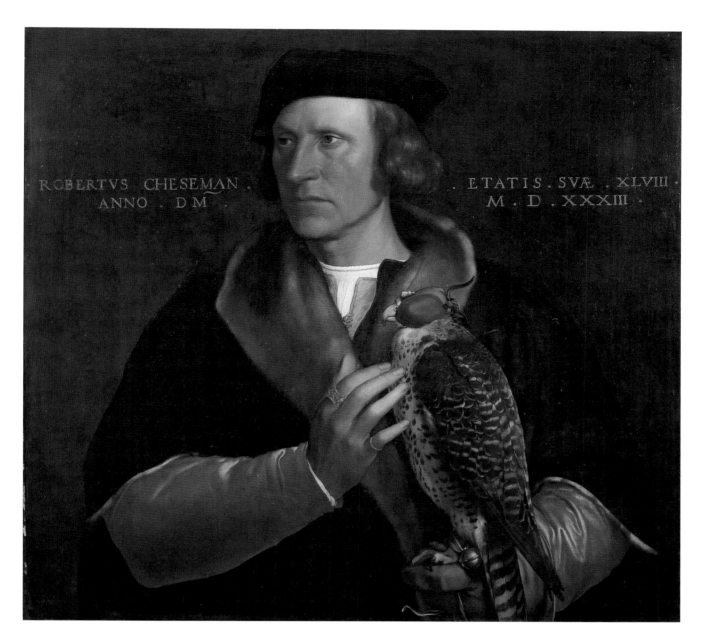

Inside the painting, the following text appears:

ROBERTVS CHESEMAN . . ETATIS . SVÆ . XLVIII .
 ANNO . DM . M . D . XXXIII .

237 *Robert Cheseman*, 1533, oil on wood,
59 × 62.5. Koninklijk Kabinet van
Schilderijen 'Mauritshuis', The Hague.

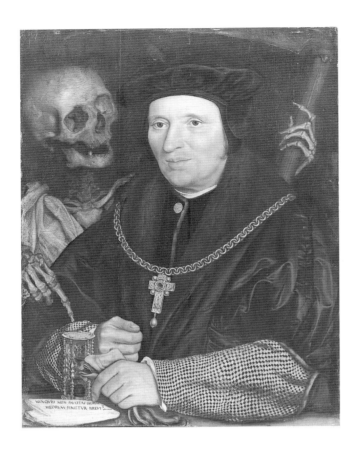

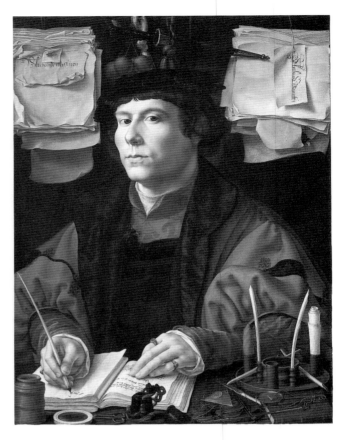

238 Copy after Holbein, *Sir Bryan Tuke with Death*, wood, 49 × 38. Bayerische Staatsgemäldesammlung, Munich.

239 Jan Gossaert (called Mabuse), *A Merchant*, *c*. 1539, oil on panel, 63.6 × 47.5. National Gallery of Art, Washington, DC.

three colours allows for the wonderful chromatic effects on the finely chequered sleeves or on the tablecloth; but all three are present together on the central point of the portrait, where we see a very rare devotional object, the crucifix with the Five Wounds of Christ. The inscription, 'NVNQVID NON PAVCITAS DIERVM MEORVM FINIETVR BREVI?' (Will my days not find their end very shortly?), repeats the words of Job (10:20), when he begs God to stop piling sufferings on his head. The rest of Job's plea, 'leave me in peace, so that I can take some comfort', is omitted, but is clearly implied. The parallel between the sufferings of Job and those endured by Christ is evident; however it was the latter's sacrifice that promised the Resurrection. At a first reading, the inscription may be seen as an acknowledgment of the vanity of all life, and the necessity to prepare oneself for death. Yet, at the same time, Tuke was bargaining with God for a few more years: the part of the inscription that has been left out contains a plea for more time in which to enjoy life. The Crucifix with its inscription 'INRI' was a magical prophylactic, intended to protect its owner against ill-health.[83] Tuke's own motto, 'DROIT ET AVANT' is a spirited challenge to life. Seen in this way, his portrait could be read as a *memento mori*. Death looms in his face, momentarily stilled, but ready to strike once again the frail old man. This powerful, but discreet evocation of Death on the sitter's physiognomy was new; a later copyist preferred to reintroduce the traditional skeleton behind the sitter (illus. 238). The Treasurer of the Royal Household, however, also ensured, albeit implicitly, that he thanked God in advance for the gift of a few more years of life. By this gift the Divine Portraitist was in effect respecting the value of his own creation: 'You have clothed me with skin and flesh, and have woven me with bones and sinews' (Job 10:11). The picture does not actually question God's right to try his servant through illness, but it

180

does contain a discreet plea to be granted some more years. This was indeed to be the case, since Tuke lived to around the age of 70, dying in 1545.

Tuke's portrait should not obscure the fact that Holbein had broadened the circle of his patrons beyond the Court. In the years 1532–3 he still worked for some land-owners, like Robert Cheseman (illus. 237),[84] who demanded a simple portrait without architecture or curtain, but who displays a falcon on his wrist, emblem of a very expensive and gentlemanly sport of the time; an unidentified patron requested other noble accessories – a lute and a partition (illus. 236); but the painter's main purveyors of work were to become Court figures and the German merchants of the London Steelyard. These wealthy dealers, members of the Hanseatic league, found in him a compatriot of great skill who could speak their language. That Holbein could fulfil their varying wishes is evident when one compares two of these portraits: those of Georg Gisze (illus. 240) and of Derich Born (illus. 30). The latter picture is strikingly simple. With the sitter's full approval, Holbein has represented a man who is keen to show himself in his natural demeanour; each detail is an understatement. The sitter, very close to the viewer, is depicted in an open space, favouring a direct, easy communication between the merchant and the beholder. The lifelike character of the face, rarely tinged with reflections on death, is of the utmost importance in the Steelyard portraits. Here we are far from the court portrait, with its complex staging. One exception to this is the portrait of Georg Gisze, a proud bourgeois. He demanded the opposite, preferring a voracious appropriation of symbols of power and of science. In complete disregard for all rules of perspective, Holbein has dilated the space in order to accommodate a wealth of symbols, designed for a merchant and a *nouveau-riche* in search of a personalized iconography.[85] Letters from colleagues surround him, all of them repeating the name of the powerful man whom his correspondents have been longing to reach: 'To the excellent Gisze, in London, England', reads the letter in his hand. A similar such bureaucratic metaphor is used in a masterly fashion by Jan Gossaert in his portrait of a merchant snowed under with documents (illus. 239). But Holbein's sitter wanted to present another aspect of his character, and a poem was attached to the back wall whose title proudly heralds the contents in pedantic Greek and Latin: 'DISTIKON. in imaginem Georgii Gysenii / Ista refert vultus, quam cernis, imago Georgi / Sic oculos vivos sic habet ille genas / Anno aetatis sua XXXIIII Anno domini 1532'. The picture invites the viewer to enthuse over the sitter's features. The second important inscription, to the left, is Gisze's motto, *'Nulla sine merore voluptas'* (No pleasure without grief), next to a pair of scales whose meaning is obvious in this context. This purportedly profound statement merely adds to the pretentiousness imbuing the whole scene. Furthermore the motto is even signed by Gisze as if he were keen to lay claim to the painstaking construction of this grand *persona*. The multiplicity of the symbolic objects surrounding the figure is so great that the eye is distracted from Gisze's representation. The face, originally intended to be frontal, was subsequently turned to the right; the nose is in profile but the eyes have been laid parallel to the plane of the picture, in such a way that we do not lose any of the details. This distortion of the face mirrors that of the whole representation of space in the picture. Immobile, almost passive, Gisze seems to offer himself to our view as a mere object at which to be gazed. He looks to our left, avoiding any direct eye contact with the viewer. The somewhat secondary importance of the face is heightened not only by the iconographical weight of the picture but also by the artistic bravura. Holbein has multiplied the textures

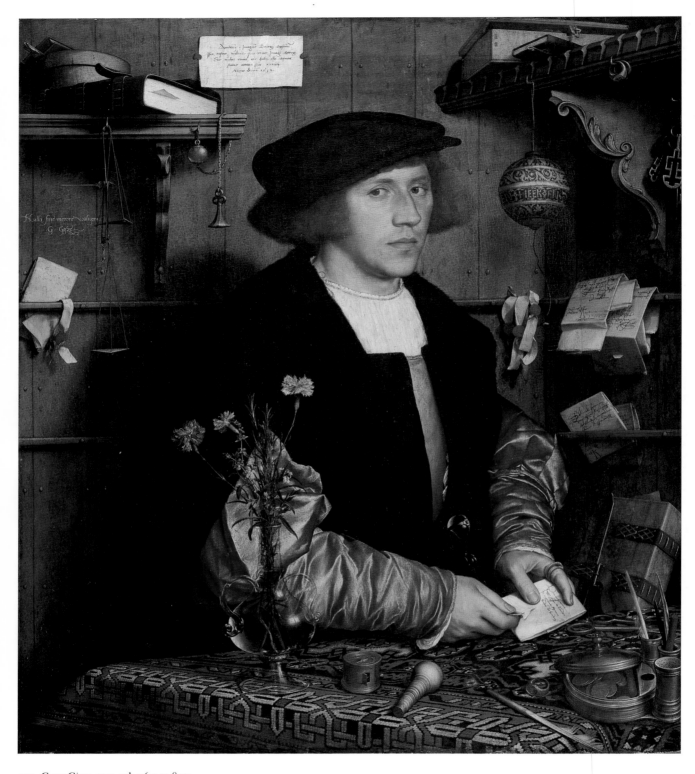

240 *Georg Gisze*, 1532, oak, 96.3 × 85.7.
Staatliche Museen zu Berlin (Gemälde-
galerie).

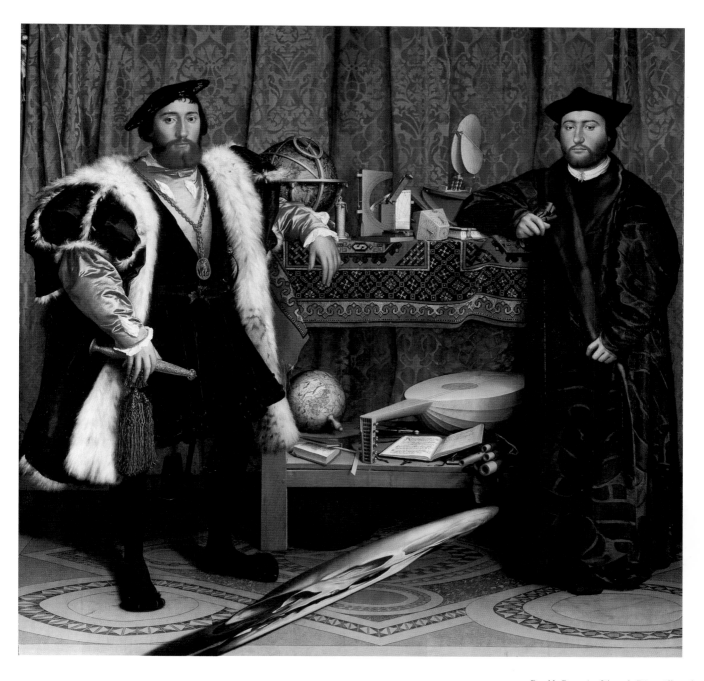

241 *Double Portrait of Jean de Dinteville and Georges de Selve ('The Ambassadors')*, 1533, oak, 206 × 209. National Gallery, London.

and no fewer than five colours are used to create the tonal harmony of the panel – the lessons learned in France, and already followed through in the *Laïs*, have borne their fruit. A glass vase parades the virtuosity of the artist, while the delicately depicted carnations herald Gisze's forthcoming wedding.[86]

In 1533 Holbein was able to attract clients whose rhetorical ambitions were no less developed than those of Gisze, but whose tastes were more prudent. The meeting of two friends allowed Holbein to complete one of the most ambitious group portraits ever painted, and the largest single panel of his career: the double portrait of Jean de Dinteville and Georges de Selve, dated 1533 (illus. 241).[87] The two friends were both French diplomats; to the left is Jean de Dinteville, Sire de Polisy, ambassador of François I to Henry VIII from February to November 1533, and to the right, Georges de Selve, Bishop of Lavaur, who was often engaged on diplomatic missions. Dinteville had arrived in London to reassure Henry VIII of France's and Rome's good intentions following François I's decision to marry his second son to the Pope's niece. Henry's relations with Rome were at that time very strained since his wish to marry Anne Boleyn had not received the Pope's seal of approval. It was during his difficult mission that Dinteville's friend De Selve came to visit him in April 1533. The two men had themselves portrayed standing on a pavement unique in England, the one made for Westminster Abbey by a Roman artist, Odoricus, in 1268. Its geometrical structure gives a quiet order to the composition. On the left, the *miles*, Dinteville, splendidly attired, wears the order of St Michel. On the right, the *clericus* and scholar, standing slightly further back, in a dark, more soberly coloured robe lined with fur. The two friends are counterpoised, 'en parangon', like a pair of Plutarch's *Parallel Lives* – an author admired by De Selve and translated by him into French.[88] The large composition, destined for Dinteville's castle at Polisy, is not only a court portrait, but also a testimony to their friendship, 'l'homme', De Selve having declared, being a 'creature de compagnie'.[89] That Holbein's work was pioneering for a Northern master becomes much more evident if a friendship portrait by Dürer is compared with one by Pontormo (illus. 242, 243). On the piece of furniture – a what-not – on which they are leaning, the two friends have laid out a number of objects of complex significance.[90] They look towards the beholder insistently, as if to point out the importance of the message carefully exhibited between them, and as well-organized as an oration by Cicero. On the two shelves are represented the sciences forming the humanists' *quadrivium* – music (lute, flutes,[91] a hymn-book on the bottom shelf to the right), arithmetic (Peter Apian's treatise published in 1527), geometry and astronomy. On the upper shelf astronomy is given the place of honour, with a celestial globe on a splendid carpet and a cylindrical sundial designed to give the time of year and the time of day – in the picture it seems to be set to 11 April 1533, at 9.30 or 10.30. Further to the right, behind another quadrant, is a white quadrant that defines the altitude of objects by measuring the shadow they cast (hence the inscription: 'VMBRA VERSA'); to the right is a polyhedral sundial, and behind a torquetum, used to determine the celestial bodies. On the lower shelf the terrestial globe describes, along with the great capitals of the world, the sentimental *mappa mundi* of Dinteville; the capital is Dinteville's Polisy. 'Baris' for Paris and 'Prittany' for Brittany betray the weak French of the German painter.

Sciences and arts, objects of luxury and glory, are measured against the grandeur of Death. The exact timing given by the cylindrical sundial, right down to the hour of the day, not only recalls the ideal *punctum* of the representation,[92] that of the first

242 Albrecht Dürer, *Paul Topler and Martin Pfinzing*, 1520, silverpoint, 12.8 × 19. Staatliche Museen zu Berlin – Preußischer Kulturbesitz (Kupferstichkabinett).

243 Jacopo Pontormo, *Double Portrait*, 1523–4, oil on wood, 88.2 × 68. Private collection.

PAGES 186 & 187
244 *Henry VIII*, *c.* 1536, oak, 27.5 × 17.5. Thyssen-Bornemisza Collection, Madrid.

245 *Edward, Prince of Wales*, 1538–9, oak, 57 × 44. National Gallery of Art, Washington, DC.

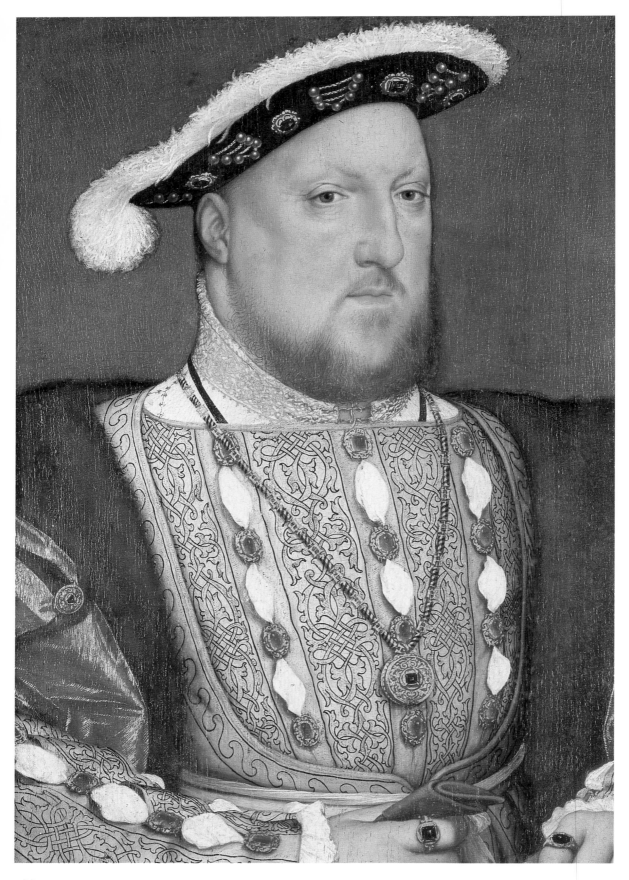

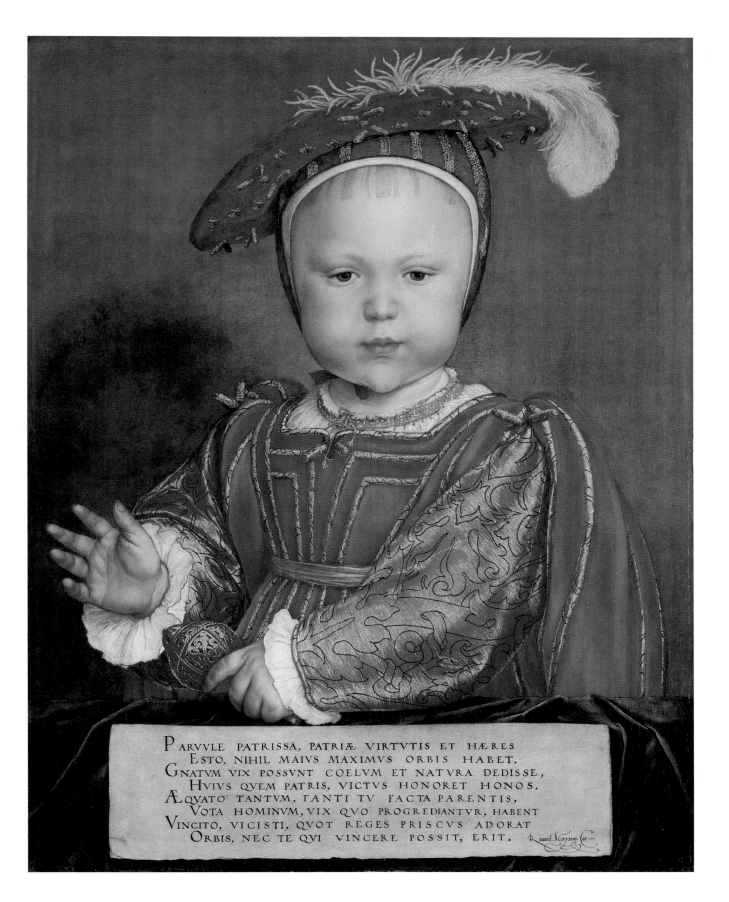

PARVVLE PATRISSA, PATRIÆ VIRTVTIS ET HÆRES
 ESTO, NIHIL MAIVS MAXIMVS ORBIS HABET.
GNATVM VIX POSSVNT COELVM ET NATVRA DEDISSE,
 HVIVS QVEM PATRIS, VICTVS HONORET HONOS.
ÆQVATO TANTVM, TANTI TV FACTA PARENTIS,
 VOTA HOMINVM, VIX QVO PROGREDIANTVR, HABENT
VINCITO, VICISTI, QVOT REGES PRISCVS ADORAT
 ORBIS, NEC TE QVI VINCERE POSSIT, ERIT. Ricard: Morysin Car:

CANONES SVPER.
NOVVM INSTRVMENTVM LVMINARIVM, DO-
centes quo pacto per illud inueniantur Solis & Lunæ medij
& ueri motus, lunationes, coniunctiones, oppositiones, caput
draconis, eclipses, horæ inæquales, & nocturnæ æquales,
ortus solis & occasus, ascendens cœli, interuallum, au
reus numerus, &c, Per Sebast. Munsterum.

246 Anonymous woodcut of eclipses of the sun and moon, after a design of Holbein for Münster's *Canones...*, Basle, 1534.

247 Gregorius Reisch, *Typus geometriæ*, woodcut in *Margarita philosophica*, Strasburg, 1505. Universitäts-Bibliothek Basle.

meeting of the two friends on 11 April 1533, but also the derisory temporality, the tightly restricted validity of the whole representation. On his dagger Dinteville's age is inscribed (29 years), and that of De Selve (25 years) is written on the book lying on the what-not. Dinteville's badge, attached to his hat, represents a skull. His personal motto was *memento mori*, the most popular caution against the vanities of human life. To reinforce that powerful message Holbein placed an apparently anamorphous shape before the two men; if the picture is viewed at close range from below on the left or from above on the right, this shape transforms – suddenly – into a human skull, while at the same time the rest of the image becomes illegible. The picture, exhibited in Polisy, was made in such a way as to cause this surprise. Thus the image is constructed according to two perspectival systems, one organizing the living figures and the world of phenomena around them, the other articulating the skull, the metaphor of Death. These two systems coexist in one painting but are at the same time mutually exclusive: to comprehend fully one of them the viewer has to lose sight of the other. This idea is reinforced by the fact that some of the instruments depicted here were made to measure shadows, that is, forms without consistency. These instruments were well-known to Holbein, and he must have been fascinated by their forms; later he designed one for a woodcut in Sebastian Münster's *Canones* (illus. 246), and with the same degree of accuracy.[93] The instruments depicted in *The Ambassadors* probably did not belong to Holbein, but were lent to him by his friend Kratzer, the Bavarian who was then Henry VIII's Astronomer. Holbein had already reproduced them with the utmost precision, including all their graduations, in his portrait of Kratzer (illus. 223).[94] In this picture, made in 1528, science is celebrated through the depiction of a close friend; but the cold, absent gaze of the sitter, his immobility, the colour of his face, so similar to that of the wood he is shown carving, everything turns him into the *Typus geometriæ*, as evoked by a woodcut made for Gregorius Reisch's popular treatise, the *Margarita philosophica* (illus. 247).[95] Holbein valued the work of his Bavarian friend, and he illuminated the manuscript of one of his treatises to be presented to the King (illus. 248).[96] The portrait of Kratzer may be read as a celebration of science, but in *The Ambassadors* the space of the *theatrum mundi*, in the light of that same science, is denounced as a pale illusion soon destined to be ravaged by Death.

The second important line of thought conveyed by the painting relates to the religious schisms that were tearing apart the Catholic world. On the lower shelf of the what-not, to the right, is an open Lutheran hymn-book (with the first lines of his version of the 'Veni Creator Spiritus', and Luther's ten commandments) and next to this a lute whose broken string symbolizes a state of discord. The pavement, a copy of the one just in front of the main altar at Westminster, recalls the place where Dinteville witnessed the coronation of Anne Boleyn on 1 June 1533, an event that was to lead to the schism with Rome. The two friends were very conscious of the need for the Catholic Church to undergo reform; both were known for their tolerance towards Protestantism.[97] De Selve was a great admirer of St Paul, frequently quoting him in his writings, and his vision of God was that of a hidden Divinity, virtually unattainable for those who sought him only through reason: God was, for him, a *Deus absconditus* who makes his presence felt solely in the Christian's heart. On the far left of the picture, half-hidden behind the green curtain, a crucifix appears in the dark.[98]

The King's Painter

It was during his second stay in England – from *c.* September 1532 to *c.* September 1538 – that Holbein was called a King's Painter, and was granted commissions on a regular basis, ranging from mural decorations to portraits and designs for jewels.[99] By then the number of his patrons had significantly increased, in spite of the constant efforts of the Painter-Stainers' Company to prevent foreigners from working in England.[100] His working methods changed slightly, especially as far as his preparatory drawings were concerned.[101] Working on smaller sheets of pink primed paper, he could afford to devote less attention to facial tones. As before he would add some notes recording observations made *ad vivum*. At court Holbein was only one of a number of artists who worked regularly for the monarch, and his status seems to have been inferior to that of the King's 'pictor-maker' Lucas Hornebout, the son of a manuscript illuminator from Ghent.[102] However, he was fairly well-paid, and on a monthly basis.[103] Henry does not seem to have been a great collector of paintings apart from the portraits of his lineage; he preferred to spend lavishly on tapestries.[104] He seems to have been keener to have Holbein depict members of his Court rather than himself; the splendid exception to this is the small portrait made *c.* 1536. By that time the artist had been introduced to the technique of the portrait miniature by Hornebout, whose image of the King is well known.[105] Even so, it was a while before Holbein learned to appreciate the rules of the genre; in particular he was loth to concentrate all attention on the head and shoulders, thus eliminating the details of hands and arms that he had valued in his larger portraits as important expressive elements. What he did appreciate though was the exquisite precision of the miniature style, and this he exploited to perfection in his *Henry VIII* (illus. 244). Of note here is the background, a deep blue that was usually selected for miniatures. Holbein, it seems, now preferred such simpler backgrounds to those, adorned with curtains and architectural elements, that are so typical of his first English period. The corpulent face and body define the whole architecture of the panel; the format seems to correspond perfectly to the two rectangular shapes of the head and arms. The shallow-brimmed hat, contrasting with the heavily bejowled face and the bull-neck, doubles the impact of the image. This is not a portrait but a royal icon, encased in silk, gold and jewels – the political body of the King, ready to become the standard for all his representations. The royal gaze is steady and powerful, outfacing the viewer with the same impact as some of the coins made during his reign, where the Roman profile was abandoned in favour of a more striking frontal view (illus. 249).

In September 1538, after a short visit to Basle, Holbein must have given up any idea of settling in Switzerland again. To show his allegiance to the English crown and his pride in his post of a Court painter, he presented Henry with a portrait of his heir, Edward, Prince of Wales, for New Year 1539 – an elegant and skilful gesture of flattery (illus. 245); another drawing (illus. 250) compares Henry with King Solomon.[106] Edward is depicted as a miniature version of his father: his hat, costume, even the rattle he holds like *regalia*, everything drives the viewer to see, as did the antiquary John Leland (see the Appendix), the father emerging in the son. This *mimesis* performed by the *genitor*, which then allowed him to survive in his own son, enabled Holbein to develop an indirect eulogy of the King. The text inscribed on the cartouche is signed by Richard Morison, a courtier close to Thomas Cromwell: it begs the small child to emulate his father, to mould himself after him. Holbein was by

Canones Horoptri.
Inuictissimo Principi HEN
RICO Octauo Regi
Anglie et Francie, Domino
Hybernie, ac fidei Defensori,
Nicolaus Cratzerus S. P. D.

FFlagitarat a me
aliquot annis, pe
ne quotidianis pre
cibus vir preſtabilis,
et idem cubicularꝰ
tuus, Princeps Inuictiſsime
Guilielmus Tylar de ortu et
occaſu ſolis, ſibi aliquã ratio
nem ac methodum vt cõſcribe
rem. Quã ego quum pfeciſſem,
et ad aulam tuã eſ redditurus

MS. Bodl. 504.

248 Illuminated letter on vellum, 1528–9, in Kratzer's *Canones horoptri*, Bodleian Library, Oxford.

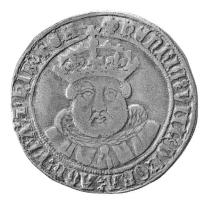

249 Silver testoon of Henry VIII. British Museum, London.

250 *Solomon Receiving Homage from the Queen of Sheba*, *c*. 1535, silverpoint, pen and brush on vellum, 22.9 × 18.3. The Royal Collection, Windsor Castle.

this time favoured by the King, but he was soon to be embroiled more than once in Henry's complex matrimonial schemes. Before any marriage was arranged the prospective bride was drawn, and her portrait submitted to the King.

In March 1538 Holbein was sent to Brussels together with an emissary, Philip Hoby, in order to portray a young widow, Christina of Denmark, Duchess of Milan. Henry, recently widowed upon the death of Jane Seymour, requested an exact and straightforward rendering of the charms of the young lady. On 12 March Holbein completed a drawing of her face. It met with a warm response from the King, and a full-length portrait was commissioned, seemingly projected by the frame (illus. 251).[107] To avoid distracting the royal gaze, Holbein chose a very plain turquoise setting, reminiscent of fifteenth-century Burgundian portraits, which were similarly framed by deep shadows along the borders. The dark garment provided an ideal means of offsetting the perfect white skin and the beautiful oval-shaped face, whose bright red lips are echoed by the red stone adorning the Duchess's left finger. The geometry of the face, seen in frontal position, is slightly disturbed by the three-quarters view of her gown. Here Holbein successfully applied a formula that is most conspicious in his portrait of 1542 of the poet Henry Howard, Earl of Surrey (illus. 255). The unusual shape of the head, observed during work on the preliminary drawing (illus. 256), is accentuated with great skill, producing a startling pictorial effect.

Henry had to content himself with Christina of Denmark's image, no doubt because the young lady knew all too well what could be her fate. The next object of the royal interest was Anne of Cleves (illus. 252). The King duly requested a picture from the ducal court, but Lucas Cranach, the Duke's painter, was ill. Other portraits were sent, which were deemed unsatisfactory, since the face of the lady was buried in 'monstruose habyte and apparell'.[108] Thus early in August 1538 Holbein was sent to Düren to depict her. Torn between the necessity of being honest and that of appeasing, he opted for a solution that is diametrically opposed to that used in the representation of Christina of Denmark. First he drew Anne's features on parchment and may then have executed a miniature of her after this sketch, a small roundel that was subsequently set in an ivory box in the form of a rose (illus. 253).[109] The geometrical composition is bold: two triangles placed one above the other with their point of intersection at the apexes. Instead of selecting a dark background, Holbein set his model against a bright shade of blue. Later, when painting the larger-format picture, he lavished gold on her costume, and chose a dark-green background to offset Anne's plain features. This choice of a dark shade was at the time rather standard, as shown by the fact that it was recommended by a poorly informed amateur like Sir Thomas Elyot in 1533.[110] The sitter's face is akin to a cheap stone mounted in too rich a setting; it disappears under the wealth of the jewels. Holbein applied a severe, striking symmetry: he almost seems to have given up on finding any interest in his sitter, happy to produce a striking, autonomous composition. Henry was deceived by the rhetoric and he arranged to marry Anne. When she arrived in England for the wedding ceremony he was deeply disappointed by her appearance, calling her a 'fat Flanders mare'. Six months later the marriage was dissolved by Act of Parliament, and Holbein seems to have lost the favour of the King. Henry had discovered, to his own expense, that *contrefeit* meant not only a portrait but a forgery too.

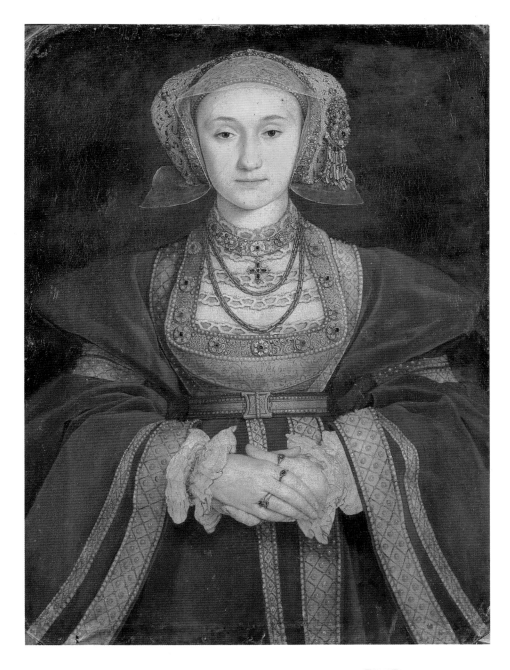

252 *Anne of Cleves*, 1538–9, parchment glued on canvas, 65 × 48. Musée du Louvre, Paris.

253 *Anne of Cleves*, after 1539, circular miniature (vellum on playing card), 4.5 *cm* diameter. Victoria & Albert Museum, London.

7 Holbein's Fame

Unlike some painters, Vermeer for example, Holbein has always enjoyed a secure place in the history of art. At the end of the sixteenth century his work as a 'limner' to the court in London was recorded by an English painter, and later historians and biographers were able to gather up enough material to allow them to devote a few paragraphs to Holbein's life and to situate him within the history of the Northern schools of art. Over the centuries his paintings have been admired for very different reasons, but even so they have always been expensive commodities, eagerly sought after by European collectors.

Holbein's artistic hallmarks may be elucidated with the help of the history of taste, that of artistic practice and that of art-historical writing. He was at first remembered only in terms of his works, but a social representation of the artist later emerged.

At first Holbein was remembered because of the celebrity of his patrons, his name often being noted in texts devoted to his patrons' lives. Thus the first Holbein portrait actually to be reproduced in a book is that of Erasmus in the act of writing (a portrait then in the Amerbach collection); Bonifacius allowed a woodcut to be made after the painting, and this was printed in Sebastian Münster's *Cosmographia universalis*, a publication known throughout Europe at the time.[1] In England, Matthew Parker, Archbishop of Canterbury, was full of praise for the diligent artist who painted his in-fluential patrons, and whose portraits were sent, like elegant letters, by scholars to their friends. We have seen how humanists commonly compared portraits with scho-larly letters. Parker, a man of great culture who could contemplate the portrait of Archbishop Warham that hung in his own palace, was no exception. Significantly, his comments on Holbein's technique are reduced to a commonplace: his portraits were 'delineated and expressed to the resemblance of life'.[2] Parker did not know much about the painter himself; when he tried to assess more precisely Holbein's wonderful accuracy, he described him as 'a Flemish artist'. Indeed, throughout the second half of the sixteenth century, Flemish followers of Holbein's style were promi-nent.

English praise

It took another twenty years before an artist praised Holbein in a treatise on art, and did so without falling back on lame clichés. Nicholas Hilliard was a famous painter of the Elizabethan period, specializing in small miniature portraits (illus. 254).[3] Born in 1547, the son of a rich goldsmith from Exeter, he wrote his *Arte of Limning* in *c.* 1599. Reading this treatise enables us more or less to imagine Holbein's practice at the court of Henry VIII. For the generation of portraitists who learned their trade during the second half of the sixteenth century, Holbein remained a great point of reference, as can be seen in Hans Eworth's *Mary, Lady Dacre* (illus. 257).

This work, by a Flemish portrait painter, provides a good illustration of the respect shown towards the great master during the 1550s: it is both the tribute of a widow, faithful to the memory of her late husband, and a homage to Holbein, whose work is displayed in a privileged position on a tapestry. Hilliard proudly acknowledges that 'Holbein's manner I have ever imitated, and hold it for the best'.[4] However, Hilliard's style had little in common with Holbein's, and we can suspect that the praise he lavished upon Holbein was not entirely disinterested.

254 Nicholas Hilliard, *Self-portrait*, 1577, miniature on vellum glued on card, 4.1 *cm* diameter. Victoria & Albert Museum, London.

Hilliard was born four years after Holbein had died, thus he must have gleaned all his information through hearsay. Certainly his own life shared many common features with Holbein's. Both had suffered from the outcome of an acute religious crisis. The Catholic reaction headed by Mary I had forced Hilliard to move abroad. He was to remain a faithful Protestant all his life, and after travelling through France he settled in Geneva, remaining there until 1559. Following her accession to the throne in 1558, Elizabeth I recalled the eminent Protestant exiles, and thus Hilliard followed his patron, John Bodley, back to England. His time in Geneva had not been wasted since he had made the acquaintance of Sir Francis Knollys, a first cousin of the Queen, through whom he must have secured several important commissions. One may assume that he travelled in Switzerland, which would have given him the opportunity to see certain of Holbein's pictures.

As a court painter Hilliard lived the life of a gentleman, while remaining poorly paid. Under James I his financial distress became so great that he had to pawn one of his own miniatures of the monarch in order to make ends meet. Like the former artist he claimed as his model, Hilliard travelled in France in search of a new patron. In 1577 he is recorded among the suite of François, duc d'Alençon and Anjou. In Paris, during his stay there in 1581–3, he was introduced to the greatest French sculptor of the time, Germain Pilon, to the poet Ronsard and to the scholar Blaise de Vigenère. Hilliard could see that in the courts of both England and France, Italian painters were honoured, even befriended by princes and kings; by contrast most British artists were not so privileged and could only gaze with envy at their Southern competitors. In the years following Holbein's death this new, glorious image of the Italian artist had been further enhanced by the publication of Vasari's *Lives of the Most Eminent Painters, Sculptors and Architects* (1550 and 1568). It was so well assimilated by international élites, that many foreign rulers, and even English aristocrats, among them Lord Leicester, did everything to lure Italian artists into their circle. This was not difficult in itself, provided that artistic quality was not a primary consideration. For example, Federico Zuccaro, by no means a great genius but an artist who was very conscious of his own importance, seemed to embody the grandeur of Michelangelo's successors. He was feted by Philip II of Spain; in May 1575 he was introduced to Elizabeth I and granted the privilege of drawing her (illus. 258).[5] British artists could surely not help but feel jealous on seeing how well their Italian counterparts were treated, especially since the latter did acknowledge the value of the British school. Zuccaro in particular expressed his thrill on contemplating Holbein's portrait of Christina of Denmark, to the point of recommending it warmly to Hendrik Goltzius.[6]

As if losing out to Italian artists were not enough, towards the end of his life Hilliard found his clients turning to younger painters; writing on the subject of his art became a means of defending his own personal style. He looked for a way of enhancing both the prestige of his own undertakings and that of his profession. Given the pres-

255 *Henry Howard, Earl of Surrey, c.* 1542,
oak, 55.5 × 44. Museu de Arte de São
Paulo Assis Chateaubriand, Brazil.

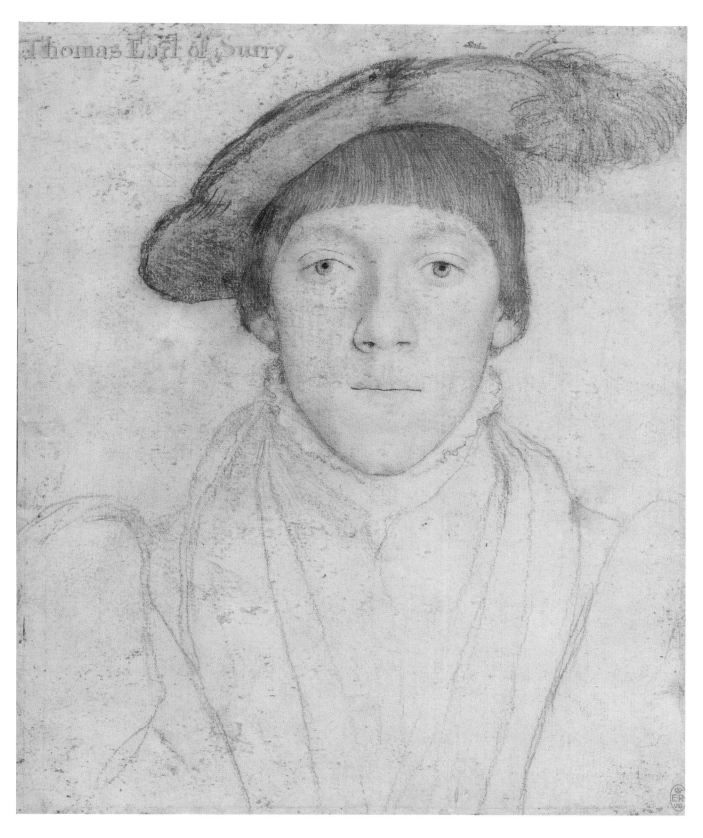

Thomas Earl of Surry.

256 *The Earl of Surrey, c.* 1542, black and
coloured chalks on paper, 24.8 × 20.3.
The Royal Collection, Windsor Castle.

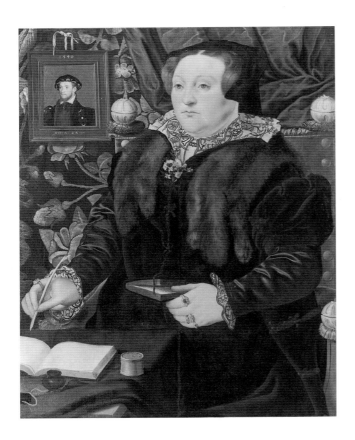

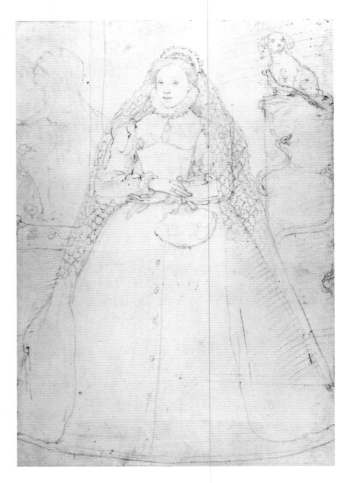

257 Hans Eworth, *Mary Neville, Lady Dacre, c.* 1550, oil on panel, 73.7 × 57.8. National Gallery of Canada, Ottawa.

258 Federico Zuccaro, *Elizabeth I,* 1575, black and red chalks on paper, 36.5 × 27.5. British Museum, London.

tige of the Italian school it is hardly surprising to find that Hilliard depicts the ideal limner wrapped in an Italian cloak. Reading Lomazzo's *Trattato dell'arte della pittura, scoltura ed architettura* (1584), translated by Richard Haydocke in 1598, he noticed that not a single paragraph was devoted to limning.[7] Hilliard therefore presented his text as a complement to Lomazzo's. He sought to convince his readers that the limner's art, too, was a noble pursuit, requiring a refined theoretical knowledge. However, Hilliard was unable to understand, and consequently to accept, the main elements of Lomazzo's theoretical background. In a country where, unlike in Italy, painters of monumental decorations were disdained as simple craftsmen, portraits of a small format, often framed like jewels, commanded much more respect. Hilliard did not try to assimilate the great humanistic concerns of Italian artists. He was happy to neglect the study of perspective, and held the science of human proportions in little esteem. Dürer embodied those values in Germany: Hilliard lavished praise on him in the *Arte of Limning*, but voiced his scepticism towards the value of his theoretical achievement. Instead, he built up a social image of the artist as courtier, which was mostly drawn from Baldassare Castiglione's *Cortigiano*.[8] The limner should be dressed in silk, and in order to improve his art, he should mingle with polite society. This glorified image of the artist was highlighted in a beautiful anecdote. Hilliard proudly recalls a sketching session with the Queen in a garden. Her Majesty, 'after showing me how she noted great difference of shadowing in the works, and the diversity of drawers of sundry nations, and that the Italians, who had the name to be cunningest and to draw best, shadowed not', decided to pose in a place in full light,

without a single tree in the vicinity.[9] The anecdote was a double exercise in praise, paying homage to Elizabeth's connoisseurship, and placing Hilliard in a position to challenge Italian artists in exactly the domain in which they excelled. If he refused most of the mathematical components of the Italian and humanistic definition of the artist–theoretician, Hilliard did make good use of others: above all, he extolled Holbein's dignity as an *inventor* – a man who, like Quintilianus' orator, conceived his subjects in his mind before translating them into painting.

Under such circumstances, Holbein was a perfect role-model for Hilliard as a court painter. Hilliard inserted a long reference to him in a passage where a most important topic was discussed, that of patronage. The *Arte of Limning* lavishes much praise on Henry VIII, and enthuses on the beneficial effects of his generous commissions. This *Eloge* had a double meaning. The limner was reminding Elizabeth of her responsibilities. An ambitious sovereign should be a great patron of the arts. And a British sovereign should, at last, pay due respect to British artists. If Hilliard acknowledged the quality of foreign artists, 'the best and most in number', he anticipated the day when British artists – himself included – would manage to surpass their foreign competitors: 'I have heard Ronsard the great French poet on a time say that the islands indeed seldom bring forth any cunning man, but when they do it is in high perfection; so then I hope there may come out of this our land such a one, this being the greatest and most famous island of Europe'.[10] Such anticipation was pure rhetoric: Hilliard was implying that the emergence of a great British artist should not need to depend on the caprice of history, but rather on the mere recognition of his own talents by the monarch. However, just like Holbein before him, he failed to secure a really prominent position at court. He seems to have believed that Holbein had died rich, showered with honours; Hilliard himself died poor and lonely, although collectors called him the Raphael of Britain, just as they had called Holbein the Apelles of his time.

The North versus Italy: Holbein by Carel van Mander

Carel van Mander is Holbein's second extant biographer. Like Hilliard, the Flemish painter was not only interested in paying respect to the great masters in his own country. At a time when artists were still regarded as mere craftsmen in the north of Europe, van Mander also endeavoured to single out their achievements. To achieve this he was faced with a historiographical model unknown to Hilliard – Vasari's *Lives*.[11] A painter himself, with a gift for writing, van Mander was well read. After ten years of labour, in 1603–4 he published his *Schilder-Boeck*, whose subtitle speaks for itself, the *Lives of the Most Illustrious Netherlandish and German Painters* (illus. 259).[12] The first book contains a short pedagogical treatise in which van Mander tried to contrast his own ideas with the Italian understanding of art. This introduction is followed by the biographies of the main Dutch and German artists (books 2–4), which follow the same pattern as do those of Vasari, and where Holbein's biography is to be found. The last section of the volume provides Dutch artists with a translation of Ovid's *Metamorphoses* into Flemish, a way of encouraging his fellow painters to explore the poem in search of higher, more erudite subjects for their paintings.

Almost every line of the *Lives* betrays the author's secret envy of the praise lavished by Vasari on Italian artists. But unlike Hilliard, van Mander had more than a scanty

259 Carel van Mander, frontispiece for his *Schilder-Boeck*, Haarlem, 1604.

knowledge of Italian culture. At a very young age he had travelled through Italy for four years, from 1573 to 1577. And he could remember that in Florence he had been able to catch a glimpse of an old bearded man overseeing some work in the Duomo – Giorgio Vasari himself. The author of the first *Lives* was to die only a few months later.[13] The young painter must have looked up with awe to the pupil of Michelangelo, the favourite painter of the popes, and one of the main architects of the Uffizi. Such admiration was probably too intense not to have been corrupted into jealousy. Van Mander became increasingly resentful of Vasari's nationalism, and his own book is a manifesto of his national pride. The artists of the North were not inferior to their Italian counterparts; one had to know how to compare the relative merits of each. Van Mander used Vasari's own weapons when he challenged his authority, even borrowing some of the Italian's rhetorical devices to enhance the image of the Northern school. Accordingly, in his representation of the main schools of art, he managed to increase the grandeur of his fellow artists by subtly demeaning the achievements of Italian artists.[14] Some key concepts of Vasari's historiography underwent a drastic change. We have seen that Hilliard called Holbein an 'inventor'. In his life of Jan van Eyck, van Mander stressed that his subject was responsible for the invention of painting in oils. Vasari had represented van Eyck as an alchemist, mixing his colours in a new, secret fashion; van Mander described him as a technician – an 'inventor' of one of the few revolutionary techniques of all time, on a par with those of gunpowder or printing.[15] Here, invention is not to be understood as the ability to find new subjects for paintings, but to develop a new technique. Van Mander went further, and showed that in some fields Northern artists had acquired greater skills than their Italian counterparts, especially in the depiction of flowers, animals and landscapes. If he accepted the Italian theory of the genres, he stressed that, above all, it was the mode of representation more than the object represented that ensured the prestige of a work of art.[16]

Writing up his biographical sketches, van Mander faced a great challenge: he noticed that a stream of Northern painters had bowed to the necessity of travelling to Italy in order to learn their trade. To explain this attraction without having to accept the value of Italian works of art as higher models, van Mander was at pains to stress that it was, above all, 'classical antiquities' – and not modern works of art – that were to remain the main source of inspiration for the artist.[17]

Holbein was, for van Mander, an almost perfect exemplum of the Northern artist. First, he was an adept of the 'neat' manner, as opposed to the 'rough' touch characteristic of the Venetian masters. His technique allowed him to obtain maximum illusory effect, and to become what van Mander called with admiration a 'bold liar'. Second, Holbein illustrated van Mander's theory of genius to perfection; if Hilliard thought that islanders could surpass all Continental artists if given the chance to do so, van Mander insisted that genius is bound neither to family nor to country. He knew that, according to an established tradition, Holbein was born in Germany, but he could not resist the temptation of declaring him to have been a Swiss citizen. This fact he then used to show that a genius could develop in one of the least artistic areas of Europe, what he described as a 'rocky, desolate' wasteland. Vasari made it clear that Florence seemed to be the 'natural' centre of artistic excellence, blessed by God. For van Mander, Holbein was a major piece of evidence in the case against Florentine 'geocentrism': he was the 'exemplum' of the genius born out of nowhere. He remarks:

One finds, however, that it has happened more than once that a remarkable and great person in our art emerges somewhere and appears in a country where none had risen up previously or before them; as proof that spirit and genius are not bound to locality or family.[18]

Van Mander may be excused such an inaccuracy, which was in perfect accordance with his historiographical outlook. By the time he was drafting his *Lives of the Most Illustrious Netherlandish and German Painters*, the great Holbein connoisseur Basilius Amerbach was already dead. Van Mander had requested some first-hand information on the artist from one of Amerbach's descendants, Ludwig Iselin.[19] (The latter did not betray Basle's reputation for being a commercial centre: he requested to be paid handsomely for his services.) It is difficult to estimate how many of Holbein's paintings van Mander ever did see; he writes on the Basle *Totentanz* he attributed to him, but we may infer that he knew more woodcuts after paintings by Holbein than he did paintings. However, it should be remembered that it was not out of purely scholarly antiquarian interest that he looked for reliable data concerning Holbein. Rather, van Mander was baffled by 'such a beautiful working manner which so completely departs from the old-fashioned, modern one', and did not know how to explain it.[20] The lack of available data did not prevent him from stating that the painter had never been in Italy. This wonderful neatness, the realism of his portraits was the work of a man from the North.

Van Mander inaugurated two important trends in Holbein's historiography. He padded out Holbein's life with some anecdotes that were to colour the artist's biography for a long time, especially during the Romantic era. He also paved the way for a parallel to be drawn between Holbein and Dürer, which was to become paramount for all historical research on both artists in the nineteenth century. Biographies of Holbein and Dürer stress the privileged relationship between, in the one case, Henry VIII and Holbein and, in the other, Dürer and the Emperor Maximilian. One day, van Mander tells us, an aristocrat expressed the wish to see Holbein in his studio. The artist declined to open his door to him, engaged as he was 'painting something from life or doing something private'.[21] His Lordship insisted with such a lack of tact that Holbein threw him down the stairs. When the aggrieved courtier complained to Henry, the King rebuked him with a simple calculation: out of seven peasants he could fashion as many lords, but not a single Holbein out of seven earls. That such anecdotes were narrative devices of van Mander's own invention, is obvious on reading his account of Dürer's life. He writes that one day Maximilian was watching Dürer, who was completing a large-scale mural. Dürer said he needed to find a ladder, whereupon the Emperor requested that one of his noblemen should lend his back to the artist. Aware of their reluctance to cooperate, Maximilian presented them with a retort similar to that given by Henry.[22] There is a striking similarity between these two anecdotes, but at the same time the description of the two artists at work reveals a contrast. Holbein was disturbed while 'painting something from life or doing something private'. Dürer, however, is presented when completing a vast programme, with attendant onlookers. Holbein's personality, jovial and fun-seeking, abandoning his wife without remorse, is the opposite of the composed, rather serious portrait of Dürer. Above all, van Mander was also keen to emphasize another object of national pride in Holbein's life: the crucial role of Erasmus in his career. As was only just, the Dutch scholar is praised for having enabled the painter to rise through superior social circles to become the King's painter.[23]

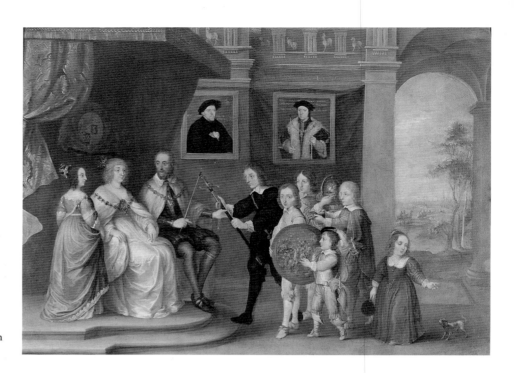

260 Philip Fruytiers, *The Family of Thomas Howard, 2nd Earl of Arundel*, oil on copper, 40.6 × 55.9. Private collection.

Collectors and scholars

During the seventeenth century Holbein attracted considerable attention from collectors as well as from scholars. Two factors were instrumental in fostering the market for his pictures: the extraordinary activity of international picture dealers in Holland, and the craze for Old Masters that developed steadily in England in the 1620s, and which led to interesting picture exchanges between the North and South of Europe.[24] Prince Charles (Charles I from 1625) and his favourite, George Villiers, 1st Duke of Buckingham, visited the Habsburg collections in Madrid in 1623. Overwhelmed by dozens of ravishing Titians and Raphaels, they swore to lay their hands on all the most beautiful pictures they could purchase.[25] It is true that they were less eager to buy German than Italian or Flemish pictures. Not only aesthetic, but also historical values were at stake: a strong sense of nostalgia for the Tudor period drove a collector like Thomas Howard, 2nd Earl of Arundel, to purchase Holbeins at almost any cost.[26] Arundel was a man of outstanding taste and great culture. He was Sir Antony van Dyck's first acquaintance in England, and Rubens called him 'one of the evangelists of our art'.[27] It is through Arundel that Rubens and van Dyck developed their great interest in Holbein.[28] By descent he belonged to the family of the dukes of Norfolk, and could recall with pride that Thomas Howard, 3rd Duke of Norfolk, had been one of Holbein's best patrons. Philip Fruytiers depicted the Earl and his family, in full ceremonial robes, sitting regally before the famous portraits of his ancestors, executed by the Old Master whom Arundel prized above all others (illus. 260). Possessing them, exhibiting this evidence of his family's past grandeur, was a source of compensation to a courtier who, under James I and Charles I, completely failed to secure a role of influence at Court, in spite of his name and dignity.[29] In those portraits, history was perceptible in the flesh. Most of these treasures, such as the superb portrait of Christina of Denmark, were passed to him by John,

Lord Lumley, who had married an Arundel; Lumley had bequeathed to him his wonderful knowledge, his passion for the Tudor period.[30] In a letter to Sir Dudley Carleton, Arundel acknowledges almost like a sickness his 'foolish curiosity in enquiring for the pieces of Holbein'.[31] But possessing them was not enough: Arundel wanted to have them engraved. For him, Wenceslaus Hollar produced a large choice of engravings after the paintings in his collection, or other works by the master; Hollar, a superb etcher from Prague, seems to have been keen to execute those reproductions that enable us to know some features of works now lost.[32]

If the King and Buckingham were not as devoted to Holbein (Charles did not think it inappropriate to exchange the artist's works for Italian pictures), they did retain some pieces of value by him. In Italy indeed, the clean manner characteristic of the Northern masters was stimulating the taste of Cosimo de' Medici for works by Holbein; it was, after all, a refreshing change to look at one in a gallery full of Florentine paintings. But instead of hunting for a rare piece on the market, the Grand-Duke wrote to Arundel, begging him to part with a jewel from his own stock, 'because I have become passionately set upon having a work by this artist'.[33] Arundel duly behaved as a perfect courtier, surrendering the only Holbein portrait he could not keep in his house, that of Sir Richard Southwell, an enemy of his beloved ancestor Henry Howard, Earl of Surrey. Arundel was duly thanked by the sovereign: a splendid triptych by Adam Elsheimer made the journey to Arundel's Thames-side palace.

261 Antony van Dyck, *Michael Le Blon* engraved by Theodore Matham, 18.4 × 28.7. Graphische Sammlung Albertina, Vienna.

From the King of England to the Arundels and Buckinghams, all collectors of good-quality paintings were bound to deal with Dutch picture dealers. One of the most prominent among them, Michel Le Blon, turned out to be a great Holbein connoisseur (illus. 261). He owned a few pictures by the master, copies or originals.[34] He was also a great opportunist. An engraver as well as a dealer, he soon owed to his connections in higher social circles the title of envoy of the court of Sweden in the United Kingdom. Like his fellow-agent Balthazar Gerbier, he knew all the major British collectors of the time, whose new passion allowed for lucrative business deals. In Holland also, pictures by Holbein were very much in fashion, but for different reasons. In about 1632–3, Le Blon travelled to Lyon in order to purchase a Holbein for Buckingham; on his way back he stopped in Basle, and bought the *Darmstadt Madonna* (illus. 118) from Johann Lucas Iselin for the very high price of 1000 *Imperiales*.[35] The destiny of this famous picture illustrates, more than any other painting, the appreciation of Holbein in seventeenth-century Europe. At a time when the *Fijnschilders* took pride in polishing their paintings to increase their aesthetic and financial value, such a picture could be seen as a rare pearl: here was a very finished painting, a real collector's item. Le Blon lauded such finished panels to his clients, like the Swedish chancellor Axel Oxenstjerna: did they not fall for such pictures – religious or, preferably, with erotic subjects, but where 'one does not see any uneven part, any beginning or any end in the colour, more, it seems to have been washed, or made with a cloud or with steam'?[36] If Holbein's pictures were not always wholly in fashion in England, in Holland they fitted perfectly the artistic ideal of Gerard Dou and of his clients. In due course Le Blon sold the *Darmstadt Madonna*: in 1638 to a Dutch collector, Johannes Lössert.[37] In a country where all the churches had been deprived of their religious ornaments, the *Madonna* was proudly displayed in a private apartment. A highly finished fake was even made after the original. Such a practice was common among unscrupulous dealers, and Le Blon may have been tempted to try to reap a double reward for his discovery of a Holbein mas-

262 Attributed to Wilhelm Stettler, *The Wife and Children of Holbein, together with Laïs Corinthiaca*, c. 1670–80, gouche drawing on parchment, 23.5 × 43. Graphische Sammlung Albertina, Vienna.

terpiece. He may have wanted to keep that fake for a while; his own collection, as we have seen, included some copies after Holbein.[38] A friend, the German painter Bartholomeus Sarburgh, undertook the thankless task with great skill, correcting here and there, and translating Holbein's style into an Italian idiom – most probably for an international clientele, keen to purchase two paintings, one of the Northern and the other of the Italian school, combined in one. Such a transformation betrays all too clearly the change of taste that separated the generation of van Mander from that of Le Blon: in Sarburgh's hands, the *Darmstadt Madonna* was becoming a perfect mix of Northern precision and Italian fashion. Sarburgh was an ideal copyist: he knew Switzerland very well since he had worked in Berne and more particularly in Basle (1621–8) before returning to The Hague. His apprentice, Johannes Lüdin, was from Muttentz near Basle.[39] From Swiss collectors as well, the *Madonna* was no less in demand. Soon after his task was completed, Sarburgh received a request from Basle: Remigius Faesch II wanted two copies of the figures of the son and daughter of Jakob Meyer. Faesch was a keen collector, who regretted the loss of a painting that had once belonged to his family. But he owned the two 1516 portraits of Jakob Meyer and of his wife, and thought that all he now needed were the heads of the children. The figures of the youngsters were copied by Lüdin, not after the original, but after Sarburgh's copy, which must have been in Le Blon's hands.[40] As the picture had long vanished from Basle, Faesch tried to imagine it with the help of some of the oral tradition linked to the work. In his hypothetical description of the picture, this staunch Protestant and antiquary reduced the painting to his own fancy. The panel, he thought, showed the family 'kneeling in front of an altar', and there was simply no place for a Virgin in his description.[41] In Switzerland it was the secular works that were rearranged in order to carry a moral message. A Swiss miniaturist of the seventeenth century – probably Wilhelm Stettler – could copy side by side the family portrait of 1528 and the *Laïs Corinthiaca*, as if they both belonged to the same picture: motherly love was opposed to love for sale – a perfect antithesis befitting a moral *oratio* (illus. 262).[42]

When, after 1637, the artist and art-theorist Joachim von Sandrart met Le Blon, the dealer had already sold his Holbein Virgin: Sandrart managed to see, among other pictures, a version of *Venus and Cupid*, and probably a copy of the *Darmstadt Madonna*.[43] In his *Teutsche Akademie*, Sandrart summed up what a gentleman traveller could be expected to know about Holbein in the seventeenth century. In England he had been welcomed by Arundel, who had shown him his treasures in person; the architect Inigo Jones had even made sure that he was able to see the Holbein drawings in the royal collection. Yet most of his details on the master were pillaged from van Mander. What is new in his biographical sketch is the insistence on the price of Holbein's pictures: his Holbein biography includes a city of Basle besieged by amateurs wanting, in vain, to buy the pictures kept there.[44]

Men such as Arundel, Le Blon and Buckingham had been collecting Holbeins all their life; nevertheless it remained the task of a Frenchman collaborating with a Swissman to produce the first *catalogue raisonné* of the artist's work, which was published, together with a short biography, in Erasmus' *Encomium moriæ*.[45] Charles Patin's fascination for Holbein may be compared with that of Arundel. It was rooted in historical consciousness: Patin was a somewhat nostalgic admirer of Erasmus. The son of an erudite and rich surgeon, Guy Patin, he had been more fortunate than the Dutch humanist in that he could afford to indulge his scholarly interests without having to seek patrons. His interests were very wide: at the age of sixteen he was studying law at Poitiers, then medicine at the Sorbonne in 1654. These studies were put to good use: Patin became, as did many surgeons of the time, a very good numismatist. Collecting and cataloguing medals was a way of socializing in the higher spheres of society.[46] Besides this there was also the fact that historians were taking visual evidence more seriously. Patin remained, throughout his life, a keen collector of paintings.[47]

Renaissance scholarship must have captured his interest at an early age. His father belonged to a circle of *libertins* who hated the Jesuits as well as all religious excesses, and who defended the right of Reason to examine matters of religion and authority. Guy Patin vowed a cult to Erasmus, whose portrait adorned his house, together with those of Montaigne and De Thou. The Council of Trent had branded Erasmus a heretic; during the seventeenth century the humanist became the apostle of tolerance in enlightened circles. Charles Patin himself seems to have suffered from the restriction that royal censorship was imposing on the intellectual life of his time. In 1667 he was even embroiled in an obscure affair related to forbidden tracts, and had to leave France in a hurry. Wandering through Europe with his precious collection of medals, he settled in Basle in 1671 and again in 1674–5. He seems to have visited the Roman site of Augst – Cæsara Augusta – with some pleasure. For trifling sums the peasants of Augst sold him beautiful coins that they had found while ploughing their fields. But on visiting the university library, he discovered with awe the most extensive grouping of Holbein's pictures in Europe: the Amerbach collection had been purchased by the city of Basle in 1661. Patin also made friends with the Faesch family, owners of a large number of pictures, and whose members were gathering material on the history of art.[48] Both Patin and Sebastian Faesch decided to edit Erasmus' *Encomium moriæ*, together with the famous manuscript illustrations made by Holbein for the Basle copy. They were copied by Wilhelm Stettler.[49] Full of enthusiasm for their project, and unrepentant catalogue makers, they expanded their project. They decided to compile a biography of the artist, and to add a list of all

known Holbeins – the first *catalogue raisonné* of the artist. Holbein's biography became influential on one account especially: Patin and Faesch noticed that on folio S4, Holbein had designed a *plump porker*, drinking while exploring the bosom of his female companion. A later, unknown, hand had added the word 'Holbein' above the figure. The two scholars read it as a comment, made by Erasmus himself, on Holbein's sinful life. This fresh imputation of the artist as a dissolute and hedonistic painter was to influence most of Holbein's biographers until the close of the nineteenth century.[50]

Patin himself attempted to buy pictures by the master, or to have copies made after the best.[51] On his travels he would never forget to point out to Faesch a Holbein painting seen in a collection, and ordered copies to be made, 'qui me seront nécessaires dans leur temps'.[52] But the key to the understanding of Patin's interest in Holbein lies in a beautiful publication made by one of Patin's daughters, Carla Catherina. The *Pitture scelte e dichiarate* of 1691 reproduces, among others, a painting by Noël Jouvenet that represents the Patin family (illus. 263).[53] Carla is at pains to excuse what may be seen as a lack of modesty: did Holbein not paint families, like that of Meyer and his wife, and even his own in Basle? However, when sitting for the painter the Patins adopted a pose that recalls, unmistakably, Holbein's group portrait of the More family. In the university collection, Patin had been able to admire the preparatory drawing for the now lost picture. He had it copied; it was published in Carla's *Pitture*.[54] The exiled Patin was draping himself in Thomas More's robe: he too was the father of very erudite daughters, and he too had been persecuted for his freedom of thought, as well as for his advocacy of religious tolerance. On the painting, even Carla herself – a very gifted woman, who was well acquainted with astronomy – wished to be represented studying a sphere; she recalled 'in the letters that Thomas More was writing to his daughter Margaret is the recommendation that she should study astronomy, which has always been my delight'.[55] Thus, the *Encomium moriæ* of

1656 offered to the reader the first *catalogue raisonné* of Holbein's works, together with the witty gospel of free humanism. Holbein's portraits of Thomas More, of Thomas Warham, with their intensity and their utmost precision, worked a miracle for Patin: they made visible, they almost revived these great apostles of tolerance, in the nostalgic dreams of a *libertin érudit*.

Delightful anecdotes: from Vertue to Walpole

For another fifty years research remained at the point at which Patin had left it, until a British engraver undertook to gather as much empirical information on British artists from 1500 to 1700 as time and dedication would permit. This engraver was George Vertue. His perspective was purely antiquarian; he patiently gathered his notes under the grand title 'Musæum pictoris Anglicanum', but his historiographical method owed much to Paolo Giovio's 'museo' and his *Eulogia virorum illustrium*.[56] Vertue was an able craftsman, whose work was sought after by publishers. His interest in Holbein must have been awoken by his own major source of income – engravings after historical portraits, many of which were copied after Holbein.[57] But while Vertue was an esteemed engraver, he was a very poor writer. His accounts of visits to country houses or collectors are fastidious; his notes juxtapose first-hand accounts with worthless gossip. In his desire to enhance the status of painting in England, he misinterpreted some important Holbeins; for him, the now lost group portrait of Henry VII, Elizabeth of York, Henry VIII and Jane Seymour was an *historia*, as Alberti had defined the word; that the picture was not in the least a narrative did not disturb him.[58]

264 Sir Joshua Reynolds, *The Hon. Horace Walpole*, 1757, oil on canvas, 127 × 101.6. Art Gallery of Ontario, Toronto.

On his death in 1756 Vertue left a mountain of notes that were not simply unpublished – they were unpublishable. They were bought up by an aristocrat who seemed to have no other purpose in life than that of killing time, but whose sharpness of mind and literary flair proved infallible. Horace Walpole – the novelist, antiquary and Member of Parliament – trawled through Vertue's notes and managed to shape them into four volumes: Walpole's own famous *Anecdotes of Painting in England* (1762–80).[59] A great art collector in his own right, Walpole was very fitted for such a task (illus. 264). The son of a former prime minister, Sir Robert Walpole, he had spent his youth at Houghton Hall, Norfolk, where one of the best private art collections in Europe was to be seen, at least until the collection was sold to Russia's Catherine the Great in 1779. One of the first intellectual undertakings of the young Walpole was to compile a descriptive catalogue of these holdings.[60] He learned at an early age the art of intertwining biographical data and descriptions of pictures. His *Anecdotes* play on the rhetorical devices dear to all art historians; his biographical entries are full of striking antitheses and *jeux de mots*, and Holbein's biography is no exception to this rule. Later in the century, William Beckford was to go further, and denounce those platitudes used by most cicerones operating in country houses; both he and Walpole were speaking from experience. In his satire *Biographical Memoirs of Extraordinary Painters* (1780), Beckford discusses the unknown works of 'Sucrewasser of Vienna', 'Watersouchy', 'Og de Basan' and 'Blunderbussiana'. All the biographical sketches are imaginary, but they assemble the most time-worn clichés about artists' lives.[61] Walpole's conscious use of such rhetoric is more complex. His readers are expected to marvel at the difference between the platitude of Vertue's

notes and the beauty of Walpole's own prose. The aristocrat wished to show some disdain of scholarly pretension in general, and more particularly towards Vertue. His tone is nothing short of patronizing towards the painstaking engraver. For Walpole, historical discourse is designed to nourish polite conversation, and to allow for the free exercise of wit. His historiographical outlook was traditional: in 1758 he had written a *Catalogue of the Royal and Noble Authors of England*, an undertaking in which the dynastic element obviously played a major role. In the *Anecdotes*, each artistic period corresponds to the reign of a British monarch: Holbein is a mere supporting statue in Henry VIII's literary monument. Each century seems to differentiate itself through its own artistic productions, and the overall impression is that all these works of art were either commissioned under the secret influence of a monarch, or were designed to pay homage to royal bountifulness. Unlike Vertue, Walpole shared no nationalistic feeling towards the English school, rather the contrary. His main aim was not so much to inform, or to celebrate, as to amuse his contemporaries with raw facts, to dig up historical gossip, and to smell the dust of the past. Last but not least, his book was meant to provide his readers and collectors with useful facts. In the case of the Holbein biography, Walpole merely combined Patin's biography and catalogue with that of van Mander, adding some details from Vertue's notes. He paid full homage to Holbein in the *Anecdotes*; his reasons were personal, but highly complex. To appreciate its originality, one should remember that during the second half of the eighteenth century Holbein was enjoying a revival in Europe. To the likes of Count Schönborn for example, a Holbein portrait epitomized a new, classical quality, for those collectors exhausted by the Late Baroque excesses of the Tiepolos.[62] Walpole himself undertook to collect copies of Holbein portraits for a very different reason: to him they were *Gothic*. Walpole's own country house, Strawberry Hill in Twickenham, marked the birth of the Gothic Revival. It had been designed for a man who thought that the Greek style was not the quintessence of architecture, and that private lodgings required a more fanciful style ('one only wants passion to feel Gothic').[63] And Strawberry Hill had a Holbein room (illus. 265).[64] Its decoration was neo-Gothic; the light was filtered by antique stained-glass windows, and the Holbein portraits, copied after drawings in the Queen's closet, were framed in black and gold borders. The chimneypiece was 'chiefly taken from the tomb of Archbishop Warham at Canterbury', while the pierced arches of the screen tried to evoke the choir of Rouen cathedral.[65] Walpole even thought that he could secure from Lord Exeter – who was refurbishing Burghley, his own country house – an old family bed suitable to the historical atmosphere of his Holbein room. Such a mansion was bound to attract medieval ghosts. In 1765 Walpole had already published one of the first Gothick novels, *The Castle of Otranto*, prompted by a vision. In his dreams he had found himself wandering in an old castle. A large staircase appeared in front of him, and a gigantic hand in an iron gauntlet touched the banister.[66] In the higher circles of society, it had became fashionable to feel the *frisson* of the Tudor period; young children were even paraded by their parents in fancy dress *à la* Holbein's *Henry VIII* (illus. 266).[67] As a true pre-Romantic spirit, Walpole focused on expression. On seeing the portrait drawing of Sir Thomas More, he enthused about the expressive power of the draughtsman.[68] Without knowing it, Walpole was paving the way for a fresh reconsideration of Holbein, whose first exponent was the celebrated Swiss physiognomist Johann Kaspar Lavater in around 1780. In a letter dated 1780 to Goethe, Lavater exemplifies those new conditions of perception:

If I have ever seen, felt, breathed in myself Inspiration in human productions, in the strictest sense of the word, it was when I saw three or four pieces by Holbein which, to my judgement, pass everything I have seen in Mannheim, Schleissheim and Düsseldorf – as far as colour, drawing and poetry are concerned. His *Last Supper*, particularly – and the *Laïs Corinthiaca* surpass everything.[69]

Holbein was a perfect painter, because through his pathos, a soul was communicating with a soul. To the analytical, detached admiration characteristic of a Le Blon, Lavater opposed the powerful spell of enthusiasm (*Schwärmerei*), a new sensibility to the atmosphere, the surroundings in which an aesthetic judgement took place. A new cult of the work of art was developing, where pseudo-religious feelings mixed with the snobbish cult of originality. Lavater warned Goethe that no print could convey the powerful effect of the original. And he begged his correspondent to kneel in front of these masterpieces in silent, respectful awe. Lavater was inaugurating a new sensitivity, for which it became fashionable to worship a masterpiece, and to bemoan the irreconcilable difference between the power of the masterpiece, in the *hic et nunc* of its apparition, and the pale shadows of its engraved reproduction.[70]

265 John Carter, *The Holbein Room, Strawberry Hill*, 1788, pen and watercolour. Lewis Walpole Collection, Yale University, New Haven.

266 Sir Joshua Reynolds, *Master Crewe as Henry VIII*, 1776, oil on canvas, 139.7 × 110.5. Private collection.

Appendix

Six Little-known Documents Relating to Holbein and his Works

1 Beatus Rhenanus (1485–1547)

Beatus Rhenanus was born in Schlettstadt (Alsace), and died in Strasburg in 1547. A gifted humanist, he worked in Basle from 1511 to 1526, where his skills were put to use by publishers of ancient texts. He was a friend of Erasmus, and edited his works in 1540. Besides his editions of classical texts, his best-known publication is *Rerum Germanicarum libri tres* (1531), a very significant compendium of German history. Rhenanus makes an important reference to Holbein, in a commentary to Pliny's *Natural History* (Beatus Rhenanus, *In C. Plinium*, Basle: Froben, 1526, pp. 29–30). In that text, Rhenanus attempts to correct a difficult passage of the text, corrupted in most manuscripts: Praefatio, 26, 'Ex illis mox velim intellegi, pingique conditoribus' (today it is reconstructed as 'ex illis mox velim intellegi pingendi fingendique conditoribus'). Rhenanus proposes the reading 'pingi ειχονων autoribus' (Charles G. Nauert, 'Humanists, Scientists, and Pliny: Changing Approaches to a Classical Author', *The American Historical Review*, L X X X I V / I, 1979, p. 85).

An vero recte pictorem appellemus conditorem nescio, hoc satis constat, etiam si pingens aliquid condere diceretur, hanc tamen lectionem ineptam esse ut Pingendi Conditoribus scribatur. Haec & alia huiusmodi monere debebant interpretes, & non satis putare, si dixissent Conditoribus, id est, compositoribus, ut legum conditores dicuntur. Significat autem Icon sive Graece ε'ίχωα imaginem, quae exemplar omnibus lineamentis exprimit vel sculpta, vel picta, παγα; του εοικεναι τω αρχετυπω, quod exemplari videlicet assimiletur. Equidem apud Olympiam eorum, qui ter ibi superavissent, statuas dicari mos erat, ex membris ipsorum similitudine expressa, quas Iconas vocant inquit Plinius Lib.34. Idem proxime sequenti libro, Panaeum Phidiae fratrem in pictura qua praelium Atheniensium adversus Persas gestum expressit, Iconicos duces pinxisse tradit, Atheniensium quidem, Miltiadem, Callimachum, Cynegirum: Barbarorum autem Darium & Thyssaphernem, adeo colorum iam usus increbuerat, adeo ars perfecta erat. Hinc Iconici pictores appellantur, qui omnibus lineamentis ad exemplar expressis rem representant. Quales apud priscos multi extitere, apud Germanos hodie sunt inter primos clari, Albertus Durerius apud Norimbergam, Argentorati Ioannes Baldugnus, In Saxonibus Lucas Cronachius, Apud Rauricos Ioannes Holbeinus Augustae Vindelicorum quidem natus, verum iamdiu Basiliensis civis, / qui E R A S M U M nostrum Roterodamum anno superiori in duabus tabulis bis pinxit felicissime, & cum multa gratia, quae postea sunt in Britanniam transmissae. Quod si tanta dignatio picturae esset apud nostrates, quanta fuit olim apud Graecos & Romanos, non dubito quin spe laudis atque commodi proposita, diligentiori exercitio ad artis consummationem pervenire facile possent. Nam verissimum est illud, Honos alit artes. Apud Graecos Philostratus Iconibus duos libros dicavit, qui singulari elegantia Attici sermonis commendantur. Porrò, quod ad opera pertineat titulo pendenti inscripta ab Iconon autoribus, refert Angelus Politianus in Miscellaneis suis, marmoream quandam veluti basin Romae se vidisse, in qua Graece sic esset ΣΕΛΕΥΚΟΣ ΒΑΣΙΛΕΥΣ. ΛΥΣΙΠΠΟΣ ΕΠΟΙΕΙ. Id Latine valet, S E L E V C V S R E X. L Y S I P P V S F A C I E B A T.

I do not know whether a painter can properly be called a 'founder', but this much is certain: even if one were to state that, by painting, a painter 'founds' something, the use of this term is none the less so ill-fitted that one could not insert 'pingendi conditoribus' into the text. The commentators should have pointed our this, and other such things. They should not have been satisfied with the word 'founders', that is, 'those composing the laws', as if one were speaking of 'Law-makers'. Now 'icon' (or Greek ειχονα) has the same meaning as 'image' – an image that depicts a model with all its features, be it a sculpture or a painting (the word derives from the fact that the image 'looks like' the model). At any rate, it was customary that at Olympia, statues were consecrated to those who had thrice been victorious there. These statues are called icons [or, more properly 'icon-like'], this literally according to Pliny in book X X X I V [§ 16]. Furthermore, in the very next book [X X X V § 57] the same Pliny states the following: 'In the painting which depicts the battle of the Athenians against the Persians, Panaios, Phidias' brother, painted the commanders – the Athenian commanders Miltiades, Kallimachos and Kynegeiros, and the Barbarians Dareios and Tyssaphernes – "in an icon-like way". That is how consummate the art already was, and how common the use of colour.' Consequently, those painters who depict things by following the actual model to represent every feature are called icon painters. There were a great number of such painters among the Ancients. Among the foremost artists in Germany today are reputed Albert Dürer in Nuremberg, Hans Baldung in Strasburg, Lucas Cranach in Saxony, and Hans Holbein in the upper Rhine area. Although Holbein was born in Augsburg, he has long since become a citizen of Basle. Last year he painted our Erasmus of Rotterdam twice, on two separate paintings. He painted a very striking likeness with much grace. Both paintings were later sent to England. If only our contemporaries valued painting as highly as the Greeks and Romans once did, I would not doubt that painters, in hope of gaining fame and acceptance, would, with careful practice, easily attain great accomplishment. The saying 'Honour feeds the Arts' is absolutely true. Among the Greek authors, Philostratus devoted two books to 'Icons', books which are to be recommended for the singular elegance of their Attic language. Furthermore, regarding those works of art, those icons marked by their creators with an accompanying inscription, Angelo Poliziano recounts in his 'Miscellanea' that he saw something like a marble pedestal in Rome on which was inscribed in Greek ΣΕΛΕΥΚΟΣ ΒΑΣΙΛΕΥΣ. ΛΥΣΙΠΠΟΣ ΕΠΟΙΕΙ. This means that Seleukos, the King, Lysippos was making it.

2 Nicolas Bourbon (1503–after 1549)

Nicolas Bourbon was a neo-Latin poet whose works were much appreciated by influential patrons, including Jean de Dinteville, Georges d'Amboise, as well as by his friends Erasmus and Alciati. Imprisoned in France for his religious opinions, he subsequently fled to England, where he met Holbein, with whom he seems to have been on good terms. His poems on the painter's works draw on all the classical commonplaces used to praise works of art. At the end of this little volume – *Nicolai Borbinii Vandoperani Lingonensis Nugarum Libri Octo. Ab autore recens aucti et recogniti. Cum Indice* (Lyon: Gryphius, 1538) – a woodcut portrays Bourbon after a design by Holbein.

De Morte picta à Hanso pictore nobili
C A R M E N C L V I I I. Lib. VII:
Dum mortis Hansus pictor imaginem exprimit,
Tanta arte mortem rettulit, ut mors vivere

Videatur ipsa: & ipse se immortalibus
Parem Dijs fecerit, operis huius gloria. (p. 427)

In picturam Hansi regii apud Britannos
pictoris & amici
CARM. XXXVI. Lib. VIII:
Sopitum in tabula puerum meus Hansus eburna
Pinxerat, & specie qua requiescit Amor:
Ut vidi, obstupui, Chaerintumq; esse putavi,
Quo mihi res non est pectore chara magis.
Accessi proprius, mox saevis ignibus arsi:
Osculaq; ut coepi figere, nemo fui. (p. 450)

3 Draft of a Contract between Hans Holbein and the City Council of Basle, made in the hope of convincing the painter to leave England and settle in Basle

Ref.: Staatsarchiv Basel Stadt, Bestallungsbuch, letter dated Basle, 16 October 1538; published by Eduard His, 'Die Basler Archive über Hans Holbein, den Jüngern, seine Familie und einige zu ihm in Beziehung stehende Zeitgenossen', *Jahrbücher für Kunstwissenschaft* Year III, 1870, pp. 113–73, text pp. 131–2.

This contract must have been addressed to Holbein while he was in Basle. The City Council or the mayor held talks with Holbein, in order to know on which conditions he would contemplate his returning to Basle. The present document is kept in the Bestallungsbuch. It may be seen as a formal proposition for a contract, following some negotiations with the artist himself. The Bürgermeister who took the initiative to retain Holbein was not Jakob Meyer zum Hasen, the banker and Bürgermeister of Basle (1516–20) who commissioned the so-called *Meyer Madonna*, but Jakob Meyer zum Hirzen, who held office from 1530 to 1542 (Cf. Paul Meyer, 'Bürgermeister Jakob Meyer zum Hirzen, 1473–1541', *Basler Zeitschrift für Geschichte und Altertumskunde*, XXIII, 1925, pp. 97–142). This important document, which has lain unnoticed since it appeared in print in 1870, proves that the City Council had agreed to let Holbein keep existing patrons in 'Franckrich, Engelland, Meylannd, unnd niderland'. The mention of Milan is clear: Holbein had patrons in northern Italy, and was probably well acquainted with that country.

Meyster Hannsen Holbeins
des mallers bestallung.

Wir Jacob Meyger Burgermeister, unnd der Rath der Statt Basel, Thund khund, unnd Bekennend, mit disem Brieff, Das wir uß sonnderem geneigten willen, den wir zu dem Erbaren, unnserem lieben Burger, Hannsen Holbein, dem maler, von wegen, das er siner Künstriche, für anndere Maler, wyt berümpt Ist, tragend, Ouch umb willen, das er uns, In sachen, unnser Stett Büw, unnd annders belanngende, dessen er verstand dreit, mit Ratten diennstbar sin, unnd ob wir zun Ziten, malwerck zemachen hettend, unns dasselbig, doch gegen zimblicher belonung, getrüwlich vertigen sölle, Erst gesagtem Hannsen Holbein, zu Rechtem unnd frigem wartgelt, uff unserem Richthus, doch mit gedingen hienach volgt, unnd allein sin lebenlang, Er sye gsund oder sich, Jerlich glich zu den vier Fronvasten geteylt, fünffzig guldin, wart unnd diennstgelt, zegeben, unnd abrichten zelassen, bewilligt, verordnet unnd zugesagt haben, Also, demnach gesagter Hanns Holbein, sich Jetzt eine gute Zit, By der künigklichen Mayestat In Engelland, enthalten, unnd alß (sinem anzeigen nach) zu ersorgen, das er villicht Innerhalb zweyen Jaren den nechsten volgende, nit wol mit Gnaden, von Hoff scheyden möge ec., da so haben wir Im, noch zwey, die nechsten Jar, von dato volgende, daselbst In Engelland zeverbliben, umb ein gnedig urlob zediennen, unnd zuerwerben, unnd dise zwey Jar, siner Husfrowen, By unns wonhafft, jedes Jars vierzig gulden, Thut alle Quatember zechen guldin, unnd die uff nechst künfftige wienacht, in der fronvastenn Lucie, Allß für das Erst Zill,

abzerichten lassen bewilligt, Mit dem Anhang, ob Hanns Holbein Innerhalb disen zweyen Jaren, in Engelland abscheiden, unnd zu unns alhar gan Basel hußheblich komen würde, das wir Im, sin geordnete fünffzig Guldin wart, unnd diennstgelt, von Stund an gan, unnd Ime die, zu den Fronvasten glich geteylt, abrichten lassen wöllen, Uund alls wir wol ermessen können, das sich gesagter Holbein, mit siner Kunst unnd Arbeit, so wit me wert, dann das sy an alte Muren, unnd Hüser, vergüttet werden sölle, allein By unns nit am Basten, gewünlich betragen mag, da so haben wir gesagtem Holbein, gutlich nachgelassen, das er unverhindert unnsers Jar Eyds, doch Allein umb siner Kunst, unnd Hantwercks, unnd sunst gar kheiner anderen unrechtmessigen, unnd arglistigen sachen willen, wie er dessen von unns gnugsam erinneret, von frömbden Küngen, Fürsten, Herren, unnd Stetten, wol möge dienstgelt erwerben, annemen, unnd empfachen, das er auch die Kunststuck, so er alhie by unns machen wirdeth, Im Jar ein mal, zwey, oder drü, doch Jeder Zit, mit unnserem gunst, unnd erloubung, unnd gar nit hinder unns, In Franckrich, Engelland, Meylannd, unnd niderland, frembden Herren zu füren, und verkouffen möge, Doch das er sych In sollichen Reysen, gefahrlicher wyse, nit ußlendisch enthalte, Sonnder sine sachen, Jeder Zit, fürderlich ußrichte, unnd sich daruff one verzug anheimsch verfüge, unnd unns wie obstat, dienstbar sye, wie er unns dann zethund Globt und versprochen hat, Uund so, wann vilgenanter Holbein, nach dem gefallen Gottes, die Schuld der natur bezalt, unnd uß dem Zit dis Jamertals, verscheiden Ist, Alßdann soll dise bestallung, diennst unnd wartgelt, mit Sampt gegenwürtigem Brieff, hin, Tod, Uund ab, Wir unnd unnsere nachkomen dessenhalb niemanden nützit mer zegeben schuldig, noch verbunden sin, Alles uffrecht, Erbarlich, unnd on geferde, Des zu warem Urkhund, haben wir vilgenantem Holbein, Gegenwürtigen Brieff, mit unnser Stett Secret anhanngendem Insigel, verwart, zu hannden gegeben, Uff mitwuchen den xvi tag Octobris, Anno xxxviii.

With this document, We, Mayor Jacob Meyer and the city council of Basle, acknowledge and let it be known that, in view of our special affection towards our dear honoured fellow citizen Hans Holbein, who is famous among painters far and wide, and also in view of the fact that he will periodically be available to serve in the building of our city and related matters, if from time to time it becomes necessary to paint paintings he will, for an appropriate fee faithfully execute them. Initially, Hans Holbein will be awarded fair and unconditional administrative pay for painting our city hall, and in addition he will be awarded a lifelong salary, payable whether he is in good or ill health, to be distributed regularly, each year, four times a year at the seasonal times of fasting, ordered and approved in the amount fifty gulden, as administrative pay and fee for service. Accordingly, in return, the named Hans Holbein, who is currently with His Majesty the King of England, will see to it that within approximately the next two years, he leaves the court, even as we graciously allow him to serve out his time in England the next two years. During these two years, his wife, who resides here, is to be paid forty gulden yearly, payable quarterly in the amount of 10 gulden starting the coming Christmas, the fast of Lucie. This is on the condition that Hans Holbein leaves England within these two years and comes home to Basle, so that we may issue him his fifty gulden from that time on, and regularly at the times of Lent thereafter. And we can certainly appreciate that the aforementioned Hans Holbein will not earn enough by plying his art and craft on old walls and houses. Since, as a rule, he will not always have the best of possibilities here with us, we have allowed the named Hans Holbein to remain unencumbered by our yearly agreement, in furtherance of his art and handiwork, yet not for the furtherance of any other illegal or malicious purpose, exactly as he confirmed to us; he may seek payment for services to foreign kings, princes, noblemen and cities; he may accept and receive pay, and he may sell those works of art he will execute here, once, twice or three times a year, as long as they are always executed under our patronage and with our permission, not behind our backs; he may sell those works in France, England, Milan or in the Netherlands. However, during his travels, he must resist the temptation and not remain out of the country, but rather he must always take care of his business quickly, so that he can subsequently make himself available without delay at home, and, as mentioned above, stand ready to serve as he promised us. Then when, according to God's will, the oft-mentioned Holbein has paid his debt to nature, and it is time for him to depart from this valley of sorrow, then this position, the salary, the

administrative pay and this present document will become invalid. And we and our progeny will, therefore, not be employable, indebted or duty-bound to anyone. This all stated in a straightforward, honest manner, without duress, we have delivered this document, to which is affixed the seal of the secretary of the city, into the hands of the oft-mentioned Holbein. Executed this Wednesday, the 15th day of October, 38.

4 Poems on Holbein by John Leland (1506–52)

John Leland was educated at Christ's College, Cambridge, and became librarian to Henry VIII before 1530; he was made the King's antiquary in 1533, but died before completing his 'History and Antiquities of this Nation'. The following poems, devoted to Holbein's portrait of the young Edward, Prince of Wales, and comparing Holbein to Apelles, are known through a manuscript kept in the Bodleian Library, Oxford (MS Tanner 464, iv, fol. 55r, 64r); they were published in Foister 1989, pp. 504–5.

In effigiem Eadueardi principis incomparabilis:

Intentis quoties oculis vultumque coloremque
Aspicio laetum dive Edoarde tuum:
Expressam toties videor mihi cernere formam
Magnanimi patris, quo nitet ore tui.
Immortale decus pictorum holbenus amoenum
Pinxit opus rara dexteritate manus

Inscriptio pictae tabellae

Fertur Alexander pictorem manus Apellem
Unum nitido constituisse sibi
Henrici effigies octavi poscit et ipsa
Holbenae pingi dexteritate manus.

5 Matthew Parker (1504–75)

Matthew Parker, a fellow of Corpus Christi, Cambridge (1527), became chaplain to Ann Boleyn in 1535. Disgraced at the end of Henry VIII's reign, Elizabeth made him Archbishop of Canterbury in 1559. His *De Antiquitate Britannicæ Ecclesiæ et Privilegiis Ecclesiæ Cantuariensis cum Archiepiscopis eiusdem* (London: Day, 1572) is the earliest English book to be privately printed. The following passage (from p. 352) belongs to the life of William Warham: it gives precious information on the two portraits commissioned from Holbein by

Warham, one destined for Erasmus, the other for the Bishop's London residence, Lambeth Palace.

Erasmus etiam ignotus propter summam doctrinam tantopere ab eo adamatus est, ut cum Basileae ageret suam imaginem arte acuratissimi et ingeniosissimi pictoris (Hans Holby Flandrensis, quem ob eximiam pingendi notitiam Henricus Rex apud se retinuit) quam simillime depingi, & ad Warhamum per eundem pictorem in Angliam perferri curavit. Isque se aliis tabulis ab eodem pictore ad vivam similitudinem expressum & delineatum ad Erasmum vicissim misit. Quae excellentissimae doctorum patrum figurae a Reverendissimo Patre D. Matthaeo Cant. Arch. antiquitatis Anglicanae sedulo exploratore ac thesauro conservantur.

6 Nicholas Hilliard (1547–1619)

The son of a prosperous goldsmith, Hilliard had to leave England at the time when Queen Mary was persecuting Protestants, including Hilliard's father, a staunch supporter of the new faith; he followed John Bodley – the father of Thomas Bodley, founder of the Bodleian Library in Oxford – into exile between 1553 and 1559, and settled in Geneva. During Elizabeth I's reign, Hilliard became a favourite miniature painter. He wrote his *Art of Limning* in 1598–9. See *Nicholas Hilliard's Art of Limning. A new Edition of A Treatise Concerning the Arte of Limning Writ by N Hilliard*, Transcription by Arthur F. Kinney, Commentary by Linda Bradley Salamon, Foreword by John Pope-Hennessy (Boston: Northeastern University Press, 1983), pp. 18–19.

Heer must I needs incert a word or two in honore and praisse of the renowned and mighty *King Henry the eight* a *Prince* of exquisit Iugment: and *Royall* bounty, soe that of cuning Stanger even the best resorted vnto him, and remoued from other courts to his, Amongst whom came the most eccelent painter and limner *Haunce Holbean*, the greatest M[as]ter truly in both thosse arts after the liffe that euer was, so cuning in both to gether, and the neatest, and the[r]withall a good inuentor soe compleat for all three, as I neuer hard of any better then hee yet had the *King* in wages for *Limning* diuers others, but *Holbeans* maner of *Limning* I haue ever Imitated, and howld it for the best, by Reason that of truth all the rare siences especially the arts of *Caruing*, *Painting*, *Gouldsmiths*, *Imbroderers*, together with the most of all the liberall siences came first vnto vs from the Strangers, and generally they are the best, and most in number, I hard Kimsard [Ronsard] the great french poet on a time say, that the Ilands indeed seldome bring forth any cunning Man, but when they doe, it is in high perfection so then I [fol. 2v] hope there maie come out of this ower land such a one, this being the greatest and most famous Iland of *Europe*.

References

I: Artistic Competition and Self-definition

1 Erasmus 1521; Heitz and Bernoulli 1895, no. 102, with other versions nos. 103–4 and 105–12; cf. Hieronymus 1984, no. 389, pp. 407–8; Hollstein 1988, vol. XIVA, no. 34, p. 30.

2 Pliny, *Naturalis historia*, XXXV, 81–3, Pliny 1967, IX, lib. 35, 81–3, pp. 320–23; Waal 1967; Gombrich 1976, pp. 15–16.

3 Holbein also borrowed the image of the divine hand for his *Allegory of Time*, which was used in 1521 for the tailpiece to Johannes Eck's *De primatu Petri*. For the iconography of the three-headed alexandrian monster see Erwin Panofsky, 'Titian's "Allegory of Prudence": A Postscript', in Panofsky 1955, pp. 181–205.

4 Ganz 1949, no. 155, p. 246; Holbein 1960, no. 167, pp. 196–7; Rowlands 1985, no. 12, p. 128; Amerbach-Kabinett 1991, Gemälde, no. 32, p. 22. Holbein's small painting for Johannes Froben was based on the printer's mark of Urs Graf, which dates from 1517, although in this latter example the hands are not represented as emerging from clouds; cf. Heitz and Bernoulli 1895, nos. 31, 46.

5 Pliny, *Naturalis historia*, XXXV, 92: 'Digiti eminere videntur et fulmen extra tabulam esse'. Pliny 1967, IX, lib. 35, 92, pp. 328–9.

6 Hieronymus 1984, no. 389, pp. 407–8, relates the small panel with the lines painted on it to the *Parabolæ* of Erasmus: just as Protogenes could recognize Apelles' hand from one single line, so can one single response allow us to know a man's wit and intellect.

7 Pliny, *Naturalis historia*, XXXV, 91; Pliny 1967, IX, lib. 35, 91, pp. 324–5; Müller 1996, no. 41, p. 58, pl. 13.

8 Horace, *De arte poetica*, v. 1–5, Horace 1939, pp. 450–1: 'Humano capiti cervicem pictor equinam / iungere si velit et varias inducere plumas / undique conlatis membris, ut turpiter atrum / desinat in piscem mulier formosa superne, / spectatum admissi risum teneatis, amici?'

9 Amerbach-Kabinett 1991, Zeichnungen, no. 100, pp. 33–4; Müller 1996, no. 63, p. 62, pl. 19.

10 Emil Maurer, 'Holbein jenseits der Renaissance. Bemerkungen zur Fassadenmalerei am Haus zum Tanz in Basel', in Maurer 1982(1), pp. 123–33; Klemm 1972.

11 Müller 1989.

12 Roskill and Harbison 1987; Müller 1989.

13 In Burckhardt's lecture series, 'Holbein & die italienische Renaissance', in Burckhardt, Jacob, Vorlesung, MS, Staatsarchiv, Basle, PA 207, 164. For this reference and documentation we should like to thank Prof. Emil Maurer, Zurich. Cf. Kaegi, 1947–77, VI/2, pp. 516–17.

14 Cennini 1971, pp. 3-4: 'e quest'è un arte che si chiama dipignere, che conviene avere fantasia e operazione di mano, di trovare cose non vedute, cacciandosi sotto ombra di naturali, e fermarle con la mano, dando a dimostrare quello che non è, sia'. André Chastel, 'Le "Dictum Horatii quidlibet audendi potestas" et les artistes (XIIIe–XVIe siècle)', in Chastel 1978, I, pp. 363–76; Kemp 1977; Summers 1981, Part I: 'Fantasy', pp. 31–282; Warnke 1993.

15 Welt im Umbruch 1980, I, pp. 76–88; Busch 1973. For the importance of the Augsburg *Mercury* for Dürer's use and understanding of Antiquity cf. Erwin Panofsky, 'Albrecht Dürer and Classical Antiquity', in Panofsky 1955, pp. 277–339; Peutinger 1520, for the first publication of the *Mercury*.

16 Panofsky 1977, pp. 117–19.

17 Dürer 1956–69, II, pp. 392–4; cf. Felix Thürlemann, 'Das "Allerheiligenbild" und die Notiz "Von Farben"', in Thürlemann 1990, pp. 71–89.

18 Holbein 1960, no. 241, p. 239. The catalogue entry mentions that Holbein corrected this 'error' in his *Darmstadt Madonna*. Cf. also Imdahl 1986(2). In the famous *Body of the Dead Christ in the Tomb* (1521 or 1522), the white linen sheet softens the edges of the painted niche and two wisps of hair and the hand of the dead man extend over it. For the question of the niche intersected by the body, Cranach's engraved portrait of Luther (1520) and the portrait of Charles V under his device *Plus ultra* (always further) can be taken as parallels. Contrasted with the cold geometry of the niche, the vivid character of the figure is enhanced. Bartsch 1978–, II (1980), no. 5 (278), p. 317, and no. 128 (294), p. 421.

19 Emil Maurer has drawn attention to the provenance of this idea from Dutch art: Emil Maurer, 'Konrad Witz und die niederländische Malerei', in Maurer 1982(1), pp. 45–63.

20 Preimesberger 1991.

21 For examples of this see the sketches of the life of the Virgin Mary and of Christ, cf. Falk 1979, no. 149, p. 75. Eisler 1970. For the *Christ as the Man of Sorrows* see Holbein d. Ae 1965, no. 42, p. 88.

22 Petrarch 1532, fol. LIV; on the long publishing history of this work cf. Manfred Lemmer in the reprint Hamburg, 1984, pp. 181–209. Pliny, *Naturalis historia*, XXXV, 65; Pliny 1967, IX, lib. 35, 65, pp. 308–9; Pliny then goes on to relate Zeuxis' double defeat at the hands of Parrhasios and the birds.

23 Pliny, *Naturalis historia*, XXXV, 86–7, 92; Pliny 1967, IX, pp. 324–5, 328–31; Kris and Kurz 1934; Reinach 1985, pp. 314–61; Junius 1694, including the *Catalogus architectorum, mechanicorum, sed praecipue pictorum, statuarorium, caelatorum, tornatorum*, 1694, pp. 16–23; Dati 1667, pp. 80–151; Pollitt 1974; Rouveret 1989; Fraenkel 1992; cf. for modern interpretations, Signatures 1991.

24 Alberti 1972, lib. III, no. 53; Massing 1990; Cast 1981.

25 Filarete 1972, II, p. 582; Dürer 1956–69, II, p. 100: 'Item vor vill hundert jorn sind etlich gros meister gewest, do fan Plinius schreibt, als der Apelles, Prothogines, Phidias, Praxideles, Politeklus, Parchasios und dy anderen. Der etlich haben künstliche pücher beschriben van der molerey, aber leider, leider, sy sind verloren. Dan sy sind uns verporgen und manglen jrer grossen sinreihkeit.'

26 Aretino's letter to Michelangelo dated 16 September 1537, in Aretino 1957–60, I, doc. XXXVIII, p. 65: 'il tempo non ha consentito che il far loro sia visso sino al dì d'oggi; cagione che noi, che pur diamo credito a ciò che ne trombeggiano le carte, sospendiamo il concedervi quella palma che . . . vi darebbero essi, se fusser posti nel tribunale degli occhi nostri' (Time has not allowed that their manner should be seen today; for this reason we, giving credit to their praise as proclaimed by the documents, must suspend giving you that palm which, if they came to the tribunal of our eyes, we should have to give to you).

27 Hind 1938–48, V, no. 29, p. 119. The geometric figures and the alcove find an echo in Filarete's architectural treatise, where the use of a ruler and a pair of compasses is recommended. The ancient painters, however, could forego these aids thanks to their surer hand. Cf. Filarete 1972, II, p. 643: 'se già non facessi come dice fu Appelle, e anche Zeisis, el quale dice che tirava le sue linee diritte col pennello, come fatto avesse proprio con la riga e più: che in su una sua sottilissima linea che lui aveva fatta el sopradetto ne tirò un' altra, la quale era molto più sottile: in uno tratto per mezzo d'essa gliene tirò un'altra. O vero, come che dice quegli ancora, l'uno girò uno tondo perfetto sanza sesto, e l'altro al primo posto punto nel mezzo misse, el sesto l'avesse proprio fatto' (already not to have done it as Apelles and also Zeuxis were said to have, who, it is said,

drew his straight lines with the brush, as if indeed they had been done with a ruler and more: that over a very fine line which he had drawn the aforesaid drew another which was much finer: in one stroke through the middle of this one the other then drew another stroke. Or indeed as someone else tells, one drew a perfect circle without a compass and the other added a point right in the centre, exactly where a compass would have defined its place).

28 Weisskunig 1887, pp. 1–558, esp. pp. 74–5, fol. 136b–137a; Falk 1968; Burgkmair 1973; cf. for the ennobling of painting and for the prince's memory of the relationship between Alexander the Great and Apelles, the letter written by Jacopo de'Barbari in 1500/01: Kirn 1925; Levenson 1981. Cf. the *Pattern-sheet with Animals, Angel, and a Savage Man*, probably from the area of the Upper Rhine, from *c.* 1430/40, Frankfurt, Städelsches Kunstinstitut, Graphische Sammlung; and the 'Holbein-Tisch' in Zurich, Landesmuseum. For this latter see Wüthrich 1990.

29 See however the letter from Francesco Florio to Jacopo Tarlati of 1477 on the subject of a portrait of Pope Eugene IV by Jean Fouquet. Florio assures Tarlati that by the verisimilitude of his portrait Fouquet has bettered Polygnot and Apelles and has almost achieved the same level of creation as had Prometheus; cf. Stechow 1966, p. 146; Salmon 1855, especially p. 105.

30 Erasmus 1523(1), p. 96: 'conveniet in quosdam scriptores, plus satis accuratos, & morosae cuiusdam diligentiae, qui sine fine premunt suas lucubrationes, semper aliquid addentes, adimentes, immutantes, & hoc ipso maxime peccantes, quod nihil peccare conantur' (It is appropriate to those writers who are more accurate than the average, and of a certain sad diligence, who rework endlessly their thoughts, always adding something, amending, altering this or that, and making the greatest error precisely in their attempt not to make any).

31 Philipp Melanchthon, Preface to his Latin translation of *Contra Aristogitonem Demosthenis orationes* (1527), in Melanchthon 1834–60, I, no. 462, cols. 888–90: 'Et ut verecunde fecerunt pictores, qui corruptam Apellis Venerem reficere voluerunt, cum desperarent, reliquo corpori eam partem responsuram esse: ita rectissimum esset, ut opinor omnino non attingere Demosthenum, cum nullius versio exprimere exemplar possit' (And as did those painters with modesty, who, as they wanted to restore the damaged Venus by the hand of Apelles, despaired to add a part, that would do justice to the rest of the body, in the same way, it would be most correct, that, so I think, one did not touch at all Demosthenes, since no-one's touched-up version can match the original in expression). Erasmus of Rotterdam, Preface addressed to Stanislaus Sturzo, in Erasmus 1525, cites the two unfinished paintings by Apelles and adds: 'Quo magis probata est artificum modestia, hoc magis detestanda est quorundam temeritas, ne dicam impietas, qui Plinianum opus, omnibus omnium sculptorum ac pictorum operibus anteponendum, sic vel describendo vel excudendo corruperunt, ut devotis animis in tam eximii scriptoris exitium conspirasse videri queant. Atqui id ne fieret, oportuit regum esse curam, quum nullus sit liber dignior qui regum manibus teratur, quod non ex alio citius hauriatur rerum omnium cognitio.'

32 Desiderius Erasmus, Preface addressed to Stanislaus Sturzo, in Erasmus 1525: 'Nonnulles operum ea divinitas fuit, ut omnium artificum manus, inimitabili quadam artis eminentia deterrent, vel à supplendo quod erat inchoatum, vel à sarciendo quod erat depravatum'. Cf. Grafton and Jardine 1986; Grafton 1990.

33 For commentaries on Pliny during the Renaissance see Charles G. Nauert in Cranz and Kristeller 1980, IV, pp. 297–422.

34 Johannes Manlius, *Locorum communium Collectanea*, 1563, in Dürer 1956–69, I, p. 327.

35 Manuscript poem in *Conradi Celtis Protucii Germani poete laureati libri quinque epigrammatum*, Kassel, Landesbibliothek, *c.* 1500, published by Wuttke 1967, p. 322; Wuttke 1980; Anzelewsky 1983; Panofsky 1942.

36 Vasari 1986, pp. 349–50; Pope-Hennessy 1974, pp. 5–8; cf. with reference to Titian: Kennedy 1964.

37 Wimpfeling 1505, fol. XXXIXb: 'eius discipulus Albertus türer & ipse alemanus hac tempestate excellentissimus est & Nurenberge imagines

absolutissimas depingit'; Pliny, *Naturalis historia*, XXXV, 96; Pliny 1967, IX, lib. 35, 96, pp. 332–3.

38 Dürer 1956–69, I, pp. 290–93; Bialostocki 1986, pp. 15–36.

39 Erasmus 1528, I, p. 68; Dürer 1956–69, I, pp. 296–7. The passage refers to Pliny, *Naturalis historia*, XXXV, 131 [about Nikias of Athens] 'lumen et umbras custodiit atque, ut eminerent e tabulis picturae, maxime curavit' (he painted the light and the shadows with care, and made his paintings in such a way that they seem to be in rilievo); Pliny 1967, IX, pp. 356–7. Cf. also the anecdote of Dürer's surly reply to the Emperor Maximilian, copying Apelles' answer, and recounted by Philipp Melanchthon in his *Dicta* published in 1556, in Dürer 1956–69, I, p. 325. Panofsky 1951; Panofsky 1969; Hayum 1985; Bialostocki 1986, pp. 15–36; E. H. Gombrich, 'The Pride of Apelles: Vives, Dürer and Bruegel', in Gombrich 1976, pp. 132–4.

40 Alberti 1972, lib. II, no. 28, pp. 64–5; cf. the letter by Jacopo de'Barbari to Friedrich den Weisen: Kirn 1925, pp. 130–34; Levenson 1981; Willibald Pirckheimer in his marginal annotation to *De his qui sero vindicantur à numine* by Plutarch: 'De arte nemo nisi expertus iudicat' (No-one apart from an expert should judge art) in Plutarch 1518, p. 134. Wittkower 1950.

41 Erasmus 1906–58, VI, no. 1740, pp. 391–2, letter to Peter Gillis (Petrus Aegidius), Basle, 29 August 1526.

42 Amico 1988, pp. 84–90; Nauert 1979.

43 Rowlands 1985, nos. 2, 5, pp. 125, 126.

44 For the signature on the Hertenstein house: Bätschmann 1989, pp. 2–4. For the title-border with Mucius Scaevola and Porsenna: Holbein 1960, no. 339, p. 287. For the design for the stained glass, dated 1519: Müller 1988, no. 22, p. 85; Müller 1996, no. 278, pp. 146–7, pl. 82. Cf. also the encoded signature *NAMBRO* of Ambrosius Holbein in the representation of Artemisia in the Great Hall of the monastery of St Georgen in Stein am Rhein: Frauenfelder 1958, p. 133, ill. 158, 184, pp. 120, 141; Konrad 1992, esp. pp. 88–9.

45 Pliny, *Naturalis historia*, Pref., 26–7; Pliny 1967, I, Pref., 26–7, pp. 16–19: 'ex illis mox velim intelligi pingendi fingendique conditoribus quos in libellis his invenies absoluta opera et illa quoque quae mirando non satiamur, pendenti titulo inscripsisse, ut "Apelles faciebat" aut "Polyclitus", tamquam inchoata semper arte et inperfecta, ut contra iudiciorum varietates superesset artifici regressus ad veniam, velut emendaturo quicquid desideraretur si non esset interceptus. Quare plenum verecundiae illud est quod omnia opera novissima inscripsere et tamquam singulis fato adempti. Tria non amplius, ut opinor, absolute traduntur inscripta; "ille fecit" (quae suis locis reddam); quo apparuit summam artis securitatem auctori placuisse, et ob id magna invidia fuere omnia ea.'

46 The edition in question is the following: *Caii Plynii Secundi Naturalis Historiæ Libri XXXVII nuper studiose recogniti, atque impressi Adiectis variis Antonii Sabellici, Raphaelis Volterrani, Beroaldi, Erasmi, Budei, Longolii adnotationibus, quibus Mundi historia locis plerisque vel restituitur, vel illustratur*, Paris: Chalder, 1516 [Stadt- und Universitätsbibliothek Bern, A.D. fol.14], with manuscript notes by Heinrich Bullinger. According to his *Diarium*, Bullinger read this book in 1520, cf. Bullinger 1904, p. 5 (18 June 1520). Bullinger, who was then sixteen years old, seems to have continued to appreciate Pliny since he included him in his *Ratio Studiorum*, cf. Bullinger 1982, II: Briefe des Jahres 1532, p. 97.

47 Poliziano 1522(2).

48 Scheurl 1509, non-paginated: 'id quem Durerum nostrum Pirchamerus, vir latine et graece vehementer eruditus, et ego te quoque ad illo mutuare iussimus; ita ago, hanc orationem plane non habui, sed habebam, non dixi, sed dicebam, non peroravi, sed perorabam'.

49 For Dürer's vision of the kingdom of God on earth in his Landauer-Altar, cf. Panofsky 1977, pp. 168–76.

50 Hollstein 1988, XIV, no. 19a, p. 75, further uses of the title-borders, p. 76; Hieronymus 1984, p. 248; Holbein 1960, no. 119, pp. 154, 159. Massing 1990, pp. 270–71 (6B); Hind 1938–48, V, no. 12, pp. 165–6; Cast 1981, pp. 66–8.

51 Article 'Lais', in Pauly 1894–1980 (1924), XII (1), cols. 513–16.

52 For the journey in France and for Holbein's revised ideal of beauty, cf. chapter Five. Holbein's painting was listed in Basilius Amerbach's

Inventar D of 1585–7, cf. Amerbach-Kabinett 1991: Beiträge zu Basilius Amerbach, p. 145; the *Venus and Cupid*, although similar in many respects, is not a pendant to the *Laïs Corinthiaca*, cf. Amerbach-Kabinett 1991, Gemälde, nos. 34, 35, pp. 23–4; Rowlands 1985, nos. 21, 22, p. 131; Meyer zur Capellen 1984 re-examines the ideas about the life of Holbein's model.

53 Peutinger 1505.

54 The inscription runs: 'PICTA LICET FACIES VI / VAE NON CEDO SED INSTAR / SVM DOMINI IVSTIS NO / BILE LINEOLIS. / OCTO IS DUM PERAGIT / TPIETH SIC GNAVITER IN ME / ID QVOD NATVRAE EST, / EXPRIMIT ARTIS OPVS. / BON. AMORBACCHIVM / IO. HOLBEIN. DEPINGEBAT / A. M. D. XIX. PRID.EID.OCTOBR'. Ganz 1950, no. 30, p. 210 gives the following translation: 'Although painted, I yield nothing to life, and I am in true lines a refined portrait of my master. In me is he so depicted through so fine an art, just as Nature made him grow after thrice eight years of his life. (*Obwohl gemalt, weiche ich nicht dem Leben, und bin in wahren Linien ein vornehmes Bild meines Herrn. In mir ist er so durch die schöne Kunst gebildet, wie ihn die Natur nach dreimal acht Jahren seines Lebens wachsen liess.*) Slight differences are to be found in Holbein 1960, no. 149, pp. 180–81; Paul H. Boerlin in Amerbach-Kabinett 1991, Gemälde, no. 30, pp. 20–21, translates the inscription into German as follows: 'Obwohl ich nur ein gemaltes Gesicht bin, stehe ich dennoch dem lebendigen [Gesicht] nicht nach, sondern bin durch wahre Züge ["Linien"] ein kenntliches Bild des Herrn. Während er achtmal drei Jahre vollendet, zeigt so mit Fleiss das Kunstwerk durch mich das, was Wirklichkeit ist'. Rowlands 1985, no. 7, pp. 126, 31–2; Roskill and Harbison 1987, pp. 11–12; Elisabeth Landolt in Amerbach-Kabinett 1991, Beiträge zu Basilius Amerbach, pp. 145, 154.

55 Pliny, *Naturalis historia*, XXXV, 63; Pliny 1967, IX, lib. 35, 63, pp. 308–9: [et athletam] 'adeoque in illo sibi placuit, ut versum subscriberet celebrem ex eo, invisurum aliquem facilius quam imitaturum'. This idea is already present in Holbein the Elder's *Madonna Montenuovo*; Holbein 1960, no. 13b, p. 71; cf. Heckscher 1967, especially pp. 137–9. Erasmus was probably already working in 1523 on the edition of Pliny, which was published in 1525 by Froben in Basle as *Historia Mundi*. Dürer replied to his detractors in the preface to his *Vier Bücher von menschlicher Proportionen* in 1528, 'das gar viel leichter sey ein Ding zu tadeln/dan selbs zu erfinden' (that it is much easier to depreciate the value of a thing than it is to create it yourself), fol. Aij. On the pilaster and its meaning, see chapter Six.

56 Plutarch 1985, pp. 38–9 [346 A], and note 16, pp. 65–6. Reinach 1985, no. 194, pp. 186–7; Heckscher 1967, p. 138, note 28, limits himself to discussing the signatures on portraits. Pliny seems to have confused Apollodorus with Zeuxis, *Naturalis historia*, XXXV, 63.

57 The *Moralia*, translated by Erasmus, was published in 1514: *Opuscula Plutarchi nuper traducta*, Basle: Froben, 1514.

58 Panofsky 1977, pp. 319–20; Hayum 1985.

59 *Disertissimi Viri Angeli Politiani linguae latinae vindicatoris, Epistulae lepidissimae*, edited by Petrus Aegidius, Antwerp: Theodoricus Martini, 1514; [Angelo Poliziano], *Angeli Politiani, et aliorum virorum illustrium, Epistolarum libri duodecim*, Basle: Cratander, 1522; Juan-Luis Vives, *De epistolis conscribendis*, Antwerp: Hillenius, 1534. These treatises were gathered together in the following edition published in Basle: [Juan-Luis Vives], *Linguae latinae exercitatio, Io. Lodo. Vivis Valentini*, Basle: Vuinter, 1543; Vives, *Linguae latinae exercitatio*, pp. 338–9; Vives, *De epistolis conscribendis*, pp. 441–2; Erasmus, *Brevissima maximaque compendaria conficiendarum epistolarum formula*, pp. 465–6; Christoph Hegendorf, *Methodus conscribendi epistolas*, p. 485; Conrad Celtis, *Methodus conficiendarum epistolarum*, pp. 485–6.

60 The portraits that Quentin Massys executed of Peter Gillis and Erasmus were sent to England.

61 Dürer 1956–69, I, p. 277: 'ut habeas Eobanum vel pictum, interim dum verum non potes: quamvis, ut spero, melius exprement literae, quam ullus Apelles, ullaque pictorum manus'.

62 Melanchthon 1991, I, texts 1–254 (1514–21), doc. 138, p. 279.

63 Cf. as examples: Lucas Cranach, *Martin Luther as an Augustinian Monk*, 1520, copperplate engraving with the inscription: 'AETHERNA IPSE SVAE MENTIS SIMVLACHRA LVTHERVS / EXPRIMIT.AT VVULTVS CERA LUCAE OCCIDVOS / M.D.X.X.'; for this see Warnke 1984. Dürer, *Portrait of Willibald Pirckheimer*, 1524, B. 106: 'VIVITVR.INGENIO.CAETERA.MORTIS. / ERVUNT.' For further examples see Luther 1983(I).

64 Peter-Klaus Schuster, 'Ueberleben im Bild. Bemerkungen zum humanistischen Bildnis der Lutherzeit', in Luther 1983(I), pp. 18–25.

65 Cf. the account by Kaspar Peucerus, *Tractatus historicus de Philippi Melanchthonis sententia de controversia Coenae Domini* (1596), in Dürer 1956–69, I, 5, p. 306: 'saepeque erupit in has voces: "Non" (inquiens), "pingi ista possunt." "At ista", inquit Durerus, "quae tu adfers, nec dici quidem nec animo concipi possunt"'; Bialostocki 1986, pp. 15–36; E. H. Gombrich, 'The Pride of Apelles: Vives, Dürer and Bruegel', in Gombrich 1976, pp. 132–4.

66 Ganz 1949, no. 53, p. 219; Holbein 1960, no. 181, p. 212; Rowlands 1985, no. 60, pp. 143–4.

67 Ganz 1949, no. 69, p. 225; Rowlands 1985, no. 44, p. 139, cf. also chapter 4, 'The King's Painter, "The Apelles of Our Time"', pp. 81–122.

68 Erasmus 1528, p. 68; Dürer 1956–69, I, pp. 296–7.

69 For Holbein's portrait of Nicholas Bourbon see Parker 1945, no. 37, p. 46; Foister 1989; Holbein 1988, no. 47, pp. 132–3.

70 Bourbon 1538, lib. III, carmen viii, p. 153; lib. VI, carmen xii, p. 338; VII, carmen clviii, p. 427; lib. VIII, carmen xxxvi, p. 450. Nicolas Bourbon wrote the introduction to the *Historiarum veteris instrumenti icones*, with illustrations by Holbein that was first published by Melchior and Gaspar Trechsel in Lyon in 1538–9. See on Bourbon: Saulnier 1954; Lauvergnat-Gagnière 1991. Rowlands 1985, ch. 4, pp. 81–122, especially pp. 90–91.

71 Erasmus 1528, p. 68; Dürer 1956–69, I, pp. 296–7.

72 Hollstein 1988, XIV, no. 9, pp. 149–51. Woltmann 1874–76, I, pp. 357–8; Holbein 1960, no. 433, pp. 338–9 (first version); Rowlands 1980.

2. Figure and Movement, Invention and Narration

1 On Hans Herbst see Wüthrich 1990; Reinhardt 1982, pp. 253–6, with the important reference to an entry in Myconius' copy of the *Laus Stultitiæ* dating from 21 December 1515 and court records of 25 July 1516.

The assumption that Ambrosius participated in the decoration of the banqueting-hall of the monastery of St Georgen in Stein am Rhein is supported by the interpretation of the annotation 'NAMBRO' as his signature (HolbeiN AMBROsius); this annotation was placed on the neck of the Artemisia. For this see Vetter 1884. Recently Konrad 1992 has suggested that Hans Holbein was also involved in this work at Stein am Rhein.

2 Rowlands 1985, pp. 21–2, no. 2, p. 125; Klemm 1980, pp. 10–13, 69; Müller 1996, nos. 92 and 93, p. 67. On Jakob Meyer: *Historisch-Biographisches Lexikon der Schweiz*, V, Neuchâtel: Administration des Historisch-Biographischen Lexikons der Schweiz, 1929, pp. 97–8; His 1870, especially p. 159.

3 Rowlands 1985, no. 1, p. 125; Amerbach-Kabinett 1991, Gemälde, nos. 22, 23, pp. 17–18; Klemm 1980, pp. 5–7, 68; Holbein 1960, 133 a, b, pp. 168–9. On Oswald Myconius see Rudolf 1945; Rüsch 1983; Margolin 1985; Hagenbach 1859, pp. 309–462; Bietenholz and Deutscher 1985–87, II, p. 475.

4 Hollstein XIV A, B; Hieronymus 1984; Reinhardt 1977; Schmid 1899.

5 Wackernagel 1907–54, III, p. 28, Basle's right to mint coins granted by Pope Julius II, dated 29 December 1512.

6 Falk 1968, pp. 57–9; Burgkmair 1973, no. 76; Rowlands 1985, pp. 21–2.

7 Falk 1968, pp. 54–5; Köln 1969, nos. 850, 851, pp. 32–4; Köln 1986, p. 19.

8 Anzelewsky 1971, nos. 60, 62, pp. 163–4; for Dürer as a portrait painter see Koerner 1993.

9 The portrait drawing of Georg Fugger (1453–1506) is now lost; in 1650 it was in the collection of Joachim von Sandrart, cf. Sandrart 1925, p. 332; on the drawn and painted portrait of Jakob Fugger (1459–1525), cf. Winkler 1936–9, III, no. 571, pp. 35–6, which dates it to 1518; Strauss

1974, IV, no. 1525/15; for the painting: Anzelewsky 1971, no. 143, p. 249; Augsburg 1988, no. 717, pp. 58 – 62.

10 Bushart 1994.

11 Anzelewksy 1971, no. 93, pp. 187 – 9; for Fugger's commission to Giulio Romano for S Maria dell'Anima, Rome, cf. Giulio 1989, pp. 77 and 262.

12 Holbein the Elder's portrait drawings of Jakob Fugger are in Berlin, SMPK, Kupferstichkabinett; cf. Lieb and Stange 1960, nos. 263 – 5, pp. 108 – 9.

13 Michael 1986; Müller 1996, no. 62, pp. 61 – 2.

14 Müller 1988, no. 1, pp. 18 – 19; Müller 1989; Müller 1996, no. 94, p. 68.

15 Falk 1979, nos. 242 – 60, pp. 96 – 9; on the Passion paintings in the Städel, Frankfurt and in Donaueschingen, Fürstenberg Sammlungen: Lieb and Stange 1960, no. 17, pp. 59 – 61 and no. 11, pp. 56 – 7; Grimm and Konrad 1990, pp. 167 – 9.

16 Müller 1988, no. 79, pp. 247 – 9; Müller 1996, no. 188, pp. 123 – 4.

17 Rowlands 1988, no. 53, pp. 80 – 81; Winkler 1936 – 9, II, nos. 333, 336, pp. 57 – 9; Strauss 1974, II, no. 1504/17, p. 760 and no. 1504/13, p. 754; on the engraving Adam and Eve of 1504 see Strauss 1976, no. 42, pp. 128 – 32.

18 Or a reversed copy, cf. Bartsch 1978 –, XV, 28, no. 29, p. 106; Carroll 1987, no. 26, p. 105.

19 Krahn 1995, no. 38, pp. 218 – 19 (the dating 1520/30 is too generous).

20 Dürer 1956 – 69, III, no. 13, p. 158; Strauss 1974, III, no. 1513/5, p. 1346.

21 Müller 1988, no. 79, pp. 247 – 9, prefers the later date, while Landolt 1972, no. 74, dates the drawing to the period around 1520.

22 Müller 1988, no. 77, pp. 243 – 4; on the so-called English Sketchbook, see Falk 1979, no. 167, Woltmann 1874 – 6, II, pp. 112 – 15 (with the description of the state of the book as it had already been changed); Müller 1996, no. 190, pp. 126 – 7, and important developments on the question of the English Sketchbook, pp. 124 – 5.

23 Dürer, 1528; Panofsky 1945, I, p. 86, II, no. 1599, p. 149; Panofsky 1921/22 and 1955.

24 Panofsky 1945, I, pp. 84 – 7, II, no. 108, p. 21; on the Apollo and Diana in the British Museum see Rowlands 1988, no. 51, pp. 78 – 80.

25 Dürer 1528: Das viert Buechlein, fol. X iiij v–fol. X v r.

26 Dürer 1528, Book I, fol. E iii verso; Holbein's drawing is discussed thoroughly in Müller 1996, no. 189, p. 126.

27 Werner 1980, no. 8, pp. 17 – 18 (1543 edition); Bartsch 1978 –, XIII, no. 34 f (480), p. 144 (1542 edition).

28 Müller 1988, nos. 77, 78, pp. 243 – 6, which dates both drawings to the period 1532 – 43 and refers to Dürer.

29 Sandrart 1675 – 9, I, part I, book 3, p. 55 (as a comparison we know that Raphael's portrait Baldassare Castiglione was worth 3500 guilders in 1639 in Amsterdam), Part 2, Book 3, p. 249. Woltmann 1866 – 8, I, pp. 243 – 6; Woltmann 1874 – 6, I, pp. 167 – 72. In 1642 the council forbade Matthäus Merian to reproduce the picture.

30 Hegner 1827, p. 78; Woltmann 1866 – 8, I, pp. 243 – 51; Woltmann 1874 – 6, I, p. 167 – 72; Holbein 1960, no. 175, pp. 204 – 5; Klemm 1980, pp. 34 – 9, 71; Rowlands 1985, pp. 62 – 3, no. 19, p. 131: Passion Altarpiece.

31 Lieb and Stange 1960, no. 21, pp. 63 – 4; Alte Pinakothek 1983, pp. 248 – 50.

32 Frankfurt Städel 1966, pp. 54 – 5; Grimm and Konrad 1990 pp. 167 – 9, Lieb and Stange 1960, nos. 17, II, pp. 59 – 61, 56 – 7; cf. the copies in Basle: Falk 1979, nos. 242 – 9, 250 – 60, pp. 96 – 9.

33 Winzinger 1975, pp. 15 – 24, nos. 9 – 24, pp. 78 – 82

34 Matth. 26:57 – 68; Mark. 14:53 – 65; for the Small Woodcut Passion see Strauss 1980, nos. 106 – 42, pp. 342 – 414; for the Engraved Passion see Strauss 1976, nos. (1512)58 – (1512)67, pp. 168 – 86.

35 John 18:12 – 24; Müller 1988, no. 49, pp. 166 – 7: Christ in front of Caiaphas, or rather Christ in front of Hannas, as for example in Martin Schongauer's engraving (Lehrs 1925, 21), because the signs identifying Caiaphas do not appear; compare with Dürer, Christ in front of Caiaphas (Small Woodcut Passion, B.29), with Caiaphas and the soldier, B.6 (1512), Engraved Passion.

36 Mantegna 1992, nos. 38 (Mantegna, Entombment, c. 1472), 39 (second state), 40 (reversed copy by Giovanni Antonio da Brescia, c. 1509).

37 Kugler and Burckhardt 1847, II, pp. 279 – 81; Woltmann 1866 – 8, I, p.

246, remarked on the use of John in Holbein's Christ on the Cross. On Raphael's Borghese Entombment Locher 1994; Raphael's picture was kept in the church of S Francesco a Prato (Perugia) until it was stolen by Scipione Borghese in 1608. Engravings after the painting are known only from the middle of the seventeenth century onwards. A French engraving was made in the sixteenth century, probably after Luca Penni's picture inspired by that of the master, Raphael 1983(2), p. 310, fig. 53; Bartsch 1978 –, XXXIII, no. 24 385, p. 301.

38 Kugler and Burckhardt 1847, II, pp. 279 – 80: 'Das Ganze trägt den Charakter angestrengten Einzelstudiums, als hätte der Künstler diessmal das Vollendetste und Durchgebildetste geben wollen, und hieraus mag sich am besten das Befangene, Bewusste und Absichtliche erklären, was diese Passion von seinen frühern und spätern Werken unterscheidet.'.

39 The publisher's address given in the first edition – 'A LYON Soubz l'escu de COLOIGNE' – is the address of the booksellers Jean and François Frellon. On Hans Lützelburger: Hieronymus 1984, p. xxx; cf. Dance of Death 1902.

40 Holbein 1960, no. 418, pp. 327 – 8; Hieronymus 1984, no. 441, pp. 495 – 7.

41 His-Heusler 1870.

42 Michael 1992. A good explanation for this late publication of the two series of woodcuts in Lyon had not been found until then.

43 Maurer 1966, pp. 203 – 317, esp. pp. 290 – 314. A second Totentanz to be found in Basle was in the cloister of the Klingental monastery; see Rudolf Riggenbach, 'Die Wandbilder des Klosters Klingental', in Maurer 1961, pp. 95 – 139.

44 Manuel 1979, nos. 94 – 130, pp. 252 – 91. That Totentanz was pulled down before 1660.

45 Landolt 1972, no. 94; on Matthäus Merian, and his engravings after Prediger-Totentanz (first edition 1621, Basle), which were often reprinted, Wüthrich 1993, pp. 345 – 62.

46 Passional Christi und Antichristi [Wittenberg: Johann Grunenberg, 1521]. In 1521 many German editions appeared, along with one in Latin (all of them without any publisher's mark), and later two copies in Erfurt and Strasburg; Cranach 1974, I, no. 218, p. 330; H. Schnabel, Lukas Cranach d.Ä. – Passional Christi und Antichristi, Berlin (DDR), 1972 (Facsimile). Petersmann 1983, pp. 172 – 89, with the remark that Holbein's representation of the pope was imitated by Georg Pencz (second sheet of the series Die sieben Planeten, 1531) and Heinrich Aldegrever (Totentanz, 1541).

47 Martin Luther, Teutscher Adel. An den christenlichen Adel deutscher Nation: von des Christenlichen Stands besserung, Wittenberg: M. Lotther, 1520; in Luther, Sämtliche Werke, VI, pp. 404 – 69. See Wirth 1963.

48 Hollstein XIVB, no. 146, p. 136; there are copies in German in Coburg and Karlsruhe, and in Oxford in Latin; see Hoffmann 1990.

49 Hoffmann 1990, esp. pp. 102 – 4; Stopp 1969.

50 Les simulachres & historiees faces de la mort, avtant elegamment pourtraictes, que artificiellent imaginées. A Lyon, Soubz l'escu de Coloigne, MCXXXVIII. Cf. The Dance of Death by Hans Holbein the Younger. A Complete Facsimile of the Original 1538 Edition of Les simulachres & historiees faces de la mort, Introduction by Werner L. Gundersheimer, New York: Dover Publications, 1971.

51 Davis 1956; Franz 1973, pp. 43 – 5. Between 1538 and 1562 Hans Holbein's Simulachres were published in no less than sixteen editions, among them five in French, nine in Latin, one in Italian and one in Spanish. Fifteen unauthorized reprints appeared soon afterwards: three between 1546 and 1551 in Venice, twelve between 1555 and 1573 in Cologne; see Franz 1973, pp. 130 – 45.

52 Himmel, Hölle, Fegefeuer 1994, no. 73, pp. 258 – 9.

53 Müller 1988, no. 47, pp. 158 – 61.

54 Wind 1937/38; Panofsky 1969; see for the objects: Amerbach-Kabinett 1991: Die Objekte im Historischen Museum, nos. 15 – 17, pp. 37 – 9.

55 Rowlands 1980. Cf. fig. 31 and further Erasmus of Rotterdam, De preparatione ad mortem, London: T. Bertheleti, 1534; Erasmus, 1969 –, V, I.

56 Holbein, Historiarum ueteris instrumenti icones ad uiuum expressae, Lyon: Frellon, 1538; Holbein 1960, no. 423, pp. 329 – 33.

57 Michael 1992, especially pp. 32 – 6; the relation between Holbein's Icones

and the Bibles illustrated by Schön and Springinklee in 1518 and 1520 was pointed out by Eduard His; see Vögelin 1879; see further Maria Netter, 'Freiheit und Bindung in der Bibelillustration der Renaissance', in *Schweizerisches Gutenbergmuseum*, IV, 1953, pp. 155–89; Kästner 1985.

58 *Das Dritte teyl des allten Testaments*, Wittemberg. MDxxiij. [Wittenberg: Cranach and Döring, 1524]; see Schmidt 1977, pp. 147–8, figs. 84, 85; Cranach 1974, I, no. 230, p. 343–8; Luther 1983(3), no. 473, pp. 355–6.

59 Osten 1953.

60 Luther, 'Vorrede' to Book of Job, 1524; and in: *Sämtliche Werke*, LB. I, pp. 393–452.

61 Schmidt 1977, pp. 149–61; Holbein 1960, no. 383, p. 307; Hieronymus 1984, no. 391, pp. 409–11.

62 Müller 1988, no. 73, pp. 232–3.

63 Michael 1992, pp. 29–31.

64 On the history of the reception of the *Icones*, see Michael 1992, pp. 36–47; Michael 1990. The question of the reception of the *Bilder des Todes* is not tackled by Petersmann 1983.

3. Monumental Decorative Works

1 Heydrich 1990, pp. 125–33.

2 Patin 1676 and 1709, nos. 48–52.

3 'Aus den Notizen des Dr. Ludwig Iselin', in: Woltmann 1874–6, II, p. 43.

4 Liebenau 1888; for the Ravensburg commercial company see Schulte 1964.

5 Reinle 1954, pp. 119–30.

6 Reinhardt 1982, p. 257; Holbein 1960, pp. 21, 28–9; Riedler 1978, pp. 10–38; Bushart 1987, p. 17.

7 His 1870, pp. 115–17.

8 Falk 1979, no. 182 v, p. 85; Müller 1988, nos. 4, 5, pp. 42–6; Müller 1996, nos. 96–7, pp. 69–71.

9 A fragment – the figure of Collatinus viewed from behind – from the fourth picture from the left on the uppermost row (*Lucretia Slaying Herself*) is in Lucerne, Kunstmuseum, oil on plaster, 136 x 65 cm; cf. Woltmann 1866–8, I, p. 224; Holbein 1992. Some small fragments from the paintings inside the house are in the Zentralbibliothek Lucerne, Graphische Sammlung. Cf. the fragments of *al secco* work from the murals in the council chamber: Holbein 1960, no. 161.1,2, p. 192.

10 [Gesta Romanorum] *Das Buch von der Geschichte oder geschehen Dingen der Römer*, Augsburg: Johann Schobsser, 1489, Erzählung XLV; cf. among many Italian fifteenth-century examples the copper engraving by the Monogrammist MZ (c. 1500, Lehrs 21), and the pen drawing on the theme by Hans Leonhard Schäufelein, *Leichenschiessen*, c. 1505, 24 x 21.8 cm, Bremen, Kunsthalle. Woltmann 1866–8, I, pp. 220–21; Stechow 1942.

11 Martindale 1979; Lightbown 1986, pp. 140–53, no. 28, pp. 424–33; Mantegna 1992, nos. 108–27, pp. 350–92. The dating is contentious; according to the catalogue of the 1992 exhibition the works are to be brought down to 1505.

12 Burgunderbeute 1969.

13 See above, chapter One.

14 Cf. above, chapter One.

15 Jakob von Strassburg, *Triumphus Caii Iulii Caesaris Primi Romanor[um] Imperatoris*..., Venice 1503, 12 sheets; Hollstein XV A, nos. 18–29, p. 205.

16 Cf. below, chapter Five.

17 Müller 1988, no. 5, pp. 45–6; Müller 1996, nos. 96–7, pp. 69–71; cf. also the watercolour copy of the mural dating from 1825 in Lucerne, Zentralbibliothek, Graphische Sammlung.

18 Müller 1988, nos. 28–30, pp. 102–15; ; Müller 1996, no. 96, pp. 70–71; for the relation of this drawing to the Hertenstein house the only evidence is the engraving (illus. 80), which shows the arrangement of the entrance door, the windows and their crossings on the ground floor.

19 Hieronymus 1984, no. 236, pp. 202–4; cf. also Koppe 1995, no. 45, pp. 117–19; cf. also the only slightly later architectonic *Title-border with the beheading of St John the Baptist* and the *Title-border with the Triumphal Procession of the Children*, first used by Johannes Froben in July 1517; cf. Koppe 1995, no. 47, pp. 121–3, no. 50, pp. 128–30. The printer's mark that Ambrosius Holbein designed for Johannes Froben and which was used

for the first time in July 1517, contains in a different combination elements similar to those Hans used at the same time; cf. Koppe 1995, no. 28, pp. 74–6.

20 Frauenfelder 1958, pp. 255–63, rightly mentions that the state of the paintings does not allow a comparison to be made; cf. below, chapter Five.

21 Klemm 1972; Emil Maurer, 'Holbein jenseits der Renaissance. Bemerkungen zur Fassadenmalerei am Haus zum Tanz in Basel', in Maurer 1982(1), pp. 123–33; Rowlands 1985, L. 4, pp. 219–20; Becker 1994.

22 Sebastiano Serlio, *Regole generali d'Architettura sopra le cinque maniere degli edifici*..., Venice: F. Marciolini, 1537 [Cicognara, 662]; cf. Serlio, *Architettura*, Venice: F. Senese and Z. Krugher Alemanno, 1566, lib. 4, cap. XI, fol. 191 v: 'I say that the architect ought not only to take care of the ornaments around the stone or the marble, but also of the artist's work to decorate the walls: and it is fitting that he should be the organizer of this, as the patron of all those who work on the building; for there have been some artists who were skilful at their job but who showed so little judgement otherwise that to show how beautiful were their colours and having no consideration for any other aspect they have disturbed and even spoiled the order since they have not considered putting the pictures in their rightful places' (*dico che l'Architettore non solamente deue prendere cura de gli ornamenti circa la pietre, & circa i marmi ma dell'opera del penello ancora, per ornare i muri: & conuiene ch'egli ne sia l'ordinatore, come padrone di tutti coloro, che nella fabrica si adoperano: perioche sono stati alcuni pittori, ualenti quanto alla pratica; nel rimanente di cosi poco giudicio, che per mostrare la uaghezza de i colori, & non ha uendo riguardo ad alcuna altra cosa hanno disconciato, & talhor guasto alcuno ordine, per non ha uer considerato di collocare le pitture ai luoghi loro*).

23 Klemm 1978; Emil Maurer, 'Holbein jenseits der Renaissance. Bemerkungen zur Fassadenmalerei am Haus zum Tanz in Basel', in Maurer 1982(1), pp. 123–33.

24 Cf. Hans Bock the Elder, *Theodor Zwinger with a Skull and the Fall of Bellerophon*, Basle, Kunstmuseum, inv. 1877; Amerbach-Kabinett 1991: Gemälde, no. 45, pp. 27–8. Dieter Koepplin, 'Ausgeführte und entworfene Hausfassadenmalereien von Holbein, Stimmer und Bock – Kunsthybris mit dem erhobenen Zeigefinger', in Stimmer 1984, pp. 35–96, nos. 14, 16, pp. 94–5. Whether Bock ever carried out the paintings for which we have the designs is not known. The prominence of Bellerophon found a continuation in Basle in the nineteenth century inasmuch as Johann Jakob Bachofen placed it at the beginning of his study of the Mutterrecht: Bachofen 1948, I, pp. 85–92.

25 [Andrea Alciatus], *Clarissimi viri D. Andreae Alciati Emblematum libellus, uigilanter recognitus, iam recèns per Wolphgangum Hungerum Bauarum, rhythmis Germanicis uersus. Parisiis. Apud Christianum Wechelum, sub scuto Basiliensi, in uico Iacobeo: & sub Pegaso, in uico Bellouacensi. Anno.* M.D.XLII. [Reprint Darmstadt: Wissenschaftliche Buchgesellschaft, 1980], CII, pp. 226–7. For information about the Lycian Chimaera see Hederich 1770, cols. 702–6.

26 Klemm 1972, pp. 169–70, 174, note 12, contrary to the earlier assumptions that it is a sketch for Amerbach's house Zum Kaiserstuhl, proposed, with reference to the different heights of storeys and land register acts, that the design could have been intended for the house Nadelberg 18 which at this time changed its name from Zum Kaiser to Zum Kaiser Sigismund.

27 Burckhardt 1914, p. 66; cf. also the unpublished lecture by Jacob Burckhardt on 'Holbein als Fassadenmaler' during Winter 1861/62 MS, Statsarchiv Basle PA 207; Klemm 1972, pp. 169–70; Becker 1994, no. 5, pp. 73–5.

28 The sketch for a facade decoration in brown ink and blue gouache in the Louvre was attributed to Holbein by Woltmann and His in the nineteenth century. The French catalogue maintains this attribution. However this decoration for a house with segment-arched windows cannot be placed geographically. The restriction of the scheme to pen and blue gouache possibly suggests an execution in *sgraffito* that would be the only example in Holbein's work. The design divides the two wings and the four floors by pedestals, girders and columns of various

proportions and closes the facade with a triangular gable on two pillars with voluptes. The entrance, painted incorrectly from the perspective point of view, is ornated with two putti, while two others hold a coat of arms through the oculi of the archway. In the spaces intended for the images, there are different figures on a blue background: in the area near the pedestals, two dogs are fighting over a bone, in another space are creatures naked to the waist and with scales on their bodies. Three others represent the Caritas Romana, the victory of a woman over a man, and a sword-fight. On the third storey, between two columns, are two bulky and bearded men with threatening looks; from the gable two men look down at the passers-by. On the first and the second floor, the columns seem to push through the horizontal limits circumscribing the fields. Woltmann 1874–6, I, pp. 148–9; His 1886, pls. 18–20; Bacou and Calvet 1968, no. 101; Dürer 1991, no. 145, pp. 159–60. The lack of correspondence between the capitals and the columns has been attributed to *pentimenti*. Since Woltmann and His, the more recent literature has not discussed the drawing.

29 Schmid 1945–8, II, pp. 345–53 (c. 1531/32); Ganz 1950, nos. 162–5, pp. 250–55 (1520/22); Klemm 1972, p. 172 (c. 1525); Rowlands 1985, no. L 4, pp. 219–20 (before 1521); Müller 1988, nos. 28–30, pp. 102–14 (c. 1520 or shortly after); Müller 1996, nos. 112–21, pp. 80–85.

30 Grotesques and column decorations were used in title-borders or printers' marks of around that time; cf. illus. 2, 8, and the title-border with the death of Marcus Licinius Crassus, 1522; cf. Hieronymus 1984, pp. 399–400; Hollstein XIV A, no. 38, pp. 39–41.

31 Zwinger, Theodor the Elder, *Methodus apodemica in eorum gratiam*, Basle: P. Pernae, 1577, p. 199: *Domus privata in platea ferri choream rusticam exhibet; a J. Holbenio XL forenorum stipendio depicta.* Cf. Woltmann 1866–8, I, p. 289; Woltmann 1874–6, I, p. 149.

32 His 1870, pp. 119–20, 125–6, with a transcription of the documents.

33 Riggenbach in Baer 1932–71, I, pp. 517–608, and supplement (1971) pp. 747–64; Basler Rathaus 1983; Heydrich 1990, pp. 14–18.

34 Gysin in Baer 1932–71, I, pp. 479–516, especially pp. 494–5; Meyer 1951; Giesecke 1994.

35 Vögelin 1887. The inscriptions are to be found in Johannes Gross, *Urbis basileae epitaphia et inscriptiones*, 1622; cf. the printing of the inscriptions in Johannes Tonjola, *Basilea sepulta*, Basle: E. König, 1661, p. 382; cf. Schmid 1896, pp. 79–81; Kreytenberg 1970, p. 80.

36 The new attempts are to be found in Kreytenberg 1970; Baer 1932–71, I, supplement by Maurer 1971; for a systematization of the material see Rowlands 1985, no. L 6, pp. 220–21; for new material see Müller 1991.

37 Müller 1991.

38 Rowlands 1985, no. 18, pp. 130–31; Müller 1988, no. 62, pp. 199–204; Klemm 1980, pp. 40–43, 72; Klemm 1973; Müller 1996, nos. 174 a–d, pp. 115–18. For Henry II and Kunigunde cf. two drawings by Hans Holbein the Elder in Holbein d. Ä 1965, nos. 62–3, pp. 100–01.

39 Etterlyn 1507, fol. XXXIA; Münster 1544 (2), pp. cclix–cclxxxvi [259–86]; Münster mentions a Council of 1060 in Basle at which Honorius I was chosen as Pope and Henry IV was crowned Emperor with the insignia brought from Rome.

40 Caillet 1985, no. 163, pp. 229–36.

41 Koegler 1931–2; Kurz 1943(2); Rowlands 1985, pp. 83–5, nos. L 13 A, B, pp. 223–4.

42 Lappenberg 1851; Dollinger 1970. The Steelyard was burned down in the Fire of London in 1666. Lappenberg 1851, p. 83, recounts the deed of gift in 1615 to Henry, Prince of Wales; Koegler 1931–2, p. 82 accepted this date although Henry died in 1612, Grossmann 1944, p. 151, corrects the date of the gift to 1609 or 1610. Sandrart, 'Lebenslauf und Kunst-Werke des WolEdlen und Gestrengen Herrn Joachims von Sandrart', in Sandrart 1675–9, I, pp. 1–24, esp. pp. 5–6.

43 Koegler 1931–2; Kurz 1943(1); Grossmann 1944.

44 Markow 1978; Holman 1980. Cf. chapter Six.

45 Hans Sachs, *Klag Antwort und urteyl, zwischen Fraw Armut und Pluto dem Gott der reichthumb welches unter yhn das pesser sey*, Nuremberg: Nicolas Meldemann, 1531; Koegler 1931–2, pp. 64–73.

46 *Hypnerotomachia Poliphili ubi humana omnia nonnisi somnium esse docet . . .*, Venice: Aldus Manutius, 1499.

47 Rowlands 1985, p. 85: 'The combined message of both canvases is obvious: the Merchants were warned not to be too downcast by adversity nor too arrogant when successful; in other words, one should be moderate in all things'.

48 For the technique of painting on Tüchleinmalerei cf. Bosshard 1982.

49 Woltmann 1866–8, II, pp. 214–18; John Stow, *The Annales of England*, London: Newbury, 1592, p. 953.

50 *Das Berliner Kupferstichkabinett. Ein Handbuch zur Sammlung*, ed. Alexander Dückers, Berlin, 1994, no. 111.63, pp. 135–7.

51 Woltmann 1866–8, II, pp. 277–81; Woltmann 1874–6, I, pp. 378–9; II, p. 165, no. 369; Rowlands 1985, no. L 14, pp. 224–6.

52 According to Rowlands 1985, p. 225, the corrected inscriptions on Leemput's 1667 copy run as follows:
'SI IVVAT HEROVM CLARAS VIDISSE FIGVRAS, / SPECTA HAS, MAIORES NVLLA TABELLA TVLIT. / CERTAMEN MAGNVM, LIS, QVAESTIO MAGNA PATERNE / FILIVS AN VINCAT. VICIT VTERQVE QVIDEM. / ISTE SVOS HOSTES, PATRIAEQVE INCENDIA SAEPE / SVSTVLIT, ET PACEM CIVIBVS VSQVE DEDIT.

XXX

FILIVS AD MAIORA QVIDEM PROGNATVS ABARIS / SVBMOVET INDIGNOSI [?INDIGNOS] SVBSTITVIT QVE PROBOS. / CERTAE VIRTVTI PAPARVM AVDACIA CESSIT, / HENRICO OCTAVO SCEPTRA GERENTE MANV / REDDITA RELIGIO EST, ISTO REGNANTE DEI QVE / DOGMATA CEPERVNT ESSE IN HONORE SVO'
(If you enjoy seeing the illustrious figures of heroes, / Look on these; no painting ever bore greater. / The great debate, the competition, the great question / is whether the father / Or the son is the victor. For both indeed are supreme. / The former often overcame his enemies, and the fires / of his country, / And finally gave peace to its citizens.
The son, born indeed for greater tasks, from the altar / Removed the unworthy, and put worthy men in their place. / To unerring virtue, the presumption of the Popes has yielded / And so long as Henry the Eighth carries the sceptre in his hand, / Religion is renewed, and during his reign / The doctrines of God have begun to be held in his honour).

53 Rowlands 1988, no. 213, p. 252. The journal of Baron Waldstein from Moravia who in 1600 saw Holbein's picture gives an account of his impression: see G. W. Gross (ed.), *The Diary of Baron Waldstein: A Traveller in Elizabethan England*, London, 1981, p. 57.

4. Religious Works: The Making of Erasmian Art

1 Woltmann 1866–8, I, pp. 255–7; Amerbach-Kabinett 1991: Gemälde, no. 27, pp. 19–20; Rowlands 1985, no. 11, pp. 127–8; Holbein 1960, no. 160, pp. 188–90; Einem 1960.

2 Rowlands 1988, no. 156, p. 185; Falk 1968, pp. 84, 111.

3 The copy made by Hans Bock (Solothurn, Kunstmuseum), may be dated to around 1580–90; it was placed with the Holy Grave during Holy Week, see Vignau-Wilberg 1973, no. 4, pp. 21–2.

4 Bätschmann 1994. Jeffrey Meyers, 'Holbein and the Idiot', in Meyers 1975, pp. 136–47; Stoichita 1995.

5 On the relation to the viewer characteristic of the 'Schmerzensmanns', the title-page for Dürer's *Great Passion* (c. 1511); Bartsch, X, no. 4, p. 98; Schiller 1969–80, II, pp. 240–41; Belting 1981.

6 Huizinga 1975, ch. 14, pp. 268–84.

7 Koegler 1943.

8 Erasmus 1515; Michael 1986; Müller 1988, no. 2a–e, pp. 20–33; Amerbach-Kabinett: Zeichnungen, nos. 98–101, pp. 33–4; Müller 1996, nos. 10–91, pp. 50–66.

9 Karlstadt 1522.

10 Huldrych Zwingli, 'Vorschlag wegen der Bilder und der Messe' [end of May 1524], in Zwingli 1905–56, III, pp. 114–19; Altendorf and Jezler 1984.

11 Manuel 1979, no. 36, pp. 184–9.

12 Dürer's description reads: 'Dis gespenst hat sich widr dy heilig geschrift erhebst zw regenspurg und ist vom bischoff ferhengt wordn czeitlichs nucz halben nit abgestelt. Gott helff uns, das wir sein werde muter nit also unern sundr in Cristo Jesu amen'. Luther 1983(3), no. 78, pp. 70–71. Kunst der Reformationszeit 1983, no. B 82, pp. 139–40. Cult of images and pilgrimage: Freedberg 1989, pp. 99–135.

13 Dürer 1525, fol. Ai v. See the single sheet published c. 1530 in Nuremberg by Erhard Schoen, 'klagrede der armen verfolgten Götzen und Tempelpilder / über so ungleich urtayl und straffe' (Nuremberg, Germanisches Nationalmuseum, H 7404). What is bemoaned here is not the destruction of pictures, but rather the failure of Christians to improve themselves, worshipping images for a long time, and then destroying them without changing themselves; Baxandall 1980, pp. 78–93; Luther 1983(3), no. 515, pp. 388–9.

14 Berchtold 1990; Hieronymus 1984; Füglister 1981; Froben 1960.

15 Berchtold 1990; Aktensammlung 1921–50, I, pp. 18, 119, 145; Roth 1942; His 1879.

16 Testament 1522(2); Schmidt 1977, pp. 93–127, records on p. 117 that the canton of Lucerne took Adam Petri to court in 1522 for his publication of Martin Luther's Kurtze, treue und christliche Vermahnung an die Eidgenossen; Petri was ordered to pay 200 florins, and to give away to Lucerne the copies he had printed. Holbein 1960, no. 383, p. 307; Hieronymus 1984, no. 391, pp. 409–11.

17 Panofsky 1969. The critical stance of Erasmus is well explained by Silver 1984, pp. 105–33. J. B. Trapp, 'Thomas More and the Visual Arts', in Trapp 1990, ch. 8.

18 Loertscher 1957, pp. 345–424.

19 Huldrych Zwingli, 'Vorschlag wegen der Bilder und der Messe' [end of May 1524], in Zwingli 1905–56, III, pp. 114–19. Erasmus 1969–, Opera omnia, I, 3, pp. 470–94 (p. 474): 'Paulus habet gladium. Bartholomæus cultro armatus est. Quid autem agas cum Georgio et equite et cataphracto, hasta simul et gladio formidabili? - Me vero quantumvis inermem non tamen eiicies, nisi simul eiecto filio, quem ulnis teneo'. The dialogue is inspired by Lucian: Lauvergnat-Gagnière 1988, ch. 7, pp. 222–3.

20 Erasmus, Modus orandi Deum [1524], in Erasmus 1969–, Opera omnia, V, I, p. 155: 'Si superstitiosa consuetudo cursitandi cum facibus in memoriam raptae Proserpinae verteretur in religiosum morem, ut populus christianus cum accensis cereis conveniret in templum in honorem Mariae Virginis'.

21 Manuel 1979, nos. 295–6, pp. 461–4; Im Hof 1980.

22 Bildersturm: Aktensammlung 1921–50, III, pp. 383–410, especially p. 399.

23 The Solothurn Madonna was removed from St Martin's in 1528, see Bätschmann and Griener 1996; Hans Oberried took his panels to Freiburg im Breisgau; Rowlands 1985, no. 9, pp. 126–7.

24 Rowlands 1985, nos. 9, 11, pp. 126–8; Müller 1988, nos. 49–62, pp. 164–204; Klemm 1980, pp. 31–43, 71–2.

25 Rowlands 1985, nos. 18, 19, 20, 23, pp. 130–32; Holbein 1960, nos. 174, 177, 178, pp. 202–3, 206–9; Klemm 1980, pp. 40–41, 72.

26 Wackernagel 1896.

27 Alte Pinakothek, Munich, 1983, no. 1044, pp. 232–3; Wind 1937–8, especially p. 159 and note 1.

28 Amiet 1879, pp. i–vii, pp. 1–46. Reinhardt 1979, p. 73 (one Christian knight); Rowlands 1985, no. 10, p. 127 (St George); Braunfels-Esche 1976.

29 The Theban legion was martyred for its faith c. 300 AD. The event took place in Agaunum (St Maurice, Valais), a military camp. In the 4th century, a church was built, followed by a cloister in 515; the cult spread widely, following the directions of the main Roman routes. According to certain legends, some members of the legion were martyred in other locations: Ursus and Victor in Solothurn; Felix, Regula and Exuperantius in Zurich; Gereon in Cologne. With St Maurice, Solothurn became a centre of worship for the cult of the Martyrs of the Theban legion; many churches in Switzerland are devoted to their cult. Reusch 1976, and the corresponding entries for each of the saints. Dupraz 1961; Berchem 1956; Haefliger 1956; Martingay 1989.

30 Morgenthaler 1923.

31 The accounts of St Martin's record a payment to Heinrich Schach for the execution of the reliquary 'für dz Heiltum Sant Ursus dz von Soloturn kam'; Staatsarchiv Basel-Stadt, Kirchenarchiv St Martin B, Zinsbuch 1451. Rechnungen des Baus, Abschriften und Urkunden 1451–1529, fol. 52b. The process of identification is characteristic: in Solothurn, the bones were unidentified remnants of the martyrs; in Basle they became the relics of St Ursus through their association with the locus of Solothurn.

32 Weber 1977. On the printer Petri, see Stehlin 1889.

33 Staatsarchiv Solothurn, Ratsmanuale 9, 1519, fol. 204, Beschluss vom 30. Mai 1519; Ratsmanuale 10, 1521, fol. 157a. Schubiger 1992; Widmer 1990. Staatsarchiv Solothurn, Ratsmanuale 1508. 3. fol. 159; Haffner 1666, pt 2, p. 198; Weber 1977.

34 See the document, which has never been discussed, and which was written on behalf of the three provisores to the bishop of Basle, Christoph von Utenheim, dated 28 April 1520: Basel-Stadt, Staatsarchiv, Klosterarchiv St Martin H 1 Allgemeines Einzelnes 1362–1687.

35 Staatsarchiv Basel-Stadt, Klosterarchiv St Martin A, Jahrzeitenbuch, 15th century; Maurer 1961, pp. 311–72, especially pp. 345–6.

36 Gerster often went to Solothurn on official business; he baptised his daughter Verena. His son Franz was appointed chaplain of the St Verena altar in the cathedral. On St Verena and Solothurn see Reinle 1948; Schubiger and Schneller 1989.

37 Amerbach-Kabinett 1991: Beiträge zu Basilius Amerbach, p. 145, the inventory D of 1585–7 describes Hans Bock the Elder's copy of Jesus: 'ein nackend kindlin sizt vf einer schlangen kompt von Holbeins gemehl durch H. Bocken vf holz mit olfarben mehrteil nachgemolt'. The painting was misunderstood for a long time, since the snake was interpreted either as an attribute of Hercules, or as an allegory of the Reformation. In fact, the snake and the grape added by Bock, express eternal life and victory over evil – a traditional iconography present in Italian art, for example in Bernardino Luini's picture at Chantilly. Bock painted clouds around the hands of the Virgin, as Holbein had done in the printer's mark for Johannes Froben (1523), also owned by Amerbach. Amerbach-Kabinett 1991, Gemälde, no. 41, p. 26, no. 32, p. 22; Droulers, p. 228; Marrou 1953, XV/2, pp. 3113–4.

38 Hans Bock the Elder along with his sons completed in 1600 for the abbot of the monastery St Blasien in Schwarzwald the Life of Mary in eighteen pictures, including a variation on Holbein's Solothurn Madonna; see Tanner 1981.

39 In 1840 the sketchbook was dismantled and remounted with other sheets. Trying to reconstruct Meyer's itinerary with the help of that document is meaningless. On the first cover-sheet is written 'Gehört Conradt Meyer. kaüfft d. 31 Augusti Anno 1638'; on the back of sheet 25 is a small view of Solothurn. The same booklet contains views of Lucens, Oron and Berne, drawings of trees, hands, figures, helmets, and a scene after Niklaus Manuel's Totentanz in Berne. Meyer used those books all his life, and arranged some of the objects depicted thematically, such as the figure of Ursus, which appears in a group of sketches of armour. Solar 1981, p. 85; Kunsthaus Zurich 1984, p. 14.

40 Charles Patin (1633–93) lived in Basle for many years, and travelled to Solothurn; see Patin 1674. The catalogue of Holbein's works – the first catalogue raisonné of the artist ever published – was based on his own research, supplemented with reference to notes made by Remigius Faesch II. Remigius Faesch II (1595–1667) and Sebastian Faesch (1647–1712) never published their copious notes, but were generous enough to put them at Patin's disposal: Remigius Faesch II, Humanae Industriae Monumenta Nova simul et antiqua [1628], Basle: Universitätsbibliothek, MS: A R I. 12; Charles Patin, 'Vita Joannis Holbenii' and 'Index operum Joh. Holbenii', in Erasmus 1676. The Solothurn Madonna is not recorded in that catalogue. It is absolutely clear that, had the painting been in Solothurn at the time, either Patin or his friends would have found it. Patin owned two works by Holbein, 'Index Operum Joh. Holbenii', nos. 57, 58, fol. e 2v. Beckmann 1807–9, I, no. 51, pp. 638–53. On Patin, see his autobiography in Patin 1682, pp. 77–104; Waquet 1985; Waquet 1979; Waquet 1989; Ivanoff 1969.

41 The chapel is the Allerheiligenkapelle. What is not known is that Buchser, shortly after having discovered the Madonna, offered it to the Kunstverein of Basle for the price of 20,000 francs; Zetter also tried to see how much they could sell it for in Strasburg. They also imagined selling it in London. The commune of Grenchen took the Kunstverein of Solothurn to court after the two men had handed over the panel to the latter after much financial dealing; Grenchen lost the case. Staatsarchiv Solothurn, *Amtsgericht Solothurn-Lebern, Amtsgericht-Civilprozessakten*, October–December 1873, Dossier 21; Studer 1961. Wälchli 1941, pp. 111–15; Zetter-Collin 1902(1), first published as Zetter-Collin 1897; see Arx 1913; the first attempts to find the connection between the picture and St Ursus in Solothurn failed; Amiet 1879; Wackernagel 1896, pp. 442–55 identified Johannes Gerster as the commissioner of the painting.

42 His 1870, pp. 153–60; on early speculations on the identity of the two children, Schlegel 1988, p. 64; Woltmann 1866–8, I, pp. 327–33; Netter 1951, p. 118, mentions briefly the possibility that one of the children could be a St John. The first correct interpretation is given by Ost 1980, especially p. 141, note 3; this was not followed by Rowlands 1985, p. 64, no. 23, pp. 131–2, nor by Imdahl 1986 or Auge 1993.

43 Hind 1938–48, III, no. 69, p. 447. In almost all representations, the young St John the Baptist is recognizable through his dress, his position – especially in connection with Christ – his halo or his cross. However, Cristofano Robetta printed in Florence *c*. 1500 an engraving showing the Virgin enthroned with angels. On her lap, Christ is leaning towards St John the Baptist, who is represented without any attribute. Hind 1938–48, I, no. 19, p. 203; Bartsch 1978–, XXV (Commentary), no. 2521, p. 547; Pt 2, p. 287, B.13 (400); that Meyer's son should put his arms around St John the Baptist is not uncommon: see another example of familiarity betwen human and divine beings, the epitaph made by Niclaus Gerhaert in Strasburg (1464), where Christ plays with the priest's joined hands, Spätgotik am Oberrhein 1970, no. 19, pp. 92–3 and pl. 29.

44 Holbein d. Ä 1965, no. 112, p. 121; Lieb and Stange 1960, no. 302, p. 114.

45 Sussmann 1929. See also the use of the iconography of the Virgin as a protector in representations of her where she is depicted as an intercessor, for example at Karlsruhe (1519), Swabian master, Karlsruhe, Kunsthalle, inv. 63; Christus und Maria 1992, no. 8, pp. 55–9.

46 Hind 1938–48, A.II.25; Pope-Hennessy 1965, no. 303, pp. 86–7; Banzato and Pellegrini 1989, no. 3, pp. 37–8 ('bronzista ferrarese').

47 Amerbach-Kabinett 1991: Die Objekte im Historischen Museum Basle, no. 74, pp. 100–1.

48 Lochner 1993–4, pp. 53, no. 10, pp. 246–7, no. 63, pp. 366–7. On the diffusion of this motif in Italy: Rogier van der Weyden, *Standing Madonna with Child and St Peter, St John the Baptist, Cosme and Damian* (the '*Medici Madonna*'), Frankfurt, Städel; discovered in 1833 in Pisa, see Panofsky 1953, I, pp. 274–6.

49 Brejon and Thiébaut 1981, inv. 339, p. 194. Lippi's picture, *in situ* until 1813 in S Spirito, was taken to the Louvre in 1814. Kubler 1962, pp. 39–53. On Botticelli's *Madonna dei Candelabri*, see Lightbown 1978, no. C 29, pp. 131–2; Shearman 1992, pp. 70–73, plate IV.

50 Pélerin 1505, fol. 10a; the Glockendon version appeared in 1509 and 1540 in Nuremberg; Ivins 1973.

51 Riggenbach 1944, pp. 472–502; Reinhardt 1954–5(2), pp. 249–50; Holbein 1960, no. 177, pp. 206–8; Rowlands 1985, pp. 64–6, no. 23, pp. 131–2. The dissertation by Auge 1993 does not cast any new light on the subject.

52 Woltmann 1866–8, I, p. 333: 'Therefore it cannot possibly be an altarpiece' (*Dennoch kann es unmöglich ein Altarbild sein*); p. 334: 'It is possible to prove that a representation such as that which we see in the Meyer Madonna was usually connected with epitaphs; thus it seems probable that our picture was also an epitaph' (*Lässt sich nun nachweisen, dass eine Darstellung, wie wir sie auf der Meyerschen Madonna sehen, gerade auf Epitaphien vorzukommen pflegt, so spricht die Wahrscheinlichkeit dafür, dass auch unser Bild ein Epitaph gewesen ist*). Rowlands 1985, p. 64: 'This is the most famous, the last and probably the greatest of Holbein's altarpieces'.

53 Winkler 1936–9, II, nos. 503–7, pp. 151–4; Anzelewsky 1971, nos. 123–4, pp. 233–6; Gothic and Renaissance Art 1986, no. 128, pp. 305–7.

54 Schramm 1954–6, II, pp. 581–2, 617–19: 'Die Reichskrone als *Signum sanctitatis*'. Fillitz 1954.

55 Heiltum Nürnberg 1487; Bayerische Staatsbibliothek. Inkunabelkatalog 1993, III, p. 112; Bartsch 1978–, LXXXVI, 8687, p. 70. Lütge 1965; Hildegard Erlemann and Thomas Stangier, 'Festum Reliquiarum', in Reliquien 1989, pp. 25–31.

56 Schramm 1954–6, III, pp. 1019–24; Yates 1975, ch. I: 'Charles V and the Idea of the Empire'; Fillitz 1993.

57 Strauss 1980, no. 188, pp. 536–7; Dodgson 1903–25, I, no. 145d, p. 339 (Unicus, printed by Hans Springinklee). See also the variations in the representation of imperial crowns in Dürer's *Landauer Altar* of 1511.

58 Gysin in Baer 1932, I, pp. 479–516, especially pp. 494–5; Giesecke 1994.

59 Etterlyn 1507; Glareanus 1514, especially fols. 3b, 13b; Hieronymus 1984, no. 134, p. 106; Hollstein, XI, no. 318, p. 153; Köbel 1545.

60 Rowlands 1985, pp. 21–2, no. 2, p. 125; Klemm 1980, pp. 10–14. In 1512 a gold florin was struck for the first time in Basle: it bore the standing Virgin and Child, the favoured type in Basle. In 1516, when Meyer became mayor, the emperor Maximilian I granted Basle the right to mint such coins.

61 His 1870, especially p. 159.

62 It may be compared with the stained glass depicting the crowned Virgin standing on the moon, a work that was donated to the charterhouse of Basle by the bishop Christian von Utenheim in 1522. Bätschmann 1989, p. 32. The Madonna of the Apocalypse bears an imperial crown. In the *Crowning of Mary* (1516) on the main altar in the Münster at Freiburg im Breisgau, Hans Baldung Grien staged God the Father and Christ, both crowned, laying an imperial crown on the Virgin's head; Osten 1983, no. 26, pp. 99–118. See also the *Crowning of Mary* by Hans Holbein the Elder, *c*. 1490: Holbein d. Ä 1965, no. 58, p. 99; Jean Claude Loutsch, 'L'armorial Miltenberg. Un armorial de la fin du XVème siècle', in *Archives héraldiques suisses 1987*–, 1989, II, pp. 95–165, and 1990, II, pp. 122–64, especially 1989, II, pp. 102–3 (no. 28, and fol. 21a of the manuscript: 'Diss sind die Empter und die Stend des Heiligen Roemschen Richs und diss die vier Hertzogen').

63 Jacobus de Voragine, *Mariale*, 5 V 197 (Mainz, 1616); Salzer 1967, pp. 487–8; Prohaska 1981, especially cols. 1046–9 (Maria).

64 Budge 1961; in his *Speculum Lapidum* (1502), Camillo lists the virtues of coral: it dries up blood, frightens ghosts, and is good against epilepsy. Most of this is borrowed from Albert the Great, *Liber Alberti Magni philosophorum maximi de mineralibus*, Venice: Johannes and Gregorius de Gregorii, 1485, fol. 7b–8a; Ritz 1962, cols. 1441–2; Hayum 1989, pp. 44–5.

65 See also the epitaph painted by Schäufelein in 1531 for Alexander Hummel: the inscription was added only in 1535, after the death of the patron, Augsburg 1978, pp. 98–9; *Meiting Epitaph* by Jörg Breu the Elder (1525) in Augsburg. Schoenen 1967; on the best examples of epitaphs in the cathedral at Augsburg: Kosel 1991.

66 German art historians have mistranslated the word from the very beginning. Kugler understood (1847) *conversazione* as 'conversation', and pointed out the position of the saints; Kugler and Burckhardt 1847, II, pp. 40–41; Kugler 1842, pt 1, pp. 143, 362. On the effect of such misunderstanding, Art. 'Sacra Conversazione', in LCI, IV, cols. 4–5 ('heilige Unterhaltung'). The Italian–German dictionary by Christian Josef Jagemann (Leipzig, 1803) gives for the word *conversazione* the German equivalents *Umgang, Gesellschaft, Zusammenkunft* and *Lebensart*, but not *Gespräch*, because the Italian equivalents are *dialogo* and *discorso*; Jagemann 1803, I, p. 302, II, p. 490.

67 Goffen 1979, especially p. 198.

68 Kosel 1991; Gilmore 1934. See in particular the arrangement of the epitaphs around the entrance to the chapterhouse in the so-called Baroque part of the west wing, which should be dated to 1505. On the right-hand side, one on top of the other, are the tomb slab and the epitaph of Heinrich and Christian von Freyberg, on the right-hand side of the entrance, the epitaph in the form of a tomb-slab of Otto von Schaumberg (1468–70) and the epitaph of Johannes Wilsgefert (1470),

over the doors are the small epitaph for Albert von Stein (1461) and the top of the epitaphs of Ulrich von Rechberg.

69 Panofsky 1964, pp. 64–5; Viaene 1965; Terner 1979.

70 The painting was kept in a small church in Evolène (Valais) at the end of the nineteenth century. It is impossible to reconstruct its original function, or even to know its original location. Sauver l'art 1982, no. 112, pp. 244–5; Lapaire 1992, no. 27, p. 30.

71 Falk 1968, pp. 13–21. In the *Breviarium Erfordensis* (1497) the reverse of the title-page bears a woodcut produced by Michael Wohlgemut's workshop, showing the Virgin Mary and the saints as if they were statues: *Breviarium capituli ecclesiae S. Mariae Erfordensis*, Nuremberg: Kaspar Hochfeder, 1497; Geisberg 1939, p. 142.

72 Hollstein, *Graf*, no. 159; Hieronymus 1984, no. 35, p. 26; see also the reuse in 1511, Hieronymus 1984, no. 39, p. 27, and in 1519.

73 Hollstein 11, no. 64, p. 99; Baldung Grien 1981, no. 53, pp. 214–15; Baldung Grien 1959, no. 11/21, p. 240. The figure kneeling down should not be seen as a donor; it rather served to allow the purchaser of the sheet to identify himself with it.

74 On a similar drawing from southern Germany, in the Berlin Kupferstichkabinett, see Dürer 1967, no. 116, p. 94. On the motif of the apparition of the Virgin from the sky, Raphael's *Sistine Madonna* offers a good parallel: it was on display, probably by 1514, in Piacenza. Raphael used not only the movement of the Virgin, but also an old device – the curtains; Putscher 1955.

75 Salzer 1967, pp. 36–8. Panofsky 1953, 1, pp. 144–8; Herzog 1956; Purtle 1982, pp. 144–56. See also the engraving after Holbein in the *Hortulus animæ*, Lyon: J. Frellon, 1546, fol. 95; Koegler 1943, XXXIII, p. 43.

76 Bosque 1975, no. 42, pp. 109–12; Silver 1984, pp. 76–7. The two wings painted in black, even if decorated with an inscription or with coats of arms, must have been intended above all as a means of protection.

77 Welt im Umbruch 1980, 11, no. 462, p. 112. On the problem of reconstructing such ensembles, see Rapp 1987; Decker 1985(2).

78 Memling 1995, pp. 35–42, pl. 1, p. 9; another similar epitaph in stone has been preserved, together with its inscription, and is now in the church of Our Lady in Bruges.

79 Schaffhausen 1989, no. 14, pp. 52–3.

80 Rowlands 1985, no. 9, pp. 126–7; Holbein 1960, nos. 156, 157, pp. 184–6.

81 P. H. Hübner, Restaurierungsprotokoll 1944/45, MS; it has been argued by Rowlands 1985, p. 127, that since the back of the two panels were left unpainted these two works cannot have been outer wings of an altarpiece; however, one should remember that some wings were decorated with a high-relief on one side, and a painting on the other side; they were made out of two different wooden panels joined together; we should like to thank Christoph Müller, Head-restorer, Augustinermuseum Freiburg im Breisgau. Hübner detailed some changes made on the paintings, but it seems that their format remained the same. Schmid 1949, nos. 16–17, pp. 203–6; Überwasser 1957.

82 Dürer, *Paumgartner Altar*, Munich, Alte Pinakothek; Alte Pinakothek 1983, no. 706, pp. 170–71; Anzelewsky 1971, nos. 50–52, pp. 155–7; Goldberg 1980.

83 Augsburg 1978, no. L. 1051, 1052, pp. 22–5; pp. 76–82. For the understanding of the collaboration of Holbein the Elder and the question of the difference between the devotional image and the epitaph, see the *Intercessio* (L. 1057) painted in 1508 for Ulrich Schwarz, an Augsburg wine merchant; Holbein 1960, no. 8, pp. 66–7; Lieb and Stange 1960, no. 28, pp. 67–8.

84 Matthew 8:1–13; see also Luke 7:1–10; John 4:46–53. *Testamentum novum*, 1521, p. 18: 'Domine, non sum idoneus ut tectum meum subeas: imo tantum dic verbum, & sanabitur famulus meus. – dico vobis, ne in Israël quidem tantam fidem reperi'.

85 Luther 1530, part I, pl. clxxvii, part II, p. ccxlvii; the edition published in 1545 was illustrated by Hans Brosamer, see Hollstein, IV, no. 341, p. 242. *Leien Bibel, jn deren fleissig zu samen bracht sind Die Fürnemeren Historien beder Testament mit jren über gesetzten Summarien*, Strasburg: Wendelin Rihel, 1540, fol. IV, fol. 4v; see Mende 1978, Ausgeschiedene Werke, nos. 586, 592, p. 66, and the later illustrations by Virgil Solis (1565) and Jost Amman (1579): Bartsch 1978–, XIX.1, p. 340, no. 1.112.316: *Biblische Figuren des newen Testaments*, Nuremberg 1565; XX.1, p. 344, no. 2.76 (366): *Künstliche Und Wolgerissene figuren der fürnembsten Evangelien*, Frankfurt 1579. Sir Thomas More, *A Treatise to Receaue the Blessed Body of Our Lorde* (1534), in More 1963–, 1, 13, p. 197: '[God] so louingly doothe vouchsafe to entre, not onely into our house (to whiche the noble man Centurio, knowledged himselfe vnwoorthye) but hys precious bodie into oure vyle wretched carkas, and his holye spirite into our poore simple soule'. After mentioning once again the centurion, p. 199: 'lette vs not forgeatte on the tother syde to consider his inestimable goodnesse, which disdeigneth not for all our vnwoorthinesse, to come vnto vs, and to be receiued of vs'.

86 Erasmus 1522(2), in Erasmus 1703–6, VII, col. 49: 'Jesus delectatus hominis fide, qui non dubitaret ipsum et absenti verbo mederi posse, quo magis redderet omnibus perspicuam insignem viri fiduciam, cum summa mentis humilitate conjuctam . . .'. The *Paraphrasis* was reprinted as early as March 1522: D. Erasmus, *Paraphrasis in Evangelium Matthaei nunc primum natam et aeditam per D. Erasmum*, Basle: Froben, 1522.

87 Rowlands 1985, no. 16, p. 130, nos. 13, 15, pp. 128–30; Amerbach-Kabinett 1991, Gemälde, no. 31, pp. 21–2.

88 Erasmus 1703–6, V, cols. 2–66; Erasmus 1971. Erasmus 1520; Hieronymus 1984, no. 184, p. 152; on Erasmus and St Martin, see Erasmus' *Chiliadis tertiae centuria III Sileni Alcibiadis*, in Erasmus 1969–, 11, 5, p. 166: 'Martino dicant: adjuva me tuis precibus, ut in tolerandis injuriis tuae lenitatis imitator esse possim'; on the notion of the *Pharmakon*, see Derrida 1989.

89 'Cristus unser höuptman für alss menschlich geschlecht gestritten under dem Banner und stammen des heiligen Creüts'. Krafft 1517; Holbein 1960, nos. 114, 115, p. 152; Hollstein XIV, p. 34.

90 Müling 1520, fol. 11r: 'Dem wol gelerten dersamen weissen hermeister Hans Gerster, der stat Basel würdigen statschreiber Cantzler und Prothonotarie'. Reinhold Köhler, 'Ueber Müling's Barbarossa', in Köhler 1898–1900, 11, pp. 315–19; *Historisch-Biographisches Lexikon der Schweiz*, Neuchâtel: Attinger, 1921, I, p. 74.

91 Hollstein XIV, nos. 3, 4, pp. 141–3; Holbein 1960, nos. 407, 408, p. 321; Hieronymus 1984, nos. 354a, 354b, pp. 362–6, ill. 626,1, no. 355, p. 366, ill. 626,2; Reinhardt 1977. It is impossible, as has been attempted, to link that woodcut with the Guillaume Farel Dispute in Basle in 1524 (Trudzinski 1984), nor to relate it to Erasmus, who was a great admirer of his patron Leo X, and who would not have condoned the sharp criticism of ancient philosophers. On the dating: Schmid 1899, p. 255. On Lützelburger: His-Heusler 1870. Dodgson 1906–7.

92 Baurmeister 1975; Leemann-Van Elck 1940, p. 87.

93 Kunst der Reformationszeit 1983, no. F 41, p. 421; Hollstein VI, nos. 17, 18, pp. 127–8 (Cranach the Younger), no. 66, pp. 40–41 (Cranach the Elder); Groll 1990; Landau 1978, p. 154, no. 132 (R 16), with a poem by Hans Sachs. On the *Blockbücher* see *Blockbücher des Mittelalters. Bilderfolgen als Lektüre*, exh. cat., Gutenberg Museum, Mainz, 1991.

94 Luther 1522, Benzing 1966, nos. 1061, 1062. On the text: Luther 1883–1993, X,1, pp. 180–247, especially pp. 209–10.

95 Luther 1883–1993, X, 1, pp. 621, 623, 625. On Luther's fight against Aristotelianism, Overfield 1984, pp. 300–2.

96 Luther 1883–1993, VII, p. 377. The woodcut *Hercules Germanicus*, dated 1522/23, is no longer attributed to Holbein since Hieronymus 1984, pp. 466–7; this would seem to be correct, in spite of Hollstein XIV, no. 1, p. 138. It is not certain whether the woodcut proposes a heroic (pro-Lutheran) or a satirical (Erasmian) representation. Saxl 1957; Wind 1938–9; Zuchold 1984. On the puppet of the pope, to be connected with a remark made by Erasmus, Reinhardt 1977, p. 242.

97 Reinhardt 1982, p. 263.

98 His 1879; with reference to the poor conditions in which some artists lived after the *Bildersturm* one can recall the Eingabe to the city council in Strasburg, 3 February 1525, Strasburg, Archives Municipales, V/1, no. 12; Rott 1933–8, III/1, pp. 304–5.

99 Ganz 1939, L. 26, 34, and vol. VII, 26, 34. Harmening 1979; Camille 1990.

100 Erasmus 1523(2); Holbein 1960, no. 397, pp. 315–16. In 1530 Holbein could not decide whether to join the Reformed community: Aktensammlung

1921–50, IV, pp. 491–2, 26 June 1530, 'Meyster Hans Holbein, der maller, spricht, man musz in den tisch basz uslegen, eb er gand'.

101 Rowlands 1985, pp. 93–4, no. 56, pp. 142–3; on Cranach's woodcuts, of which only two copies are known (London, British Museum, and Weimar) and related pictures, Cranach 1974, II, nos. 353, 354, pp. 505–10.

5. Italian and Northern Art

1 Livy, VII, 6; Valerius Maximus, V, 6; Braun 1954.

2 This wall painting is dated 1516 and signed with a complex monogram that probably records the intervention of many hands – if it is authentic; Frauenfelder 1958, pp. 112–44; Konrad 1992, with new attributions. No document records the work executed for the abbot David von Winkelsheim, whose Great Hall was decorated in 1515–16.

3 Marcantonio Raimondi, so-called *Series of the Four Roman Horse-riders* (B.188–91). Bartsch 1978–, XXVI, pp. 184–7; see the engravings *Horatius Cocles*, *c*. 1509, 17.5 x 11.9 cm, Vienna, Albertina, inv. 1970/414 (B.190) and *Marcus Curtius*, *c*. 1509, 17.7 x 11.5 cm, Vienna, Albertina, inv. 1970/416 (B.191); see Bologna e l'umanesimo 1988, no. 38, pp. 169–71.

4 Stimmer 1984, pp. 35–96; Stimmer's *Design for a Stained Glass with Marcus Curtius*, 1560s, no. 258, pp. 415–16.

5 Sandrart 1675–9, I, part 2, book 3, p. 254.

6 The palace no longer exists; Furlan 1988, D 73, p. 307; Pordenone 1984, no. 4.45, p. 225; Schweikhart 1984, pp. 121–2.

7 The old building burned down in 1505, whereupon the Senate of Venice decided to have it rebuilt for the sake of the German merchants, in order both to develop foreign commerce and to control it; Simonsfeld 1887; Rösch 1986, pp. 51–72; Gunther Schweikhart, 'Der Fondaco dei Tedeschi: Bau und Ausstattung im 16. Jahrhundert', in Venedig und Oberdeutschland 1993, pp. 41–9.

8 Carlo Ridolfi, *Le Maraviglia dell'arte o vero le Vite degli illustri Pittori Veneti e dello stato*, 2 vols, Venice: G.B. Sgaua, 1648, new edn by Detlev von Hadeln, 2 vols, Berlin: G. Grote, 1914–24, I, p. 100: 'on the facade facing the canal (the other part facing the bridge was allotted to Titian), he designed trophies, ignudi bodies, heads in chiaroscuro; and in the corners he painted geometers who measure the diameter of the world, views of columns, and between them men on horseback and other fantasies that showed how well he was mastering fresco painting in colour' ('della facciata verso il Canale (come à Titiano fù allogata l'altra parte verso il ponte), nella quale divise trofei, corpi ignudi, teste a chiaro scuro; e ne' cantoni fece Geometri, che misurano la palla del Mondo, prospettiva di colonne, e trà quelle, uomini a cavallo e altre fantasie dove si vede quanto egli fosse pratico nel maneggiar colori a fresco'). Milesio 1882, pp. 19–51; Wethey 1969–75, III, pp. 5–10; Giorgione 1978, pp. 117–42.

9 Vasari already bemoaned the near disparition of such works in the first edition of the *Vite* (1550), Vasari 1976, IV, part 3: Giorgione da Castelfranco. *Pittor viniziano*, pp. 41–7, especially pp. 44–5.

10 Schweikhart 1973, no. 73, facade of the house no. 1274, Corso Cavour 1, with two scenes with horse-riders by Niccolò Giolfino, before 1500, see figs. 143–50; Margarete Baur-Heinhold, *Bemalte Fassaden. Geschichte, Vorbild, Technik, Erneuerung*, Munich, 1975, p. 24 (facade on the Via Larga in Trento).

11 Daniel Burckhardt, 'Einige Werke der lombardischen Kunst in ihren Beziehungen zu Holbein', in *Anzeiger für schweizerische Altertumskunde*, n.s., VII, 1905/06, pp. 297–304.

12 Titian 1993, no. 37, pp. 299–301; Freedberg 1970, pp. 92–3. Wilde 1974, pp. 99–100. Sebastiano's paintings were commissioned by Alvise Ricci, vicar of S Bartolomeo from 1507 to 1509; his coat of arms is painted on the outer side of the doors.

13 Manuel 1979, no. 140, pp. 306–7; see also nos. 260–61, pp. 419–21; Dürer 1991, no. 136, pp. 148–9.

14 Anzelewsky 1971, pp. 64–9, no. 93, pp. 187–99, especially p. 189.

15 It was commissioned by Alberto de'Cattanei; Emiliani 1985, pp. 75–6; Bologna 1987, no. 98, p. 66.

16 Del Cossa placed the donors between the bishop and the Virgin, behind the throne; such a choice is rare since they usually appear in the foreground, at the feet of the saints, or *in abisso*. There are countless examples of donors in the foreground of the *sacra conversazione*, among them, van Eyck's *Madonna van der Paele*, Piero della Francesca's *Pala di Montefeltre*, Andrea Mantegna's *Madonna della Vittoria*, and an example from the Lombard school, Ambrogio Bevilacqua's *Madonna and Child, St Peter Martyr and King David*; for this last panel see *Pinacoteca di Brera. Scuole lombarda e piemontese 1300–1535*, Milan, 1988, no. 89, pp. 112–14. Chastel 1977.

17 See chapter Four.

18 Two documented examples may be mentioned: the *Sacra conversazione with St Romano and St Anthony*, *c*. 1450, fresco, Ascona, S Maria della Misericordia, south nave wall; and Bernardino Luini, *Sacra conversazione with St Anthony abbot and St Barbara*, 1521, fresco, 226 x 175 cm, formerly in S Maria di Brera, as part of the decoration of a chapel (now in Milan, Brera).

19 See also the *sacra conversazione* by Andrea Mantegna in the National Gallery, London; there is no carpet, but the majesty of the group is enhanced through the low viewpoint; Lightbown 1986, no. 32, pp. 436–7.

20 It almost collapsed and had to be demolished in 1594; the panel was then housed in the Sala dei Mercanti; Ffoukes and Maiocchi 1909, pp. 234–7; Wittgens p. 76, no. XCVII, pp. 104–5.

21 'Bei diesem Allem sind seine Werke von äusserst verschiedenartigem Styl; er war ein frühreifes und höchst bewegliches Talent und nahm Einflüsse von verschiedensten Seiten auf, bis die ursprüngliche Richtung bereichert wieder hervortrat': Kugler 1847, II, p. 273.

22 See chapter One, Reference 13. On this new view of art history according to the notion of 'task', see Huse 1977, and Horst W. Janson, *Form follows Function – or does it? Modernist Design Theory and the History of Art*, The First Gerson Lecture, University of Groningen, 1981, Maarssen, 1982.

23 Schmid 1945–8, I, pp. 65–6; Vitruvius, *De Architectura Libri Dece traducti de latino in Vulgare*, ed. Cesare Cesariano, Como: Gotardus de Ponte, 1521, Book I, fol. 6; Müller 1988, no. 35, pp. 124–5; Müller 1996, no. 140, p. 95.

24 A few recent studies have focused on the orientation of the whole fresco towards the beholder – appropriate gestures chosen by the artist, perspective, etc.; Huber 1990, pp. 182–202; Kemp 1986.

25 Shearman 1992, pp. 62–7.

26 Holbein 1960, no. 363, pp. 297, 299; Hieronymus 1984, no. 365, p. 375; Hollstein 1988, XIV, no. 29, p. 212; see also for the iconography typical of the *Intercessio*: Anderes and Hoegger 1988, p. 246 (stained glass for Johannes von Sur, 1518, from a Zurich workshop), and pp. 258–9 (stained glass of 1590); see Susan Marti and Daniela Mondini, ' "Ich manen dich der brüsten min, Das du dem sünder wellest milte sin!" Marienbrüste und Marienmilch im Heilsgeschehen', in Himmel, Hölle, Fegefeuer 1994, pp. 79–90, no. 101, pp. 298–9.

27 Bushart 1994, pp. 15–18, pp. 99–111; Lieb 1952.

28 Museum Lisbon 1977, pp. 56–58; Bushart 1977. Bushart has justly remarked that the title of this picture is not accurate. The date of 1519 is probably also not correct. The panel was most probably completed before Holbein the Elder's departure from Augsburg, that is before 1516. The connection with Lombardo's tomb of the Doge Andrea Vendramin is by far not conclusive: see the architecture in the drawing by Lorenzo Costa, *Christ in the House of Simon the Pharisee*, *c*. 1500, Oxford, Christ Church; see Byam Shaw 1976, I, no. 861, II, pl. 525. This can be compared with the Master of the Virgo inter Virgines, *The Virgo inter Virgines*, Amsterdam, Rijksmuseum; Thiel 1976, p. 637 (A 501); Friedländer 1927, pp. 70–71 (c. 1480): for another similar iconography see the Master of the Lucia Legend, *Madonna and Saints*, Brussels, Musées Royaux des Beaux-Arts.

29 Winkler 1936–9, II, no. 466, pp. 133–4; Kaiser 1978, II, p. 526. The changes that occurred during the work's execution are limited to the opening out of the right side, and to details, for instance the coffered ceiling.

30 On Michelozzo's work for S Miniato al Monte: Ferrara and Quinterio 1984, pp. 243–5, with the remark on Masaccio's fresco *Trinità* (*c*. 1425) in S Maria Novella; Caplow 1977, I, pp. 444–52.

31 Konrad 1992, pp. 94–7; Rowlands 1985, R.15, p. 231; the attribution of that panel by Koegler (1923) has met with considerable reluctance, Holbein 1960, no. 158, pp. 186–7; Klemm 1980, p. 77 (doubtful).

32 Müller 1988, no. 25, pp. 95–7; Amerbach-Kabinett 1991, Zeichnungen, no. 105, p. 35; Landolt 1990. On the iconography, see Bandmann 1970; Müller 1996, no. 110, pp. 78–9.

33 Müller 1988, no. 24, pp. 91–4; Müller 1996, no. 109, pp. 77–8.

34 Neilson 1938, pp. 79–96; Geiger.

35 Rowlands 1985, p. 32, no. 8, p. 126; Amerbach-Kabinett 1991, Gemälde, no. 28, p. 20; Klemm 1980, pp. 28–31, 71.

36 On the drawings for stained glasses, generally dating from 1519/20, Müller 1988, nos 11, 12, pp. 60–65.

37 Reinhardt 1978; Reinhardt 1975–6; Müller 1988, nos 49–58, pp. 164–90; Müller 1996, nos 162–73, pp. 109–15; see chapter Two.

38 A letter from Erasmus to Willibald Pirckheimer, June 1524, bears testimony to this French journey; Erasmus 1906–58, v, 1488, pp. 534–5. The models for the drawings were identified by Jacob Burckhardt in 1873; see Burckhardt 1949–86, v, no. 619, p. 211 (letter to Eduard His, 26 September 1873). Müller and Christian, 1988, nos 46a, 46b, pp. 152–7; Müller 1996, nos 150–51, pp. 99–101.

39 Mellen 1971, pp. 24–36.

40 Leonardo da Vinci, *Codex Atlanticus*, Milan, Biblioteca Ambrosiana, fol. 247; Leonardo da Vinci, *The Literary Works*, 2 vols, ed. Jean Paul Richter [1883], reprinted as *The Notebooks*, 2 vols, New York, 1970, I, no. 612, p. 315; Leonardo da Vinci, *Traité de la peinture*, trans. and introd. by André Chastel, Paris, 1987; Leonardo da Vinci, *Isabella d'Este*, 1499, black and coloured chalks, 60 x 46 cm, Paris, Louvre, Département des Arts Graphiques, MI 753; Bernardino Luini, *Young Lady with a Fan*, c. 1520–24, black and coloured chalks, Vienna, Albertina, inv. no. 59 (L.174); the corresponding picture is in Washington, DC, National Gallery of Art.

41 Mellen 1974, no. 2, p. 213, see the miniature no. 128, p. 233.

42 Müller 1988, no. 67, pp. 215–16, and the portrait ascribed by Rowlands to a follower of Holbein now at Drumlanrig Castle, Dumfries: Rowlands 1985, no. R.25, pp. 233–4; Müller 1996, no. 158, p. 108.

43 Bildhafte Zeichnungen 1995.

44 Rowlands 1985, p. 87, no. 53, pp. 141–2.

45 Mellen 1971, pp. 49–50, no. 141, pp. 237–9 (with discussion of the attribution and date), preparatory drawing no. 31, p. 218; Scailliérez 1992, no. 1, pp. 42–3 (Jean and François Clouet, c. 1520).

46 Rowlands 1985, p. 114, no. L 14 c, p. 226 (copy in Rome, Galleria Nazionale dell'Arte Antica).

47 Scailliérez 1991, pp. 96–9; besides the original portrait in Philadelphia, Museum of Art, there are five replicas from his workshop; Gossaert 1965, no. 38, pp. 215–16, dated between 1525 and 1530; the sitter, a member of the Burgundian court, has not been identified, see Osten 1961; Berlin Staatliche Museen 1975, no. 586 A, p. 180; Cox-Rearick 1995, pp. 8–11.

48 Amerbach-Kabinett 1991: Beiträge zu Basilius Amerbach, p. 145 (Inventar D); the two paintings *Venus and Cupid* and *Laïs Corinthiaca* are not pendants, see Amerbach-Kabinett 1991, Gemälde, nos. 34, 35, pp. 23–4; Rowlands 1985, pp. 63–4, nos. 21, 22, p. 131; Meyer zur Capellen 1984.

49 Cox-Rearick 1995, no. IV-2, pp. 144–6.

50 Scailliérez 1992, no. 42, p. 111, compare with no. 31, pp. 92–3, and no. 33, pp. 96–7; Cox-Rearick 1995, no. VI-5, pp. 214–17.

51 Holbein 1960, no. 186, pp. 215–16 (dated after 1532); Chamberlain 1913, I, pp. 95–8; Rowlands 1985, no. 17, pp. 130, 61–2 (dated after the journey to France in 1524).

52 Cox-Rearick 1995, no. V-1, pp. 166–7; Lucas van Leyden B.77, B.77a.

53 Only three drawings from the German school which develop this Italian theme may be found that predate Holbein; Albrecht Dürer drew in 1511–13 the *Madonna with the Child and St John*, adding, perhaps later, a sketch for architectural elements. In around 1518/19 Dürer re-examined the same subject in a large-scale drawing; Winkler 1936–9, III, no. 515, pp. 9–10; no. 538, pp. 17–18; Strauss 1974, III, pp. 1278, 1782. A drawing in chalk, attributed to Grünewald and dated 1519, shows Jesus with the Virgin Mary and, behind them, the small St John the

Baptist as a child; Ruhmer 1970, no. 28, pp. 92–3, pl. 33. Corresponding panels by Dürer or Grünewald do not exist; however after Holbein, Lucas Cranach the Elder and Hans Baldung Grien adopted such a motif; Osten 1983, no. 82, pp. 227–9; Körner 1988; Lucas Cranach the Elder (workshop), *Madonna with Child and St John the Baptist*, 1551, Gotha, Schlossmuseum.

54 Other examples: Bernardino de'Conti, *Madonna with the Child and St John*, 1522, Milan, Brera, inv. 5506; Aronberg Lavin 1955; Aronberg Lavin 1961. Masseron 1957.

55 Leonardo's *Virgin of the Rocks*, 1483; collection of François I, Paris, Louvre, inv. 777. Cox-Rearick 1972, pp. 14–21, especially pp. 15–16; Cox-Rearick 1995, no. IV-1, pp. 140–43.

56 Raphael 1983(2), no. 6, pp. 81–4: 'La "Belle Jardinière" certainly belonged to François I' (p. 81); Scailliérez 1992, no. 38, pp. 104–5; Cox-Rearick 1995, cat. V-11, pp. 179–81; compare with Raphael or Gian Francesco Penni, *Virgin with the Veil*, Raphael 1983(2), no. 17, pp. 111–14; and the other versions of the Virgin with the two children by Raphael: *Madonna on the Grass*, 1506, Vienna, Kunsthistorisches Museum; *Madonna del Cardellino*, 1507, Florence, Uffizi. See also the engraving by Agostino Veneziano – a member of the Raphael circle – with a Virgin in half-figure with the two children, a variation after the *Madonna Aldobrandini* of 1510; Raphael 1983(2), no. Madonne XLIII, p. 210.

57 Chastel 1996, ch. 2. The Leonardo is now in the National Gallery, London.

58 This painting was bought in 1861 as a Filippo Lippi; since Berenson's reattribution, it has been downgraded to a picture of the Florentine school; Cornu 1862, no. 204; Berenson 1963, I, p. 211.

59 On the church of S Maria della Misericordia in Ascona, Gilardoni 1979, II, pp. 152–4, ill. nos. 175, 176; Pittura in Italia 1988, I, p. 78.

60 Pinacoteca di Brera 1988, no. 145, pl. 145, pp. 325–30; see also Romano, Biraghi and Collura 1978.

61 Mander 1618, fol. 142b; Sandrart 1675–9, I, part 2, book 3, p. 249.

62 Mander 1935; Sandrart 1675–9, I, part 2, book 3, p. 249.

63 Mander 1991, p. 113. According to van Mander, Federico Zuccaro copied the two Triumphs by Holbein during his stay in London (1575).

64 'Wo früher Einzelnes dergleichen vorkömmt, da genügt noch die Annahme, dass Holbein Kupferstiche der Schule Mantegna's vor Augen gehabt; für die folgende Zeit dagegen wird man wohl einen wenn auch kurzen Aufenthalt im Süden, wenigstens in Oberitalien zugeben müssen, insofern gerade die Anklänge an Leonardo da Vinci allzu augenfällig sind'; Kugler and Burckhardt 1847, II, p. 278.

65 Jacob Burckhardt, 'Holbein & die italienische Renaissance', in Burckhardt, Jacob, Vorlesung, MS, Staatsarchiv Basel-Stadt, PA 207, 164.

66 Klemm 1972.

67 Rowlands 1985, pp. 29–30. The scholars who are inclined to accept the idea of his journey to Italy are normally criticized by fellow art historians who quote Carel van Mander; cf. Holbein 1988, pp. 12–14, and the review by Borries 1989, with reference to Carel van Mander; Reinhardt 1982, p. 257.

68 Salvini 1984.

69 Strieder 1959.

70 Weitnauer 1931; Lieb 1952; Andrew J. Martin, 'Motive für den Venedigaufenthalt oberdeutscher Maler. Von Albrecht Dürer bis Johann Carl Loth', in Venedig und Oberdeutschland 1993, pp. 21–30; Levenson 1981.

71 Liebenau 1888; Lauber 1962; Holbein 1992.

72 For Basle as a point of exchange between North and South see Luchsinger 1953; Bietenholz 1959; Vetter 1952.

73 Staatsarchiv Basel-Stadt, Bestallungsbuch, 16 October 1538; His 1870, pp. 131–2; Wornum 1867, p. 164; Woltmann 1874–6, I, pp. 143–4. This document is reprinted in our Appendix.

74 '. . . das er auch die Kunststuck, so er alhie by unns machen wirdeth, Im Jar ein mal, zwey, oder drü, doch Jeder Zit, mit unnserem gunst, und erloubung, unnd gar nit hinder unns, In Frankrich, Engelland, Meylannd unnd niderland, frembden Herren zu füren, und verkouffen möge'.

6. The Portrait, Time and Death

1 Parshall 1993; Claudia Swan, '"Ad vivum, naer het leven", from the life: defining a mode of representation', *Word & Image*, XI/4, 1995, pp. 353–72; among the innumerable publications on Renaissance portraiture, see Dülberg 1990; Castelnuovo 1988; Pope-Hennessy 1979; Campbell 1990; Boehm 1985; Andrew Martindale, *Heroes, Ancestors, Relatives and the Birth of the Portrait*, Gerson Lecture, Groningen, 1988; one of the most brilliant essays on German Renaissance portraiture is Koerner 1993.

2 'Ut te omnium historiarum seriem non legere sed oculo intueri te existimabis . . . omnia vivere putabis'. See Adrian Wilson, *The Making of the Nuremberg Chronicle*, Amsterdam, 1976, pp. 208–9.

3 Martin Kemp, 'The "Super-Artist" as Genius: The Sixteenth-century View', in *Genius: The History of an Idea*, ed. Penelope Murray, Oxford, 1989, pp. 32–53.

4 Parshall 1995 points out that a good picture is defined by the word *curiosa*, that is interesting to look at and which shows the care the artist has put into it; André Labhardt, 'Curiositas: Notes sur l'histoire d'un mot et d'une notion', *Musæum Helveticum*, XVII, 1960, pp. 206–24. Hans Blumenberg, *Die Legitimität der Neuzeit*, Frankfurt, 1966, p. 336.

5 'Contrafactum' meant portrait, effigy, resemblance, likeness, forgery. This word was in use around 1500 in Germany.

6 Holman 1980, p. 156.

7 Franciscus Petrarca, *Von der Artzney bayder Glück des Guten und Widerwertigen*, Augsburg: Steyner, 1532, II, fol. XXII, 'Von Verlierung der Zeit'.

8 In Latin, *persona* means both 'mask' and 'person', 'character'.

9 'SVA.CVIQVE./. PERSONA'; Raffaello, *Scritti. Lettere, firme, soneti, saggi tecnici e teorici*, ed. Ettore Camesasca, Milan, 1994 (with bibliography) Testo 7, p. 72; Dülberg 1990, cat no. 172 and ill. 126.

10 Louis Marin, *Masque et portrait. Sur l'opérateur 'masque' dans quelques textes du XVIIème siècle français*, Urbino, 1993, especially pp. 4–5.

11 *Selecta Epigrammata graeca latine versa, ex septem Epigrammatum Graecorum libris*, ed. Andrea Alciati, Ottomaro Lusci and Ianus Cornarius, Basle: Bebel, 1529, p. 241.

12 Andrea Fulvio, *Illustrium imagines*, Rome: Mazocchi, 1517, fol. Va: 'Janus qui primus inchoandis præesse creditus est initium picturæ virorum ac mulierum illustrium ab archetypis auspicabitur tum quod primus æra signaveri: in quibus ut Saturno memoriam rederet: qui in Italiam navi advectus fuerat quemque in regni societatem asciverat ex una quidem parte sui capitis idest gemini effigiem: ex altera vero navi expressit ideo biceps dictus quod rex pudentissimus extiterit: ut qui præterita cognosceret & futura prospiceret'.

13 Heinrich Pantaleon, *Prosopographiæ Heroum atque illustrium virorum totius Germaniæ*, Basle: Brylinger, 1565 [I; II], 1566 [III]. I, pp. 15–17: NOHE QUI ET IANUS DICITUR, spec. p. 17: 'Sunt qui tradunt ipsum in Italia obiisse, atque ob diuturnam vitam Ianum dictum, quem antiqui bifrontem, propter duo secula quibus claruerat, magno mysterio finxerunt'.

14 J. Prinz, 'Johannes Münstermann. Zu einem Bildnis von Hermann tom Rings', *Westfalen*, XL, 1962, pp. 175–94; Roland Barthes, *La Chambre claire. Notes sur la photographie*, Paris, 1980, pp. 47–9.

15 Leon Battista Alberti, *De Pictura*, trans. John R. Spencer, New Haven, 1966, book II, p. 63. The exchange between the temporality of nature and that of painting is admirably commented on by Erasmus. In one of his *Colloquia*, the *Convivium religiosum*, he sets up a dialogue between Eusebius, the owner of a beautiful house, and his visitors. They admire the garden, and a room with a painted garden. When asked if that second garden was not inferior to the other, due to its sheer size, he answered that the latter, unlike the first, could boast of having all known species of plants; it is true, the painted garden had no smell, but it did not require any special care. Both gardens bore testimony of God's creativity, even if through the hand of an artist. When a guest, Thimoteus, complained that the painted garden satisfied the sight only, Eusebius answered that is does, but then continously. A painting may get old, but, contrary to Man, ages beautifully. On one side, the representation is characterized by its failures, but time works in its favour. Such a balanced view is typical of the Renaissance. Erasmus, *Cinq banquets*, critical edition by J. Chomarat and D. Menager, Paris, 1981, p. 73.

16 Müller 1996, cat. 22, p. 54; Michael 1986, pp. 71, 355, 358.

17 Dülberg 1990.

18 1470–75. Munich, Alte Pinakothek; and Kress Collection, National Gallery of Art, Washington, DC. See *The Art of Devotion* 1994, p. 44; *Triptych with the Crucifixion*, Frankfurt, Städel Museum, end of the fifteenth century, in Sander 1995, p. 103, cat. 38, and p. 200 (with inscription 'COGITA MORI').

19 For the Braque *Triptych*, see Dülberg 1990, pp. 100, 154, 155 and ill. 24. There is a similar inscription on a portrait (1502) by Andrea Previtali with, on the other side, these words: 'HIC.DECOR.HEC.FORMA.MANET HEC.LEX.OMNIBUS.UNA', Milan, Museo Poldi-Pezzoli; *Museo Poldi-Pezzoli. Dipinti*, Milan, 1982, cat. 122, pp. 125–6; Matthias Winner, 'Annibale Carracci's self portraits and the Paragone Debate', *World Art: Themes of Unity in Diversity*, Acts of the XXVIth International Congress of the History of Art, ed. Irving Lavin, University Park, PA, 1989, II, pp. 509–20; Rosario V. Cristaldi, '"Homo ille melancholicus". Il "trantasettenne" di Lorenzo Lotto', *Synaxis*, II, 1984, pp. 201–38.

20 Dülberg 1990, p. 155, and nos. 16, 17, 19, ills. 219–22.

21 The literature on the subject is very extensive; Rosenfeldt 1966; Peter Felder, 'Memento Mori: Art and the Cult of the Dead in Central Switzerland', in *1000 Years of Swiss Art*, ed. Heinz Horat, New York, 1992, pp. 128–41; but above all the brilliant essay by Christian Kiening 1995 (with extensive bibliography); Davis 1956.

22 *Les Simulachres & historiees faces de la mort, avtant elegamment pourtraictes, que artificiellement imaginées*, Lyons: Gaspar and Melchior Trechsel, 1538 fol. Aiii recto; the text was written by Jean de Vauzelles; Kiening 1995, p. 1158.

23 As Seneca said, 'For the artists it is more agreable to paint, than to have painted. . . . The pleasure is not the same, for the artist who removes his hand from a finished painting. That artist enjoys the finished work, while another painter would rather enjoy the practice of his art' ('Artifici jucundius est pingere, quam pinxisse. Illa in opere suo occupata sollicitudo, ingens oblectamentum habet in ipsa occupatione. Non aeque delectatur, qui ab opere perfecto removit manum. Iam fructu artis suae fruitur; ipsa fruebatur arte, cum pingeret'), Seneca, *Epist.* 9.

24 Kiening 1995, p. 1159 (*Simulachres*, fol. Aiii verso).

25 This *Totentanz* is known through a copy made by Albrecht Kauw, in 1649 (Historisches Museum, Berne). Manuel 1979, cat. no. 116, pl. 71.

26 Holbein 1960, cat. 13; the two panels are not two parts of a diptych, as stated in that catalogue.

27 'ALS.ICH.WAS.52.IAR.ALT/DA.HET.ICH.DIE.GESTALT'.

28 The pattern used in the two paintings is the same. Formerly Bentick–Thyssen Collection, sold at auction, Sotheby's, London, 6 December 1995, cat. no. 64.

29 Dülberg 1990, cat. 270, the double painting dated around 1487, and showing Hieronymus Tschekkenbürlin on one side, and a skeleton on the other side; Kunstmuseum Basle.

30 Foister 1989, p. 87; and the very pertinent analyses by Müller 1996, cats 92, 93, 153–5; Ainsworth 1990.

31 Reinhardt 1981; Treu 1959; Lisa Jardine, *Erasmus, Man of Letters: The construction of Charisma in Print*, Princeton, NJ, 1993, especially chapters I and II; Alois Gerlo, *Erasme et ses portraitistes*, Nieuwkoop, 1950 and 1969; Panofsky 1951; Panofsky 1969; Bodar 1989; Trapp 1991.

32 Letter by Erasmus to Willibald Pirckheimer, Basle, 3 June 1524, in Erasmus 1906–58, V, no. 1452, pp. 468–71, quotation p. 470; on 1 December 1523, Erasmus had finished his paraphrasis of Marcus' Evangelium, and dedicated it to the King of France.

33 Letter by Erasmus to Thomas More, Antwerp, 8 September 1517, Erasmus 1906–58, III, no. 654, p. 76; see also his letter to Thomas More, Antwerp, 30 May 1517, Erasmus 1906–58, II no. 584, pp. 576–7; Campbell 1990, no. 178–9; Trapp 1990; Bek 1988.

34 Vasari 1986, II, p. 916.

35 Letter by Erasmus to Thomas More, Louvain, 16 September 1517,

Erasmus 1906–58, III, no. 669, pp. 92–3, he says: 'If you could spring and fly to here, how we would both come back to life!'.

36 Letter of Thomas More to Peter Gillis, Calais, 7 October 1517, Erasmus 1906–58, III, no. 683, pp. 105–7.

37 On Erasmus, and St Jerome see Eugene F. Rice, *St Jerome in the Renaissance*, Baltimore and London, 1985, pp. 116–36; Wind 1937–8; E. Fahy, 'A Portrait of a Renaissance Cardinal as St Jerome', *Minneapolis Institute of Arts Bulletin*, LIX, 1970, pp. 1–19; Ph. H. Jolly, 'Antonello da Messina's "St Jerome in his Study": A Disguised Portrait?', *Burl. Mag.*, CXXIV, 1982, pp. 27–9; Heckscher 1967, pp. 144–5; Strümpel 1925–6; John Oliver Hand, '"St Jerome in his Study" by Joos van Cleve', in *A Tribute to Robert A. Koch. Studies in the Northern Renaissance*, Princeton: Department of Art & Archaeology, 1994, pp. 53–68; Anthony Grafton, 'Comment créer une bibliothèque humaniste: le cas de Ferrare', in *Le pouvoir des bibliothèques. La mémoire des livres en Occident*, ed. Marc Baratin and Christian Jacob, Paris, 1996, pp. 189–203, especially p. 197: Angelo Decembrio, *De Politia litteraria*, MS Biblioteca Apostolica Vaticana, Vat. Lat. 1794 fol. 9r, recommends a St Jerome painting for a library.

38 Amerbach-Kabinett 1991, Die Objekte im Historischen Museum Basel, no. 17, pp. 38–9; Edgar Wind, 'Aenigma Termini', *JWCI*, I, 1937–8, pp. 66–9; .

39 Letter by Erasmus to Nicholas Everard, Antwerp, 17 April 1520, Erasmus 1906–58, IV, no. 1092, pp. 237–8, where he calls the medal 'Plumbeum Erasmum'; letter by Erasmus to Albrecht von Brandenburg, Louvain, 15 May 1520, Erasmus 1906–58, IV, no. 1101, pp. 259–60.

40 Müller 1996, cat. 156, pp. 104–5; Rowlands 1985, no. 35.

41 Erasmus to Willibald Pirckheimer, Basle, 30 July 1526, Erasmus 1729, VI, pp. 371–2: 'Alberto Durero quam gratiam referre queam cogito. Dignus est æterna memoria. Si minus respondet effigies, mirum non est. Non enim sum is qui fui ante annos quinque. Iam fere biennium est, quod sub Februarium laborans calculo sic concussus sum vomitionibus, ut ex hoc tempore semper decreverit corpusculum, quod ante solet post morbum sarciri'; see the letter from Erasmus to Willibald Pirckheimer, Basle, 19 July 1523, Erasmus 1906–58, V, no. 1376, p. 307: 'S. Durero nostro gratulor ex animo: dignus est artifex qui nunquam moriatur. Coeperat me pingere Bruxellae: utinam perfecisset!'; letter from Erasmus to Willibald Pirckheimer: Basle, 8 January 1525, Erasmus 1906–58, VI, no. 1536, pp. 2–3: 'Accepi meum Bilibaldum, primum fusilem, cum anulo et litteris; nunc etiam pictum ab Appelle. ... A Durero cuperem pingi, quidni a tanto artifice? Sed qui potest? Coeperat Bruxellae carbone, sed iam dudum excidi, opinor. Si quid ex fusili et memoria sua potest, faciat in me quod in te fecit; cui addidit aliquid obesitatis. Pharmaco tuo nondum ausus sum uti'; Erasmus to Willibald Pirckheimer: Basle, 14 March 1525, Erasmus 1906–58, VI, no. 1558, pp. 44–52, p.46: 'Habes Erasmum fusilem. A Durerio, tanto nimirum artifice, pingi non recusem; sed qui possit, non video. Nam olim me Bruxellæ deliniavit tantum, at coeptum opus interruperunt aulici salutatores. Quanquam iam olim infelix exemplar exhibeo pictoribus, indies exhibiturus infelicius'; Panofsky 1969.

42 Letter from Erasmus to Peter Gillis, Basle, 29 August 1526, Erasmus 1906–58, VI, no. 1740, pp. 391–2: 'Qui has reddit is qui me pinxit: eius commendatione te non gravabo, quanquam est insignis artifex. Si cupiet visere Quintinum, nec tibi vacabit hominem adducere, poteris per famulum commonstrare domum. Hic frigent artes, petit Angliam ut corradat aliquot angelatos: per eum poteris quae voles scribere'; see also the letter by Erasmus to John Faber, Basle, 21 November 1523, Erasmus 1906–58, V, no. 1397, p. 349: 'Ex tua salutatione, quam mihi per Olpeium misisti, melius habui: erat enim accurata et veniebat ab amico et per hominem amicum'; letter by Conrad Glocenius to Dantiscus, Bishop of Kulm and ambassador of the King of Poland to the Emperor, Louvain, 2 June 1531: 'I have so close a friendship with Holbein that I can get whatever I want from him', document published by Gerlo 1950, p. 52.

43 Müller 1996, cat. 73.

44 Letter by Erasmus to William Warham, Basle, 4 September 1524, Erasmus 1906–58, V, no. 1488, p. 534: 'Amplissime Præsul, arbitror tibi redditam imaginem pictam, quam misi ut aliquid haberes Erasmi, si me Deus hinc evocarit. Mense Aprili graviter periclitatus sum pituita. Vix

convalueram, successit calculus, tam atrociter ut omnino sperarem malorum finem. Nunc aliquanto commodius habeo. Hæc scribo quo magis mihi gratuleris, cui scio meam incolumitatem anxie cordi esse: siquidem, ut scribis, me periclitante concuteris, et rursus me victore recipis animum'; Heckscher 1967; Rowlands 1985, cat. 13.

45 Rowlands 1985, cat. 16; Gerlo 1950, pp. 39–58; Holbein used that type to produce the Louvre portrait of Erasmus, see Rowlands 1985, no. 15 and Foucart-Walter 1985, pp. 9–26.

46 Rowlands 1985, nos. 21 and 22. Another example by Ambrogio de Predis – active in Milan c. 1522 – a portrait of a young lady, *Meisterwerke der Malerei aus Privatsammlungen im Bodenseegebiet*, Bregenz, Künstlerhaus, Palais Thurn und Taxis, 1965, p. 63, no. 77b and col. pl. I.

47 Lucas Cranach, *Venus and Love*, 1509, St Petersburg, Hermitage; *The Hermitage. Catalogue of Western European Painting. German & Austrian Painting. Fifteenth to Eighteenth Century*, ed. Nikolai N. Nikulin, Florence, 1987, cat. 14; a wonderful analysis was proposed by Anna-Marie Bonnet, 'Der Akt im Werk Lucas Cranachs. Bedeutung und Spezifität der "nacketen Bilder" innerhalb der deutschen Renaissance-Malerei', in *Lucas Cranach. Ein Maler-Unternehmer aus Franken*, ed. Claus Grimm, Johannes Erichsen and Evamaria Brockhoff, exhibition catalogue, Leipzig, Museum der Bildenden Künste, 1994, pp. 139–49, where the woodcut is discussed.

48 Letter by Thomas More to Erasmus, Greenwich, 18 December 1526, Erasmus 1906–58, VI, no. 1770, pp. 441–3: 'Pictor tuus, Erasme charissime, mirus est artifex; sed vereor ne non sensurus sit Angliam tam foecundam ac fertilem quam sperabat. Quanquam ne reperiat omnino sterilem, quoad per me fieri potest, efficiam'; John Fletcher, 'A Panel-maker's Brand Mark and Holbein's Stay at Antwerp in 1526', *The Antiquaries Journal*, LXI, 1981, pp. 339–40; LXIII, 1983, pp. 373–4; John Fletcher, 'Panel Examination and Dendrochronology', *J. P. Getty Museum Journal*, X, 1982, pp. 21–38 and 39–44; John Fletcher and Margaret Cholmondeley-Tapper, 'Hans Holbein the Younger at Antwerp and in England, 1526–28', *Apollo*, CXVII, 1983, pp. 87–93.

49 Parker 1945, no. 3; Roberts 1993 no. 2; Ainsworth 1990; Dynasties 1995–6, pp. 21–6.

50 Roberts 1993, no. 2, pp. 28–9; Parker, see Appendix; Rowlands 1985, no. 24, pp. 132–3; Langdon pp. 66–7; Stanley Morison, *The Likeness of Thomas More: An Iconographical Survey of Three Centuries*, ed. and supplemented by Nicholas Barker, London, 1963; J. B. Trapp, 'Thomas More and the Visual Arts', in *Essays on the Renaissance and the Classical Tradition*, Aldershot, 1990, essay VIII. More was normally simply dressed; J. B. Trapp, Hubertus Schulte Herbrüggen, *'The King's Good Servant'. Sir Thomas More 1477/78–1535* exhibition catalogue, London, National Portrait Gallery, 1977–8.

51 Müller 1988, no. 65, pp. 209–12; Müller 1996, no. 157, pp. 106–8; Rowlands 1985, no. L. 10c; one of the two copies by Rowland Lockey is at Nostell Priory (coll. Lord St Oswald) and the other in the National Portrait Gallery, London, no. 2765; Dynasties 1995–6, no. 76; unlike Bernhard Strigel's *Family of Emperor Maximilian I*, Kunsthistorisches Museum, Vienna (see Dülberg 1990, no. 243), the figures are not purely juxtaposed. The drawings for the faces of the family members and relatives are preserved in Windsor, see Roberts 1993, nos. 1–5; Parker 1945, nos. 1–7.

52 Letter from Erasmus to Thomas More, Freiburg im Breisgau, 5 September 1529, Erasmus 1906–58, VIII, no. 2211, pp. 271–3: 'Utinam liceat adhuc semel in vita videre amicos mihi charissimos! quos in pictura quam Olpeius exhibuit, utcunque conspexi summa cum animi mei voluptate. Bene vale cum tibi charissimis omnibus'. Letter from Erasmus to Margaret Roper, Freiburg im Breisgau, 6 September 1529, Erasmus 1906–58, VIII, no. 2212, p. 274: 'Vix ullo sermone consequi queam, Margareta Ropera, Britanniæ tuæ decus, quantam animo meo persenserim voluptatem, quum pictor Olpeius totam familiam istam adeo feliciter expressam mihi repraesentavit ut, si coram adfuissem, non multo plus fuerim visurus.

53 Rowlands 1985, no. 27, p. 133–4; the preliminary drawing is kept in Windsor, see Roberts 1993, no. 8; Parker 1945, no. 12.

54 Foucart-Walter 1985, nos. 27–36; Rowlands 1985, no. 27.

55 Letter by Thomas More to Erasmus, Calais, 7 October 1517, Erasmus 1906–58, III, no. 683, p. 104.

56 Rowlands 1985, cat. 28.

57 Müller 1996, no. 159; Holbein 1978–9, no. 13; Roberts 1993, no. 6, the drawing for Sir Henry's portrait.

58 Pierre Grimal, *Dictionnaire de la mythologie grecque et romaine*, Paris, 1951, p. 168.

59 Leon Battista Alberti, *De re ædificatoria*, Florence: Alamani, 1485, fol. 159b, 'aut gorgoneos vultus colubribus inter se rixantibus imponerent'.

60 Andrea Alciati, *Clarissimi Viri D. Alciati Emblematum Libellus, vigilanter recognitus, et iam recens per Wolphgangum Hungerum Bavarum, rhythmis Germanicis versus*, Paris: Wechel, 1542, emblem 157, with German poem: 'The beautiful youth . . . lies buried here through the displeasure of death to the special grief of his schoolfriend. On his grave he erected a Medusa's head and two wild dolphins in his honour and as an eternal image of death'. Henkel-Schöne col. 1248–9; the archaeological origin of this image has been rediscovered recently in notes taken by Alciati himself on Antique monuments, now kept in the Biblioteca Apostolica Vaticana, Rome, Vat. lat 5236 fol. 60r, drawing of the tomb of the Campilii, fol. 59v: 'Alterum Campliæ gentis egregii artificis manus ostentat, non solum vulgaris literaturæ periti, sed et hieroglyphicæ. Caput enim Medusæ, quod delphines inversi ambiunt, fato properam mortem significat, quod inter pisces nullus est delphino celerior...'; Florence Vuilleumier and Pierre Laurens, 'De l'archéologie à l'emblème: la genèse du "Liber Alciati"', *Revue de l'Art*, CI, 1993, pp. 86–95, especially note 42.

61 Alciati used his archaeological notes to compose his epigrams and emblems. On Alciati's epigrams and Bonifacius Amerbach, see Alciati's manuscript of his epigrams, corrected by Amerbach: MS O IV 8 N 21, Universitätsbibliothek, Basle; *Bonifacius Amerbach* 1995, no. 13, p. 50; the book: *Selecta Epigrammata graeca latine versa, ex septem Epigrammatum Graecorum libris*, ed. Andrea Alciati, Ottomaro Lusci and Ianus Cornarius, Basle: Bebel, 1529. On Planude, a Byzantine monk (1255–1305), see Nigel Wilson, *Scholars of Byzantium*, London, 1983, and More 1963–, III, 2.

62 *Selecta Epigrammata*, p. 202: More (after Ausonius): 'Saltavit Nioben, Saltavit Daphnida Memphis, / Ligneus ut Daphnen, saxeus ut Nioben'.

63 *Selecta Epigrammata*, p. 335: More (translation from Greek): 'Dii ex viva lapidem facere, at quum lapis essem, / Me vivam fecit denuo Praxiteles'; More 1963–, III, 2, no. 26, p. 93.

64 More 1963–, III, 2 no. 98, p. 157, on an unsuccessful portrait.

65 *Selecta Epigrammata*, p. 213: 'Morus: Ipse tacet Sextus, Sexti meditatur imago, / Ipsa est rhetor imago, ab imagine rhetor imago est'. More 1963–, III, 2, p. 119 no. 26.

66 Rowlands 1985, cat. 69.

67 His 1886, no. 290 (XIX, 8b), with the inscription 'LOT GEN[esis]. 19'. London, British Museum, *Catalogue of Drawings*, Holb 35e; see other examples of drawings, *Skizzen* 1989, no. 32; Müller 1996, no. 199.

68 On that particular question, our interpretation differs from the purely iconographical one suggested in Harbison 1995, p. 122.

69 Benvenuto Cellini, *Due Trattati uno intorno alle otto principali arti dell'oreficeria. L'altro in materia dell'Arte della Scultura; dove si veggono infiniti segreti nel lavorar le Figure du Marmo, & nel gettare di Bronzo*, Florence: Valente Panizzi, Marco Peri, 1568, fol. 22a: 'Parmi anchora d'avvertire in questo luogo l'Orefice, che dovendo fermare in simili lavori Gioie grande e piccole, vega con disegno & giudicio di applicarle alla sua invenzione. Percioche bene spesso alcuni Orefici accomodono qualche Gioia grande per ornamento di qualche Figurina con grande sproporzione, credendo d'essere scusati per la necessità che apporta seco la grandezza della Gioia'. He tells how he received an important commission from Clemens VII Medici, for having found the best way of setting a precious diamond into a fibula: 'mostrassi il mio Modello, vedde che io have haveva posto il Diamanta in guisa d'uno Scabelletto dove il Dio Padre sopra si posasse, la qual invenzione cotanto gli piacque insieme col Modello che subito mi fece consegnar l'opera. Perciò avvertisco l'Orefice (com'ho detto) che dovendo legar simili Gioie le

70 Rowlands 1985, no. 31; Holbein left a drawing portraying John, see Parker 1945, no. 22; Roberts 1993, no. 14; Holbein 1978–9, no 40.

71 Bek 1988, pp. 469–79.

72 'DERICHUS SI VOCEM ADDAS IPSISSIMUS HIC SIT / HUNC DUBITES PICTOR FECERIT AN GENITOR / DER BORN ETATIS SVAE 23 ANNO 1533.' Rowlands 1985, no. 44.

73 Michel de Montaigne, *Les Essais*, ed. Pierre Villey, Lausanne, 1965: II, xxxvii, p. 763.

74 Rowlands 1985, no. 32; Holbein 1960, no. 180.

75 Klemm 1980, pp. 50–53; Rowlands 1985, no. 32.

76 Ganz 1919, p. 212; this copy seems to be rather accurate: the top of Elsbeth's bonnet forms a little crest; that crest was not cut off, but when the portrait was glued on panel, the detail was overpainted in black.

77 She had to part with the picture in her own lifetime as she was clearly in financial difficulties; see Rowlands 1985, no. 32.

78 Ganz 1919, p. 213: 'Die Liebe zum Gott heisst Charitas'. It is in the Musée des Beaux-Arts, Lille.

79 Anne Boleyn, in particular, seems to have helped Holbein's career; E. W. Ives, 'The Queen and the Painters: Anne Boleyn, Holbein and Tudor Royal Portraits', *Apollo*, CXL, 1994, pp. 36–45.

80 Letter by Erasmus to Bonifacius Amerbach, Freiburg, 22 March, 10 April 1533, Erasmus 1906–58, X, no. 2788, pp. 192–3: 'Sic Olpeius per te extorsit litteras in Angliam. At is esedit Antwerpiæ supra mensem, diutius mansurus, si invenisset fatuos. In Anglia decepit eos quibus fuerat commendatus'.

81 Hand 1980; Rowlands 1985, no. 64.

82 Sir Bryan Tuke, preface for *The Workes of Geffray Chaucer Newly Printed, with Dyvers Which Were Never in Print Before*, London: Thomas Godfray, 1532; autograph by Tuke in copy, Clare College, Cambridge; Hand 1980, p. 37 note 11; on the title-page of the book, see R. B. McKerrow and F. S. Ferguson, *Title-page Borders used in England and Scotland 1485–1640*, London, 1932, no. 19, pp. 16–18; it was used from 1530 onwards; unsigned, it is based on a design by Holbein, as used for the title-page to Erasmus' *Aliquot Epistolæ* of 1514; see also Alfred Forbes Johnson, *German Renaissance Title-borders*, Oxford, 1929 no. 63, a very similar woodcut used from 1524 in Germany, and also based on the same design.

83 In his splendid study of the picture, Hand 1980, pp. 33–50, quotes the following inscription with magic formulæ, found inside a medieval ring (Coventry ring, British Museum, London) with the Five Wounds of Christ:
 'Wulnera quinq dei sunt medecina mei
 crux et passio xti sunt medecina mei jaspar
 melchior balthasar ananyzapta tetragrammaton'.

84 Rowlands 1985, nos. 46, 49; Holbein satirized such gentlemen posing with hawks in his illustrations for *Encomium moriæ* (1515); Müller 1996, no. 37.

85 On the empirical view of perspective, which prevailed after Dürer's time, see Keil 1985; Roskill and Harbison 1987.

86 It seems that the carnations were meant to indicate that the sitter was about to marry, as he did wed Christine Krüger from Danzig in 1535; Campbell p. 34; on the Steelyard portraits, Thomas S. Holman, 'Holbein's Portraits of the Steelyard Merchants: An Investigation', *Metropolitan Museum Journal*, XIV, 1980, pp. 139–58; Deborah Markow, 'Hans Holbein's Steelyard Portraits Reconsidered', *Wallraf–Richartz Jahrbuch*, XL, 1978, pp. 43–7; Roskill and Harbison 1987; Rowlands 1985, no. 74 (G. Gisze), no. 77 (D. Born).

87 Claussen 1993 provides the best recent study of this picture, together with Levey 1959, pp. 47–54 (with bibliography); Hoffmann 1975; Rowlands 1985, no. 47; later, Jean de Dinteville did commission another portrait of himself as St George, which is extant, see Pope-Hennessy 1979, pp. 245–52; Hervey 1900.

88 *En ce present volume sont contenues les vies de huict excellens et renommez personnaiges grecz et romains, escriptes premierement en grec par Plutarque de Cherronée, et depuis translatées en françois par feu R.P. en Dieu Georges de Selve*, Paris, 1543, rep. 1548; the manuscript Bibliothèque de France Ms fr. 733:

lives of Thémistocles, Péricles, Alcibiades, Timoleon, Camillus, Fabius Maximus, Coriolanus, Paulus-Emilius.

89 Plutarch, *Les Vies de huit excellens et renommez personnages grecz et romains, mis au parangon l'un de l'autre*, trans. Georges de Selve, Lyon: de Tournes, 1548, prologue; Keller 1967; Dülberg 1990.

90 For Georges de Selve, history was 'comme une table de peinture, là où se voient les conseilz, oeuvres & paroles des . . . hommes de noms, retraitz et exprimez après le vif', Plutarch 1548, p. 12.

91 Mary Rasmussen, 'The Case of the Flutes in Holbein's "The Ambassadors" ', *Early Music*, XXIII/1, 1995, pp. 114–23.

92 Roland Barthes, *La Chambre claire*, Paris: Seuil, 1980.

93 Sebastian Münster, *Canones super novu instrumentum luminarium*, Basle: Cratander, 1534.

94 The inscription reads: 'IMAGO AD VIVAM EFFIGIEM EXPRESSA Nicolai Kratzeri monacensis qui bavarus erat quadragesimu primu annu tempore illo complebat 1528'; Pächt 1944; Rowlands 1985, no. 30; Foucart-Walter 1985, pp. 37–48.

95 Gregorius Reisch's *Margarita philosophica*, Strasburg: Schott, 1504.

96 Alistair C. Crombie, 'Experimental Science and the Rational Artist in Early Modern Europe', *Art and Science*, CXV, 1986, pp. 49–74.

97 *Oeuvres de Feu Reverend Père en Dieu, George de Selve, Evesque de Lavaur: contenans un Sermon, quelques Exhortations, Oraisons, Contemplations, Lettres, Discours, Sommaire de l'escripture saincte, Moyen de faire & entretenir paix, & deux Remonstrances aux Alemans: Comme il est plus à plain contenu en la Table*, Paris: Galliot du Pré, 1559, and particularly the 'Discours du vray et seul moyen de faire une bonne et perpetuelle paix, entre l'empereur et le roy treschrestien: faict par George de Selve, Evesque de la Vaur, estant ambassadeur dudict seigneur Roy treschrestien, vers ledict Empereur', fol. 39a, where he says that Lutheranism did take off thanks to the corruption in the Catholic ranks; on the de Selve family, see Germain Lefèvre-Pontalis, *Correspondance politique de Odet de Selve, Ambassadeur de France en Angleterre 1546–1549*, Paris, 1888.

98 *Oeuvres de Feu Reverend Père en Dieu, George de Selve, Evesque de Lavaur*, Paris: Galliot du Pré, 1559, fol. 29b–35b. 'Summaire et vray argument de toute l'Escripture saincte, declairant la fin du vieil et du nouveau Testament', especially fol. 30a, 'Ou trouverons–nous sens suffisant pour pouvoir contempler la non pareille fabrique de l'edifice de ce monde basty pour l'homme, orné & meublé d'ustensiles en si grande multitude, diversité, beaulté & utilité? Le tout par ordre si parfaict disposé & arrengé, que, si nous regardons a nous mesmes, nous aurons cause de nous esbahyr sans mesure, que Dieu d'un si petit oyseau ayt tant tenu de compte, qu'il luy ayt voulu donner une telle cage'.

99 The household accounts covering the years 1533–7 are missing, Holbein is called a King's Painter from 1536 onwards. Rowlands 1985, p. 96; Foister 1989, pp. 204–58.

100 Foister 1993.

101 Foister 1989, p. 87; Roberts 1993; Dynasties 1995–6.

102 Dynasties 1995–6, p. 118; Artists of the Tudor Court 1983, pp. 34–41; Lorne Campbell and Susan Foister, 'Gerard, Lucas and Susanna Horenbout', *Burl. Mag.*, CXXVIII, 1986, pp. 719–26.

103 Foister 1989. We have drawn much inspiration from this splendid study; see p. 210, with the remarks on Holbein's position at court.

104 Tom Campbell, 'School of Raphael Tapestries in the Collection of Henry VIII', *Burl. Mag.*, February 1996, pp. 69–78.

105 Dynasties 1995–6, no. 65 (with literature); Artists of the Tudor Court 1983, no. 5.

106 Dynasties 1995–6, no. 6 (with literature); Rowlands 1985, no. 70.

107 Rowlands 1985, no. 66; Levey 1959, no. 2475.

108 The documentation related to this portrait is to be found in Artists of the Tudor Court 1983, no.. 30, pp. 48–9; on Holbein's portrait, now in the Louvre, Rowlands 1985, no. 67; Foucart-Walter 1985, pp. 52–64.

109 Dynasties 1995–6, no. 66, p. 119; Artists of the Tudor Court 1983, no. 30, p. 48.

110 Thomas Elyot, in his *Of the Knowledg whiche maketh a wise man*, London: Berthelet, 1533, fol. 19a, recommends a background 'of the deepest black colours that may come by'.

7. Holbein's Fame

1 Münster 1550, p. 407; see the letter written by Bonifacius Amerbach, to S.M., Basle, 1 August 1549, in Erasmus 1906–58, X, 2, no. 3180, p. 281, where the painting is referred as 'effigiem a nobilissimo huius temporis pictore Iohanne Holbeinio coloribus ad vivum bene feliciter expressam . . .'; see also the portrait medallion published in Lichtenau 1537–8; Koegler 1920.

2 Matthew Parker, *De Antiquitate Britannicae Ecclesiae et Privilegiis Ecclesiae Cantuariensis cum Archiepiscopis eiusdem*, London: Day, 1572, p. 352, 'ad vivam similitudinem expressum & delineatum', on Warham's portrait. Holbein is called 'Hans Holby Flandrensis, quem ob eximiam pingendi notitiam Henricus Rex apud se retinuit'.

3 Artists of the Tudor Court 1983, pp. 58–91; Costa de Beauregard 1987; Costa de Beauregard 1991; M. Edmond, 'Limners and Picture-makers: New Light on the Lives of Miniaturists and large-scale Portrait Painters working in London in the Sixteenth- and Seventeenth Century', *Walpole Society*, XLVII, 1978–80, pp. 60–242; Foister 1993, pp. 32–50; Dynasties 1995–6.

4 Hilliard 1992, pp. 48–9.

5 Hugh Trevor-Roper (Lord Dacre), *Princes and Artists: Patronage and Ideology at four Habsburg Courts 1517–1633*, London, 1991, pp. 69–71; Dynasties 1995–6, nos. 99 and 100, pp. 152–3.

6 Mander 1994, I, p. 149–50; Popham 1944.

7 Lomazzo 1598, introduction, where Haydocke states that he convinced Hilliard to write his treatise.

8 The famous treatise was translated into English: Baldessare Castiglione, *The Courtier, of Baldessar Castilio, devided into foure books*, London: John Wolfe, 1588.

9 Hilliard 1992, pp. 64–5.

10 Hilliard 1992, p. 49.

11 Vasari 1986.

12 Mander 1604; Mander 1618; Mander 1994 contains an excellent commentary on the different editions; Melion 1991.

13 Mander 1994, II, pp. 50–51.

14 Melion 1991, p. 111; Mander included only the Italian painters' lives, leaving out all the sculptures by Michelangelo.

15 Mander 1994, I, fols 199v–200r (Life of the van Eycks).

16 Mander 1618, Preface to the Groundwork; Melion 1991, pp. 39, 72; Müller 1993.

17 For example, Heinrich Goltzius – a major figure in van Mander's book, not unlike that of Michelangelo in Vasari's *Lives* – showed how refreshing is the Northern artist's outlook on the remnants of antiquity. Unlike the Ancients, the Moderns should not be copied; Mander 1994, I, fol. 283r.

18 Mander 1994, I, fol. 220r.

19 Mander 1994, I, fol. 220v.

20 Mander 1994, I, fol. 220v.

21 Mander 1994, I, fol. 221v.

22 Mander 1994, I, fol. 208v.

23 Melion 1991, p. 82.

24 Haskell 1989, pp. 203–31, especially pp. 216–18; Art and Patronage in the Caroline Courts 1993.

25 The Duke of Buckingham owned eight Holbeins, and Charles I about twenty; the latter was inclined to exchange a Holbein for an Italian picture; L. Betcherman, 'The York House Collection and its Keeper', *Apollo*, XCII, 1970, pp. 250–59; R. Davies, 'An Inventory of the Duke of Buckingham's Pictures etc., at York House in 1635', *Burl. Mag.*, X, 1907, pp. 376–82 (Buckingham was murdered in 1628); G. Martin, 'Rubens and Buckingham's Fayrie ile', *Burl. Mag.*, CVIII, 1966, pp. 613–18; I. G. Philip, 'Balthazar Gerbier and the Duke of Buckingham's Pictures', *Burl. Mag.*, XCIX, 1957, pp. 155–6; M. G. de Boer, 'Balthazar Gerbier', *Oud Holland*, 1903, pp. 129–60; on Holbein's Italian style, as opposed to the 'Gothic' Dürer, see Pierre-Jean Mariette, *Abecedario*, Paris: Dumoulin, 1851–60, II, p. 359: 'Le goût d'Holbein est plus épuré que celui d'Albert; sa manière tient davantage de celle de l'Italie'; Jonathan Brown, *Kings and Connoisseurs: Collecting Art in Seventeenth-century Europe*, Princeton, NJ, 1995.

26 N.F.S. Hervey, *The Life, Correspondence and Collections of Thomas Howard, Earl of Arundel*, Cambridge, 1921; Howarth 1985.

27 Howarth 1985, p. 149.

28 Rubens 1977.

29 A reconciliation took place between the two men, but only after Buckingham's death.

30 Vertue 1929–52, IV, p. 30; Howarth 1985, p. 10.

31 Howarth 1985, p. 69: letter from Arundel to Sir Dudley Carleton, Arundel House, 17 September 1619.

32 Hollar met Arundel in Cologne in 1636, and followed him. In 1637 he lived in Arundel House; on Hollar, see Howarth 1985, pp. 177–8; *Wenzel Hollar. Radierungen und Zeichnungen aus dem Berliner Kupferstichkabinett*, ed. Hans Mielke, exhibition catalogue, Berlin, Kupferstichkabinett, 1984; Gustav Parthey, *Wenzel Hollar. Beschreibendes Verzeichniss seiner Kupferstiche*, Berlin: Nicolai, 1853.

33 Howarth 1985, p. 69. Letter from Cosimo II to Arundel, 12 September 1620. Holbein had become a great name in Italy by then; see Giulio Mancini, *Considerazioni sulla Pittura* [written *c.* 1614–30], I, ed. Adriana Marucchi, preface by Lionello Venturi, Rome: Accademia dei Lincei, 1956, p. 40.

34 H. de la Fontaine Verwey, 'Michel Le Blon Graveur, Kunsthandelaar, Diplomaat', *Amstelodanum*, 1969, pp. 103–23; see Le Blon's portrait by Sir Antony van Dyck: Erik Larsen, *The Paintings of Antony van Dyck*, Freren: Luca, 1988, II, no. 542, p. 219, painted 1632, Toronto, Art Gallery of Ontario; engraved by Theodore Matham for van Dyck's *Iconographia*, see Fr. Wiribal, *L'iconographie d'Antoine van Dyck*, Leipzig: Danz, 1877, no. 183, p. 145; Neil de Marchi and Hans J. van Migroet, 'Art, Value, and Market Practices in the Netherlands in the Seventeenth Century', *AB*, LXXVI/3, September 1994, pp. 451–64; John-Michael Montias, *Le marché de l'art aux Pays-Bas, XVème–XVIIème siècle*, Paris, 1996.

35 Remigius Faesch, *Humanæ Industriæ Monumenta Nova simul et antiqua* [*c.* 1628 but corrected later], Universitätsbibliothek Basle, shelfmark MS: AR I 12, fols 35a–35b. Published in Woltmann 1874–6, II, pp. 48–50. A so-called portrait of Charles V by Holbein was bought by Le Blon in Lyon on behalf of the Duke of Buckingham.

36 Letter by Michel Le Blon to the collectors Pierre Spiering and Axel Oxenstjerna, 17 November 1635, Staatsarchiv Stockholm. Quoted from W. Martin, *Gerard Dou. Sa Vie et Son Oeuvre*, trans. Louis Dimier, Paris: Jouve, 1911, pp. 46–7; to paint in a 'sauber' (clean) fashion was an ideal for Sandrart, see his remark on Le Blon's cabinet of pictures, Sandrart 1675–1679, I, 2, p. 249: 'eine Venus mit dem Cupido uberaus sauber gemahlt . . .'; Le Blon was also purveyor of pictures to Queen Christina of Sweden, see Max Rooses and Ch. Ruelens, *Correspondance de Rubens et documents épistolaires concernant sa vie et ses oeuvres*, Antwerp: De Backer etc., 1887–1909, VI, pp. 13–14, p. 318; Peter Hecht, *De Hollandse Fijnschilders*, Amsterdam: SDU, Rijksmuseum, 1989; Wood 1995.

37 See Oskar Bätschmann and Pascal Griener, *Die Darmstädter Madonna. Von imperialen Schutzbild zum Epitaph*, forthcoming.

38 Sandrart 1675–9, I, 2, pp. 249–51.

39 Major 1910; it is wrong to assume, as does Sandrart, that the Darmstadt picture was sold to Marie de' Medici, Queen of France, while in exile. At that time she was in financial disarray, and could not contemplate buying such pictures; on Marie's collections of art, see M. N. Baudouin-Matuszek, 'La succession de Marie de Médicis et l'emplacement des cabinets de peinture au palais du Luxembourg', *Bulletin de la Société de l'Histoire de Paris et de l'Ile-de-France*, 1990, pp. 285–93.

40 Faesch must have contacted Sarburgh, because Lüdin was only an assistant to the painter. See the correspondence between Sarburgh and Johann Rudolph Faesch published in Major in 1910; Sarburgh was too busy with making portraits to produce such copies; Carl Brun, *Schweizerisches Künstler-Lexicon*, II, Frauenfeld: Huber, 1908, p. 284.

41 Patin, in his *catalogue raisonné* of Holbein's works, only follows Faesch's description – he did not see the original. Desiderius Erasmus, *Encomium moriæ. Stultitiae Laus*, Basle: Typis Genathianis, 1676 fols 32b–34; Sebastian Faesch, *Iter per Galliam, Anglia, Belgica, et Tractum Rheni*, MS, 1667–9, Universitätsbibliothek Basle, MS: AN VI 15, fol. 6a; S. Faesch

helped Patin to produce his edition of the *Encomium Moriæ*, see Universitätsbibliothek Basle Ms G2 I 32 document no. 124, the memorandum written by Patin for Faesch for that purpose; see the very interesting letter by Bartolomeus Sarburgh to Johann Rudolf Faesch, The Hague, 12 March 1634, in Major in 1910, especially pp. 318–19: 'Der M. Leblon von Amsterdam ist ietz undt Secretarius beym Canzler Oxenstern . . .'.

42 Veronika Birke and Janine Kertesz, *Die Italienischen Zeichnungen der Albertina*, Vienna: Böhlau, 1992–5, III, pp. 1664–5, inv. no. 3248; the authors should like to thank Mr Dominique Radrizzani (University of Lausanne) for having pointed out this important document; Oskar Bätschmann, 'Gelehrte Maler in Bern. Josef Werner (1637–1710) und Wilhelm Stettler (1643–1708)', in *Im Schatten des Goldenen Zeitalters. Künstler und Auftraggeber im bernischen 17. Jahrhundert*, ed. Georges Herzog, Elisabeth Ryter and Johanna Strübin Rindisbacher, Berne: Kunstmuseum, 1995, II, pp. 165–200.

43 His description is accurate: 'eine stehende Maria auf eine Tafel gemahlt mit dem Kindlein auf dem Arm unter der ein Teppich worauf etliche vor ihr knien die nach dem Leben contrafätet seyn', Sandrart 1675–9, I, 2, p. 249.

44 Sandrart 1675–9, I, 2, pp. 249–52.

45 Desiderius Erasmus, *Encomium moriæ. Stultitiae Laus*, Basle: Typis Genathianis, 1676, fols 32v–34.

46 Francis Haskell, *History and its Images*, New Haven and London, 1993, pp. 13–25.

47 Waquet 1989, pp. 979–1000; Waquet 1979 pp. 125–48; Waquet 1985; *Numismatische Literatur 1500-1864. Die Entwicklung der Methoden einer Wissenschaft*, ed. by Peter Berghaus, in *Wolfenbütteler Forschungen*, LXIV, 1995, the articles by Giovanni Gorini, 'Der Arzt und Numismatiker Charles Patin in Padua', pp. 39–45, and Herbert Cahn, 'Charles Patin in Basel', p. 37 (a scanty, poor study); C. Dekesel, *Charles Patin: A Man without a Country*, Gand, 1990; Charles Patin, *Relation historique en forme de Lettre de Mr. Charles Patin Medecin de Paris*, Strasburg: Paulli, 1670; see his description of the imperial collection in Vienna, pp. 68ff., and his taste for Holbeins.

48 See the notes by Remigius Faesch (1595–1667), Universitätsbibliothek, Basle, MS O III 25 fol. 25v, related to the purchase of a copy of Vasari's *Vite* in Lyon, 1646.

49 Sebastian Faesch, *Iter per Galliam, Anglia, Belgica, et Tractum Rheni*, MS, 1667–9, Universitätsbibliothek Basel, AN VI 15, fol. 6a; S. Faesch did collaborate actively on the making of the *Encomium moriæ*, see Universitätsbibliothek Basle Ms G2 I 32 document no. 124, the memorandum written by Patin for Faesch, for this purpose.

50 The famous book collector Francis Douce must have compared his own copy of the *Encomium moriæ* to the Basle copy, because he added Holbein's name above the engraving that reproduced that drawing, in his copy, E 155, Bodleian Library, Oxford; *The Douce Legacy. An Exhibition to Commemorate the 150th Anniversary of the Bequest of Francis Douce 1757-1834*, exhibition catalogue, Bodleian Library, Oxford, 1984; Michael 1986, drawing no. 66.

51 On Patin, see his autobiography in Patin 1682, pp. 77–104; N. Ivanoff, 'La collezione Rosa-Patin ed alcuni artisti stranieri a Padova nel XVI. secolo', *Arte Veneta*, XXIII, 1969, pp. 236–8; Patin 1674, pp. 108, 119–30; J. Beckmann, *Literatur der älteren Reisebeschreibungen*, Göttingen: Röwer, 1808, I, no. 51, pp. 638–53.

52 See his letter dated Milan, 12 November 1675, Universitätsbibliothek Basle, MS, G2 I 32 doc. no. 125, fol. 1b, noting the presence of a Holbein in Zurich, and his letter dated Padua, 7 January 1676, Universitätsbibliothek, MS, G2 I 32 doc. no. 129, fol. 4b.

53 Patin 1691, p. 221; Bruce Manfield, *Phoenix of his Age: Interpretations of Erasmus c. 1550–1750*, Toronto, 1979; Andreas Flitner, *Erasmus im Urteil seiner Nachwelt. Das literarische Erasmus-Bild von Beatus Rhenanus bis zu Jean le Clerc*, Tübingen, 1952; René Pintard, *Le libertinage érudit dans la première moitié du XVIIème siècle* [1943], Geneva and Paris, 1983; René Pintard, *La Mothe le Vayer, Gassendi, Guy Patin*, Paris, 1943; Jean-Claude Margolin, 'Guy Patin lecteur d'Erasme', *Colloquia Erasmiana Turonensis*, 2 vols, Toronto, 1972, pp. 1323–58.

54 Patin 1691, 'Familia Thomae Mori', p. 211.

55 Patin 1691, p. 221.

56 'Mr Vertue took Burford in his way to Gloucester and saw & took a sketch with the inscriptions of it of Hans Holbein's painting of the Family of Sir Thomas More, in the hands of Mr Lenthall. Mr Vertue mightily commends it. It being a Family piece, and only lent to old Lenthal, it really belongs to some one of the Descendents of the Mores', *Remarks and Collections of Thomas Hearne*, ed. D. W. Rannie, Oxford, 1885–1921, X, p. 152, 3 July 1729; it is the copy of a now lost painting, which represents the More family: Rowlands 1985, no. L.10c pp. 222–3; Dynasties 1995–6, no. 76, pp. 128–9.

57 Thomas Birch, *The heads of illustrious persons of Great Britain. Engraven by Mr Houbraken, and Mr Vertue*, London: J. and P. Knapton, 1743–51; besides, Vertue showed some interest in the history of collecting in England; see Catalogue 1757 nos. 30, 43, 46, 48, 49; Catalogue 1758; on engraved portraits, see Marcia Pointon, *Hanging the Head: Portraiture and Social Formation in Eighteenth-century England*, New Haven and London, 1993, pp. 53–104.

58 See his description of that work, as engraved by Hollar, in Vertue's *Description of four ancient paintings*, 1740, 'George Vertue, Art Historian', *Walpole Society*, LIV, 1988, pp. 1–148.

59 Walpole 1782; Lipking 1970, pp. 127–63; Edward Edwards, *Anecdotes of Painters who have resided or been born in England; with critical remarks on their productions*, London: Leigh, Sotheby etc., 1808, preface, pp. 1–3. Edwards helped Walpole with the composition of his *Anecdotes*.

60 Horace Walpole, *Aedes Walpolianæ, or, A Description of the Collection of Pictures at Houghton Hall, Norfolk, the seat of the Right Honourable Sir Robert Walpole, Earl of Orford*, London, 1747.

61 William Beckford, *Biographical Memoirs of Extraordinary Painters*, London, 1780, reprinted with an introduction by Philip Ward, Cambridge and New York, 1977; Beckford boasted the possession of many 'Holbeins', see the six works attributed to him in the Fonthill Abbey sale, *The Pictures and Miniatures at Fonthill Abbey. Catalogue of … Paintings, Miniatures and Drawings by Ancient and Modern Masters*, sale by Phillips, Fonthill Abbey, 10, 14 and 15 October 1823: nos. 58, 101, 116, 139, 154, 172; and *Catalogue of the valuable and costly effects … of the late William Beckford*, sale cat., 24 July 1848, 3rd sale, p. 16, nos. 9, 36; 5th sale, nos. 15, 29.

62 Count Schönborn owned Holbein's portrait of Hermann Wedigh, now in the Metropolitan Museum of Art, New York; on the Schönborn collection in Pommersfelden, see *Die Grafen von Schönborn. Kirchenfürsten Sammler Mäzene*, exhibition catalogue, Germanisches Nationalmuseum, Nuremberg, 1989; Christian von Holst, *Creators Collectors and Connoisseurs: The Anatomy of Artistic Taste from Antiquity to the Present Day*, Preface by Herbert Read, New York, 1967, p. 178; Gerald Reitlinger, *The Economics of Taste: The Rise and Fall of Picture Prices 1760–1960*, London, 1961, pp. 342–3.

63 On the Neo-Gothic, see the magnificent monograph by Georg Germann 1972, pp. 54–5; McCarthy 1987.

64 See, on the Holbein room, the description left by Thomas Gray, in a letter to Thomas Wharton, in *The Correspondence of Thomas Gray*, ed. Paget Toynbee, Leonard Whibley and H. W. Starr, Oxford, 1971, II, no. 303, pp. 641–2; Walpole owned the *Catalogue des Tableaux de la Galerie impériale de Vienne*, published by Christian von Mechel; he noted carefully the presence of many Holbeins: Horace Walpole, *Horace Walpole's Miscellany 1786–1795*, ed. Lars E. Troide, New Haven, 1978 pp. 137–8.

65 Horace Walpole, *Description of Strawberry Hill, Works*, London, 1798, II; Walpole 1760; and Catalogue 1842, 11th sale, no. 57, 20th sale (Holbein Chamber); Paget Toynbee, *Strawberry Hill Accounts: A record of expenditure in building furnishing etc kept by Mr Horace Walpole from 1747 to 1795*, Oxford, 1927, pp. 102–3; the Holbein drawings had been rediscovered at the beginning of the eighteenth century in the royal collection; they were not published at first, because Queen Caroline feared that the originals might be spoilt in the process; see the testimony of Viscount Percival, 7 August 1735, visiting Richmond: 'I saw in the Queen's closet the famous collection of Holbein's heads of eminent persons in King Henry 8th reign. The Queen found them neglected in a book, shut up in a common table drawer, saved out of the fire at Whitehall in King William's reign. It is a pity they are not graved by some good master', *Historical Manuscripts Commission. Manuscripts of the Earl of Egmont. Diary of Viscount Percival afterwards first earl of Egmont*, London: HMSO, 1920–23, II, p. 190; II, p. 210 (8 December 1735), and II, p. 297 (6 September 1736); on the publication of these documents, see Dyson 1983; Parker 1945; Walpole 1826–8, I, p. 145. See also McEvansoneya 1996.

66 Letter of Horace Walpole to William Cole, 9 March 1765. Walpole 1970, I, pp. 88–9.

67 *Reynolds*, exhibition catalogue ed. N. Penny, London, Royal Academy of Arts, 1986, no. 97, pp. 269 and 128, *Master Crewe as Henry VIII* (1776).

68 Walpole 1826–8, I, p. 145.

69 'Hab ich jemal *Inspiration* im eigenthlichsten Sinn, in Menschenwerken gesehen, gefühlt, in mich geathmet, so war's in Drey oder Vier Stücken Hohlmeins, die, meines Ermessens, alles übertreffen, was ich in Manheim Schleissheim, u. Düsseldorf sahe – in Ansehung der Zeichnung, des Colorites, und der Poesie. Sein Nachtmal besonders u. – die *Lais Corinthiaca* gehen über alles', letter from Lavater to Goethe, Zurich, 5 August 1780, in *Goethe und Lavater. Briefe und Tagebücher*, ed. Heinrich Funck Weimar: Goethe-Gesellschaft, 1901 (Schriften der Goethe-Gesellschaft 16), no. 18, pp. 128–9; there are several references to Holbein in his famous publication: Johann Kaspar Lavater, *Physiognomische Fragmente, zur Beförderung der Menschenkenntnis und Menschenliebe*, Leipzig, Winterthur: Weidmann, Reich and Steiner, 1775–8, I, pp. 79, 82, for example, where the facial expressions of Judas and Christ in the *Last Supper* at Basle, are thoroughly analysed.

70 One of the best recent publications on Lavater and Germany: Martin Bircher and Gisold Lammel, *Helvetien in Deutschland. Schweizer Kunst aus Residenzen deutscher Klassik 1770–1830*, Zurich, 1990; *Retaining the Original. Multiple Originals, Copies, and Reproduction*, in *Studies in the History of Art*, XX, 1989; Susan Lambert, *The Image Multiplied: Five Centuries of Printed Reproductions of Paintings and Drawings*, London, 1987.

Select Bibliography

Abbreviations

AB	*The Art Bulletin*
Burl. Mag.	*The Burlington Magazine*
DNB	*Dictionary of National Biography*
GBA	*Gazette des Beaux-Arts*
JWCI	*Journal of the Warburg and Courtauld Institutes*
LCI	*Lexikon der christlichen Ikonographie*, ed. E. Kirschbaum and W. Braunfels, 8 vols, Freiburg im Breisgau, 1968–76
RDK	*Reallexikon zur Deutschen Kunstgeschichte*, ed. O. Schmitt and the Zentralinstitut für Kunstgeschichte Munich, 8 vols (until 1987), Stuttgart, 1937; Munich, 1987
RMN	Editions de la Réunion des Musées Nationaux
SIK	Schweizerisches Institut für Kunstwissenschaft
ZAK	*Zeitschrift für Schweizerische Archäologie und Kunstgeschichte.*
ZfK	*Zeitschrift für Kunstgeschichte*

Ainsworth 1990
Ainsworth, M., '"Paternes for phiosioneamyes": Holbein's Portraiture Reconsidered', *Burl. Mag.*, CXXXII, 1990, pp. 173–86

Aktensammlung 1921–50
Aktensammlung zur Geschichte der Basler Reformation, 6 vols, Basle: Historische und Antiquarische Gesellschaft zu Basel, 1921–50

Alberti 1972
Alberti, Leon Battista, *De Pictura*, ed. C. Grayson, London, 1972

Alciatus 1542
[Andrea Alciatus] *Clarissimi viri D. Andreae Alciati Emblematum libellus, uigilanter recognitus, 6 iam recèns per Wolphgangum Hungerum Bauarum, rhythmis Germanicis uersus. Parisiis. Apud Christianum Wechelum, sub scuto Basiliensi, in uico Iacobeo: & sub Pegaso, in uico Bellouacensi. Anno. M.D.XLII*, reprinted Darmstadt, 1980

Alioth, Barth and Huber 1981
Alioth, M., U. Barth and D. Huber, *Basler Stadtgeschichte*, Basle, 1981

Altarpiece in the Renaissance 1990
The Altarpiece in the Renaissance, ed. P. Humfrey and M. Kemp, Cambridge, 1990

Altdeutsche Malerei 1963
Altdeutsche Malerei. Alte Pinakothek München. Katalog II, Munich, 1963

Alte Pinakothek 1983
Alte Pinakothek München, Erläuterungen zu den ausgestellten Gemälden, Munich, 1983

Altendorf and Jezler 1984
Altendorf, H.-D., and P. Jezler, *Bilderstreit – Kulturwandel in Zwinglis Reformation*, Zurich, 1984

Amerbach–Kabinett 1991
Sammeln in der Renaissance. Das Amerbach–Kabinett., catalogue of an exhibition in Basle 1991, 5 vols, Basle: Öffentliche Kunstsammlung and Historisches Museum, 1991

Amerbachkorrespondenz 1942–
Die Amerbachkorrespondenz, ed. A. Hartmann *et al.*, Basle: Universitätsbibliothek, 10 vols published, 1942–

Ames-Lewis 1979
Ames-Lewis, F., 'Fra Filippo Lippi and Flanders', *ZfK*, XLII, 1979, pp. 255–73

Amico 1988
Amico, J. d', *Theory and Practice in Renaissance Textual Criticism: Beatus Rhenanus between Conjecture and History*, Los Angeles, Berkeley and London, 1988

Amiet 1879
Amiet, J., *Hans Holbein's Madonna von Solothurn und der Stifter Nicolaus Conrad, der Held von Dorneck und Novarra*, Solothurn, 1879

Anderes and Hoegger 1988
Anderes, B., and P. Hoegger, *Die Glasgemälde im Kloster Wettingen*, Baden, 1988

Anzelewsky 1971
Anzelewsky, F., *Albrecht Dürer. Das malerische Werk*, Berlin, 1971

Anzelewsky 1983
Anzelewsky, F., *Dürer-Studien*, Berlin, 1983

Aquinas 1852–73
Aquinas, Thomas, *Sancti Thomae Aquinatis Doctoris Angelici Opera omnia*, 16 vols, Rome, 1882–1948

Archives héraldiques suisses 1987–
Archives héraldiques suisses [various places of publication]: Société suisse d'héraldique, 1987–

Aretino 1957–60
[Aretino, Pietro], *Lettere sull'arte di Pietro Aretino*, ed. F. Pertile, C. Cordié and E. Camesasca, 3 parts in 4 vols, Milan, 1957–60

Aronberg Lavin 1955
Aronberg Lavin, M., 'Giovanni Battista: A Study in Renaissance Religious Symbolism', *AB*, XXXVII, 1955, pp. 85–101

Aronberg Lavin 1961
Aronberg Lavin, M., 'Giovanni Battista: A Supplement', *AB*, XLIII, 1961, pp. 319–26

Art and Patronage in the Caroline Courts
Art and Patronage in the Caroline Courts: Essays in Honour of Sir Oliver Millar, ed. D. Howarth, Cambridge, 1993

Art of Devotion 1994
The Art of Devotion in the Late Middle-Ages in Europe 1300-1500, ed. H. van Os, exh. cat., Amsterdam, Rijksmuseum; London, 1994

Artists of the Tudor Court 1983
Artists of the Tudor Court: The Portrait Miniature rediscovered 1520–1620, ed. R. Strong, with contributions from V. J. Murrell; exh. cat., London, Victoria and Albert Museum, 1983

Arx 1913
Arx, C. von, 'Meine persönlichen Erinnerungen bei der Auffindung der Madonna H. H. 1522 in der Allerheiligenkapelle zu Grenchen', *Solothurner Tagblatt*, suppl. no. 51, 1 March 1913 and no. 56, 7 March 1913

Auge 1993
Auge, C., *Zur Deutung der Darmstädter Madonna* (Bochumer Schriften zur Kunstgeschichte, vol. 19), Berne, 1993

Augsburg 1978
Staatsgalerie Augsburg. Städische Kunstsammlungen, vol.I: Altdeutsche Gemälde. Katalog, 2nd edn, Munich, 1978

Augsburg 1988
Staatsgalerie Augsburg, Städtische Kunstsammlungen I, Altdeutsche Gemälde, Munich, 1988

Aurenhammer 1987
Aurenhammer, H. H., 'Künstlerische Neuerung und Repräsentation in Tizians "Pala Pesaro"', *Wiener Jahrbuch für Kunstgeschichte*, XL, 1987, pp. 13–44

Bachofen 1948
Bachofen, J. J., *Das Mutterrecht. Eine Untersuchung über die Gynaikokratie der*

Alten Welt nach ihrer religiösen und rechtlichen Natur [1861], ed. K. Meuli, 2 vols, Basle, 1948

Bacou and Calvet 1968
Bacou, R., and A. Calvet, *Dessins du Louvre. Ecoles allemande, flamande, hollandaise*, Paris, 1968

Baer 1932–71
Baer, C. H., *Die Kunstdenkmäler des Kantons Basel-Stadt*, 5 vols, Basle, 1932–71, vol. I, supplement by F. Maurer

Baetjer 1980
Baetjer, K., *European Paintings in the Metropolitan Museum of Art. A Summary Catalogue*, 3 vols, New York, 1980

Baldung Grien 1959
Hans Baldung Grien, exh. cat., Karlsruhe, Staatlichen Kunsthalle, 1959

Baldung Grien 1981
Hans Baldung Grien: Prints and Drawings, exh. cat. ed. J. H. Marrow and A. Shestack, Washington, D.C., National Gallery of Art,1981

Bandmann 1970
Bandmann, G., 'Höhle und Säule auf Darstellungen Mariens mit dem Kind', *Festschrift für Gert von der Osten*, Cologne, 1970, pp. 130–48

Banzato and Pellegrini 1989
Banzato, D. and F. Pellegrini, *Bronzi e placchette dei Musei Civici di Padova*, Padua, 1989

Bartsch 1978–
The Illustrated Bartsch, ed. W. L. Strauss, New York, 1978–

Basler Chroniken 1872–1987
Basler Chroniken, ed. W. Fischer, A. Bernoulli *et al.*, 11 vols, Leipzig, 1872–1987

Basler Rathaus 1983
Das Basler Rathaus, ed. Staatskanzlei des Kantons Basel-Stadt, with essays by U. Barth *et al.*, Basle, 1983

Bätschmann 1989
Bätschmann, Oskar, *Malerei der Neuzeit* (Ars Helvetica, VI), Disentis, 1989

Bätschmann 1994
Bätschmann, O., 'Ferdinand Hodler the Painter', *Ferdinand Hodler. Views & Visions*, exh. cat., Cincinnati, New York, Toronto, Hartford, CT, 1994–5; Zurich, 1994, pp. 26-65

Bätschmann and Griener 1994
Bätschmann, O., and P. Griener, 'Holbein-Apelles. Wettbewerb und Definition des Künstlers', in: *ZfK*, 57, 1994, pp. 625-650

Bätschmann and Griener 1996
Bätschmann, O. and P. Griener, 'Die Solothurner Madonna von Hans Holbein d.J. Eine Sacra Conversazione im Norden', *Neue Zürcher Zeitung*, 30–31 March 1996, no. 76, p. 69

Baurmeister 1975
Baurmeister, U., 'Einblattkalender aus der Offizin Froschauer in Zürich, Versuch einer Uebersicht', *Gutenberg Jahrbuch*, 1975, pp. 122–5

Baxandall 1977
Baxandall, M., *Painting and Experience in Fifteenth-century Italy: A Primer in the Social History of Pictorial Style*, Oxford, 1972; German edn: *Die Wirklichkeit der Bilder. Malerei und Erfahrung im Italien des 15. Jahrhunderts*, Frankfurt-am-Main, 1977

Baxandall 1980
Baxandall, M., *The Limewood Sculptors of Renaissance Germany*, New Haven and London, 1980; German edn: *Die Kunst der Bildschnitzer. Tilman Riemenschneider, Veit Stoss und ihre Zeitgenossen*, Munich, 1984, 2nd edn 1985

Bayerische Staatsgemäldesammlung 1972
Bayerische Staatsgemäldesammlungen. Alte Pinakothek München. Altdeutsche Gemälde. Köln und Nordwestdeutschland, ed. G. Goldberg and G. Scheffler, 2 vols, Munich, 1972

Bayerische Staatsbibliothek. Inkunabelkatalog 1993
Bayerische Staatsbibliothek. Inkunabelkatalog, vol. 3, Wiesbaden, 1993

Becker 1994
Becker, M., *Architektur und Malerei. Studien zur Fassadenmalerei des 16. Jahrhunderts in Basel* (162. Neujahrsblatt, Gesellschaft für das Gute und Gemeinnützige), Basle, 1994

Beckmann 1807–09
Beckmann, J., *Literatur der älteren Reisebeschreibungen*, 2 vols, Göttingen, 1807–09

Beissel 1991
Beissel, S., *Die Verehrung der Heiligen und ihrer Reliquien in Deutschland im Mittelalter* (1890/1892), Darmstadt, 1991

Bek 1988
Bek, L., 'Thomas More on the Double Portrait of Erasmus and Pierre Gillis: Humanist Rhetoric or Renaissance Art Theory?', *Acta Conventus Neo-Latini Guelpherbytani. Proceedings of the Sixth International Congress of Neo-Latin Studies*, Wolfenbüttel, 1985, ed. S. P. Revard *et al.*, New York, 1988, pp. 469–79

Belting 1981
Belting, H., *Das Bild und sein Publikum im Mittelalter. Form und Funktion früher Bildtafeln der Passion*, Berlin, 1981

Belting 1990
Belting, H., *Bild und Kult. Eine Geschichte des Bildes vor dem Zeitalter der Kunst*, Munich, 1990

Bentivoglio and Valtieri 1976
Bentivoglio, E., and S. Valtieri, *Santa Maria del Popolo*, Rome, 1976

Benzing 1966
Benzing, J., *Lutherbibliographie*, Baden-Baden, 1966

Berchem 1956
Berchem, D. van, *Le martyre de la légion thébaine. Essai sur la formation d'une légende* (Schweizerische Beiträge zur Altertumswissenschaft no. 8), Basle, 1956

Berchtold 1990
Berchtold, A, *Bâle et l'Europe. Une histoire culturelle*, 2 vols. Lausanne, 1990

Berenson 1963
Berenson, B., *Italian Pictures of the Renaissance: A list of principal artists and their works with an index of places, Florentine School*, 2 vols, London, 1963

Berlin Staatliche Museen 1975
Staatliche Museen Preussischer Kulturbesitz. Gemäldegalerie. Katalog der ausgestellten Gemälde, Berlin-Dahlem, 1975

Bialostocki 1986
Bialostocki, J., *Dürer and his Critics 1500–1971. Chapters in the History of Ideas*, Baden-Baden, 1986.

Bialostocki 1987
Bialostocki, J., 'Raffaello e Dürer come personificazioni di due ideali artistici nel Romanticismo', *Studi su Raffaello*, ed. M. S. Hamoud and M. L. Strocchi, 2 vols, Urbino, 1987

Bibel 1974
Die Bibel oder die ganze Heilige Schrift des Alten und Neuen Testaments nach der Uebersetzung Martin Luthers mit Apokryphen, Stuttgart, 1974

Biblia Sacra 1982
Biblia Sacra iuxta Vulgatam Clementinam, nova editio, Madrid, 1982

Biblische Figuren 1565
Biblische Figuren des newen Testaments, Nuremberg, 1565

Bietenholz 1959
Bietenholz, P. G., *Der italienische Humanismus und die Blütezeit des Buchdrucks in Basel. Die Basler Drucke italienischer Autoren von 1530 bis zum Ende des 16. Jahrhunderts* (Basler Beiträge zur Geschichtswissenschaft, vol. 73), Basle and Stuttgart, 1959

Bietenholz and Deutscher 1985–7
Bietenholz, P. G., and T. B. Deutscher, *Contemporaries of Erasmus: A Biographical Register of the Renaissance and Reformation*, 3 vols, Toronto, 1985–7

Bildersturm 1973
Bildersturm. Die Zerstörung des Kunstwerks, ed. M. Warnke, Munich, 1973

Bildhafte Zeichnungen 1995
Bildhafte Zeichnungen von der Zeit Dürers and Holbeins bis zum Gegenwart. Meisterwerke aus dem Kupferstichkabinett Basel, exh. cat. ed. E. Franz and D. Koepplin, Münster, 1995

Black 1863
Black, W. H., 'Discovery of the Will of Hans Holbein', *Archaeologia*, XXXIX, 1863, pp. 1–18

Bodar 1989
Bodar, A., 'Erasmus en het geleerdenportret', *Leids Kunsthistorisch Jaarboek*, VIII, 1989, pp. 17–68

Boehm 1985
Boehm, G., *Bildnis und Individuum. Über den Ursprung der Porträtmalerei in der Italienischen Renaissance*, Munich, 1985

Bologna 1987
La Pinacoteca Nazionale di Bologna. Catalogo Generale delle Opere Esposte, ed. C. Bernardini *et al.*, Bologna, 1987

Bologna e l'umanesimo 1988
Bologna e l'umanesimo. 1490–1510, exh. cat. ed. M. Faietti and K. Oberhuber; Bologna, Pinacoteca Nationale; Vienna, Albertina; 1988

Borries 1988
Borries, J. E. von, 'Besprechung von John Rowlands, *The Paintings of Hans Holbein the Younger, Complete edition.* Oxford, 1985', *Kunstchronik*, XLI, 1988, pp. 125–31

Borries 1989
Borries, J. E. von, 'Besprechung der Ausstellung von Zeichnungen Holbeins in Basel 1988',*Kunstchronik*, XLII, 1989, pp. 288–97

Bosque 1975
Bosque, A. de,*Quentin Metsys*, Brussels, 1975

Bosshard 1982
Bosshard, E. P., 'Tüchleinmalerei – eine billige Ersatztechnik?', *ZfK*, XLV, 1982, pp. 31–42

Bourbon 1538
[Bourbon, Nicolas], *Nicolai Borbonii van Doperani Lingonensis nugarum libri octo*, Lyon, 1538

Boureau 1984
Boureau, A., *La Légende dorée (Le système narratif de Jacques de Voragine +1298)*, preface by J. Le Goff, Paris, 1984

Brachert
Brachert, T., restoration report on the *Solothurner Madonna*, Swiss Institute for Art Research, Zurich, ctr. no. 9217

Brachert 1972
Brachert, T., 'Die Solothurner Madonna von Hans Holbein aus dem Jahr 1522', *Maltechnik/Restauro*, I, 1972, pp. 6–21

Brand 1971
Brand P. L., *The Ghent Altarpiece and the Art of Jan van Eyck*, Princeton, NJ, 1971

Braun 1954
Braun, E. W., Art. 'M. Curtius', *RDK*, III, Stuttgart, 1954, cols. 881–91

Braun 1924
Braun, J., *Der christliche Altar in seiner geschichtlichen Entwicklung*, 2 vols, Munich, 1924

Braun 1988
Braun, J., *Tracht und Attribute der Heiligen in der deutschen Kunst* [1943], Berlin, 1988

Braunfels-Esche 1976
Braunfels-Esche, S.,*Sankt Georg. Legende. Verehrung. Symbol*, Munich, 1976

Brejon and Thiébaut 1981
Brejon de Lavergnée, A., and D. Thiébaut, *Catalogue sommaire illustré des peintures du musée du Louvre, Vol. 2: Italie, Espagne, Allemagne, Grande-Bretagne et divers*, Paris, 1981

Breviarium capituli 1497
Breviarium capituli ecclesiae S. Mariae Erfordensis, Nuremberg: Kaspar Hochfeder, 1497

Budge 1961
Budge, E. A. Wallis, *Amulets and Talismans: the original texts with translations and descriptions of a long series of Egyptian, Sumerian, Assyrian, Hebrew, Christian, Gnostic and Muslim amulets and talismans and magical figures . . .*, New Hyde Park (N.Y.), 1961

Bullinger 1904
[Bullinger, H.], *Heinrich Bullingers Diarium (Annales Vitae) der Jahre 1504-1574* (Quellen zur schweizerischen Reformationsgeschichte, vol. 2), ed. E. Egli, Basle, 1904

Bullinger 1982
[Bullinger, H.], *Heinrich Bullingers Briefwechsel*, ed. U. Gäbler *et al.*, vol. 2: *Briefe des Jahres 1532*, Zurich, 1982

Burckhardt Vorlesung
Burckhardt J., *Vorlesung Ausseritalienische neuere Kunst seit dem XV. Jahrhundert*, Basel Staatsarchiv, PA 207, 164.

Burckhardt 1845
Burckhardt, J., Art. 'Holbein (Hans), der Jüngere,' *Allgemeine deutsche Real-Encyklopädie für die gebildeten Stände*, VII, Leipzig, 1845, pp. 255–6

Burckhardt 1898
Burckhardt, J., *Beiträge zur Kunstgeschichte von Italien*, Basle, 1898

Burckhardt 1914
Burckhardt, J., *Briefwechsel mit Geymüller*, Munich, 1914

Burckhardt 1930–33
Burckhardt, J., *Gesamtausgabe*, 14 vols, Stuttgart, Berlin and Leipzig, 1930–33

Burckhardt 1949–86
Burckhardt, J., *Briefe*, ed. M. Burckhardt, 10 vols, Basle, 1949–86

Burckhardt 1988
Burckhardt, J., *The Altarpiece in Renaissance Italy*, trans. and ed. P. Humfrey, Oxford, 1988

Burgkmair 1973
Hans Burgkmair. Das graphische Werk, exh. cat., Augsburg, Städtische Kunstsammlungen, 1973

Burgunderbeute 1969
Die Burgunderbeute und Werke burgundischer Hofkunst, exh. cat., Berne, Bernisches Historisches Museum, 1969

Bürner
Bürner, H., *Die Dresdner Gemälde-Gallerie* I, Dresden, n.d.

Busch 1973
Busch, R. von, *Studien zu deutschen Antikensammlungen des 16. Jahrhunderts*, doctoral thesis, Tübingen 1973

Bushart 1977
Bushart, B., 'Der "Lebensbrunnen" von Hans Holbein dem Aelteren', *Festschrift Wolfgang Braunfels*, ed. F. Piel and J. Traeger, Tübingen, 1977, pp. 45–68

Bushart 1987
Bushart, B., *Hans Holbein der Ältere*, Augsburg, 1987

Bushart 1994
Bushart, B., *Die Fuggerkapelle bei St. Anna in Augsburg*, Munich, 1994

Byam Shaw 1976
Byam Shaw, J., *Drawings by Old Masters at Christ Church Oxford*, 2 vols, Oxford, 1976

Caillet 1985
Caillet, J.-P., *L'antiquité classique, le haut moyen-âge et Byzance au musée de Cluny*, Paris, 1985

Camille 1990
Camille, M., *The Gothic Idol: Ideology and Image-Making in Medieval Art*, Cambridge, 1990

Campbell 1990
Campbell, L., *Renaissance Portraits: European Portrait-painting in the 14th, 15th and 16th centuries*, New Haven and London, 1990

Caoursin 1979–80
Caoursin, G., *Historia von Rhodis*, translation: Johannes Adelphus Müling, Strasburg: Flach, 1513; reprinted Johannes Adelphus Müling, *Ausgewählte Schriften*, ed. B. Gotzkowski, 3 vols, Berlin and New York, 1979–80

Caplow 1977
Caplow, H. McNeal, *Michelozzo*, 2 vols, New York and London, 1977

Carroll 1987
Carroll, E. A., *Rosso Fiorentino: Drawings, Prints, and Decorative Arts.* exh. cat., Washington, D.C., National Gallery of Art, 1987

Cast 1981
Cast, D.,*The Calumny of Apelles: A Study in the Humanist Tradition*, New Haven and London, 1981

Castelfranchi-Vegas 1984
Castelfranchi-Vegas, L., *Italia e Fiandra nella Pittura del Quattrocento,*

Milan, 1983; German edn: *Italien und Flandern. Die Geburt der Renaissance*, Stuttgart and Zurich, 1984

Castelnuovo 1988
 Castelnuovo, E., *Das künstlerische Portrait in der Gesellschaft. Das Bildnis und seine Geschichte in Italien von 1300 bis heute*, trans. M. Kempter, Berlin, 1988

Catalogue 1757
 A Catalogue and Description of King Charles the First's Capital Collection of Pictures, limnings, statues, bronzes, medals, ed. William Bathoe after George Vertue's notes, London, 1757

Catalogue 1758
 A Catalogue of the curious collection of Pictures of George Villiers, Duke of Buckingham, ed. William Bathoe after George Vertue's notes, London, 1758

Catalogue 1842
 Catalogue of the classic contents of Strawberry Hill collected by Horace Walpole, sale cat., 25 April 1842

Cennini 1971
 Cennini, Cennino, *Il Libro dell'Arte*, with commentary and notes by F. Brunello and an introduction by L. Magagnato, Vicenza, 1971

Chamberlain 1913
 Chamberlain, A. B., *Hans Holbein the Younger*, 2 vols, London, 1913

Chastel 1977
 Chastel, A., 'Le Donateur "in Abisso" dans les "Pale" ', *Festschrift für Otto von Simson zum 65. Geburtstag*, ed. L. Grisebach and K. Renger, Frankfurt-on-Main, 1977, pp. 273–83

Chastel 1978
 Chastel, A., *Fables, Formes, Figures*, 2 vols, Paris, 1978

Chastel 1990
 Chastel, A., 'Fra Bartolomeo's Carondelet altarpiece and the theme of the 'Virgo in unibus' in the High Renaissance', *The Altarpiece in the Renaissance*, ed. P. Humfrey and M. Kemp, Cambridge and New York, 1990, pp. 129–42

Chastel 1996
 Chastel, A., *French Art. The Renaissance, 1430–1620*, trans. D. Dusiberre, Paris, 1996

Christensen 1977
 Christensen, C. C., 'Patterns of Iconoclasm in the Early Reformation: Strasbourg and Basel', *The Image and the Word*, ed. J. Guttmann, Misoula, MT, 1977, pp. 107–48

Christensen 1979
 Christensen, C. C., *Art and the Reformation in Germany*, Athens, OH, 1979

Christus und Maria 1992
 Christus und Maria. Auslegungen christlicher Gemälde der Spätgotik und Frührenaissance aus der Karlsruher Kunsthalle, exh. cat. ed. I. Dresel, D. Lüdke and H. Vey, Kunsthalle Karlsruhe, 1992

Cicognara 1821
 Cicognara, L., *Catalogo ragionato dei libri d'arte e d'antichità posseduti dal Conte Cicognara*, 2 vols, Pisa, 1821

Clare 1985
 Clare, E. G., *St. Nicholas, his Legends and Iconography* (Pocket Library of 'Studies' in Art, xxv), Florence, 1985

Clasen 1974
 Clasen, K. H., *Der Meister der Schönen Madonnen. Herkunft, Entfaltung und Umkreis*, Berlin and New York, 1974

Claussen 1975
 Claussen, P. C., *Chartres-Studien. Zur Vorgeschichte, Funktion und Skulptur der Vorhallen*, Wiesbaden, 1975

Claussen 1993
 Claussen, P. C., 'Der doppelte Boden unter Holbeins Gesandten', *Hülle und Fülle. Festschrift für Tilmann Buddensieg*, ed. A. Beyer and V. Lampugnani, Alfter, 1993, pp. 177–202

Cornu 1862
 Cornu, S., *Catalogue des tableaux, des sculptures de la Renaissance et des majoliques du Musée Napoléon III*, Paris, 1862

Corpus Reformatorum 1834–1956
 Corpus Reformatorum, 101 vols, Halle *et al.*, 1834–1956

Costa de Beauregard 1987
 Costa de Beauregard, R., *Le Portrait elisabéthain dans l'oeuvre de Nicholas Hilliard*, Thesis Microfilms, ANRT University of Lille III, 1987

Costa de Beauregard 1991
 Costa de Beauregard, R., *Nicholas Hilliard et l'imaginaire élisabethain 1547–1619*, Paris, 1991

Cox-Rearick 1972
 Cox-Rearick, J., *La Collection de François Ier* (Les dossiers du département des Peintures, Musée du Louvre), Paris, 1972

Cox-Rearick 1995
 Cox-Rearick, J., *Chefs-d'oeuvre de la Renaissance. La collection de François Ier*, Paris, 1995

Cranach 1974
 Lukas Cranach. Gemälde Zeichnungen Druckgraphik, exh. cat. ed. D. Koepplin and T. Falk, 2 vols, Kunstmuseum Basle, 1974

Cranz and Kristeller 1980
 Cranz, E. F., and P. O. Kristeller, *Catalogus translationum et commentariorum. Mediaeval and Renaissance Latin Translations and Commentaries*, vol. IV, Washington, D.C., 1980

Danai 1987
 Danai, I., *Die Darstellung des Kranken auf den spätgotischen Bildnissen des heiligen Martin von Tours (1280-1520)* (Studien zur Medizin-, Kunst- und Literaturgeschichte 12), Herzogenrath, 1987

Dance of Death 1902
 The Dance of Death in a Series of Engravings on Wood from Designs attributed to Hans Holbein with a Treatise of the Subject by Francis Douce, also Holbein's Bible Cuts consisting of ninety Engravings on Wood with an Introduction by Thomas Frognall Dibdin, London, 1902

Danube School 1969
 Prints and Drawings of the Danube School, exh. cat. ed. C. Talbot and A. Shestack, New Haven, Yale University Galleries, 1969

Dati 1667
 Dati, C., *Vite de' pittori antichi*, Florence, 1667

Davies 1972
 Davies, M., *Rogier van der Weyden. An Essay with a Critical Catalogue of Paintings Assigned to him and to Robert Campin*, London, 1972

Davis 1956
 Davis, N. Z., 'Holbein's Pictures of Death and the Reformation in Lyons', *Studies in the Renaissance*, III, 1956, pp. 97–130

Decker 1985(1)
 Decker, B., *Das Ende des mittelalterlichen Kultbildes und die Plastik Hans Leinbergers* (Bamberger Studien zur Kunstgeschichte und Denkmalpflege, vol. 3), Bamberg, 1985

Decker 1985(2)
 Decker, B., 'Notizen zum Heller-Altar', *Städel-Jahrbuch*, X, 1985, pp. 179–92

Decker 1990
 Decker, B., 'Reform within the Cult Image: the German winged Altarpiece before the Reformation', *The Altarpiece in the Renaissance*, ed. P. Humfrey and M. Kemp, Cambridge, 1990, pp. 90–105

Denis 1987
 Denis, P., *Le Christ Etendard. L'homme-Dieu au temps des réformes (1500-1565)*, Paris, 1987

Derrida 1989
 Derrida, J., *La pharmacie de Platon*, in Platon, *Phèdre*, Paris, 1989, pp. 255–401

Descamps 1753
 Descamps, J. B., *La Vie des Peintres flamands, allemands et hollandois, avec des Portraits Gravés en Taille-douce, une indication de leurs principaux Ouvrages, & des Réflexions sur leurs différentes manieres*, 4 vols, Paris, 1753

Dizionario francescano 1983
 Dizionario francescano. Spiritualità, ed. E. Caroli, Padua, 1983

Dodgson 1906/07
 Dodgson, C., 'Hans Lützenburger and the Master N. H.', *Burl. Mag.*, X, 1906/07, pp. 319–22

Dodgson 1903–25
 Dodgson, C., *Catalogue of Early German and Flemish Woodcuts preserved in the British Museum*, 2 vols, London, 1903–25

Dollinger 1970
 Dollinger, P., *The German Hanse*, Stanford, CA, 1970

Dominique 1943
 Dominique, E., 'Le retable de Jean de Furno', *Les retables de l'église des Cordeliers. Trois chefs-d'oeuvre de l'art suisse à Fribourg*, Zurich, 1943, pp. 119–36

Dresden 1884
 Verzeichniss der Königlichen Gemälde-Gallerie zu Dresden, 5th edn, suppl. by K. Woermann, Dresden, 1884

Dresden 1989
 La vendita di Dresda, ed. J. Winkler, Modena, 1989

Droulers
 Droulers, E., *Dictionnaire des attributs, allégories, emblêmes et symboles*, Turnhout, n.d.

Dubois 1965
 Dubois, J., *Le martyrologe d'Usuard* (Subsidia Hagiographica vol. 40), Brussels, 1965

Dülberg 1990
 Dülberg, A., *Privatportraits. Geschichte und Ikonologie einer Gattung im 15. und 16. Jahrhundert*, Berlin, 1990

Dupraz 1961
 Dupraz, L., *Les Passions de St Maurice d'Agaune. Essai sur l'historicité de la tradition et contribution à l'étude de l'armée pré-dioclétienne (260–286) et des canonisations tardives de la fin du IVème siècle* (Studia Friburgensia, n.s. 27), Fribourg, 1961

Durand 1854
 Durand, G., *Rational ou Manuel des divins offices*, 5 vols, Paris, 1854

Dürer 1525
 [Dürer, Albrecht] *Underweysung der messung mit dem zirckel und richtscheyt in Linien ebnen unnd gantzen corporen durch Albrecht Dürer zuo samen getzogen . . .*, Nuremberg, 1525, 2nd edn 1538

Dürer 1528
 Dürer, Albrecht, *Vier Bücher von menschlicher Proportion*, [Nuremberg] 1528; reprinted Nördlingen: Uhl, 1980

Dürer 1956–69
 Dürers schriftlicher Nachlass, ed. H. Rupprich, 3 vols, Berlin, 1956–69

Dürer 1967
 Dürer und seine Zeit. Meisterzeichnungen aus dem Berliner Kupferstichkabinett, exh. cat., Berlin, 1967

Dürer 1971
 Dürer's Cities: Nuremberg and Venice, exh. cat. ed. C.C. Olds, E. Verheyen and W. Tresidder, University of Michigan Museum of Art, Ann Arbor, 1971

Dürer 1991
 Dessins de Dürer et de la Renaissance germanique dans les collections publiques parisiennes, exh. cat., Paris, Louvre, 1991

Dussler 1971
 Dussler, L., *Raphael: A Critical Catalogue of his Pictures, Wall-Paintings and Tapestries*, London and New York, 1971

Dynasties 1995–6
 Dynasties: Painting in Tudor and Jacobean England ,1530–1630, exh. cat. ed. K. Hearn, London, Tate Gallery, 1995

Dyson 1983
 Dyson, A., 'The Engravings and Printing of the "Holbein Heads" ', *The Library*, 6th series, v/3, 1983, pp. 223–36

Early Italian Engravings 1978
 Early Italian Engravings from the National Gallery of Art, exh. cat. ed. J. A. Levinson, K. Oberhuber and J. L. Sheehan, Washington, D.C., National Gallery of Art, 1978

Eggenberger 1989
 Eggenberger, C. and D., *Malerei des Mittelalters* (Ars Helvetica, vol. v), Disentis, 1989.

Eidgenössische Abschiede 1869
 Die Eidgenössischen Abschiede aus dem Zeitraume von 1500 bis 1520, ed. A. P.

Segesser (Amtliche Abschiedesammlung vol. III, 2), Lucerne, 1869

Einem 1960
 Einem, H. von, 'Holbeins "Christus im Grabe" ', *Mainzer Akademie der Wissenschaften und der Literatur. Abhandlungen der geistes- und sozialwissenschaftlichen Klasse*, IV, 1960, pp. 401–19

Eisler 1970
 Eisler, C., 'Aspects of Holbein the Elder's Heritage', *Festschrift für Gert von der Osten*, Cologne, 1970, pp. 149–58

Eisler 1989
 Eisler, C., *The Genius of Jacopo Bellini*, New York, 1989

Emiliani 1985
 Emiliani, A., *Tre artisti nella Bologna dei Bentivoglio: Francesco del Cossa, Ercole Roberti, Niccolò dell'Arca*, exh. cat., Bologna 1985

Erasmus 1515
 Erasmi Roterodami Encomium moria i.e. Stultitiae Laus, Basle: Johannes Froben, 1515 [copy belonging to Oswald Myconius with marginal drawings by Ambrosius and Hans Holbein, since 1585/87 in Basilius Amerbach's collection] Basle, Öffentliche Kunstsammlung, Kupferstichkabinett; Facsimile-Edition, 2 vols, ed. H. A. Schmid, Basle, 1931

Erasmus 1520
 Erasmus, Desiderius, *Enchiridion oder Handbüchlin eins Christenlichen und Ritterlichen Lebens*, Basle: Petri, 1520

Erasmus 1521
 Erasmus von Rotterdam, *Enchiridion oder handtbüchlin eins waren Christenlichen uñ strytbarlichen lebens . . .*, trans. Johannes Adelphus Mülich and Leo Jud, Basle: V. Curio, 1521

Erasmus 1522(1)
 Erasmus, Desiderius, *Erasmi Roterodami in novum testamentum*. Basle: Wolff, 1522

Erasmus 1522(2)
 Erasmus, Desiderius, *Paraphrasis in Evangelium Matthaei nunc primum natam & aeditam per D. Erasmum*, Basle: Froben, 1522

Erasmus 1523(1)
 Erasmus, Desiderius, *Adagiorum Proverbiorum Chilias*, Basle: Froben, 1523

Erasmus 1523(2)
 Erasmus, Desiderius, *Precatio dominica*, Basle: Froben, 1523

Erasmus 1525
 Erasmus, Desiderius, *C. Plinii Secundi Historia mundi denuo emendata, non paucis locis emendata*, Basle: Froben, 1525

Erasmus 1528
 Erasmus, Desiderius, *Dialogus de recta Latini Graecique sermonis pronuntiatione*, Basle: Froben, 1528

Erasmus 1676
 Moriae Encomium. Stultitiae Laus Des. Erasmi Rot. Declamatio. Cum comentariis Ger. Listrii, ed. Charles Patin, Basle: Typis Genathianis, 1676

Erasmus 1703–06
 Erasmus, Desiderius, *Opera omnia*, 10 vols, Leiden: van der Aa, 1703–06

Erasmus 1906–58
 Erasmus, Desiderius, *Opus Epistolarum*, ed. P. S. Allen, 12 vols, Oxford, 1906–58

Erasmus 1931
 Erasmus, Desiderius, *Erasmi Roterodami Encomium Moria i.e. Stultitiae Laus*, Basle: Johannes Froben, 1515; facsimile edn by H. A. Schmid, Basle, 1931

Erasmus 1969–
 Erasmus, Desiderius, *Opera omnia*, 9 vols published, Amsterdam, 1969–

Erasmus 1971
 Erasmus, Desiderius, *Enchiridion militis christiani*, André-Jean Festugière ed., (Bibliothèque des textes philosophiques), Paris: Vrin, 1971.

Erasmus 1972
 Erasmus, Desiderius, *Colloquia*, ed. L. H. Halkin, F. Bierlaire and R. Hoven, Amsterdam, 1972

Esch 1987
 Esch, A., 'Staunendes Sehen, gelehrtes Wissen: zwei Beschreibungen römischer Amphitheater aus dem letzten Jahrzehnt des 15. Jahrhunderts', *ZfK*, L, 1987, pp. 385–93

Esch 1990
Esch, A., 'Mit Schweizer Söldnern auf dem Marsch nach Italien. Das Erlebnis der Mailänderkriege 1510–1515 nach bernischen Akten', *Quellen und Forschungen aus italienischen Archiven und Bibliotheken*, L X X, 1990, pp. 348–440

Etterlyn 1507
Etterlyn, Petermann, *Kronica von der loblichen Eydtgenoschaft Ir har kommen und sust seltzam stritten, und geschichten*, Basle: Furtter, 1544

Etterlyn 1544
Etterlyn, Petermann, *Kronica von der loblichen Eydtgenossenchaft Ir har kommen und sust seltzam stritten, und geschichten*, Basle: Furtter, 1507

Europa und der Orient 1989
Europa und der Orient 800–1900, exh. cat. ed. G. Sievernich and H. Budde, Berlin, 1989

Falk 1968
Falk, T., *Hans Burgkmair. Studien zu Leben und Werk des Augsburger Malers* (Bruckmanns Beiträge zur Kunstwissenschaft), Munich, 1968

Falk 1976
Falk, T., 'Notizen zur Augsburger Malerwerkstatt des Aelteren Holbein', *Zeitschrift des Deutschen Vereins für Kunstwissenschaft*, X X X, 1976, pp. 3–20

Falk 1979
Falk, T., *Katalog der Zeichnungen des 15. und 16. Jahrhunderts im Kupferstichkabinett Basel* (Kupferstichkabinett der Öffentlichen Kunstsammlung Basle, vol. I I I/I), Basle and Stuttgart, 1979

Ferguson 1961
Ferguson, G., *Signs and Symbols in Christian Art*, New York, 1961

Ferrara and Quinterio 1984
Ferrara, M., and F. Quinterio, *Michelozzo di Bartolomeo*, Florence, 1984

Ffoukes and Maiocchi 1909
Ffoukes, C. J., and R. Maiocchi, *Vincenzo Foppa of Brescia, Founder of the Lombard School: His Life and Work*, London and New York [1909]

Filarete 1972
Antonio Averlino detto Il Filarete, *Trattato di architettura*, ed. A. M. Finoli and L. Grassi, 2 vols, Milan, 1972

Fillitz 1954
Fillitz, H., *Die Insignien und Kleinodien des Heiligen Römischen Reichs*, Munich and Vienna, 1954

Fillitz 1993
Fillitz, H., 'Bemerkungen zur Datierung und Lokalisierung der Reichskrone', *ZfK*, L V I, 1993, pp. 313–34

Fischbach 1883
Fischbach, F., *Die künstlerische Ausstattung der bürgerlichen Wohnung*, Basle, 1883

Florence 1965
The Art of Painting in Florence and Siena from 1250 to 1500, exh. cat. by The National Trust, London, 1965

Foister 1983
Foister, S., *Drawings by Holbein from the Royal Library, Windsor Castle*, 2 vols, New York, 1983

Foister 1989
Foister, S., *Holbein and his English Patrons*, PhD thesis, Courtauld Institute, University of London, 1989

Foister 1993
Foister, S., 'Holbein, van Dyck and the Painter-Stainers Company', *Art & Patronage in the Caroline Courts: Essays in Honour of Sir Oliver Millar*, ed. D. Howarth, Cambridge, 1993, pp. 32–50

Foister 1996
Foister, S., ' "My foolish curiosity". Holbein in the collection of the Earl of Arundel', *Apollo*, August 1996, pp. 51–6

Foucart-Walter 1985
Foucart-Walter, E., *Les peintures de Hans Holbein le Jeune au Louvre*, (Les Dossiers du Département des Peintures 29), Musée du Louvre, Paris, 1985

Fraenkel 1992
Fraenkel, B., *La signature. Genèse d'un signe*, Paris, 1992

Frankl 1960
Frankl, P., *The Gothic: Literary Sources and Interpretation*, Princeton, NJ, 1960

Franz 1973
Franz, G., *Huberinus, Rhegius, Holbein*, Nieuwkop, 1973

Franz von Assisi
Achthundert Jahre Franz von Assisi: Franziskanische Kunst und Kultur des Mittelalters, exh. cat., Kremstein, Minoritenkirche, 1982 (catalogue of Niederösterreichischen Landesmuseums N.F. no. 122), Vienna 1982

Frauenfelder 1958
Frauenfelder, R., *Der Bezirk Stein am Rhein* (Kunstdenkmäler des Kantons Schaffhausen, vol. 2), Basle, 1958

Freedberg 1989
Freedberg, D., *The Power of Images: Studies in the History and Theory of Response*, Chicago and London, 1989

Freedberg 1970
Freedberg, S. J., *Painting in Italy, 1500 to 1600* (The Pelican History of Art), Harmondsworth, 1970

Friedländer 1922
Friedländer, M. J., *Holzschnitte von Hans Weiditz*, Berlin, 1922

Friedländer 1927
Friedländer, M. J., *Die altniederländische Malerei*, Berlin, 1927

Friedländer 1971
Friedländer, M. J., *Early Netherlandish Painting VII: Quentin Massis*, Leiden, 1971

Friedländer 1978
Friedländer, M. J., and J. Rosenberg, *The Paintings of Lucas Cranach*, revd edn, Ithaca, N.Y., 1978

Froben 1960
Johannes Froben und der Basler Buchdruck des 16. Jahrhunderts, exh. cat., Basle, Gewerbemuseum, 1960

Füglister 1981
Füglister, H., *Handwerksregiment: Untersuchungen und Materialien zur sozialen und politischen Struktur der Stadt Basel in der ersten Hälfte des 16. Jahrhunderts* (Basler Beiträge zur Geschichtswissenschaft, vol. 143), Basle and Frankfurt, 1981

Furlan 1988
Furlan, C., *Il Pordenone*, Milan, 1988

Füssli 1755–6
Füssli, Johann Caspar, *Geschichte und Abbildung der besten Mahler in der Schweitz*, 2 parts, Zurich: David Gessner, 1755–1756

Ganz 1909
Ganz, P., 'Hans Holbeins Italienfahrt', *Süddeutsche Monatshefte*, V I, 1909, pp. 596–612

Ganz 1919
Ganz, P., *Hans Holbein d.J.: Des Meisters Gemälde* (Klassiker der Kunst, vol. 20), Stuttgart, 1919

Ganz 1939
Ganz, P., *Les dessins de Hans Holbein le Jeune. Catalogue raisonné*, 8 vols, Geneva, 1939

Ganz 1949
Ganz, P., *Hans Holbein. Die Gemälde. Eine Gesamtausgabe*, Cologne, 1949

Ganz 1950
Ganz, P., *Hans Holbein. Die Gemälde. (Phaidon Ausgabe)*, Basle, 1950

Ganz 1960(1)
Ganz, P. L., *Die Miniaturen der Basler Universitätsmatrikel*, Basle & Stuttgart: Schwabe, 1960.

Ganz 1960(2)
Ganz, P. L., 'Franz Gerster (um 1490–1531). Ein Basler Dilettant der Holbeinzeit', *ZAK*, X X, 1960, pp. 35–40

Garber 1915
Garber, J., 'Das Haller Heiltumbuch mit den Unika-Holzschnitten Hans Burgkmairs des Aelteren', *Jahrbuch der kunsthistorischen Sammlungen der allerhöchsten Kaiserhauses*, X X X I I, Heft 6, 1915

Gardner 1973
Gardner, J., 'Arnolfo di Cambio and Roman Tomb Design', *Burl. Mag.*, C X V, 1973, pp. 420–39

Garside 1966
Garside, C., *Zwingli and the arts*, New Haven and London, 1966

Geiger
Geiger, G. L., *Filippino Lippi's Carafa Chapel: Renaissance Art in Rome*, Kirksville, n.d.

Geigy 1899
Geigy, A., *Katalog der Basler Münzen und Medaillen der im Historischen Museum zu Basel deponierten Ewig'schen Sammlung*, Basle, 1899

Geisberg 1939
Geisberg, M., *Geschichte der deutschen Graphik vor Dürer*, Berlin, 1939

Gerlo 1950
Gerlo, A., *Erasme et ses portraitistes. Metsij, Dürer, Holbein*, Brussels, 1950

Germann 1972
Germann, G., *Gothic Revival in Europe and Britain: Sources, Influences and Ideas*, London, 1972

Germann 1993
Germann, G., *Einführung in die Geschichte der Architekturtheorie*, Darmstadt, 1980, 3rd edn, 1993

Gesta Romanorum
[Gesta Romanorum] *Das Buch von der Geschichte oder geschehen Dingen der Römer*, Augsburg: Johann Schobsser, 1489.

Giesecke 1994
Giesecke, B., *Glasmalereien des 16. und 20. Jahrhunderts im Basler Rathaus*, Basle, 1994

Gilardoni 1979
Gilardoni, V., *I Monumenti d'Arte e di Storia del Canton Ticino*, vol. 2, Basle, 1979

Gilmore 1934
Gilmore, E., *Die Augsburger Andachtsepitaphien in Zusammenhang mit der monumentalen Plastik*, Munich, 1934

Giorgione 1978
Giorgione a Venezia., exh. cat., Milan, Galleria dell' Accademia, 1978

Giulio 1989
Giulio Romano., exh. cat., with essays by E. H. Gombrich, M. Tafuri *et al.*, in Mantua and Milan, 1989

Glareanus 1514
Glareanus, Heinrich, *Ad divum Maximilianum Romanorum imperatorum, semper Augustum, Henrici Glareani Helvetii Poe. Laure. Panegyricon*, Basle: Petri, 1514

Goddard 1984
Goddard, S. H., *The Master of Frankfurt and his Shop*, Brussels, 1984

Godin 1982
Godin, A., *Erasme lecteur d'Origène*, Geneva, 1982

Goffen 1979
Goffen, R., '*Nostra Conversatio in Caelis Est*: Observations on the *Sacra Conversazione* in the Trecento', *AB*, L X I, 1979, pp. 198–222

Goffen 1986
Goffen, R., *Piety and Patronage in Renaissance Venice: Bellini, Titian and the Franciscans*, New Haven and London, 1986

Goffen 1989
Goffen, R., *Giovanni Bellini*, New Haven and London, 1989

Goldberg 1980
Goldberg, G., 'Zur Ausprägung der Dürer-Renaissance in München', *Münchner Jahrbuch der bildenden Kunst*, X X X I, 1980, pp. 129–75

Gombrich 1966
Gombrich, E. H., *Norm and Form: Studies in the Art of the Renaissance*, London, 1966

Gombrich 1976
Gombrich, E. H., *The Heritage of Apelles: Studies in the Art of the Renaissance*, Oxford, 1976

Gorse 1990
Gorse, G. L., 'Between Empire and Republic: Triumphal Entries into Genoa during the Sixteenth Century', *'All the World's a Stage': Art and Pageantry in the Renaissance and Baroque*, ed. B. Wisch and S. Scott Munshower, 2 vols, (Papers in Art History from the Pennsylvania State University, vol. I V), University Park, PA, 1990, I, pp. 188–256

Gossaert 1965
Jan Gossaert genaamd Mabuse, exh. cat., Rotterdam and Bruges, 1965

Gothic and Renaissance Art 1986
Gothic and Renaissance Art in Nuremberg 1300-1550, exh. cat., New York, Metropolitan Museum of Art, 1986

Grafton 1990
Grafton, A., *Forgers and Critics: Creativity and Duplicity in Western Scholarship*, Princeton, NJ, 1990

Grafton and Jardine 1986
Grafton, A., and L. Jardine, *From Humanism to the Humanities.: Education and the Liberal arts in Fifteenth- and Sixteenth-century Europe*, Cambridge, MA, 1986

Grams-Thieme 1991
Grams-Thieme, M., Art. 'Koralle', *Lexikon des Mittelalters*, Zurich and Munich, 1991, v, cols. 1441–2

Gregory the Great 1982
Die Messe Gregors des Grossen. Vision, Kunst, Realität., exh. cat., Cologne, Schnütgen Museum, 1982

Griener, *see* Bätschmann and Griener

Griener 1993
Griener, P., 'Le préconstruit d'une restauration: le travail d'Andreas Eigner (1801–1870) sur la Madone de Soleure d'Hans Holbein le Jeune (1522)', *Geschichte der Restaurierung in Europa. Akten des internationalen Kongresses 'Restaurierungsgeschichte', Basel, 1991*, Worms, 1993, pp. 104–20

Grimm 1981
Grimm, C., *The Book of Picture Frames*, New York, 1981

Grimm and Konrad 1990
Grimm, C., and B. Konrad, *Die Fürstenberg Sammlungen Donaueschingen: altdeutsche und schweizerische Malerei des 15. und 16. Jahrhunderts*, Munich, 1990

Groll 1990
Groll, K., *Das 'Passional Christi und Antichristi' von Lucas Cranach d.Ä.*, Berne, 1990

Grossmann 1944
Grossmann, F., 'Notes on the Arundel and Imstenraedt Collections', *Burl. Mag.*, L X X X I V, pp. 151–4; L X X X V, pp. 173–6

Grote 1961
Grote, L., *Die Tucher. Bildnis einer Patrizierfamilie* (Bibliothek des Germanischen Nationalmuseums Nürnberg zur deutschen Kunst- und Kulturgeschichte, vol. 15/16), Munich, 1961

Grundmann 1972
Grundmann, G., *Die Darmstädter Madonna. Der Schicksalsweg des berühmten Gemäldes von Hans Holbein d.J.*, 2nd edn, Darmstadt, 1972

Grünewald 1989
Le Retable d'Isenheim et la sculpture au nord des Alpes à la fin du Moyen Age. Actes du colloque de Colmar, 1987, ed. C. Heck (Bulletin de la Société Schongauer), Colmar, 1989

Gy 1992
Gy, P.-M., *Guillaume Durand Evêque de Mende (c. 1230–1296), Canoniste, liturgiste et homme politique*, Paris, 1992

Haefliger 1956
Haefliger, E., 'Urs und Viktor und die thebäische Legion', *Jahrbuch für Solothurner Geschichte*, X X I X, 1956, pp. 212–21

Haffner 1666
Haffner, Franciscus, *Der klein Solothurner Allgemeine Schaw-Platz historischer Geist- auch Weltlicher vornembsten Geschichten und Händlen*, 2 parts, Solothurn: Bernhardt, 1666

Hagenbach 1859
Hagenbach, K.-R., *Johann Oekolampad und Oswald Myconius die Reformatoren Basels. Leben und ausgewählte Schriften*, Elberfeld, 1859

Hale 1988
Hale, J. R., 'The Soldier in Germanic Graphic Art of the Renaissance', *Art and History: Images and Their Meaning*, ed. R. I Rotberg and T. K. Rabb, Cambridge, 1988, pp. 85–114

Hale 1990
Hale, J. R., *Artists and Warfare in the Renaissance*, New Haven and London, 1990

Hall 1985
Hall, E., and H. Uhr, 'Aureola super Auream: Crown, and Related

Symbols of Special Distinction for Saints in Late Gothic and Renaissance Iconography', *AB*, L X V I I, 1985, pp. 567–603

Halm and Berliner 1931
Halm, P. M., and R. Berliner, *Das Hallesche Heiltum. Man. Aschaffenburg 14*, Berlin, 1931

Hand 1980
Hand, J. O., 'The Portrait of Sir Brian Tuke by Hans Holbein the Younger', *Studies in the History of Art, National Gallery of Art, Washington*, I X, 1980, pp. 33–49

Harbison, C. *see* Roskill, M.

Harbison 1995
Harbison, C., *La Renaissance dans les pays du Nord*, Paris, 1995

Harmening 1979
Harmening, D., *Superstitio. Ueberlieferungs- und theoriegeschichtliche Untersuchungen zur kirchlich-theologischen Aberglaubensliteratur des Mittelalters*, Berlin, 1979

Haskell 1989
Haskell, F., 'Charles I's Collection of Pictures', *The Late King's Goods: Collections, Possessions and Patronage of Charles I in the Light of the Commonwealth Inventories*, ed. A. McGregor, London and Oxford, 1989, pp. 203–31

Hausbuch-Meister 1985
The Master of the Amsterdam Cabinet, or the Housebook Master, ca. 1470-1500, ed. J. P. Filedt-Kok, Princeton, NJ, 1985

Häusel 1980
Häusel, B., 'Die Restaurierung des Altars aus Sta. Maria im Calancatal', *Historisches Museum Basel, Jahresberichte*, 1980, pp. 40–55

Hayum 1985
Hayum, A., 'Dürer's Portrait of Erasmus and the Ars Typographorum', *Renaissance Quarterly*, X X X V I I I, 1985, pp. 650–87

Hayum 1989
Hayum, A., *The Isenheim Altarpiece: God's Medicine and the Painter's Vision*, Princeton, NJ, 1989

Heckscher 1967
Heckscher, W. S., 'Reflections on Seeing Holbein's Portrait of Erasmus at Longford Castle', *Essays in the History of Art Presented to Rudolf Wittkower*, London, 1967, I, pp. 128–48

Hederich 1770
Hederich, Benjamin, *Gründliches mythologisches Lexicon*, Leipzig: in Gleditschens Handlung, 1770

Hegner 1827
Hegner, U., *Hans Holbein der Jüngere*, Berlin, 1827

Heiltum Nürnberg 1487
[Heiltum zu Nürnberg] Wie das hochwirdigist Auch kaiserlich heiligthum. Vnd die grossen Roemischen gnad darzu gegeben. Alle Jaer ausgerueffi vnd geweist wirdt. In der loeblichen Statt. Nueremberg, Nuremberg: Peter Vischer, 1487

Heinecken 1782
Heinecken, Friedrich von, *Abrégé de la vie des peintres, dont les tableaux composent la galerie électorale de Dresde. Avec le détail de tous les Tableaux de cette Collection & des Eclaircissements historiques sur ces Chefs-d'oeuvres de la Peinture*, Dresden, 1782

Heitz and Bernoulli 1895
Heitz, P., and C. C. Bernoulli, *Basler Büchermarken bis zum Anfang des 17. Jahrhunderts*, Strasburg, 1895

Helmrath 1987
Helmrath, J., *Das Basler Konzil 1431-1449. Forschungsstand und Probleme*, Vienna and Cologne, 1987

Hendy 1964
Hendy, P., *Some Italian Renaissance Pictures in the Thyssen-Bornemisza Collection*, Lugano-Castagnola: Villa Favorita, 1964

Henkel-Schöne 1967
Emblemata. Handbuch zur Sinnbildkunst des XVI. und XVII Jahrhunderts, ed. A. Henkel and A. Schöne, Stuttgart, 1967

Hervey 1900
Hervey, M., *Holbein's Ambassadors: The Picture and the Men, A Historical Study*, London, 1900

Herzog 1956
Herzog, E., 'Zur Kirchenmadonna van Eycks', *Berliner Museen (Berichte)*, n.s., V I/I, 1956, pp. 2–16

Heydrich 1990
Heydrich, C., *Die Wandmalereien Hans Bocks d.Ä. von 1608-1611 am Basler Rathaus. Zu ihrer Geschichte, Bedeutung und Maltechnik*, Bern and Stuttgart, 1990

Heyer 1969–86
Heyer, H. R., *Die Kunstdenkmäler des Kantons Basel-Landschaft*, Basle, 1969–86

Hieronimus 1938
Hieronimus, K. W., *Das Hochstift Basel im ausgehenden Mittelalter*, (Quellen und Forschungen), Basle, 1938

Hieronymus 1984
Hieronymus, F., *Oberrheinische Buchillustration 2. Basler Buchillustration 1500 bis 1545*, exh. monograph, Basle, 1984]

Hilliard 1992
Hilliard, Nicholas, *A Treatise concerning the Arte of Limning, together with A more compendious discourse concerning ye art of liming by Edward Norgate*, ed. R.K.R. Thornton and T.G.S. Cain, Ashington, 1992

Himmel, Hölle and Fegefeuer 1994
Himmel, Hölle, Fegefeuer. Das Jenseits im Mittelalter, exh. cat. ed. P. Jezler, Landesmuseum Zurich, 1994

Hind 1938–48
Hind, A. M., *Early Italian Engravings*, 7 vols, London, 1938–48

Hirth 1882
Hirth, G., *Das deutsche Zimmer der Renaissance. Anregungen zu Häuslicher Kunstpflege*, 2nd edn, Munich, 1882

His 1870
His, E., 'Die Basler Archive über Hans Holbein den Jüngeren, seine Familie und einige zu ihm in Beziehung stehende Zeitgenossen', *Jahrbücher für Kunstwissenschaft*, I I I, 1870, pp. 113–73

His 1879
His, E., 'Holbeins Verhältnis zur Basler Reformation', *Repertorium für Kunstwissenschaft*, I I, 1879, pp. 156–9

His 1886
His, E., *Dessins d'ornement de Hans Holbein*, Paris, 1886

His 1891
His, E, 'Einige Gedanken über die Lehr-und Wanderjahre Hans Holbeins des Jüngeren', *Jahrbuch der Königlich Preussischen Kunstsammlungen*, X I I, 1891, pp. 59–66

His-Heusler 1870
His-Heusler, E., 'Hans Lützenburger', *GBA*, X I I, 1870, pp. 481–9

Hoch 1987
Hoch, A. S., 'St Martin of Tours: His Transformation into a Chivalric Hero and Franciscan Ideal', *ZfK*, L, 1987, pp. 471–82

Hofer and Mojon 1952–69
Hofer, P., and L. Mojon, *Die Kunstdenkmäler des Kantons Bern. Die Stadt Bern*, 5 vols, Basle, 1952–69

Hoffmann 1975
Hoffmann, K., 'Hans Holbein d.J.: Die "Gesandten"', *Festschrift für Georg Scheja zum 70. Geburtstag*, Sigmaringen, 1975, pp. 133–50

Hoffmann 1990
Hoffmann, K., 'Holbeins Todesbilder', *Ikonographia. Anleitung zum Lesen von Bildern* (Festschrift Donat de Chapeaurouge), ed. B. Brock and P. Achim, Munich, 1990, pp. 97–110

Holbein d.J. 1871
Katalog der Holbein-Ausstellung zu Dresden. 15. August bis 15. October 1871, Dresden, 1871

Holbein d.Ä. 1965
Hans Holbein der Ältere und die Kunst der Spätgotik, exh. cat., Rathaus Augsburg, 1965

Holbein 1960
Die Malerfamilie Holbein in Basel, exh. cat., Kunstmuseum Basle, 1960

Holbein 1978–9
Holbein and the Court of Henry VIII, exh. cat., The Queen's Gallery, Buckingham Palace, London, 1978–9

Holbein 1988
 Holbein. Zeichnungen vom Hofe Heinrichs VIII. Fünfzig Zeichnungen aus der Sammlung Ihrer Majestät Queen Elizabeth II, Windsor Castle, exh. cat. by The Hon. J. Roberts, Hamburger Kunsthalle; Kunstmuseum Basle; 1988
Holbein 1992
 Hans Holbein der Jüngere und das Hertensteinhaus, exh. cat. by C. Hermann, J. Hesse and L. Wechsler, Lucerne, Historisches Museum, 1992
Hollstein 1988
 Hollstein's German Engravings, Etchings and Woodcuts 1400-1700, XIV and XIVa: Robert Zijlma, *Ambrosius to Hans Holbein the Younger*, ed. T. Falk; Koninklijke van Poll, Rosendaal, 1988
Holman 1980
 Holman, T. S., 'Holbein's Portraits of the Steelyard Merchants: An Investigation', *Metropolitan Museum Journal*, XIV, 1980, pp. 139–58
Horace 1939
 Horace, *Satires, Epistles and Ars poetica*, trans. H. R. Fairclough, London and Cambridge, MA, 1939
Horaz 1957
 Horaz, *Sämtliche Werke*, Latin text with German translation, Munich, 1957
Howarth 1985
 Howarth, D., *Lord Arundel and his Circle*, New Haven and London, 1985
Huber 1990
 Huber, F., *Das Trinitätsfresko von Masaccio und Filippo Brunelleschi in Santa Maria Novella zu Florenz*, Munich, 1990
Huizinga 1975
 Huizinga, J., *L'Automne du Moyen-Age*, trans. J. Bastin, Paris, 1989; German edn: *Herbst des Mittelalters. Studien über Lebens-und Geistesformen des 14. und 15. Jahrhunderts in Frankreich und in den Niederlanden*, ed. K. Köster, Stuttgart, 1975
Humfrey 1993
 Humfrey, P., *The Altarpiece in Renaissance Venice*, New Haven and London, 1993
Huse 1977
 Huse, N., 'Anmerkungen zu Burckhardts 'Kunstgeschichte nach Aufgaben'', *Festschrift Wolfgang Braunfels*, ed. F. Piel and J. Träger, Tübingen, 1977, pp. 157–66
Illustrierte Flugblätter
 Illustrierte Flugblätter aus den Jahrhunderten der Reformation und der Glaubenskämpfe, exh. cat. ed. W. Harms and B. Rattay, Kunstsammlungen der Veste Coburg, 1983
Im Hof 1980
 Im Hof, U., 'Niklaus Manuel und die reformatorische Götzenzerstörung', *ZAK*, XXXVII, 1980, pp. 297–300
Imdahl 1986(1)
 Imdahl, M., 'Anschauungssinn und Vorstellungssinn: Zur Deutung der Szene in Holbeins "Darmstädter Madonna"', *Studien zu Renaissance und Barock. Manfred Wundram zum 60. Geburtstag*, ed. M. Hesse and M. Imdahl, Frankfurt-on-Main, Berne and New York, 1986, pp. 89–109
Imdahl 1986 (2)
 Imdahl, M., 'Hans Holbeins "Darmstädter Madonna" – Andachtsbild und Ereignisbild', *Wie eindeutig ist ein Kunstwerk?*, ed. M. Imdahl, Cologne, 1986, pp. 9–39
Ivanoff 1969
 Ivanoff, N., 'La collezione Rosa-Patin ed alcuni artisti stranieri a Padova nel XVII Secolo', *Arte Veneta*, XXIII, 1969, pp. 236–8
Ivins 1973
 Ivins, W. M., *On the Rationalization of Sight: With an Examination of Three Renaissance Texts on Perspective*, New York, 1973
Jaccard 1992
 Jaccard, P.-A., *Skulptur (Ars Helvetica, VIII)*, Disentis, 1992
Jagemann 1803
 Jagemann, C. G., *Dizionario Italiano-Tedesco e Tedesco-Italiano*, 2 vols, Leipzig, 1803
Junius 1694
 Junius, F., *De Pictura veterum libri tres*, Rotterdam, 1694

Kaegi 1947–77
 Kaegi, W., *Jacob Burckhardt. Eine Biographie*, 6 vols, Basle and Stuttgart, 1947–77
Kaiser 1978
 Kaiser, U. N., *Der skulptierte Altar der Frührenaissance in Deutschland*, 2 vols. Bamberg, 1978
Karlstadt 1522
 Karlstadt, Andreas Bodenstein [a.k.a.], *Von abtuhung der Bylder, und das keyn Betdler unther den Christen sein soll*, Wittenberg: Nickel Schirlentz, 1522, and Strasburg: Morhart, 1522
Kästner 1985
 Kästner, M., *Die Icones Hans Holbeins des Jüngeren. Ein Beitrag zum graphischen Werk des Künstlers und zur Bibelillustration am Ende des 15. Jahrhundert und in der ersten Hälfte des 16. Jahrhunderts*, 2 vols, Heidelberg, 1985
Keil 1985
 Keil, R., 'Die Rezeption Dürers in der deutschen Kunstbuchliteratur des 16. Jahrhunderts', *Wiener Jahrbuch für Kunstgeschichte*, XXXVIII, 1985, pp. 133–50
Kelberg 1983
 Kelberg, K., *Die Darstellung der Gregorsmesse in Deutschland*, doctoral thesis, Münster, 1983
Keller 1967
 Keller, H., 'Entstehung und Blütezeit des Freundschaftsbildes', *Essays in the History of Art Presented to Rudolf Wittkower*, London, 1967, I, pp. 161–73
Kemp 1976
 Kemp, M., '"Ogni dipintore dipinge se": A Neoplatonic Echo in Leonardo's Art Theory?', *Cultural Aspects of the Italian Renaissance: Essays in Honour of Paul Oskar Kristeller*, ed. C. H. Clough, Manchester and New York, 1976, pp. 311–21
Kemp 1977
 Kemp, M., 'From "Mimesis" to "Fantasia": The Quattrocento Vocabulary of Creation, Inspiration and Genius in the Visual Arts', *Viator*, VIII, 1977, pp. 347–98
Kemp 1986
 Kemp, W., 'Masaccios "Trinität" im Kontext', *Marburger Jahrbuch für Kunstwissenschaft*, XXI, 1986, pp. 44–72
Kennedy 1964
 Kennedy, R. W., 'Apelles Redivivus', *Essays in Memory of Karl Lehmann*, ed. L. Freeman-Sandler, New York, 1964, pp. 160–70
Kiening 1995
 Kiening, C., 'Le double décomposé. Rencontres des vivants et des morts à la fin du Moyen Age', *Annales*, September–October 1995, no. 5, pp. 1157–90
Kinkel 1869
 Kinkel, G., 'Zur Holbein-Literatur', *Zeitschrift für Bildende Kunst*, IV, 1869, pp. 167–75, 194–203
Kirn 1925
 Kirn, P., 'Friedrich der Weise und Jacopo de'Barbari', *Jahrbuch der Preussischen Kunstsammlungen*, XLVI, 1925, pp. 130–34
Kitzinger 1977
 Kitzinger, E., *Byzantine Art in the Making: Main Lines of Stylistic Development in Mediterranean Art, 3rd–7th Century*, London, 1977
Klauser 1969
 Klauser, T., *A Short History of the Western Liturgy*, London, 1969
Klemm 1972
 Klemm, C., 'Der Entwurf zur Fassadenmalerei am Haus "Zum Tanz" in Basel. Ein Beitrag zu Holbeins Zeichnungsoeuvre', *ZAK*, XXIX, 1972, pp. 165–75
Klemm 1973
 Klemm, C., 'Die Orgelflügel. Eine alte Bildgattung und ihre Ausformung bei Holbein', *Das Münster*, XXVI, 1973, pp. 357–62
Klemm 1978
 Klemm, C., Art. 'Fassadenmalerei', *RDK*, VII, 1978, cols. 690–742
Klemm 1980
 Klemm, C., *Hans Holbein d.J. im Kunstmuseum Basel (Schriften des*

Vereins der Freunde des Kunstmuseums Basel, no. 3), Basle, 1980

Klemm 1986
 Klemm, C., *Joachim von Sandrart. Kunst-Werke und Lebens-Lauf*, Berlin, 1986

Köbel 1545
 Köbel, Jakob, *Wapen. Des heyligen Römischen Reichs Teutscher Nation*, Frankfurt: Jakob, 1545

Koegler 1909
 Koegler, H., 'Der Hortulus Animae, illustriert von Hans Holbein d.J.', *Zeitschrift für bildende Kunst*, n.s., XIX, 1908, pp. 236–7; XX, 1909, pp. 35–41

Koegler 1910
 Koegler, H., 'Hans Holbeins d.J. Holzschnitte für Sebastian Münsters "Instrument über die zwei Lichter" ', *Jahrbuch der Königl. Preuszischen Kunstsammlungen*, XXXI, 1910, pp. 254–68

Koegler 1920
 Koegler, H., 'Hans Holbein d.J. Holzschnitt Bildnisse von Erasmus und Luther', *Jahrbuch der öffentlichen Kunstsammlung Basel*, n.s., XVII, 1920, pp. 35–47

Koegler 1931–2
 Koegler, H., 'Holbeins Triumphzüge des Reichtums und der Armut', in: *Öffentliche Kunstsammlung Basel, Jahresberichte 1931–1932*, n.s., XXVIII–XXIX, pp. 57–95

Koegler 1940
 Koegler, H., 'Die illustrierten Erbauungsbücher, Heiligenlegenden und geistlichen Auslegungen im Basler Buchdruck des XVI. Jahrhunderts', *Basler Zeitschrift für Geschichte und Altertumskunde*, XXXIX, 1940, pp. 53–157

Koegler 1943
 Koegler, H., *Hans Holbein d.J. Die Bilder zum Gebetbuch Hortulus Animae*, Basle, 1943

Koerner 1993
 Koerner, J. L., *The Moment of Self-portraiture in German Renaissance Art*, Chicago and London, 1993

Köhler 1898–1900
 Köhler, R., *Kleine Schriften*, ed. J. Bolte, Weimar and Berlin, 1898–1900

Köln 1961
 Kölner Maler der Spätgotik, exh. cat., Cologne, Wallraf–Richartz–Museum, 1961

Köln 1965
 Wallraf–Richartz–Museum Köln. Verzeichnis der Gemälde, Cologne, 1965

Köln 1969
 Katalog der deutschen und niederländischen Gemälde im Wallraf–Richartz–Museum und im Kunstgewerbemuseum der Stadt Köln (Kataloge des Wallraf-Richartz-Museums, vol. V), ed. I. Hiller and H. Vey, Cologne, 1969

Köln 1986
 Wallraf–Richartz–Museum Köln. Vollständiges Verzeichnis der Gemäldesammlung, ed. C. Hesse and M. Schlagenhaufer, Cologne and Milan, 1986

Konrad 1992
 Konrad, B., 'Die Wandgemälde im Festsaal des St Georgen-Klosters zu Stein am Rhein', *Schaffhauser Beiträge zur Geschichte*, LXIX, 1992, pp. 75–III

Koppe 1995
 Koppe, K., *Kostbare illustrierte Bücher des sechzehnten Jahrhunderts in der Stadtbibliothek Trier* (Ausstellungskataloge Trierer Bibliotheken, vol. 27), Wiesbaden, 1995

Körner 1979
 Körner, H., *Der früheste Einblattholzschnitt* (Studia Iconologica, ed. H. Bauer and F. Piel, vol. 3), Mittenwald, 1979

Körner 1988
 Körner, H., 'Hans Baldungs "Muttergottes mit der Weintraube" ', *Pantheon*, LXVI, 1988, pp. 50–60

Kosel 1991
 Kosel, K., *Der Augsburger Domkreuzgang und seine Denkmäler*, Sigmaringen, 1991

Krafft 1517
 Krafft, U., *Das ist der geistlich streit gemacht unnd gepredigt worden durch den Hoch gelertenn Bayder Rechtenn Doctor Ulrich krafft pfarrer zu Ulm . . .*, Strasburg: Haselberger, 1517

Krahn 1995
 Krahn, V., ed., *Von allen Seiten schön. Bronzen der Renaissance und des Barock*, exh. cat, Berlin, Alten Museum, 1995–6

Kranz 1981
 Kranz, G., *Das Bildgedicht. Theorie. Lexikon. Bibliographie*, 2 vols, Cologne and Vienna, 1981

Kraut 1986
 Kraut, G., *Lukas malt die Madonna. Zeugnisse zum künstlerischen Selbstverständnis in der Malerei*, Worms, 1986

Kreytenberg 1970
 Kreytenberg, G., 'Hans Holbein d.J. – Die Wandgemälde im Basler Ratsaal', *Zeitschrift des Deutschen Vereins für Kunstwissenschaft*, XXIV, 1970, pp. 77–100

Kris and Kurz 1934
 Kris, E., and O. Kurz, *Die Legende vom Künstler. Ein geschichtlicher Versuch*, Vienna, 1934; new edn: Frankfurt-on-Main, 1980; English edn: *Legend, Myth, and Magic in the Image of the Artist: A Historical Experiment*, Foreword by E. H. Gombrich, New Haven and London, 1979

Kristeller 1990
 Kristeller, P. O., 'The European Diffusion of Humanism', *Italica*, XXXIX, 1962, pp. 1–20, and in Kristeller, *Renaissance Thought and the Arts: Collected Essays*, Princeton, NJ, 1990, pp. 69–88

Krom and Oellermann 1992
 Krohm, H., and E. Oellermann, eds, *Flügelaltäre des späten Mittelalters*, Berlin, 1992

Kruft 1985
 Kruft, H.-W., *Geschichte der Architekturtheorie. Von der Antike bis zur Gegenwart*, Munich, 1985

Krummer-Schroth 1964
 Krummer-Schroth, I., 'Zu Grünewalds Aschaffenburger Maria-Schnee Altar', *Anzeiger des Germanischen Nationalmuseums*, 1964, pp. 32–43

Kubler 1962
 Kubler, G., *The Shape of Time: Remarks on the History of Things*, New Haven and London, 1962; German edn: *Die Form der Zeit. Anmerkungen zur Geschichte der Dinge*, trans. B. Blumenberg with an introduction by G. Boehm, Frankfurt-on-Main, 1982

Kugler 1842
 Kugler, F., *A Hand-Book of the History of Painting, I: The Italian Schools*, ed. C. L. Eastlake, London, 1842

Kugler and Burckhardt 1847
 Kugler, F., *Handbuch der Geschichte der Malerei seit Constantin dem Grossen*, 2nd enlarged edn by J. Burckhardt, 2 vols, Berlin, 1847

Kultzen 1975
 Kultzen, R, *Alte Pinakothek München. Katalog Bd. V: Italienische Malerei*, Munich, 1975

Kunst der Reformationszeit 1983
 Kunst der Reformationszeit, exh. cat., Berlin, Staatliche Museen, 1983

Kunstführer Schweiz 1982
 Kunstführer durch die Schweiz, by H. Jenny, ed. Gesellschaft für Schweizerische Kunstgeschichte, 3 vols, 5th edn, Wabern, 1982

Kunsthaus Zurich 1984
 Kunsthaus Zürich. Meisterwerke aus der graphischen Sammlung, exh. cat., Zurich, Kunsthaus, 1984

Kurz 1943(1)
 Kurz, O., 'An Architectural Design for Henry VIII', *Burl. Mag.*, LXXXII, 1943, pp. 81–3

Kurz 1943(2)
 Kurz, O., 'Holbein and Others in a Seventeenth-century Collection', *Burl. Mag.*, LXXXIII, 1943, pp. 279–82

Landau 1978
 Landau, D., *Catalogo completo dell'opera grafica di Georg Pencz*, Milan, 1978

Landolt 1958
Landolt, H., 'Hans Holbein der Ältere und die Renaissance', *ZAK*, XVIII, 1958, pp. 167–71

Landolt 1972
Landolt, H., *100 Meisterzeichnungen des 15. und 16. Jahrhunderts aus dem Basler Kupferstichkabinett*, ed. Schweizerischer Bankverein, Basle, 1972

Landolt 1990
Landolt, H., 'Zu Hans Holbein d.J. als Zeichner', *Festschrift to Erik Fischer: European Drawings from Six Centuries*, Copenhagen, 1990

Langdon 1993
Langdon, H., *Holbein*, London, 1993

Lapaire 1992
Lapaire, C., *Peintures du Moyen Age*, Geneva, 1992

Lappenberg 1851
Lappenberg, J. M., *Urkundliche Geschichte des Hansischen Stahlhofes zu London*, Hamburg, 1851

Lauber 1962
Lauber, W., *Hans Holbein der Jüngere und Luzern* (Luzern im Wandel der Zeiten, vol. 22), Lucerne, 1962

Lauvergnat-Gagnière 1988
Lauvergnat-Gagnière, C., *Lucien de Samosate et le lucianisme en France au XVIème siècle. Athéisme et polémique*, Geneva, 1988

Lauvergnat-Gagnière 1991
Lauvergnat-Gagnière, C., 'Un peu de nouveau sur Nicolas Bourbon l'ancien', *Bibliothèque de l'Humanisme et de la Renaissance*, LIII, 1991, pp. 663–93

Lecoq 1987
Lecoq, A.-M., *François Ier imaginaire. Symbolique et politique à l'aube de la Renaissance française*, Paris, 1987

Leemann-Van Elck 1940
Leemann-Van Elck, P., *Die Offizin Froschauer. Zürich's berühmte Druckerei*, Zurich, 1940

Lefèvre d'Etaples 1523
Lefèvre d'Etaples, Jacques, *Commentarii initiatorii in quatuor Evangelien*, Basle: Cratander, 1523

Legenda 1535
Legenda. Opus Aureum quod Legenda Sanctorum vulgo nuncupatur, ed. Claudius de Rota, Lyon: Nicolas Petit, 1535

Legendario 1536
Legendario di santi vvulgare hystoriato novamente revisto, con summa diligentia castigato, Venice: Bernardin de Bendoni, 1536

Lehrs 1925
Lehrs, M., *Katalog der Kupferstich Martin Schongauers*, Vienna, 1925

Levenson 1981
Levenson, J. A., '*Jacopo de' Barbari and Northern Art of the Early Sixteenth Century*', PhD thesis, New York University 1978; Ann Arbor, MI: University Microfilms, 1981

Levey 1959
Levey, M., *National Gallery Catalogue: The German School*, London, 1959

Levi d'Ancona 1957
Levi d'Ancona, M., *The Iconography of the Immaculate Conception in the Middle Ages and Early Renaissance* (Monographs on Archaeology and the Fine Arts, vol. 7), New York, 1957

Lexer 1872–78
Lexer, M., *Mittelhochdeutsches Handwörterbuch*, 3 vols, Leipzig, 1872–78

Lichtenau 1537–38
Lichtenau, Conrad, *Chronicum Abbatis Urspergensis*, Strasbourg: Mylius, 1537–38

Lieb 1952
Lieb, N., *Die Fugger und die Kunst im Zeitalter der Spätgotik und frühen Renaissance* (Studien zur Fuggergeschichte vol. 10), Munich, 1952

Lieb and Stange 1960
Lieb, N., and A. Stange, *Hans Holbein der Ältere*, Munich, 1960

Liebenau 1888
Liebenau, T. von, *Hans Holbein d.J. Fresken am Hertenstein-Hause in Luzern nebst einer Geschichte der Familie Hertenstein*, Lucerne, 1888

Lightbown 1978
Lightbown, R., *Sandro Botticelli*, 2 vols, London, 1978

Lightbown 1986
Lightbown, R., *Mantegna. With a Complete Catalogue of the Paintings, Drawings and Prints*, Oxford, 1986

Lipking 1970
Lipking, L., *The Ordering of the Arts in Eighteenth-century England*, Princeton, NJ, 1970

Locher 1994
Locher, H., *Raffael und das Altarbild der Renaissance. Die 'Pala Baglioni' als Kunstwerk im sakralen Kontext*, Berlin, 1994

Lochner 1993–4
Stefan Lochner Meister zu Köln. Herkunft, Werke, Wirkung, exh. cat. ed. F. G. Zehnder, Cologne, Wallraf–Richartz–Museum, 1993–4

Loertscher 1957
Loertscher, G., *Die Kunstdenkmäler des Kantons Solothurn*, vol. 3: *Die Bezirke Thal, Thierstein und Dorneck*, Basle, 1957, pp. 345–424

Lomazzo 1598
Lomazzo, Paolo Giovanni, *A Tracte containing the Artes of curious Paintinge Caruinge & Buildinge written first in Italian, and englished by Richard Haydocke*, Oxford: Barnes for Haydocke, 1598

Luchsinger 1953
Luchsinger, F., *Der Basler Buchdruck als Vermittler italienischen Geistes 1470–1529* (Basler Beiträge zur Geschichtswissenschaft, vol. 45), Basle, 1953

Lütge 1965
Lütge, F., 'Der Untergang der Nürnberger Heiltumsmesse', *Jahrbücher für Numismatik und Geldgeschichte*, CLXXVIII, 1965

Luther, *see* Testament

Luther 1522
Luther, Martin, *Auszlegung der Episteln und Evangelien [..] vom Christag biß Uff den Sonntag nach Epiphanie*, Wittemberg: Grunenberg, 1522

Luther 1530
Luther, Martin, *Auslegung der Evangelien von Ostern bis auffs Advent, gepredigt durch Martinum Luther zu Wittemberg*, Wittemberg: Rhau, 1530

Luther 1883–1993
Luther, Martin, *D. Martin Luthers Werke*, 65 vols, Weimar: Böhlau *et al.*, 1883–1993

Luther 1983(1)
Köpfe der Lutherzeit, exh. cat. ed. W. Hofmann, Kunsthalle Hamburg, 1983

Luther 1983(2)
Luther und die Folgen für die Kunst, exh. cat. ed. W. Hofmann, Kunsthalle Hamburg, 1983

Luther 1983(3)
Martin Luther und die Reformation in Deutschland, exh. cat., Nuremberg, Germanisches National Museum, 1983

Lutz 1958
Lutz, H., *Conrad Peutinger* (Abhandlungen zur Geschichte der Stadt Augsburg; Schriftenreihe des Staatsarchives Augsburg, vol. 9), Augsburg, 1958

Major 1910
Major, E., 'Der mutmassliche Verfertiger des Dresdener Madonnenbildes', *Anzeiger für Schweizerische Altertumskunde*, n.s. XII, 1910, pp. 318–24

Major 1911
Major, E., 'Basler Horologienbücher mit Holzschnitten von Hans Holbein d.J.', *Monatshefte für Kunstwissenschaft*, IV, 1911, pp. 77–81

Mander 1604
Mander, Carel van, *Het Leven der Doorluchtighe Nederlandtsche en Hooghduytsche Schilders*, Alckmaer: Passchier van Westbusch, 1604

Mander 1618
Mander, Carel van, *Het Leven der Doorluchtighe Nederlandtsche en Hooghduytsche Schilders*, Amsterdam: van der Plasse, 1618

Mander 1935
Mander, Carel van, *Hans Holbein. A Biography*, trans. C. van de Wall, New York, 1935

Mander 1991
Mander, Carel van, *Das Leben der niederländischen und deutschen Maler (von 1400 bis ca. 1615)*, trans. H. Floerke, Worms, 1991

Mander 1994
Mander, Carel van, *The Lives of the Illustrious Netherlandish and German Painters from the first edition of the 'Schilder-boeck' (1603–1604)*. Intro. trans. and ed. H. Miedema, Dornspijk, 1994 [2 vols published]

Mansi 1901–27
Mansi, J. D., *Sacrorum Conciliorum nova et amplissima collectio*, 53 vols, Paris, 1901–27

Mantegna 1992
Andrea Mantegna., exh. cat. ed. J. Martineau; New York, Metropolitan Museum of Art; London, Royal Academy of Arts; 1992

Manuel 1979
Niklaus Manuel Deutsch. Maler, Dichter, Staatsmann, exh. cat., Kunstmuseum Berne, 1979

Marc'hadour 1963
Marc'hadour, G., *L'univers de Thomas More. Chronologie critique de More, Erasme, et leur époque (1477–1536)*, Paris, 1963

Margolin 1985
Margolin, J.-C., 'Un échange de correspondance humaniste à la veille de la Réforme: Henri Glarean et Oswald Myconius (1517–1524)', *La correspondance d'Erasme et l'épistolographie humaniste*, Colloquium, 1983 (Travaux de l'Institut international pour l'étude de la Renaissance et de l'Humanisme, 8), Brussels, 1985, pp. 145–81

Markow 1978
Markow, D., 'Hans Holbein's Steelyard Portraits, reconsidered', *Wallraf-Richartz-Jahrbuch*, XL, 1978, pp. 39–47

Marrou 1953
Marrou Henri, C., F. and F. and H. Leclercq, eds, *Dictionnaire d'archéologie chrétienne*, 15 vols, Paris, 1907–53

Martindale 1979
Martindale, A., *The Triumph of Caesar by Andrea Mantegna in the Collection of Her Majesty the Queen at Hampton Court*, London, 1979

Martingay 1989
Martingay, C., *Pour Saint Maurice et ses compagnons martyrs*, Geneva, 1989

Masseron 1957
Masseron, A, *Saint Jean Baptiste dans l'art*, Paris, 1957

Massing 1990
Massing, J. M., *Du texte à l'image. La Calomnie d'Apelle et son iconographie*, Strasburg, 1990

Maurer 1982(1)
Maurer, E., *Fünfzehn Aufsätze zur Geschichte der Malerei*, Basle, 1982

Maurer 1982(2)
Maurer, E., 'Vom Ziborium zum Triumphbogen. Skizzen zu einer Ikonologie des frühen Bilderrahmens', *Architektur und Sprache*, ed. C. Braegger, Munich, 1982, pp. 191–215

Maurer 1961
Maurer, F., *Die Kunstdenkmäler des Kantons Basel-Stadt*, vol. 4: *Die Kirchen, Klöster und Kapellen*, Basle, 1961

Maurer 1966
Maurer, F., *Die Kunstdenkmäler des Kantons Basel-Stadt*, vol. 5: *Die Kirchen, Klöster und Kapellen*, Basle, 1966

McCarthy 1987
McCarthy, M., *The Origins of the Gothic Revival*, New Haven and London, 1987

McEvansoneya 1996
McEvansoneya, P., 'Vertue, Walpole and the Documentation of the Buckingham Collection', *Journal of the History of Collections*, VIII/1, 1996, pp. 1–14

Meisen 1981
Meisen, K., *Nikolauskult und Nikolausbrauch im Abendlande. Eine Kultgeographisch-volkskundliche Untersuchung*, Düsseldorf, 1931 (reprinted Gesellschaft für Mittelrheinische Kirchengeschichte, 1981. Quellen und Abhandlungen zur Mittelrheinischen Kirchengeschichte, 41)

Meister 1986
Meister E.S. Ein oberrheinischer Kupferstecher der Spätgotik, exh. cat., Munich and Berlin 1986–7

Melanchthon 1596
Melanchthon, Philipp, *Tractatus historicus de Philippi Melanchthonis sententia de controversia Coenae Domini*, 1596

Melanchthon 1834–60
Melanchthon, Philipp, *Opera*, ed. C. G. Bretschneider and H. E. Bindsell, 28 vols, Halle, 1834–60

Melanchthon 1991
Melanchthon, Philipp, *Briefwechsel*, vol. 1: *Texte 1–254 (1514–1521)*, ed. R. Wetzel, Stuttgart and Bad Cannstatt, 1991

Melion 1991
Melion, W. S., *Shaping the Netherlandish Canon. Karel van Mander's 'Schilder-Boeck'*, Chicago and London, 1991

Mellen 1971
Mellen, P., *Jean Clouet: Complete Edition of the Drawings, Miniatures and Paintings*, London, 1971

Memling 1995
Memling, exh. cat., Paris, Louvre, 1995

Mende 1978
Mende, M., *Hans Baldung-Grien, Das graphische Werk*, Unterschneidheim, 1978

Meyer 1951
Meyer, F., *Die Beziehungen zwischen Basel und den Eidgenossen in der Darstellung der Historiographie des 15. bis 16. Jahrhunderts* (Basler Beiträge zur Geschichtswissenschaft, vol. 39), Basle, 1951

Meyer zur Capellen 1984
Meyer zur Capellen, J., 'Hans Holbeins "Laïs Corinthiaca"', *ZAK*, XLI, 1984, pp. 22–34

Meyers 1975
Meyers, J., *Painting and the Novel*, Manchester, 1975

Michael 1986
Michael, E., *The Drawings by Hans Holbein the Younger for Erasmus' 'Praise of Folly'* (Outstanding Doctoral Theses in the Fine Arts), New York and London, 1986

Michael 1990
Michael, E., 'Some Sixteenth-century Venetian Bible Woodcuts Inspired by Holbein's "Icones"', *Print Quarterly*, VII, 1990, pp. 238–47

Michael 1992
Michael, E., 'The Iconographic History of Hans Holbein the Younger's *Icones* and Their Reception in the Later Sixteenth Century', *Harvard Library Bulletin*, III, 1992, pp. 28–47

Michalski 1984
Michalski, S., 'Aspekte der protestantischen Bilderfrage', *Idea*, III, 1984, pp. 65–85

Miedema 1968
Miedema, H., 'The Term *Emblema* in Alciati', *JWCI*, XXXI, 1968, pp. 234–50

Mielke 1988
Mielke, H., *Albrecht Altdorfer. Zeichnungen, Deckfarbenmalerei, Druckgraphik*, exh. cat., Berlin and Regensburg, 1988

Milesio 1882
[Milesio, Giovanni Battista], 'G. B. Milesio's Beschreibung des Deutschen Hauses in Venedig. Aus einer Handschrift in Venedig', ed. G. M. Thomas, *Abhandlungen der philosophisch-philologischen Classe der königlich bayerischen Akademie der Wissenschaften*, XVI, 1882, pp. 1–100

Mitchell 1986
Mitchell, B., *The Majesty of the State: Triumphal Progresses of Foreign Sovereigns in Renaissance Italy (1494–1600)*, Florence, 1986

Momigliano 1950
Momigliano, A., 'Ancient History and the Antiquarian', *JWCI*, XIII, 1950, pp. 285–315

Monbritius 1910
Monbritius, B., *Sanctuarium seu Vitae Sanctorum*, Paris, 1910

Montias 1996
Montias, J.-M., *Le marché de l'art aux Pays-Bas, XVème-XVIIème siècle*, Paris, 1996

Monumenta Germaniae
Monumenta Germaniae Historica, Scriptores rerum merovingicarum, ed. B. Krusch, 7 vols, Hannover, 1884–1920

Morand 1991
Morand, K., *Claus Sluter. Artist at the Court of Burgundy*, Austin, TX, 1991

More 1963–
More, Sir Thomas, *The Yale Edition of the Complete Works of St Thomas More*, ed. G. E. Haupt, 14 vols published, New Haven and London, 1963–

Morgenthaler 1923
Morgenthaler, H., 'Die Auffindung und Erhebung der Thebäer-Reliquien in Solothurn 1473–74', *Zeitschrift für Schweizerische Kirchengeschichte*, XVII, 1923, pp. 161–81

Müling 1512
Müling, Johannes Adelphus, *Warhafftige Sag oder Red von dem Rock Jesu Christi Neulich in der heiligen Stat Trier erfunden*, Nuremberg: Weysenburger, 1512

Müling 1520
Müling, Johannes Adelphus, *Barbarossa. Ein warhafftige Beschreibung des Lebens und der Geschichte Keiser Friderichs des ersten genannt Barbarossa*, Strasburg: Grueniger, 1520

Müller 1988
Müller, C., *Hans Holbein d.J. Zeichnungen aus dem Kupferstichkabinett der Öffentlichen Kunstsammlung Basel*, exh. cat., Basle, Kunstmuseum, 1988

Müller 1989
Müller, C., 'Hans Holbein d.J. Ueberlegungen zu seinen frühen Zeichnungen', *ZAK*, XLVI, 1989, pp. 113–29

Müller 1991
Müller, C., 'New Evidence for Hans Holbein the Younger's Wall Paintings in Basel Town Hall', *Burl. Mag.*, CXXXIII, 1991, pp. 21–6

Müller 1993
Müller, J., *Concordia Pragensis. Karel van Manders Kunsttheorie im Schilder-Boeck. Ein Beitrag zur Rhetorisierung von Kunst und Leben am Beispiel der rudolfinischen Hofkünstler* (Veröffentlichungen des Collegium Carolinum, vol. 77), Munich, 1993

Müller 1996
Müller, C., *Öffentliche Kunstsammlung Basel. Kupferstichkabinett. Katalog der Zeichnungen des 15. und 16. Jahrhunderts. Teil 2A: Die Zeichnungen von Hans Holbein dem Jüngeren und Ambrosius Holbein*, Basle, 1996

Münster 1544(1)
Münster, Sebastian, *Cosmographiae universalis libri VI*, Basle: Petri, 1544

Münster 1544(2)
Münster, Sebastian, *Cosmographia Beschreibung aller Lender*, Basle: Petri, 1544

Münster 1550
Münster, Sebastian, *Cosmographiae universalis libri VI*, Basle: Petri, 1550

Muraro and Rosand 1976
Muraro, M., and D. Rosand, *Tiziano e la silografia veneziana del cinquecento*, exh. cat., Venice, Fondazione Giorgio Cini, 1976

Museum Lisbon 1977
Museu de Arte Antiga Lisboa, Lisbon, 1977

Museum Solothurn 1904
Museum der Stadt Solothurn. Katalog der Kunst-Abteilung. Herausgegeben von der Kunst-Kommission, Solothurn, 1904

Museum Solothurn 1950
Museum der Stadt Solothurn. Hundert Jahre Malerei aus Solothurner Privatbesitz. Ausstellung zur Hundertjahrfeier des Solothurner Kunstvereins, Solothurn, 1950

Nauert 1979
Nauert, C. G., 'Humanists, Scientists, and Pliny: Changing Approaches to a Classical Author', *The American Historical Review*, LXXXIV, 1979, pp. 72–85

Neilson 1938
Neilson, K. B, *Filippino Lippi: A Critical Study*, Cambridge, MA, 1938

Netter 1951
Netter, M., 'Hans Holbeins d.J. "Madonna des Bürgermeisters Jacob Meyer zum Hasen" und ihre Geheimnisse', *Basler Jahrbuch*, 1951, pp. 109–25

Numismatische Literatur 1500–1864
Numismatische Literatur 1500–1864. Die Entwicklung der Methoden einer Wissenschaft, ed. P. Berghaus, *Wolfenbütteler Forschungen*, LXIV, 1995

Ochsenbein
Ochsenbein, W., 'Der Prozess um die "Holbeinische Madonna"', *Gedenkschrift zum 75. Jährigen Jubiläum 1858–1933 Musik-Verein Helvetia Grenchen*, ed. W. Marti, W. Strub and A. Ochsenbein, Grenchen, 1933 pp. 69–105

Ost 1980
Ost, H., 'Ein italo-flämisches Hochzeitsbild und Ueberlegungen zur ikonographischen Struktur des Gruppenporträts im 16. Jahrhundert', *Wallraf-Richartz-Jahrbuch*, XLI, 1980, pp. 133–41

Osten 1953
Osten, G. von der, 'Job and Christ', *JWCI*, XVI, 1953, pp, 153–8

Osten 1961
Osten, G. von der, 'Studien zu Jan Gossaert', *De artibus opuscula XL: Essays in Honor of Erwin Panofsky*, ed. M. Meiss, 2 vols, New York, 1961, pp. 454–76

Osten 1983
Osten, G. von der, *Hans Baldung Grien. Gemälde und Dokumente*, Berlin, 1983

Overfield 1984
Overfield, J. H., *Humanism and Scholasticism in Late Mediaeval Germany*, Princeton, NJ, 1984

Pächt 1944
Pächt, O., 'Holbein and Kratzer as Collaborators', *Burl. Mag.*, LXXXIV, 1944, pp. 134–9

Panofsky 1921/22
Panofsky, Erwin, 'Dürers Stellung zur Antike', *(Wiener) Zeitschrift für Kunstgeschichte*, I, 1921/22, pp. 43–92

Panofsky 1942
Panofsky, E., 'Conrad Celtes and Kunz von der Rosen: Two Problems in Portrait Identification', *AB*, XXIV, 1942, pp. 39–54

Panofsky 1943
Panofsky, E., *Albrecht Dürer*, 2 vols, Princeton, NJ, 1943, second edn 1945

Panofsky 1949
Panofsky, E., 'Who is Jan van Eyck's "Tymotheos"?', *JWCI*, XII, 1949, pp. 80–90

Panofsky 1951
Panofsky, E., '"Nebulae in Pariete"; Notes on Erasmus' Eulogy on Dürer', *JWCI*, XIV, 1951, pp. 34–41

Panofsky 1953
Panofsky, E., *Early Netherlandish Painting: Its Origins and Characters*, 2 vols, Cambridge, MA, 1953

Panofsky 1955
Panofsky, E., *Meaning in the Visual Arts*, Garden City, NY, 1955

Panofsky 1964
Panofsky, E., *Tomb Sculpture. Four Lectures on its Changing Aspects from Ancient Egypt to Bernini*, ed. H. W. Janson, New York, 1964

Panofsky 1969
Panofsky, E., 'Erasmus and the Visual Arts', *JWCI*, XXXII, 1969, pp. 200–27

Panofsky 1975
Panofsky, E., *Meaning in the Visual Arts*, New York, 1955; German edn: *Sinn und Deutung in der bildenden Kunst*, Cologne, 1975

Panofsky 1977
Panofsky, E., *Das Leben und die Kunst Albrecht Dürers*, Munich, 1977

Panofsky 1979
Panofsky, E., *Renaissance and Renascenses in Western Art*, Stockholm, 1960; German edn: *Die Renaissancen der europäischen Kunst*, Frankfurt-on-Main, 1979

Panofsky 1993
Panofsky, E., *Grabplastik. Vier Vorlesungen über ihren Bedeutungswandel von*

Alt Aegypten bis Bernini, ed. H. W. Janson, prefatory notes by M. Warnke, Cologne, 1993

Pantaleon 1578
Pantaleon, H., *Der Erste Theil Teutscher Nation wahrhafften Helden*, Basle, 1578

Paret 1988
Paret, P., *Art as History: Episodes in the Culture and Politics of Nineteenth-century Germany*, Princeton, NJ, 1988

Parker 1945
Parker, K. T., *The Drawings of Hans Holbein in the Collection of His Majesty the King at Windsor Castle*, Oxford, 1945

Parler 1978
Die Parler und der schöne Stil 1350–1400. Europäische Kunst unter den Luxemburgern, exh. handbook ed. A. Legner, 6 vols, Cologne, City Museums, 1978

Parshall 1993
Parshall, P., 'Imago contrafacta: Images and Facts in the Northern Renaissance', *Art History*, XVI/4, 1993, pp. 554–79

Parshall 1995
Parshall, P., 'Art and Curiosity in Northern Europe', *Word & Image*, XI/4, 1995, pp. 327–31

Patin 1691
Patin, C. C., *Pitture scelte e dichiarate da Carla Catherina Patina Parigina, Accademica*, Venice: Hertz, 1691

Patin 1670
Patin, Charles, *Relation historique en forme de Lettre de Mr. Charles Patin Medecin de Paris*, Strasburg: Paulli, 1670

Patin 1674
Patin, Charles, *Relations historiques et curieuses de voyages, en Allemagne, Angleterre, Hollande, Bohême, Suisse, etc.*, Lyons: Muguet, 1674

Patin 1676
Patin, Charles, 'Index operum Joh. Holbenii', *Moriae Encomion, Stultitiae Laus, Des. Erasmi Rot. Declamatio*, Basle: Typis Genathianis, 1676

Patin 1682
Patin, Charles, *Lyceum Patavinum*, Padua: Frambotti, 1682

Patin 1709
[Patin, Charles], 'A Catalogue of the Paintings of Hans Holbein', in Desiderius Erasmus, *Moriæ Encomium or, a Panegyrick upon Folly*, London: Woodward, 1709

Patrologia 1844–65
Patrologiae cursus completus series latina, ed. J. P. Migne, 221 vols, Paris, 1844–65

Patrologia 1958–74
Patrologiae cursus completus series latina supplementum, ed. A. Hamman, 5 vols, Paris, 1958–74

Pauly 1894–1980
Paulys Real-Encyklopädie der classischen Altertumswissenschaft, ed. G. Wissowa and W. Kroll, 66 vols with 16 suppl. vols, Stuttgart, 1894–1980

Pélerin 1505
Pélerin, Jean [le Viateur], *De artificiali perspectiva*, Toul 1505, 2nd enlarged edn 1509, 3rd edn 1521

Perrig 1986
Perrig, A., 'Masaccios "Trinità" und der Sinn der Zentralperspektive', *Marburger Jahrbuch für Kunstwissenschaft*, XXI, 1986, pp. 11–43

Perrig 1987
Perrig, A., *Albrecht Dürer oder Die Heimlichkeit der deutschen Ketzerei. Die Apokalypse Dürers und andere Werke von 1495 bis 1513*, Weinheim, 1987

Petersmann 1983
Petersmann, F., *Kirchen- und Sozialkritik in den Bildern des Todes von Hans Holbein d.J.*, Bielefeld, 1983

Petrarch 1532
[Petrarch], *Franciscus Petrarcha, Von der Artzney bayder Glück / des guoten vnd widerwertigen. Unnd wess sich ain yeder inn Gelück vnd vnglück halten sol. Auss dem Lateinischen in das Teütsch gezogen. Mit künstlichen fyguren durchauss / gantz lustig vnd schoen gezyret. Mit künigklicher May. Gnad vnd Privilegio. Gedruckt zuo Augspurg durch Heynrich Steyner. M.D.XXXII*, reprinted Hamburg, 1984

Peutinger 1505
Peutinger, Conrad, *Romanae Vetustatis Fragmenta in Augusta Vindelicorum et ejus diocesi*, Augsburg: Ratoldus, 1505

Peutinger 1520
Peutinger, Conrad, *Inscriptiones vetustae Roman. et earum fragmenta*, Mainz: Schoeffer, 1520

Peutinger 1923
Peutinger, C., *Konrad Peutingers Briefwechsel*, ed. E. König, Munich, 1923

Philippot 1970
Philippot, P., *Pittura fiamminga e Rinascimento italiano*, Turin, 1970

Pieper 1964
Pieper, P., 'Ein Muttergottesbild von Hermann tom Ring', *Anzeiger des Germanischen Nationalmuseums*, 1964, pp. 57–70

Pinacoteca di Brera 1988
Pinacoteca di Brera. Scuole lombarda e piemontese 1300–1535, Milan, 1988.

Pittura in Italia 1988
La pittura in Italia, Il Cinquecento, ed. G. Briganti, 2 vols, Milan, 1988

Platter 1987
Platter, F., *Beschreibung der Stadt Basel 1610 und Pestbericht 1610–1611* (Basler Chroniken, vol. 11), Basle and Stuttgart, 1987

Plinius Secundus
C. Plinius Secundus, *Naturalis historiae libri XXXVII*, lib. 35; Latin text with German translation: *Naturkunde*, book 35, ed. R. König and G. Winkler, Munich and Darmstadt, 1978

Pliny 1967
Pliny, *Natural History*, 10 vols, ed. H. Rackham (Loeb Classical Library), London and Cambridge, MA, 1967

Plutarch 1518
[Plutarch], *Plutarchi Chaeronensis opuscula quaedam*, Basle: Johannes Froben, 1518

Plutarque 1985
Plutarque, *De Gloria Atheniensium*, Jean-Claude Thiolier ed., Paris: Presses de l'Université Paris-Sorbonne, 1985

Podro 1983
Podro, M., *The Critical Historians of Art*, New Haven and London, 1983

Poeschke 1993
Poeschke, J., ed., *Italienische Frührenaissance und nordeuropäisches Mittelalter. Kunst der frühen Neuzeit im europäischen Zusammenhang*, Munich, 1993

Poliziano 1514
[Poliziano, Angelo], *Disertissimi Viri Angeli Politiani linguae latinae vindicatoris, Epistulae lepidissimae*, ed. Petrus Aegidius, Antwerp: Theodoricus Martini, 1514

Poliziano 1522(1)
[Poliziano, Angelo], *Angeli Politiani, et aliorum virorum illustrium, Epistolarum libri duodecim*, Basle: Cratander, 1522

Poliziano 1522(2)
Poliziano, Angelo, *Miscellaneorum centuria una*, Basle: Curio, 1522

Pollitt 1974
Pollitt, J. J., *The Ancient View of Greek Art: Criticism, History and Terminology*, New Haven and London, 1974

Pope-Hennessy 1965
Pope-Hennessy, J., *Renaissance Bronzes from the Samuel H. Kress Collection*, London, 1965

Pope-Hennessy 1974
Pope-Hennessy, J., *Fra Angelico*, 2nd edn, London, 1974

Pope-Hennessy 1979
Pope-Hennessy, J., *The Portrait in the Renaissance*, Princeton, NJ, 1979

Pope-Hennessy 1985
Pope-Hennessy, J., *Donatello*, Florence, 1985

Popham 1944
Popham, A. E., 'Hans Holbein's Italian Contemporaries in England', *Burl. Mag.*, LXXXIV, 1944, pp. 12–17

Pordenone 1984
Il Pordenone, exh. cat. ed. C. Furlan, Pordenone, 1984

Portrait Medals 1994
The Currency of Fame: Portrait Medals of the Renaissance, exh. cat. ed. S. K. Scher, Washington, D.C.; New York, Frick, 1994

Preimesberger 1991
Preimesberger, R., 'Zu Jan van Eycks Diptychon der Sammlung Thyssen-Bornemisza', *ZfK*, LIV, 1991, pp. 459–89

Prohaska 1981
Prohaska, W., Art. 'Feige, Feigenbaum', *RDK*, Munich, 1981, VII, cols. 1010–56

Puppi 1962
Puppi, L., *Bartolomeo Montagna*, Venice, 1962

Purtle 1982
Purtle, C. J., *The Marian Paintings of Jan van Eyck*, Princeton, NJ, 1982

Putscher 1955
Putscher, M., *Raphael Sixtinische Madonna. Das Werk und seine Wirkung*, Tübingen, 1955

Puttfarken 1992
Puttfarken, T., 'Tizians Pesaro-Madonna: Massstab und Bildwirkung', *Der Betrachter ist im Bild. Kunstwissenschaft und Rezeptionsästhetik*, ed. W. Kemp, 2nd edn, Berlin, 1992, pp. 94–122

Quednau 1984
Quednau, R., 'Päpstliches Geschichstdenken und seine Verbildlichung in der Stanza dell'Incendio', *Münchner Jahrbuch der bildenden Kunst*, XXXV, 1984, pp. 83–128

Quednau 1992
Quednau, R., 'Kunstgeschichte im europäischen Kontext: Italienische Frührenaissance und nordeuropäisches Spätmittelalter', *Kunstchronik*, XLV, 1992, pp. 186–211

Rahmen 1990
Italian Renaissance Frames, exh. cat. ed. T. J. Newbery, G. Bisacca and L. B. Kanter; New York, Metropolitan Museum of Art, 1990

Raphael 1983(1)
Raphael dans les collections françaises, exh. cat., Grand Palais, Paris, 1983–4

Raphael 1983(2)
Raphael et l'art français, exh. cat., Paris, Grand Palais, 1983–4

Raphael 1985
Raphael invenit. Stampe da Raffaello nelle collezioni dell'istituto nazionale per la grafica., exh. cat. ed. G. Bernini Pezzini, S. Massari and S. Prosperi Valenti Rodinò, Rome, 1985

Rapp 1987
Rapp, J., 'Das Ligsalz-Epitaph des Münchner Renaissancemalers Hans Mielich', *Anzeiger der Germanischen Nationalmuseums Nürnberg*, 1987, pp. 161–93

Réau 1956–9
Réau, L., *L'iconographie de l'art chrétien*, 6 vols, Paris, 1956–9

Reinach 1985
Reinach, A., *Textes grecs et latins relatifs à l'histoire de la peinture ancienne [Recueil Milliet]* (1921), ed. A. Rouveret, Paris, 1985

Reindl 1977
Reindl, P., *Loy Hering. Zur Rezeption der Renaissance in Süddeutschland*, Basle, 1977

Reinhardt 1954–5(1)
Reinhardt, H., 'Bemerkungen zum Spätwerk Hans Holbeins d.Ae.', *ZAK*, XV, 1954–5, pp. 11–19

Reinhardt 1954–5(2)
Reinhardt, H., 'Die Madonna des Bürgermeisters Meyer von Hans Holbein d. J.. Nachforschungen zur Entstehungsgeschichte und Aufstellung des Gemäldes', *ZAK*, XV, 1954–5, pp. 244–54

Reinhardt 1965
Reinhardt, H., *Historisches Museum Basel. Die Barfüsserkirche* (Schweizerische Kunstführer, vol. 40), Berne, 1965

Reinhardt 1975–6
Reinhardt, H., 'Hans Holbein le jeune et Grünewald', *Cahiers Alsaciens d'Archéologie, d'Art et d'Histoire*, XIX, 1975–6, pp. 167–72

Reinhardt 1977
Reinhardt, H., 'Einige Bemerkungen zum graphischen Werk Hans Holbeins des Jüngeren', *ZAK*, XXXIV, 1977, pp. 229–60

Reinhardt 1978
Reinhardt, H., 'Baldung, Dürer und Holbein', *ZAK*, XXXV, 1978, pp. 206–16

Reinhardt 1979
Reinhardt, H., 'Die holbeinische Madonna des Basler Stadtschreibers Johann Gerster von 1520 im Museum zu Solothurn', *Basler Zeitschrift für Geschichte und Altertumskunde*, LXXIX, 1979, pp. 67–80

Reinhardt 1981
Reinhardt, H., 'Erasmus und Holbein', *Basler Zeitschrift für Geschichte und Altertumskunde*, LXXXI, 1981, pp. 41–70

Reinhardt 1982
Reinhardt, H., 'Nachrichten über das Leben Hans Holbeins des Jüngeren', *ZAK*, XLIX, 1982, pp. 253–76

Reinhardt 1983
Reinhardt, H., 'Hans Herbst. Un peintre bâlois, originaire de Strasbourg', *Cahiers Alsaciens d'Archéologie, d'Art et d'Histoire*, XXVI, 1983, pp. 135–50

Reinle 1948
Reinle, A., *Die heilige Verena von Zurzach. Legende, Kult, Denkmäler*, Basle, 1948

Reinle 1954
Reinle, A., *Die Kunstdenkmäler des Kantons Luzern*, vol. 3: *Die Stadt Luzern*, Part II, Basle, 1954

Reinle 1976
Reinle, A., 'Der Lehrstuhl für Kunstgeschichte an der Universität Zürich bis 1939', *Jahrbuch 1972/73 des Schweizerischen Instituts für Kunstwissenschaft*, Zurich, 1976, pp. 71–88

Reliquien 1989
Reliquien. Verehrung und Verklärung, ed. A. Legner, Cologne, 1989

Retables italiens 1978
Retables italiens du XIIIe au XVe siècle, exh. cat. ed. C. Ressort, Paris, Louvre (Les dossiers du Département des Peintures), 1978

Reusch 1976
Reusch, F., Art. 'Thebäische Legion', *LCI*, VIII, cols. 429–32

Riedler 1978
Riedler, M., *Blütezeit der Wandmalerei in Luzern*, Lucerne, 1978

Riggenbach 1944
Riggenbach, R., 'Die Besitzungen der Walliser in Basel', *Blätter aus der Walliser Geschichte*, IV, 1944, pp. 472–502

Ringbom 1984
Ringbom, S., *Icon to Narrative: The Rise of the Dramatic Close-up in Fifteenth-century Devotional Painting* (Acta Academiae Aboensis, Ser. A, Vol. 31, 2), 1965, 2nd edn, Dornspijk, 1984

Ritz 1962
Ritz, G. M., *Der Rosenkranz*, Munich, 1962

Roberts 1987
Roberts, A. M., 'North meets South in the Convent: The Altarpiece of Saint Catherine of Alexandria in Pisa', *ZfK*, L, 1987, pp. 187–206

Roberts 1993
Roberts, The Hon. J., *Holbein and the Court of Henry VIII: Drawings and Miniatures from The Royal Library, Windsor Castle*, exh. cat., Edinburgh, National Galleries of Scotland, 1993

Robertson 1968
Robertson, G., *Giovanni Bellini*, Oxford, 1968.

Roda 1986
Roda, B. von, *Der Peter-Rot Altar* (Basler Kostbarkeiten 7), Basle, Historisches Museum, 1986

Romano, Biraghi and Collura 1978
Romano, G., M. T. Biraghi and D. Collura, *Il Maestro della pala sforzesca* (Quaderni di Brera 4), Florence, 1978

Rosand 1982
Rosand, D., *Painting in Cinquecento Venice: Titian, Veronese, Tintoretto*, New Haven and London, 1982

Rösch 1986
Rösch, G., 'Il Fondaco dei Tedeschi', *Venezia e la Germania: arte, politica, commercio, due civiltà confronto*, ed. S. Biadene and L. Corrain, Milan, 1986, pp. 51–72

Rosenfeldt 1966
Rosenfeldt, H., "Der Totentanz als europäisches Phänomenon", *Archiv für Kunstgeschichte*, XLVIII, 1966, pp. 54–83

Roskill and Harbison 1987
Roskill, M., and C. Harbison, 'On the Nature of Holbein's Portraits', *Word and Image*, III, 1987, pp. 1–26

Roth 1942
Roth, P., *Durchbruch und Festsetzung der Reformation in Basel. Eine Darstellung der Politik der Stadt Basel im Jahre 1529 auf Grund der öffentlichen Akten* (Basler Beiträge zur Geschichtswissenschaft, vol. 8), Basle, 1942

Rott 1933–8
Rott, H., *Quellen und Forschungen zur südwestdeutschen und schweizerischen Kunstgeschichte im XV. und XVI. Jahrhundert*, 6 vols, Stuttgart, 1933–8

Rouveret 1989
Rouveret, A., *Histoire et imaginaire de la peinture ancienne* (Bibliothèque des Ecoles françaises d'Athènes et de Rome, fascicule 274), Paris and Rome, 1989

Rowlands 1980
Rowlands, J., 'Terminus, The Device of Erasmus of Rotterdam: A Painting by Holbein', *The Cleveland Museum of Art Bulletin*, LXVII, 1980, pp. 50–54

Rowlands 1985
Rowlands, J., *Holbein: The Paintings of Hans Holbein the Younger. Complete Edition*, London and Boston, 1985

Rowlands 1988
Rowlands, J., *The Age of Dürer and Holbein: German Drawings 1400–1550*, exh. cat., London, British Museum, 1988

Rubens 1977
Rubens, Peter Paul, *Drawings after Hans Holbein's Dance of Death*, ed. I.Q. van Regteren Altena, 2 vols, Amsterdam, 1977

Rudolf 1945
Rudolf, F., 'Oswald Myconius, der Nachfolger Oekolampads', *Basler Jahrbuch*, 1945, pp. 14–30

Ruhmer 1958
Ruhmer, E., *Tura. Paintings and Drawings: Complete Edition*, London, 1958

Ruhmer 1970
Ruhmer, E., *Grünewald Drawings: Complete Edition*, London, 1970

Rüsch 1983
Rüsch, E. G., *Vom Humanismus zur Reformation. Aus den Randbemerkungen von Oswald Myconius zum 'Lob der Torheit' des Erasmus von Rotterdam* (Theologische Zeitschrift, XXXIX, 1983, special edition), Basle, 1983

Sachs 1531
Sachs, Hans, *Klag Antwort und urteyl, zwischen Fraw Armut und Pluto dem Gott der reichthumb welches unter yhn das pesser sey*, Nuremberg: Niclas Meldemann, 1531

Salmon 1855
Salmon, A., 'Description de la ville de Tours sous le règne de Louis XI par F. Florio', *Mémoires de la société archéologique de Touraine*, VII, 1855, pp. 82–108

Salvini 1971
Salvini, R., and H. W. Grohn, *L'opera pittorica completa di Holbein il Giovane*, Milan, 1971

Salvini 1984
Salvini, R., 'Congetture su Holbein in Lombardia', *Fra Rinascimento, Manierismo e Realtà. Scritti di Storia dell'arte in memoria di Anna Maria Brizio*, ed. P. C. Marani, Florence, 1984, pp. 85–93

Salvini 1987
Salvini, R., *Raffaello e Dürer*, in: *Studi su Raffaello*, ed. M. S. Hamoud and M. L. Strocchi, Urbino, 1987, I, pp. 145–50

Salzer 1967
Salzer, A., *Die Sinnbilder und Beiworte Mariens in der deutschen Literatur und lateinischen Hymnenprosa des Mittelalters* [1886–1894], reprinted Darmstadt, 1967

Sambucus 1566
Sambucus, Johannes, *Emblemata*, Antwerp: Plantin, 1566

Sander 1995
Sander, J., *"Die Entdeckung der Kunst". Niederländische Kunst des 15. und 16. Jahrhunderts in Frankfurt*, exh. cat., Frankfurt-on-Main, Städel, 1995

Sandner 1983
Sandner, I., *Hans Hesse. Ein Maler der Spätgotik in Sachsen*, Dresden, 1983

Sandrart 1675–79
Sandrart, Joachim von, *L'Accademia Todesca della Architettura, Scultura et Pittura, oder Teutsche Academie der Edlen Bau-, Bild- und Mahlerey-Künste*, 2 vols, Nuremberg and Frankfurt: Christian Forberger, 1675–79; reprint of vol. I, intro. C. Klemm, Nördlingen, 1994

Sandrart 1925
Joachim von Sandrarts Academie der Bau-, Bild- und Mahlerey-Künste von 1675, ed. A. R. Peltzer Munich, 1925

Saulnier 1954
Saulnier, V.-L., 'Recherches sur Nicolas Bourbon l'ancien', *Bibliothèque de l'Humanisme et de la Renaissance*, XVI, 1954, pp. 172–91

Sauver l'art 1982
Sauver l'art? Conserver, analyser, restaurer, exh. cat., Musée Rath Geneva, Geneva, 1982

Saxl 1957
Saxl, F., 'Holbein and the Reformation', *Lectures*, London, 1957, I, pp. 277–85

Scailliérez 1991
Scailliérez, C., *Joos van Cleve au Louvre* (les dossiers du Département des peintures, 39), Paris, 1991

Scailliérez 1992
Scailliérez, C., *François Ier et ses artistes dans les collections du Louvre* (Monographies des musées de France), Paris, 1992

Scarisbrick 1994
Scarisbrick, D., *Jewellery in Britain 1066–1837: A Documentary, Social, Literary and Artistic Survey*, Norwich, 1994

Schabacker 1974
Schabacker, P. H., *Petrus Christus*, Utrecht, 1974

Schaffhausen 1989
Museum zu Allerheiligen Schaffhausen. Katalog der Gemälde und Skulpturen (SIK Kataloge Schweizer Museen und Sammlungen, 13), Schaffhausen, 1989

Scheurl 1509
Scheurl, Christoph, *Oratio doctoris Scheurli attingens litterarum prestantiam, necnon laudem ecclesie collegiate Vittenburgensis*, Leipzig: Martinus Herbipotesis, 1509

Schiller 1969–80
Schiller, G., *Ikonographie der christlichen Kunst*, 5 vols and index, Gütersloh, 1969–80

Schlegel 1988
Schlegel, A. W., *Les Tableaux*, trans. A.-M. Lang, E. Peter, Preface by Jean-Luc-Nancy, Paris, 1988

Schlink 1991
Schlink, W., *Der Beau-Dieu von Amiens. Das Christusbild der gotischen Kathedrale*, Frankfurt-on-Main, 1991

Schmid 1892
Schmid, H. A., *Hans Holbeins d. J. Entwicklung in den Jahren 1515–1526. I. Holbeins früheste Gemählde*, doctoral thesis, Würzburg, Basle: Druckerei der Allgemeinen Schweizer Zeitung, 1892

Schmid 1896
Schmid, H. A., 'Die Gemälde von Hans Holbein d. J. in Basler Grossratsaal', *Jahrbuch der Königlich Preussischen Kunstsammlungen*, XVII, 1896, pp. 73–96

Schmid 1899
Schmid, H. A., 'Holbeins Tätigkeit für die Basler Verleger', *Jahrbuch der Königlich Preussischen Kunstsammlungen*, XX, 1899, pp. 232–62

Schmid 1936
Schmid, H. A., *Die Wandgemälde im Festsaal des Klosters St. Georgen in Stein am Rhein*, Frauenfeld, 1936

Schmid 1945–8
Schmid, H. A., *Hans Holbein der Jüngere. Sein Aufstieg zur Meisterschaft und sein englischer Stil*, 3 vols, Basle, 1945–8

Schmidt 1977
Schmidt, P., *Die Illustration der Lutherbibel 1522–1700. Ein Stück abendländische Kultur- und Kirchengeschichte*, Basle: Reinhardt, 1962; reprinted Birsfelden and Basle, 1977

Schoenen 1967
Schoenen, P., Art. 'Epitaph', *RDK*, V, 1967, cols. 872–921

Scholtens 1938
Scholtens, H.J.J., 'Jan van Eyck's "H. Maagd met den Kartuizer" en de Exeter-Madonna te Berlijn', *Oud Holland*, LX, 1938, pp. 49–62

Schramm 1954–6
Schramm, P. E., *Herrschaftszeichen und Staatssymbolik. Beiträge zu ihrer Geschichte vom dritten bis zum sechzehnten Jahrhundert* (Schriften der Monumenta Germaniae historica, 13), 3 vols, Stuttgart, 1954–6

Schubiger 1992
Schubiger, B., 'Der hl. Ursus von Solothurn: Beobachtungen zum Kult und zur Ikonographie seit dem Hochmittelalter. Der Stellenwert eines lokalen Märtyrers im Leben einer Stadt', *ZAK*, XLIX, 1992, pp. 19–38

Schubiger and Schneller 1989
Schubiger, B., and D. Schneller, *Denkmäler in Solothurn und in der Verenaschlucht*, Solothurn, 1989

Schulte 1964
Schulte, A., *Geschichte der grossen Ravensburger Handelsgesellschaft: 1380–1530*, Wiesbaden, 1964

Schwabe 1983
Schwabe-Burckhardt, H. R., *Zunft zu Weinleuten in Basel (1233–1983)*, Basle, 1983

Schweikhart 1973
Schweikhart, G., *Fassadenmalerei in Verona vom 14. bis zum 20. Jahrhundert*, Munich, 1973

Schweikhart 1985
Schweikhart, G., 'L'influsso del Pordenone nei paesi del Nord', *Il Pordenone* (Atti del convegno internazionale di studio, Pordenone 1984), ed. C. Furlan, Pordenone, 1985, pp. 171–4

Schweizerisches Institut für Kunstwissenschaft 1973
Schweizerisches Institut für Kunstwissenschaft, exh. cat., 20th anniversary of the Swiss Institute for Art Research, Zurich, 1971

Shearman 1992
Shearman, J., *Only connect...: Art and the Spectator in the Italian Renaissance*, Princeton, NJ, 1992

Signatures
'Signatures', *Les Cahiers du Musée national d'art moderne*, XXXVI, 1991

Sille 1987
Sille, S., *Die gestickten Eckquartiere der Juliusbanner von 1512 und eine mailändische Werkstatt?*, M.A. thesis, University of Berne, 1987

Silver 1984
Silver, L., *The Paintings of Quinten Massys. With Catalogue Raisonné*, Montclair, NJ, 1984

Silver 1990
Silver, L., 'Paper Pageants: The Triumphs of Emperor Maximilian I', *'All the World's a Stage'. Art and Pageantry in the Renaissance and Baroque*, ed. B. Wish and S. Scott Munshower (Papers in Art History from the Pennsylvania State University, Vol. IV), University Park, PA, 1990, I, pp. 292–331

Simonsfeld 1887
Simonsfeld, H., *Der Fondaco dei Tedeschi und die deutsch-venezianischen Handelsbeziehungen*, 2 vols, Stuttgart, 1887, new edn Aalen, 1968

Skizzen 1989
Skizzen. Von der Renaissance bis zum Gegenwart aus dem Kupferstichkabinett Basel, exh. cat., Bielefeld, Kunsthalle; Basle, Öffentliche Kunstsammlung; 1989

Smith 1956
Smith, B. E., *Architectural Symbolism of Imperial Rome in the Middle Ages*, Princeton, NJ, 1956

Solar 1981
Solar, G., *J. Hackaert, die Schweizer Ansichten 1653–56*, Zurich, 1981

Spätantike und frühes Christentum 1983/84
Spätantike und frühes Christentum, exh. cat., Frankfurt, Liebighaus, 1983/84

Spätgotik am Oberrhein 1970
Spätgotik am Oberrhein, exh. cat., Kunsthalle Karlsruhe, 1970

Speyer 1983
Speyer, Wolfgang, Art. 'Gürtel', *Reallexikon für Antike und Christentum*, XIII, Stuttgart, 1983, cols. 1255–6

St Girons 1990
St Girons, B., 'Michel-Ange et Raphael: les enjeux d'une confrontation 1662–1824', *Les fins de la peinture*, ed. R. Démoris, Paris, 1990, pp. 173–94

St. Birgitta 1972
St. Birgitta, *Opera Minora II. Sermo angelius*, ed. S. Eklund, Uppsala, 1972

Stadler 1936
Stadler, F., *Hans von Kulmbach*, Vienna, 1936

Staehelin 1927–34
Staehelin, E., *Briefe und Akten zum Leben Oekolampads*, 2 vols, Leipzig, 1927–34

Staehelin 1960
Staehelin, A., *Professoren der Universität Basel aus fünf Jahrhunderten*, Basle, 1960

Stechow 1942
Stechow, W., 'Shooting at Father's Corpse', *AB*, XXIV, 1942, pp. 213–25

Stechow 1966
Stechow, W., *Northern Renaissance Art, 1400–1600*, Englewood Cliffs, NJ, 1966

Stehlin 1889
Stehlin, K., 'Regesten zur Geschichte des Buchdrucks 1501–1520', *Anhang zum Archiv für Geschichte des Deutschen Buchhandels*, XII, Part III, Leipzig, 1889

Steinberg 1974
Steinberg, R. M., 'Fra Bartolomeo, Savonarola and a Divine Image', *Mitteilungen des Kunsthistorischen Instituts in Florenz*, XVIII, 1974, pp. 319–28

Stimmer 1984
Tobias Stimmer 1539–1584. Spätrenaissance am Oberrhein, exh. cat., Kunstmuseum Basle, 1984

Stirm 1977
Stirm, M., *Die Bilderfrage in der Reformation*, Gütersloh, 1977

Stoichita 1995
Stoichita, V. I., 'Ein Idiot in der Schweiz. Bildbeschreibung bei Dostojevski', *Beschreibungskunst – Kunstbeschreibung*, ed. G. Boehm and H. Pfotenhauer, Munich, 1995, pp. 425–44

Stopp 1969
Stopp, F. J., 'Verbum Domini Manet in Aeternum: The Dissemination of a Reformation Slogan, 1522–1904 ', *Essays in German Language, Culture and Society*, ed. S. S. Prayer, London, 1969, pp. 123–35

Strauss, Jacobus 1523
Strauss, Jacobus, *Ein kurth Christenlich unterricht des grossen irrthumbs, so im heiligthüm zuo eren gehalten, dass dan nach gemainem gebrauch der abgötterey gantz gleich ist*, Erfurt: Buchführer, 1523

Strauss 1974
Strauss, W. L., *The Complete Drawings of Albrecht Dürer*, 6 vols, New York, 1974

Strauss 1976
Strauss, W. L., ed, *The Intaglio Prints of Albrecht Dürer: Engravings, Etchings & Drypoints*, New York, 1976

Strauss 1980
Strauss, W. L., ed., *Woodcuts and Woodblocks*, New York, 1980

Strieder 1959
Strieder, P., 'Hans Holbein d. Ae. und die deutschen Wiederholungen des Gnadenbildes von Santa Maria del Popolo', *ZfK*, XX, 1959, pp. 252–67

Strong 1967
Strong, R., *Holbein and Henry VIII*, London, 1967

Strong 1969
Strong, R., *Tudor and Jacobean Portraits*, 2 vols, London, 1969

Ströter-Bender 1992
Ströter-Bender, J., *Die Muttergottes. Das Marienbild in der christlichen Kunst . Symbolik und Spiritualität*, Cologne, 1992

Strub 1962
Strub, M., *Deux maîtres de la sculpture suisse du XVIème siècle: Hans Geiler et Hans Gieng*, Fribourg, 1962

Strümpel 1925–6
Strümpel, A., 'Hieronymus im Gehäus', *Marburger Jahrbuch für Kunstwissenschaft*, II, 1925–6, pp. 173–252

Stückelberg 1902–08
Stückelberg, E. A., *Geschichte der Reliquien in der Schweiz* (Schriften der schweizerischen Gesellschaft für Volkskunde, 5), 2 vols, Basle, 1902–08

Studer 1961
Studer, C., 'Der Prozess um die Solothurner Madonna von Hans Holbein dem Jüngeren', *Festgabe Max Obrecht*, Solothurn, 1961, pp. 59–67

Summers 1981
Summers, D., *Michelangelo and the Language of Art*, Princeton, NJ, 1981

Superstitio 1979
Superstitio. Ueberlieferungs- und theoriegeschichtliche Untersuchungen zur kirchlich-theologischen Aberglaubensliteratur des Mittelalters, Berlin, 1979

Sussmann 1929
Sussmann, V., 'Maria mit dem Schutzmantel', *Marburger Jahrbuch für Kunstwissenschaft*, v, 1929, pp. 285–351

Tanner 1981
Tanner, P., 'Das Marienleben von Hans Bock und seinen Söhnen im Kloster Einsiedeln', *ZAK*, xxxviii, 1981, pp. 75–93

Tappolet 1962
Tappolet, W., *Das Marienlob der Reformatoren. Martin Luther. Johannes Calvin. Huldrych Zwingli. Heinrich Bullinger*, Tübingen, 1962

Terner 1979
Terner, R., 'Bemerkungen zur "Madonna des Kanonikus van der Paele" ', *ZfK*, xlii, 1979, pp. 83–91

Testament 1522(1)
Das Newe Testament Deutzsch, ed. and trans. Martin Luther, 2 parts, Wittemberg: Cranach, 1522

Testament 1522(2)
Das neuw Testament yetzund recht gründlich teuscht. Welchs allein Christum unser seligkeit recht und klärlich leret. Mit gantz gelehrten und richtigen vorreden und der schweristen örteren kurtz aber gut ausslegung, Zu Basel durch Adam Petri im Christmond dess Jars M.D.xxij, trans. Martin Luther

Testament 1523
Das newe Testament klerlich ausz dem rechten grundt Teüscht. Mit gar gelerten vorreden Und kurtzer ettlicher schwerer örtter ausslegung, Zu Basel Durch Thomas Wolff im iar MDXXIII im Augustmonat, trans. Martin Luther

Testament 1523–24
Das Alte Testament deutsch, trans. Martin Luther, 3 parts, Basle: Petri, 1523–24

Testamentum novum 1521
Testamentum novum, trans. Desiderius Erasmus, Basle: Cratander, 1521

Thiel 1976
Thiel, P.J.J. van, *et al.*, *All the Paintings of the Rijksmuseum in Amsterdam. A complete illustrated Catalogue*, Amsterdam, 1976

Thürlemann 1990
Thürlemann, F., *Von Bild zum Raum. Beiträge zu einer semiotischen Kunstwissenschaft*, Cologne, 1990

Tizian
Tizian und sein Kreis. 50 venezianische Holzschnitte aus dem Berliner Kupferstichkabinett., cat. by P. Dreyer, Berlin n.d.

Tizian 1993
Le siècle de Titien. L'âge d'or de la peinture à Venise, exh. cat., Grand Palais, Paris, 1993

Tonjola 1661
Tonjola, Johannes, *Basilea sepulta*, Basle: E. König, 1661.

Trapp 1990
Trapp, J. B., *Essays on the Renaissance and the Classical Tradition* (Collected Studies, 323), Aldershot, 1990

Trapp 1991
Trapp, J. B., *Erasmus, Colet, and More: The Early Tudor Humanists and their Books*, London, 1991

Treitzsauerwein, M., *see* Weisskunig 1887

Trésor de Saint Nicolas de Fribourg 1983
Trésor de la cathédrale Saint Nicolas de Fribourg, ed. Y. Lehnherr and H. Schöpfer, exh. cat., Fribourg, Musée d'Art et d'Histoire, 1983

Treu 1959
Treu, E., *Die Bildnisse des Erasmus von Rotterdam*, Basle, 1959

Trudzinski 1984
Trudzinski, M., 'Von Holbein zu Brueghel. "Christus Vera Lux, Philosophi et Papa in Foveam Cadentes" ', *Niederdeutsche Beiträge zur Kunstgeschichte*, xxiii, 1984, pp. 63–116

Überwasser 1957
Überwasser, W., 'Der Universitätsaltar von Hans Holbein d.J.', *Kunstwerke aus dem Besitz der Albert-Ludwig-Universität Freiburg i.Br., 1457-1957*, Berlin, 1957, pp. 53–60

Uhle-Wettler 1994
Uhle-Wettler, S., *Kunsttheorie und Fassadenmalerei (1450–1750)*, doctoral thesis, University of Bonn, Alfter: VDG, 1994

Unger 1863
Unger, F. W., 'Ueber Holbein's Todesjahr', *Recensionen und Mittheilungen über bildende Kunst*, 11, no. 22, 26 December 1863, p. 273

Usuard 1965
Le martyrologe d'Usuard (Subsidia hagiographica no. 40), ed. J. Dubois Brussels, 1965

Vasari 1976
Vasari, Giorgio, *Le Vite de' più eccelenti pittori, scultori e architettori, nella redazione del 1550 e 1568. Testo a cura di Rosanna Bettarini. Commento secolare a cura di Paola Barocchi*, Florence: Studio per edizioni scelte, 1976

Vasari 1986
Vasari, Giorgio, *Le Vite de'più eccelenti Architetti, Pittori, et Scultori italiani da Cimabue insino a' Tempi nostri*, Florence: Lorenzo Torrentino, 1550, ed. L. Bellosi and A. Rossi, Turin, 1986

Venedig und Oberdeutschland 1993
Venedig und Oberdeutschland in der Renaissance. Beziehungen zwischen Kunst und Wirtschaft (Studi. Schriftenreihe des Deutschen Studienzentrums in Venedig, vol. 9), ed. B. Roeck, K. Bergdolt and A.J. Martin, Sigmaringen, 1993

Venturi 1882
Venturi, A., *La R. Galleria Estense in Modena*, Modena, 1882

Verougstraete-Marcq 1989
Verougstraete-Marcq, H., and R. van Schoute, *Cadres et supports dans la peinture flamande aux 15ème et 16ème siècles*, Heure-le-Romain, 1989

Vertue 1929–52
Vertue, George, 'Note-books', *Walpole Society*, xviii, xx, xxii, xxiv, xxvi, xxix, xxx, 1929–52

Vetter 1884
Vetter, F., 'Das S. Georgen-Kloster zu Stein am Rhein. Ein Beitrag zur Geschichte und Kunstgeschichte', *Schriften des Vereins für Geschichte des Bodensee's und seiner Umgebung*, no. 13, 1884, pp. 24–109

Vetter 1952
Vetter, V., *Baslerische Italienreisen vom ausgehenden Mittelalter bis in das 17. Jahrhundert* (Basler Beiträge zur Geschichtswissenschaft, vol. 44), Basle, 1952

Viaene 1965
Viaene, A., 'Het grafpaneel van Kannunik van de Paele', *Biekorf: Westvlaams Archief voor Geschiedenis, Oudheidkunde en Folklore*, xi, 1965, pp. 261–5

Viale 1969
Viale, V., *Catalogo del Civico Museo Francesco Borgogna. I dipinti*, Vercelli, 1969

Vignau-Wilberg 1973
Vignau-Wilberg, P., *Museum der Stadt Solothurn. Gemälde und Skulpturen*, (Swiss Institute for Art Research, Zurich. Catalogues of Swiss Museums and Collections, 2), Solothurn, 1973

Vitruvius 1511
M. Vitruvius per Iocundum solito castigatior factus cum figuris et tabula ut iam legi et intellegi possit, ed. Fra Giocondo, Venice: Tridinus, 1511

Vitruvius 1521
Vitruvius, *De Architectura*, ed. Cesare Cesariano, Como, 1521; reprinted Munich, 1969

Vives 1534
Vives, Juan-Luis, *De epistolis conscribendis*, Antwerp: Hillenius, 1534

Vives 1543
[Vives, Juan-Luis], *Linguae latinae exercitatio, Io. Lodo. Vivis Valentini*, Basle: Vuinter, 1543

Vögelin 1879

Vögelin, S., 'Ergänzungen und Nachweisungen zum Holzschnittwerk Hans Holbeins des Jüngeren', *Repertorium für Kunstwissenschaft*, II, 1879, pp. 336–7

Vögelin 1887

Vögelin, S., 'Wer hat Holbein die Kenntnis des classischen Althertums vermittelt?', *Repertorium für Kunstwissenschaft*, X, 1887 pp. 345–71

Vogelsang 1985

Vogelsang, U., *Gemälderestaurierung im 19. Jahrhundert am Beispiel Andreas Eigner*, doctoral thesis, University of Cologne, Stuttgart: Polyfoto & Vogt, 1985

Volz 1972

Volz, P., *Conrad Peutinger und das Entstehen der deutschen Medaillensitte zu Augsburg 1518*, doctoral thesis, University of Heidelberg, 1972

Voragine 1516

Voragine, Jacobus de, *Legende Sanctorum Revenredissimi Fratris Jacobi de Voragine Genuensis Archiepiscopi ordinis predicatorum sanctorum ac festorum per totum annum*, Venice: Nicolas de Franckfordia, 2 September 1516

Voragine 1965

Voragine, Jacobus de, *Legenda sanctorum*, ed. J.G.Th. Graesse, Dresden and Leipzig, 1846, reprinted Osnabrück, 1965

Waal 1967

Waal, H. van de, 'The linea Summae tenuitatis of Apelles', *Zeitschrift für Aesthetik und allgemeine Kunstwissenschaft*, XII, 1967, pp. 5–32

Wackernagel 1951–75

Wackernagel, H. G., *Die Matrikel der Universität Basel*, 4 vols, Basle, 1951–75

Wackernagel 1896

Wackernagel, R., 'Der Stifter der Solothurner Madonna Hans Holbeins', *Zeitschrift für die Geschichte des Oberrheins*, 50, n.s. vol. XI, 1896, pp. 442–55

Wackernagel 1907–54

Wackernagel, R., *Geschichte der Stadt Basel*, 4 vols and index, Basle, 1907–54

Waelchli 1941

Waelchli, G., *Frank Buchser (1828–1890) Leben und Werk*, Zurich, 1941

Waetzoldt 1938

Waetzoldt, W., *Hans Holbein der Jüngere. Werk und Welt*, Berlin, 1938

Walpole 1760

Walpole, Horace, *Catalogue of Pictures and Drawings in the Holbein-Chamber at Strawberry Hill*, Strawberry Hill, 1760

Walpole 1782

Walpole, Horace, *Anecdotes of Painting in England*, 3rd edn, 5 vols, London: Dodsley, 1782

Walpole 1826–8

Walpole, Horace, *Anecdotes of Painting in England*, ed. J. Dallaway, 5 vols, London, 1826–8

Walpole 1970

Walpole, Horace, *Walpole's Correspondence with the Rev. William Cole*, ed. N. S. Lewis and A. Dayle Wallace, 2 vols, New Haven, 1970

Wang 1975

Wang, A., *Der 'Miles christianus' im 16. und 17. Jahrhundert und seine mittelalterliche Tradition. Ein Beitrag zum Verhältnis von sprachlicher und graphischer Bildlichkeit*, Berne, 1975

Wanner 1969

Wanner, G. A., 'Wein und Brot in alten Basel. Die Zünfte zu Weinleuten, zu Rebleuten und zu Brotbecken', *Staatskalender mit Haushaltungsbuch*, 1969, pp. 7–22

Wappenbuch der Stadt Basel

Wappenbuch der Stadt Basel, ed. W. R. Staehelin, 2 vols, Basle, 1917–29

Waquet 1979

Waquet, F., 'Guy et Charles Patin père et fils, et la contrebande du livre à Paris au XVIIème siècle', *Journal des Savants*, 1979, pp. 125–48

Waquet 1985

Waquet, F., 'Charles Patin (1633–1693) et la République des lettres: étude d'un réseau intellectuel dans l'Europe du XVIIème siècle', *Lias*, XII, 1985, pp. 115–36

Waquet 1989

Waquet, F., 'Collections et érudition au XVIIème siècle: l'exemple de Charles Patin', *Annali della Scuola Normale Superiore di Pisa*, n.s. 3, XIX, 1989, pp. 979–1000

Warburg 1979

Warburg, A., *Ausgewählte Schriften und Würdigungen* (Saecula spiritualia, vol. I), ed. D. Wuttke and C. G. Heise, Baden-Baden, 1979

Warnke 1984

Warnke, M., *Cranachs Luther. Entwürfe für ein Image*, Frankfurt-on-Main, 1984

Warnke 1993

Warnke, M., 'Chimären der Phantasie', *Pegasus und die Künste*, exh. cat. ed. C. Brink and W. Hornbostel, Hamburg, Museum für Kunst und Gewerbe, 1993, 1993, pp. 61–9

Weale 1928

Weale, W.H.J., *The van Eycks and their Art*, London, 1912, reprinted 1928

Weber 1977

Weber, B., '"Die Auffindung des heiligen Ursus". Ein unbekannt gebliebener Holzschnitt von Urs Graf (1519)', *ZAK*, XXXIV, 1977, pp. 261–9

Weckwerth 1957

Weckwerth, A., 'Der Ursprung des Bildepitaphs', *ZfK*, XX, 1957, pp. 147–85

Wedgwood 1964 see Kennedy 1964

Weiss-Bass 1958

Weiss-Bass, F., *Weingewerbe und Weinleutenzunft im alten Basel. Beiträge und Dokumente*, Basle, 1958

Weisskunig 1887

Der Weisskunig nach den Dictaten und eigenhändigen Aufzeichnungen Kaiser Maximilians I., zusammengestellt von Marx Treitzsauerwein von Ehrentreitz, ed. A. Schultz, in *Jahrbuch der kunsthistorischen Sammlungen des Allerhöchsten Kaiserhauses*, VI, 1887, pp. 1–558

Weitnauer 1931

Weitnauer, A., *Venezianischer Handel der Fugger: nach der Musterbuchhaltung des Matthaeus Schwarz* (Studien zur Fuggergeschichte, vol. 3), Munich and Leipzig, 1931

Welt im Umbruch 1980

Welt im Umbruch. Augsburg zwischen Renaissance und Barock, exh. cat., 2 vols, Augsburg, 1980

Werner 1980

Werner, G., *Nützliche Anweisung zur Zeichenkunst. Illustrierte Lehr-und Vorlagenbücher* (Kataloge des Germanischen Nationalmuseums Nürnberg), Nuremberg, 1980

Wethey 1965–75

Wethey, H. E., *The Paintings of Titian. Complete Edition*, 3 vols, London, 1969–75

Widmer 1990

Widmer, B., 'Der Ursus- und Viktorkult in Solothurn', *Solothurn. Beiträge zur Entwicklung der Stadt im Mittelalter: Kolloquium vom 13.–14. November 1987 in Solothurn*, ed. B. Schubiger (Veröffentlichungen des Instituts für Denkmalpflege an der ETH Zürich, vol. 9), Zurich, 1990, pp. 33–81

Wilde 1929

Wilde, J., 'Die "Pala di San Cassiano" von Antonello da Messina', *Jahrbuch der kunsthistorischen Sammlungen in Wien*, n.s. 3, 1929, pp. 57–72

Wilde 1974

Wilde, J., *Venetian Art Form from Bellini to Titian*, Oxford, 1974

Wimpfeling 1505

Wimpfeling, Jacob, *Epithoma rerum Germanicarum usque ad nostra tempora*, Strasburg: Prüs, 1505

Wind 1937/38

Wind, E., 'Studies in Allegorical Portraiture I', *JWCI*, I, 1937/38, pp. 138–62.

Wind 1938/39

Wind, E., '"Hercules" and "Orpheus": Two Mock-heroic Designs by Dürer', *JWCI*, II, 1938/39, pp. 206–18

Winkler 1936–39
Winkler, F., *Die Zeichnungen Albrecht Dürers*, 4 vols, Berlin, 1936–39
Winkler 1959
Winkler, F., *Hans von Kulmbach. Leben und Werk eines fränkischen Künstlers der Dürerzeit* (Die Plassenburg. Schriften für Heimatforschung und Kulturpflege in Ostfranken, vol. 14), Kulmbach, 1959
Winner 1992
Winner, M., ed., *Der Künstler über sich in seinem Werk* (International Symposium of the Bibliotheca Hertziana Rome 1989), Weinheim, 1992
Winzinger 1975
Winzinger, F., *Albrecht Altdorfer. Die Gemälde*, Munich and Zurich, 1975
Wirth 1963
Wirth, K.-A., 'Imperator pedes papae deosculatur', *Festschrift für Harald Keller*, Darmstadt, 1963, pp. 175–221
Wirth 1981
Wirth, J., 'Le dogme en image, Luther et l'iconographie', *Revue de l'Art*, LII, 1981, pp. 9–23
Wirth 1989
Wirth, J., *L'image médiévale. Naissance et développements (VIe–XVe siècle)*, Paris, 1989
Wittgens
Wittgens, F., *Vincenzo Foppa*, Milan, n.d.
Wittkower 1950
Wittkower, R., 'The Artist and the Liberal Arts', *Eidos. A Journal of Painting Sculpture and Design*, 1950, pp. 11–17
Wölfflin 1931
Wölfflin, H., *Italien und das deutsche Formgefühl*, Munich, 1931
Woltmann 1863(1)
Woltmann, A., *De Johannis Holbenii, celeberrimi pictoris, origine, adolescentia, primis operibus. Dissertatio inauguralis*, 26 November 1863, Breslau [1863]
Woltmann 1866–68
Woltmann, A., *Holbein und seine Zeit*, 2 vols, Leipzig, 1866–68
Woltmann 1874–76
Woltmann, A., *Holbein und seine Zeit. Des Künstlers Familie, Leben und Schaffen*, 2 vols, 2nd corrected edn, Leipzig, 1874–76.
Wood 1995
Wood, C., '"Curious Pictures" and the Art of Description', *Word & Image*, 11/4, 1995, pp. 332–52
Wornum 1867
Wornum, R. N., *Some Account of the Life and Works of Hans Holbein, Painter, of Augsburg*, London, 1867
Würzbach 1856–90
Würzbach, C. von, *Biographisches Lexicon des Kaiserthums Österreichs*, 60 vols, Vienna, 1856–90
Wüthrich 1972
Wüthrich, L., 'Hans Herbst, ein Basler Maler der Frührenaissance', *Actes du 22ème congrès international d'histoire de l'art, Budapest, 1969. Evolution générale et développements régionaux en histoire de l'art*, 3 vols, ed. G. Rozsa, Budapest, 1972, II, pp. 771–8, III, pp. 587–90
Wüthrich 1978
Wüthrich, L., 'Ein Altar des ehemaligen Klosters Sankt Maria Magdalena in Basel. Interpretation des Arbeitsvertrags von 1518 und Rekonstruktionsversuch', *ZAK*, XXXV, 1978, pp. 108–19
Wüthrich 1990
Wüthrich, L., *Der sogenannte "Holbein-Tisch". Geschichte und Inhalt der bemalten Tischplatte des Basler Malers Hans Herbst von 1515. Ein frühes Geschenk an die Burger-Bibliothek Zürich, 1633* (Mitteilungen der Antiquarischen Gesellschaft in Zürich, vol. 57), Zurich, 1990
Wüthrich 1993
Wüthrich, L. H., *Das druckgraphische Werk von Matthaeus Merian d.Ae.*, vol. 3: *Die grossen Buchpublikationen*, Hamburg, 1993
Wuttke 1967
Wuttke, D.r, 'Unbekannte Celtis-Epigramme zum Lobe Dürers', *ZfK*, XXX, 1967, pp. 321–5
Wuttke 1980
Wuttke, D., 'Dürer und Celtis: von der Bedeutung des Jahres 1500 für den deutschen Humanismus. Jahrhundertfeier als symbolische Form', *Journal of Medieval and Renaissance Studies*, X, 1980, pp. 73–129
Yates 1975
Yates, F. A., *Astraea: The Imperial Theme in the Sixteenth Century*, London, 1975
Zehnder 1990
Zehnder, F. G., *Katalog der Altkölner Malerei*, (Catalogue of the Wallraf–Richartz–Museum, XI), Cologne, 1990
Zetter-Collin 1897
Zetter-Collin, F.-A., 'Die Zetter'sche Madonna von Solothurn', *Die Schweiz*, I, 1897 no. 15, pp. 319–22; no. 16, pp. 338–42; no. 18, pp. 375–8
Zetter-Collin 1902(1)
Zetter-Collin, F.-A., 'Die Zetter'sche Madonna von Solothurn von Hans Holbein dem Jüngern vom Jahre 1522. Ihre Geschichte, aus Originalquellen ergänzt und zusammengestellt', *Denkschrift zur Eröffnung von Museum und Saalbau der Stadt Solothurn*, Solothurn, 1902, pp. 121–50
Zetter-Collin 1902(2)
Zetter-Collin, F.-A., 'Geschichte des Kunstvereins der Stadt Solothurn und seiner Sammlungen', *Denkschrift zur Eröffnung von Museum und Saalbau der Stadt Solothurn*, Solothurn, 1902, pp. 43–120
Zuchold 1984
Zuchold, G. H., 'Luther=Herkules. Der antike Heros als Siegessymbol für Humanismus und Reformation', *Idea*, III, 1984, pp. 49–64
Zwingli 1905–56
Zwingli, H., *Sämtliche Werke*, ed. E. Egli, 14 vols, Berlin, Leipzig and Zurich, 1905–56

Photographic Acknowledgements

The authors and publishers wish to express their thanks to the following sources of illustrative material and/or permission to reproduce it (excluding those already named in the captions):

Städtische Kunstsammlungen Augsburg: 152, 153; Uffico dei monumenti storici, Bellinzona: 198; Staatliche Museen Preussischer Kulturbesitz, Berlin/ Jörg P. Anders: 39, 42, 93, 109, 133, 219, 236, 240, 242; Archiv Oskar Bätschmann, Berne: 8, 14, 16, 17, 33, 57, 59, 61, 62, 63, 64, 81, 82, 90, 119, 128, 137, 142, 149, 163, 164, 168, 176, 179, 183, 201, 212, 213, 217, 218, 228, 243, 246, 261; Institut Royal du Patrimoine Artistique/ A.C.L., Brussels: 48; Martin Bühler: 3, 24, 25, 34, 40, 41, 46, 56, 87, 88, 97, 98, 99, 100, 103, 104, 112, 122, 129, 165, 172, 184, 185, 186, 188, 189, 191, 194, 196, 209, 226, 234; Richard Carafelli: 245; Stephen Chapman: 28; Cleveland Museum of Art, gift of Dr & Mrs Sherman E. Lee in memory of Milton S. Fox: 215; A.C. Cooper Ltd: 229; Foto Dreissler: 37, 38; Staatliche Kunstsammlungen Dresden/Deutsche Fotothek/Ludwig: 232; Sächsiche Landesbibliothek Dresden/Körner: 51; A. Eaton: 19; National Galleries of Scotland, Edinburgh: 161; Deposito della Sopraintendenza per i Beni Artistici et Storici di Firenze: 202; Fratelli Alinari: 170, 171, 175; Photographie Giraudon: 190; Stichting Vrienden van het Mauritshuis, The Hague: 237; © Her Majesty the Queen: 31, 110, 197, 222, 233, 250, 256; Luiz Hossaka: 255; Bernd-Peter Keiser: 11, 167; Gottfried Keller-Stiftung: 79; Klut/Dresden: 193; Rheinisches Bildarchiv, Köln: 35, 36; Courtauld Institute of Art, London: 260; E.T. Archive, London: front of jacket; National Gallery, London: 28; Royal Academy of Arts, London: 266; Photo © Thyssen-Bornemisza Collection, Madrid: 244; Bayerische Staatsgemäldesammlungen, Munich: 58, 125, 140; Metropolitan Museum of Art, New York, Rogers Fund: 20; Art Gallery of Ontario, Toronto, bequest of John Paris Bicknell: 264; Agence Photographique de la Réunion des Musées Nationaux, Paris: 106, 136, 150, 187, 195, 199, 200, 206, 207, 216; Agence Photographique de la Réunion des Musées Nationaux/G. Blot/C. Jean: 224, 252; Agence Photographique de la Réunion des Musées Nationaux/Hervé Lewandowski: 192; Agence Photographique de la Réunion des Musées Nationaux/Jean Schormans: 223; Bibliothèque Cantonale Jurassienne, Porrentruy: 174; Getty Centre for Art History and the Humanities, Santa Monica, CA: 173, 178, 259, 263; Scala Fotografico: frontispiece; H.A. Schmid: 81; Yves Siza: 144; Sotheby's, London: 210; Dr Willi Vomstein: 154, 155, 156; National Gallery of Art, Washington, DC: Ailsa Mellon Bruce Fund 239, Samuel H. Kress Collection 132, Rosenwald Collection 10, Andrew W. Mellon Collection 235, 245; Rodney Todd-White Ltd: 197; O. Zimmermann: 113; Schweizerisches Institut für Kunstwissenschaft, Zurich: 117, 151, 160 and 169.

Index

252